ANNUAL ILL

university college
for the creative arts
at canterbury, epsom, farnham
maidstone and rochester

Maidstone, Oakwood Park, Maidstone, Kent, ME16 8AG 01622 620120

This book is to be returned on or before the last date stamped below.
Fines will be charged on overdue books.

SOCIETY OF ILLUSTRATORS
47TH ANNUAL OF AMERICAN ILLUSTRATION

FROM THE EXHIBITION HELD IN THE GALLERIES OF THE
MUSEUM OF AMERICAN ILLUSTRATION AT THE SOCIETY OF ILLUSTRATORS
128 EAST 63RD STREET, NEW YORK CITY
FEBRUARY 9 – MAY 7, 2005

PUBLISHED BY SOCIETY OF ILLUSTRATORS AND COLLINS DESIGN

COLLINS|DESIGN
An Imprint of HarperCollinsPublishers

ILLUSTRATORS 47

Society of Illustrators, Inc.
128 East 63rd Street, New York, NY 10021-7303
www.societyillustrators.org

HarperCollins books may be purchased for educational, business, or sales promotional use.
For information, please write: Special Markets Department, HarperCollins Publishers Inc.,
10 East 53rd Street, New York, NY 10022.

First Edition

While the Society of Illustrators makes every effort possible to publish full and correct credits for each
 work included in this volume, sometimes errors of omission or commission may occur. For this the
 Society is most regretful, but hereby must disclaim any liability.

As this book is printed in four-color process, a few of the illustrations reproduced here may appear to be
 slightly different than in their original reproduction.

Photo credits: Steve Brodner by Marianne Barcellona, Peter Kuper by Holly Kuper

Published by:
Collins Design
An Imprint of HarperCollins*Publishers*
10 East 53rd Street
New York, NY 10022
Tel: (212) 207-7000
Fax: (212) 207-7654
collinsdesign@harpercollins.com
www.harpercollins.com

Library of Congress Control Number: 2005936322

ISBN10: 0-06-084787-5
ISBN13: 978-0-06-084787-6

Distributed throughout the world by:
HarperCollins*Publishers*
10 East 53rd Street
New York, NY 10022
Fax: (212) 207-7654

Editor, Jill Bossert
Book and jacket design by Erin Mayes and DJ Stout, Pentagram Design
Jacket cover illustration by Paul Davis

First Printing, 2006
Printed in Korea

SI 47
TABLE OF CONTENTS

As an artist starting out in my studies, I spent countless hours poring over the pages of the Society of Illustrators Annuals. It was there that I learned what illustration was and could be. It inspired me, as it has so many others before and since, to create the best work possible and to push the boundaries of the field. Years later it continues to inspire, and it remains both the best and most comprehensive annual exhibition of the art of illustration.

It's been a great honor to chair the Society of Illustrators 47th Annual Exhibition of American Illustration and to have had the opportunity to work with so many generous and talented individuals in putting this show together. This year, over 5,000 entries were submitted from virtually every corner of the globe, and the 510 pieces selected are a testament to the quality and diversity of our field. This exhibit makes clear how vital this art form remains, and it displays the broad vision that illustration represents in the 21st century.

It's also been a rewarding experience to witness the process in person and to see the commitment that the artists, jurors, and staff bring to the undertaking. It takes an amazing group of people to make a show like this happen and it's been awe-inspiring to observe the hard work that goes on behind the scenes. I'd like to extend my thanks to some of the folks who've been a part of that effort, beginning with past chair Anita Kunz for inviting me to be involved in this project, as well as my co-chair Tim Bower, whose insight helped steer me through some of the curves encountered along the way. I'd also like to thank artist Gary Taxali and designer Devin Pedzwater, who created the Call for Entries poster and collateral materials for this year's show. Their work set the tone for the Annual and beautifully represented the hopes and anxieties we all feel when facing the judgment of our peers. And, of course, the wonderful staff at the Society: Terry, Phyllis, Michael, Mark, and in particular, Kevin Schneider, who collected, sorted, and organized every aspect of this show so seamlessly that it appeared to run itself. Thanks also to Erin Mayes and DJ Stout of Pentagram for their extraordinary work on the design of this Annual, and to photographer Nils Juuhl-Hansen for his generous contribution. Last but certainly not least, the jury of 44 top art directors and illustrators who gave their time and expertise in selecting the work you see in these pages. I may be biased, but I think they've put together one of the best exhibits in years and I'm deeply grateful to them.

Marc Burckhardt

MARC BURCKHARDT
Chair, 47th Annual Exhibition

Portrait by Tim Bower

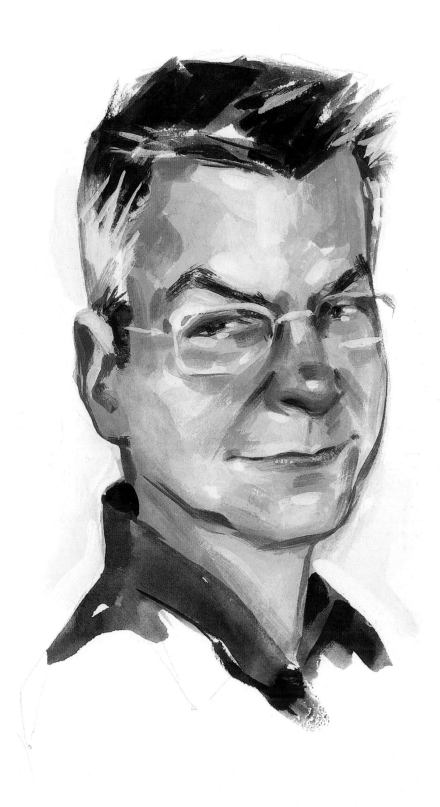

Hall of Fame 2005
and
Hamilton King Award

Since 1958, the Society of Illustrators has elected to its Hall of Fame artists recognized
for their "distinguished achievement in the art of illustration."
The list of previous winners is truly a "Who's Who" of illustration. Former presidents of
the Society meet annually to elect those who will be so honored.

The Hamilton King Award, created by Mrs. Hamilton King in memory of her husband
through a bequest, is presented annually for the best illustration of the year by a member of the Society.
The selection is made by former recipients of this award and may be won only once.

From an address delivered at the Society of Illustrators
President's Dinner on June 23, 2005.

To me, Jack Davis is to humorous illustration what Joe Di Maggio was to baseball. And now, the induction of Davis to the Society of Illustrators Hall of Fame makes the similarity to Di Maggio that much more evident. Both grew up as shy, tall, lanky, modest young men who realized early on that they wanted to do what they loved to do most and then dedicated themselves to that end. Both knew the best place for them to showcase their talent was New York and that's where their efforts eventually took them. Davis married his childhood sweetheart, Dena; Di Maggio later married the nation's sweetheart, Marilyn. And both Davis and Di Maggio rose to the top of their respective fields, drawing and center.

Perhaps the most important similarity between these men is how many young people they have destroyed! Their talents are so natural that they make it seem as though what they do is easy and accessible to all. If you ever watched either of them at work in their respective professions, you'd say, "Hell, I can do that!" Well, the horrible truth about that level of natural talent is that when translated into the language of reality, it becomes, "Sorry, but no, you can't do that!" The best advice you can offer students of either game is, "Stay in school and, in addition to that special thing you love, learn how to do something that makes you a living, like accounting! And if you're talented enough, bright enough, dedicated, and most of all, original enough, maybe someday you, too, will be enshrined in the Illustrators or Baseball Hall of Fame. If not, hey, the Accountant's Hall of Fame isn't so bad. Your name right up there with Harold Burkheimer who never in 56 years of ledger work forgot to carry the three into the next column! How's that for a Hall of Fame stat? There's no way hitting safely in 56 straight games as Di Maggio did, or doing a full-color *MAD* magazine in 56 minutes as Davis did, can top that!

This isn't a negative attitude; it's a realistic one. Natural talent, like Davis's or Di Maggio's can neither be taught nor learned. It's either there or it ain't. If it's there, hard work can help expand and develop it. If it ain't, even Davis and Di Maggio can't teach you how to get it. These guys are the worst teachers you can have because they don't know what they do. They haven't a clue! The Yankees hired Di Maggio as a batting coach after he retired, but there hasn't been one Baseball Hall of Famer who can point to him and say, "He taught me everything I know!" These young rookies would stand around the batting cage and Joe would say, "You gotta keep your eye on the ball and

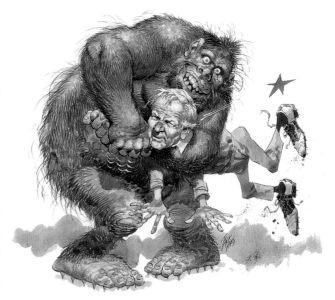

if the pitch is over the plate, you swing at it and watch it sail!" Thanks a lot, Joe! Now that I know his secret, give me a bat and stand back...

And Jack Davis? The truth is he can't help but draw funny. It just pours out of him. His advice to young art students who idolize his work? "You take a pencil and a clean sheet of paper and you draw the figure doin' something crazy and then you put an expression like this on his face and then you ink it! The art directors love it!" Thanks a lot, Jack. Now that I know his secret, give me a brush and a bottle of ink and stand back...

But that's where the similarity ends. Sports and creativity are worlds apart, especially since an abundance of natural talent in sports will just about guarantee a successful career. Bat .300, hit 40 home runs, post 22 game wins and an ERA of 2.14 and you can go deposit your check. The arts are totally subjective and an abundance of natural talent guarantees nothing if it doesn't fit the needs or taste of art directors, producers, gallery owners, etc. However great your talent, you have to earn your success as Jack Davis did.

The artist was born in 1926 in Atlanta, Georgia. With a minimal of formal art training at the University of Georgia and a year of evening classes

Right: Unpublished illustration for *Golf Digest*

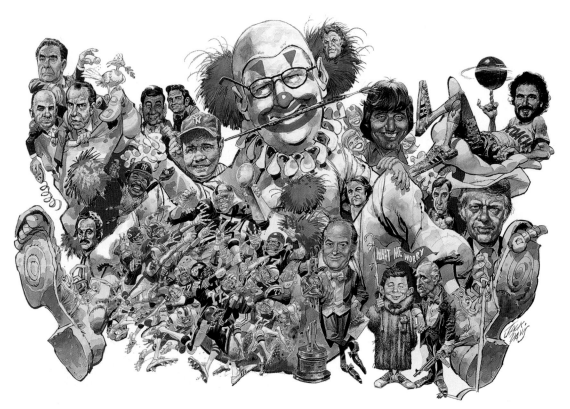

at the Art Students League in New York City, Davis was able to secure work assisting comic strip feature artists by doing backgrounds and inking. His facile brushwork was expressive in its thick and thin variations and, more important, fast. For him, working with pen was far too arduous and time consuming in the comic art profession, a world known for tough deadlines and payment based on quantity as much as quality. He was able to master his dense crosshatching, invariably a pen technique, with a brush that held more ink, which meant "Less time spent dipping." Davis's ability to turn out great work in little time became legend in the industry and he was often referred to as the "fastest brush in the South." Once his reputation was established and his illustration horizons expanded into more profitable assignments, Davis enjoyed working with pen and ink as well, combining it with brush and experimenting with different color media for various effects that maintained his foundational line work.

From his early beginnings as a comic artist, this distinguished southern gentleman was the antithesis of everything he captured on paper. Always fighting an internal war with the E.C. Comics horror stories that brought him his initial commercial success, but which he did only because he *had* to, Davis found a happier niche when *MAD* magazine's creator, Harvey Kurtzman, assigned him the lead story in *MAD* #1, a comic magazine spoof of the publisher's own horror stories that Davis felt so uncomfortable drawing. More of the same followed in *MAD* #2 with Davis's cover and lead-off story, but here the artist got to draw one of his two favorite subjects: sports. His good fortune didn't end there—*MAD* #3 offered him a chance at drawing his other favorite subject: Westerns. Davis's rendition of "The Lone Stranger" in that issue can arguably be considered his launching pad into graphic parody.

Davis approaches his drawing of the human form with a unique balance between exaggeration and credibility. This lends more humor to the work than if the emphasis were focused on plausible reality alone. The figure looks correct, and yet, well, *no* human anatomy is capable of *that* action! A Davis drawing of a wide receiver reaching into the air to snag a pass makes a

photo of a player doing the same thing look comparatively earthbound. Even in drawings loaded with accurate detail (a common occurrence in much of Davis's work), the artist's involvement with the *feel* of the subject always takes precedence over the objective reality.

Davis approaches caricature in the same manner. With an observant eye for the features which project the likeness most, the artist exaggerates here, underplays there, adds subtle changes to the expression and somehow the subject's personality emerges as much as the resemblance.

Davis's talent has been showcased in many of *MAD*'s film and television satires as well as covers and illustrations for *TV Guide*, *TIME* magazine, more than eighty books, record album covers, and over fifty movie posters. Many examples of his art are included in two books of his work published by Stabur Press: the hardcover edition, *The Art of Jack Davis* by Hank Harrison in 1987 and the softcover edition, *Some of My Good Stuff*, compiled by Hank Harrison in 1990.

Davis was honored by the National Cartoonists Society with a Lifetime Achievement Award in 1996, and then again in 2001 when the same organization voted him the prestigious Reuben Award, the "Oscar" of the cartooning world.

And now the Society of Illustrators Hall of Fame. Jack Davis has been in a state of disbelief since he got the letter telling him he was elected by his peers for this great tribute. Like Joe Di Maggio, the natural place to be honored for his enormous natural talent. If there were a Hall of Fame for decent, warm, and generous people in the world, Jack Davis would be enshrined there as well.

NICK MEGLIN

Above: Promotional poster for Gerald Rapp
Right: Outlaw gunman, personal work

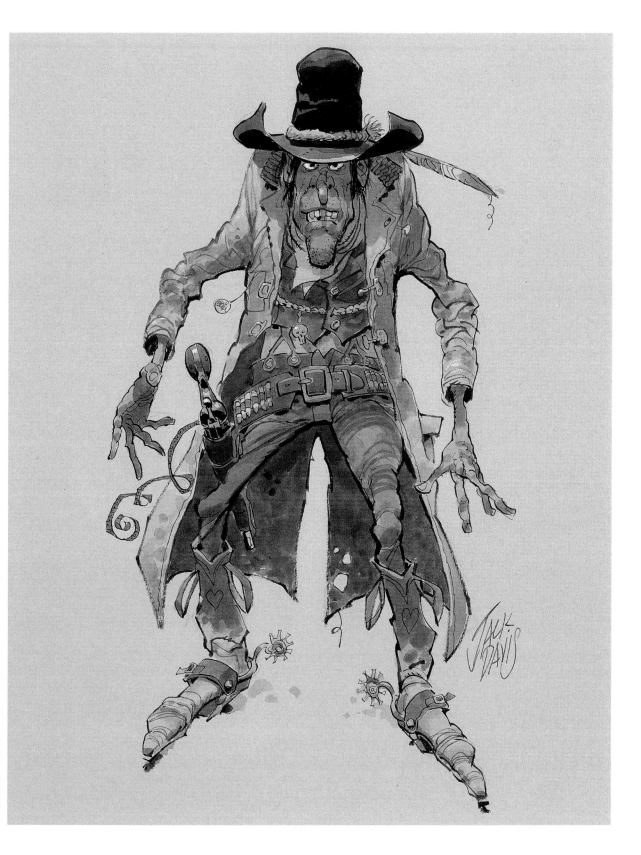

BRAD HOLLAND

[b. 1943]

In 1968 Brad Holland became my first and only mentor. I was just 17, he was 24 and his most memorable lessons focused on the ethics of making art. He taught me that an illustrator, cartoonist, and even an art director could make a decisive contribution not only to a publication, but to culture. He offered inspiration to a kid who desperately wanted to be some kind of an artist but was indoctrinated into believing that commercial art was a lesser art. Holland convinced me otherwise.

I met Holland by accident through an ad I'd placed in *The Village Voice* for contributors to a small magazine I was starting with money set aside for college. *Borrowed Time* was its title. It was a literary/poetry anthology that lacked a real direction and point of view. Holland was one of 40 prospective artists and writers who'd answered the ad. He was the only one who brought a point of view.

At our first meeting in the basement apartment of a brownstone on East 10th Street, Holland arrived with the largest portfolio I had ever seen. He was tall, skinny, and sported an Abe Lincoln-esque beard. Like the proverbial rube just off the bus from points west he looked excruciatingly out of place in hippie Greenwich Village. Originally from Arkansas, he had worked for a few years at Hallmark Cards in Kansas City but had come to New York to make a different kind of hallmark. During the hour we were together he uttered only a few words, his eyes never once looked directly at me but rather were fixed intently on his work as I slowly turned over the large, image-laden boards. "Good stuff," I told him, holding my awe in check at the sight of his meticulously rendered line drawings featuring surreal fantasies and allegorical vignettes. "I like 'em. But can you illustrate literature? Can you stick close to the text?"

Literature, indeed! I had no idea what I was talking about. Nonetheless, Holland agreed to contribute—and for no fee—so long as I agreed that he would retain complete control over the content of what he did. "Sure," I said.

Actually, I was surprised that he returned a week later for a meeting I'd organized to explain the purpose of the magazine to the anointed contributors. Holland patiently listened to my pedantic monologue about the blah blah blah "philosophy" of *Borrowed Time*. He also stuck around until everyone had left, at which point he said, "I'll help you design this thing." "But I already have an art director," I replied curtly, referring to an old high school buddy who pretended to know layout. "He doesn't know shit about designing a magazine," Holland replied defiantly. "And frankly, you don't know

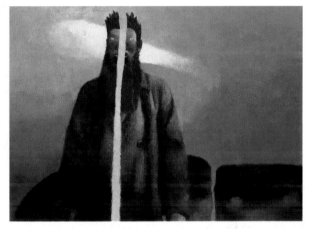

much about putting a magazine together either, so I want to be involved at least where my drawings are concerned." His words pierced my ego like rusty X-acto blades.

After that I wasn't sure I even wanted him around, but he was curiously persistent. He was also right about my so-called "art director," who resigned the day after we started pasting up the first pages. Holland took over by default and the very first thing he did was introduce me to the art of typography. In fact, he did all the type composition himself, cutting and pasting strips of phototype on the floor of his apartment. Using Herb Lubalin as his model and *Avant Garde* magazine as his prime example (incidentally, he published his first major editorial illustration there in 1968), he showed me the expressive nuances achieved by smashing, overlapping and otherwise allowing type to speak. While I resented that he was so much better than me, I knew that what he imparted was the equivalent of months, possibly years, of art school. I was torn between feeling gratitude and a slew of baser emotions.

Yet I truly admired Holland's passion and I listened with envious attention as he told me about his duels with editors and art directors over his sacred principle never to render anyone else's idea (a common practice at that time) but rather always find a better, more personal solution to any illustration problem. He never illustrated verbatim but always reinterpreted a text in metaphorical visual terms. Moreover, he stuck to his guns at the expense of losing a job, which happened from time to time. His actions sometimes seemed foolhardy. Yet I remember when they paid off—when

Left: Courtesy of artist
Above: *Splitting Image, Penthouse*, 16 x 22 inches, acrylic on board.

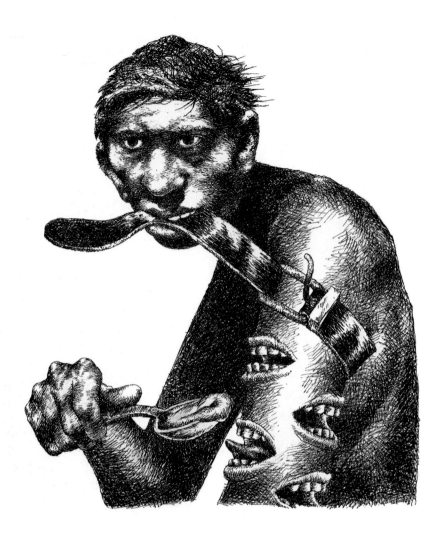

something without equal was published in a national magazine or on a book jacket or even a poster. I understood that Holland was not only fighting against accepted wisdom—that an illustrator was merely the extension of an art director's, or worse, an editor's hands—he was trying to radically alter, if not expunge, the conventions of narrative, sentimental illustration and create a more intimately expressive art. He once confided that he would either win or quit—there was no middle ground.

It worked! Within the year of our first meeting, he earned steady work in *Playboy*, *Evergreen Review*, and even the staid *Redbook*. He eventually became a principal artist for *The New York Times*. Drawing on the legacies of such acerbic graphic commentator-artists as Kathe Kollwitz, Georg Grosz, Henrich Kley, and his beloved Goya, Holland's stark black-and-white drawings raised the conceptual bar of an antiquated field that was rooted in Rockwellian romanticism. But just as he refused to be dictated to by editors and art directors, he was never sanguine about maintaining signature styles. He once told me, "My models were always writers, guys who could write essays, poetry, plays, whatever they chose, and try different approaches. There's no reason why an artist can't take a similar approach. Use charcoal one day and bright colors the next. Do a series of white-on-white paintings

and then do a handful of messy drawings as if you were five years old. I mean you can't get everything into a single picture. Every picture is just a piece of a whole. It's kind of like the old cliché of the blind guys feeling the elephant. Every day you feel a new part of who you are." And so he evolved his methods and manners to suit his needs, often surprising, sometimes shocking those who commissioned him.

I wished I had Holland's courage. Frankly, the frustration of being limited by my own meager abilities was painful. I couldn't draw realistically if my life depended on it. I couldn't come up with the visual metaphors that seemed to flow from Holland with ease. Yet at the time I continued to draw little cartoons, and tried to get them published with some success in various underground newspapers. Getting published was fine, but more important for me was earning Holland's approval for what I was doing. I wanted validation that my art was good. But since he never said so in as many words—at least I never heard him—at age 18 I decided to stop drawing.

Sounds childish now, but I presumed that since I couldn't compete with Holland, who was not yet at the top of his game, and since I liked art directing anyway, I'd just stop doing one and focus on the other. It was a sound career move. But I also figured that if I stopped drawing I'd

be hurting him, not me. Indeed, six months after I had published my last cartoon, I met Holland in the street and he asked, "How come I don't see your drawings anymore?" "I decided to never to do them again," I said with an angry edge to my voice. "Too bad, some of them were really good," he said. Victory!!??

I had given Holland power and abused our relationship. Yet a new relationship took hold. As an art director I was under his watchful eye, but I was not in direct competition with him. And so I allowed him to teach me about the history of satiric art and visual commentary—the same history that informed his work. Holland also became a regular contributor to underground papers that I designed, *The New York Review of Sex*, *The East Village Other*, *Screw*, and *The New York Ace*, and I was able to apply some of the lessons I'd learned from him. For instance, I gave license to artists who sought to redefine their briefs so that their more personal solutions were possible.

By the early 1970s Holland was a fixture at *The New York Times* OpEd page and had made such a mark that he was copied far and wide. The OpEd page was the most important illustration outlet in America, and he contributed illustration that both complemented the articles and stood on their own as integral artworks. In 1974 I became OpEd art director, and working with Holland was a great perk. Over time we became equals, though I still get a bit nervous when I think about how harshly, but humanely, he critiqued all that I did. These days we don't see each other often, but our bonds will never be broken. I have never really known anyone who exerted such a fundamental impact on the way I practice. Without Holland, I doubt if I would be doing what I do today. And without Holland's fervency and passion for mass communication I am certain American illustration would not be as conceptually astute; rather, it might still be locked between those old verities, sentiment and romanticism.

STEVEN HELLER
Art Director, the New York Times *Book Review and*
Co-chair, School of Visual Arts MFA Design Program

Above Left: *Feeding Frenzy*, *The New York Times*, 12 x 11 inches, ink on paper.
Above Right: *Hard Rain*, Swiss Art Directors Club, 10 x 13 inches, pastel on paper.

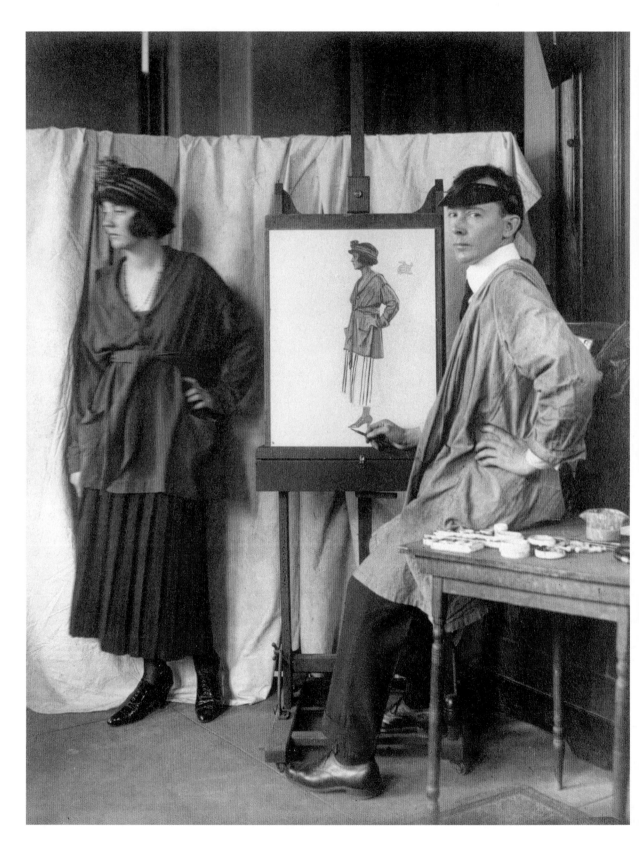

Herbert Paus was at his most effective depicting subjects that were, in one way or another, larger than life. The work he produced during World War I was essentially a precursor to his stunning advertisements and poster-like magazine covers. The strong visual impact of his more graphic designs was balanced by his ability to wield fine detail in decorative headings for magazine stories and works of fiction for youngsters.

But it was mainly his World War I poster designs that attracted the editorial attention of the mainstream press, including the *New York Herald*. In late December 1919, the *Herald* published an item on Paus, saying, in part: "No mere inspiration of the moment, sudden mood, or flitting fancy, but rather true inspiration, aided by deep study and painstaking execution are responsible for the forceful, effective results that he obtains."

By the end of World War I, Paus was already firmly established in the pantheon of successful American illustrators. Indeed, periodicals aimed at commercial artists and those who commissioned them were already singing Paus's praises at least as early as 1912. He was, above all else, a versatile graphic communicator, ready and able to adjust his approach to the sensibilities of the assignment. He made substantial contributions to several aspects of illustration, from delicate watercolors for children's books to powerful images and striking compositions for posters, and from vibrant art for magazine covers to the creation of comic strips.

While Paus carried a big graphic stick, he was an illustrator who spoke softly. According to one magazine profile, "He is extremely adaptable to any age, but is reserved except when in the company of intimate friends, and it takes time to know and appreciate the exceptional merits of this talented and overly modest artist."

As was the case with many great illustrators of his day, Paus had not only a certain innate ability but also a reliable and strong technique. He was, according to *Graphic Arts*, a sure and thorough draftsman, with "a fine

sense of color and a maker of absolutely practical advertising pictures in a truly artistic manner."

With that talent and the resulting popularity, he was afforded the luxury of choosing assignments that suited him. Paus continued to build his reputation, finding it "conducive to be able to select such commissions as are most interesting and best-suited to his qualifications." He showed a level of commitment to his advertising work that was, in many respects, at the vanguard of the changing look of advertisements—in stark contrast to the ads turned out by the studios. He believed that "as much art belongs in an advertising design as in a magazine cover, and he puts it there with the keen graphic touch, appreciation for color, and sense of correct values that are possessions of his and few others."

Paus would immerse himself in attention to detail, far beyond careful reading of the manuscript. His covers for *Popular Science* showed he was well versed enough in the cutting edge of science to provide a viable and artistic representation of scientific advances. His designs became closely associated with *Popular Science*, and he produced all their covers from mid-1927 through early 1931.

Even during this period, Paus was readily adaptable and far from a slave to the technical constraints associated with the magazine. In its series on "Notable American Illustrators," Walker Engraving Company spotlighted Paus "because his color is as daring as the scale of his monumental figures. (Daring—but beautifully arranged.)" His colors were "daring" to the point of being truly vibrant. Such vivid colors were achieved by his manipulation of traditional media, allowing for a concentration of pigment that made his color choices stand out. Paus wore a visor while working to keep ambient light from diffusing his perception of the color he had just laid down—and as an aid to keep him focused on the task at hand.

For subjects involving single figures, he would usually work directly from life, often posing his wife for whom, according to a story in *Redbook* of January 1929, "the wearing and draping of clothes amount to an art."

By the tender age of seven, Herbert was already showing artistic interest and ability. His parents encouraged the youngster's budding talent, sending him for half the day each Saturday to the house of local (St. Paul, Minne-

Left: The artist at his easel. Courtesy of Illustration House, Inc.
Above: Illustration for *Woman's Home Companion,* ca. 1935. Courtesy of the Museum of American Illustration at the Society of Illustrators.

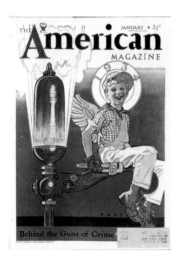
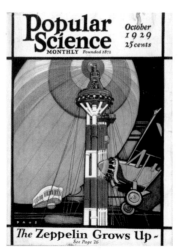

sota) artist Burt Harwood, where Herbert and several other boys learned about things artistic.

Harwood had studied in Europe and he was eccentric enough to capture the kids' imaginations. Every Saturday it was as though the boys had stepped into another world. It was in this secluded, yet invigorating atmosphere that Paus began to thrive artistically. When the Paus family left St. Paul for the Puget Sound area of Washington state, Herbert—then eleven years old—continued study with his mentor, spending three of the next five summers studying with Harwood.

When Paus was sixteen, he went in search of a job. Through the influence of Harwood, Paus landed a job at the *St. Paul Pioneer Press* newspaper. At the time, R.F. Outcault's "Yellow Kid" comic strip was forever changing the relationship between newspapers and illustration. The *Pioneer Press*'s editorial cartoonist left the paper and Paus, who had shown a proclivity toward editorial and humorous drawing, took over as staff cartoonist.

After about two years, however, according to *Graphic Arts*, Paus "decided that art and journalism were not yet reconciled to each other and joined the Binner Engraving Company of Chicago, which was just discovering commercial illustration." Shortly after Paus moved to Chicago, Binner decided that a New York office would be of prime importance to assure the company's growth. The New York studio opened in about 1899 with the 19-year old Paus on staff. When he wasn't at Binner, Paus was refining his abilities in classes at the Chase School of Art with legendary instructors Robert Henri, George Bridgman, and F.V. DuMond.

By 1902, Paus made another change, deciding that freelance illustration, with its relative artistic freedom and flexibility, was the best path to follow. His early clients included *The Ladies' Home Journal, Life, Delineator, Pictorial Review, St. Nicholas* and *The Associated Sunday Magazine*. In this period, Paus also created theatrical set designs for a variety of productions. He had become a hardworking, successful illustrator—and one whose work was about to become immensely popular by virtue of events that were beyond his control.

The United States entrance into World War I brought a pressing need for professionally produced artwork to inspire the citizenry. The Division of Pictorial Publicity shouldered much of the responsibility for choosing and directing the most talented artists. Paus was among the first recruited to lend a hand.

He was committed to doing whatever he could for the war effort. *The New York Tribune*'s 1919 profile lauds the "willingness and promptness with which he gave his services unrewarded..." Paus created boldly heroic inspirational images that communicated the message effectively. Through a masterful combination of bright colors, strong composition, and qual-

ity technique, the intent in Paus's poster designs was always clear, urging Americans to join up for service overseas as well as for projects closer to home (such as the Woman's Land Army), to save money with War Savings Stamps, and to work harder because "Your work is an important factor in the fight for freedom."

His style had become so recognizable through the omnipresent posters that the demand for his work in other areas of illustration grew. For instance, during the war years, Paus created many covers for *Collier's*, a weekly that devoted much space to battle reports. During the week of March 10th, 1917, the circulation of *Collier's* surpassed a million; the impact of the cover art certainly played a role in the reaching of this milepost.

The 1919 *New York Tribune* article referred to earlier lists Paus's hobbies as designing and building furniture in the summer and playing billiards in the winter—activities that require precision, craftsmanship, foresight, and patience. Likewise, these characteristics continually show themselves in Paus's illustration work.

Many contemporary sources on Paus's work say he preferred craftsmanship over decoration. The two, decoration and craftsmanship, are no longer considered to be mutually exclusive. It was the craftsmanship of decoration that Paus seems to have found most rewarding—the methodical yet sure journey toward an ideal image of compositions that convey universal truths.

In keeping with the idea that as much art belonged in an advertisement as in a magazine cover, Paus believed advertising and decoration to be closely related. In looking at his advertising images, it's apparent that what's being sold is the *idea* of the product rather than the product itself—he's bringing to life the seed of the viewers' ideas of what the product can do for them, not simply telling viewers a story about the product. Over 50 years after his death, the broad imaginative appeal of Paus's artwork remains as fresh to the eye today.

FRED TARABA
Director Illustration House

Above Left: Cover illustration for *American Magazine,* 1934. Courtesy of Illustration House, Inc.
Above Right: Cover illustration for *Popular Science,* October 1929. Courtesy of Illustration House, Inc.
Right: Illustration for *Popular Science,* May 1930. Courtesy of Illustration House, Inc.

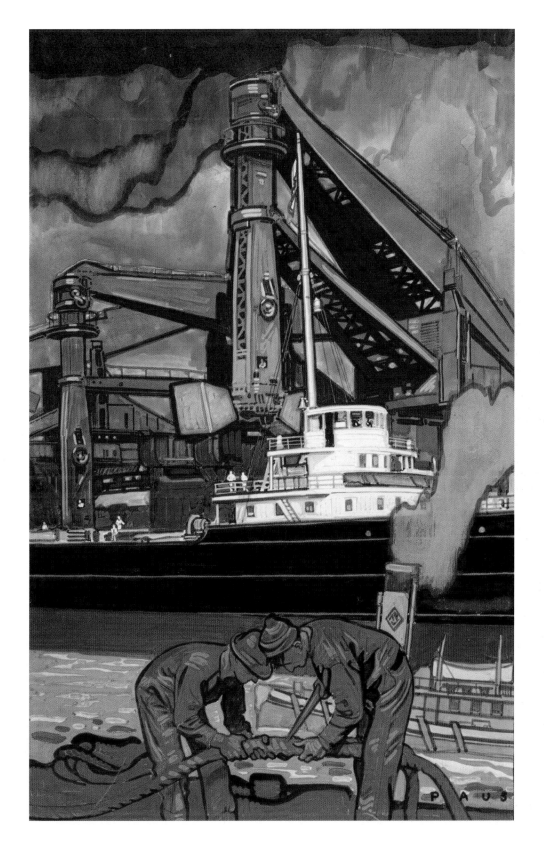

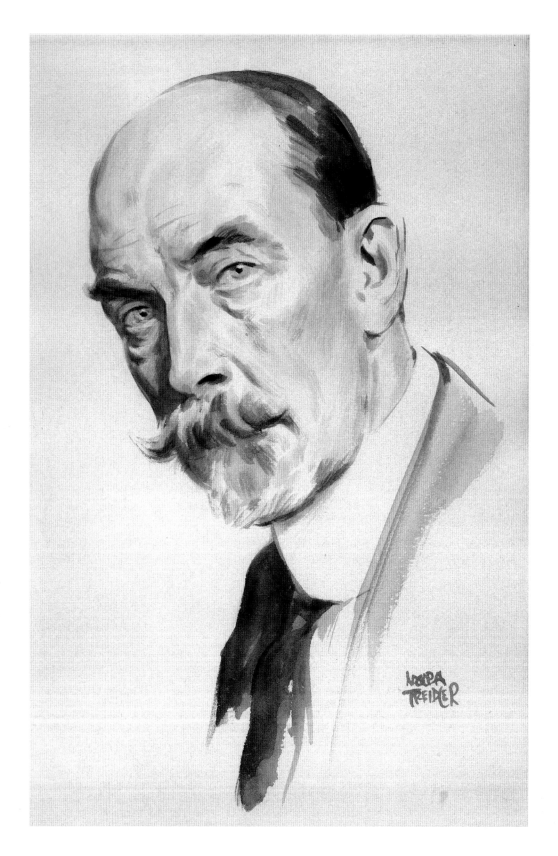

Albert Beck Wenzell

[1864–1917]

The Belle Époche, prior to World War I, was a prosperous and extravagant era when royalty governed most of Europe. At the same time in the United States, great fortunes were being made through unfettered trusts and monopolies, creating a class of Nouveau Riche. This ambitious society of Robber Barons and their social-climbing wives was just as stratified as their regal European counterparts, but lacked the accompanying pedigrees. During this period there was a beneficial intermingling of interests. American families sought titles through arranged marriages of their daughters, and the lavish lifestyles of eligible counts and crown princes required infusions of cash.

No American artist better presented that colorful era than Albert Beck Wenzell. From a wealthy family himself and with solid academic training in Munich and in Paris he knew his subjects well and could paint them with great authority. His opulently gowned, imperious, and always-beautiful young women were depicted with a dazzling display of artful exaggeration; the young men wore their colorful uniforms or full dress with an assured careless swagger.

Two large volumes of his illustrations were published by Collier's: *The Passing Show* and *Vanity Fair* in 1896 and 1900. He was awarded medals in the 1901 Pan American Exposition in Buffalo, New York, and in 1904 from the Louisiana Purchase centennial exposition in St. Louis. One of the founding members of the Society of Illustrators, he was elected its president in 1902 and he became a member of the Mural Painters Association, having painted a large mural in 1903 for the New Amsterdam Theater.

Born in Detroit, Michigan, his early interest in art was encouraged by his parents. After introductory local art classes, they arranged for him to study in Munich under Stahuber and Loefftz. This was followed by further schooling in Paris at the Académie Julien where his instructors were Gustave Boulanger and Jules Lefebvre. It was a rigorous seven years of schooling which prepared him for several career options. His early ambitions were to

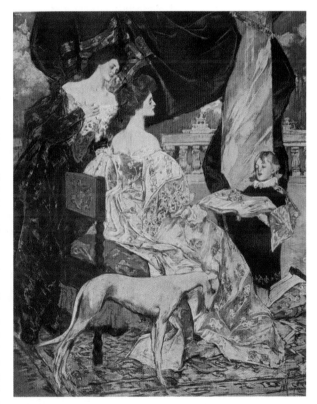

Left: In June 1894, *The Ladies' Home Journal* published a biographical introduction of the artist, describing him as "extremely good to look upon. He is of medium height, slight figure and fair complexion. His hair, mustache and Van Dyke beard are brown, and his eyes a clear blue. His manner is dignified, earnest and somewhat reserved, though his humorous perceptions are of the keenest." Portrait of the artist by Adolph Treidler. Courtesy of the Museum of American Illustration at the Society of Illustrators.
Right: *Christmas in the Middle Ages—Gifts for the Princess* from *The Passing Show, Drawings by A.B. Wenzell*, P.F. Collier & Son, MCMIII. Courtesy of Illustration House, Inc.

do portraiture and landscape paintings and he was invited by William Meritt Chase to assist in critiquing his students' efforts. However, this quickly felt like a dead end to Wenzell, who found the students hopelessly inept and after three months he decided to go his own way.

His first efforts, to find portrait commissions in his Detroit home area, produced few patrons. Discouraged, he decided to offer his services as an illustrator in New York. After repeated rejections he finally found a regular patron in the old *Life* magazine—a humorous publication then—which accompanied its two- or three-line jokes with fully realistic illustrations. Since the humor regularly focused on the peccadilloes of the wealthy and their social

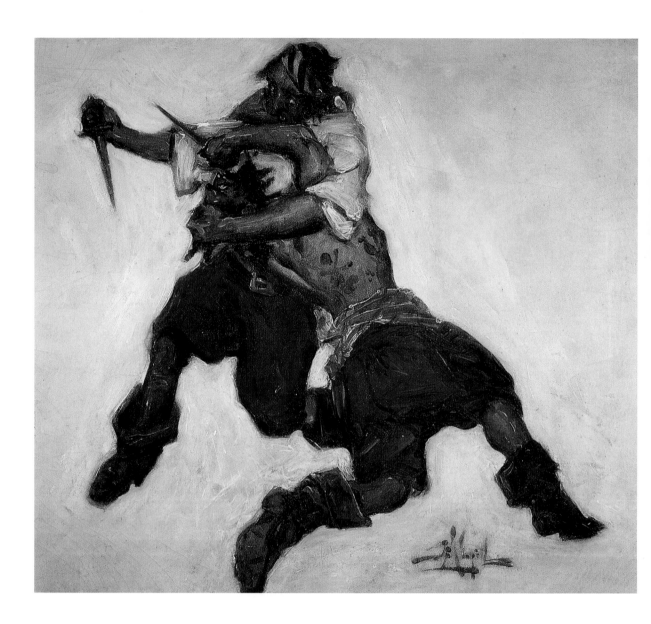

climbing, it gave Wenzell the opportunity to do many drawing room scenes, peopled with women in silk and taffeta gowns (which he could paint with dazzling verisimilitude) and men in be-medaled officers' regalia, in opulent interiors. The public loved his pictures and other magazines began to vie for his talents, eventually including *Harper's Monthly*, *Scribner's*, *Truth*, *Metropolitan*, *Collier's*, *The Saturday Evening Post*, as well as publications on the continent including the prestigious German satiric magazine *Die Fliegende Blätter*.

In addition to his magazine short stories, he also illustrated many serialized novels, among them *The House of Mirth* by Edith Wharton, and

Above Left: *Pirates in Mortal Combat.* Courtesy of the Museum of American Illustration at the Society of Illustrators.
Above Right: *After Dinner* from *The Passing Show, Drawings by A.B. Wenzell*, P.F. Collier & Son, MCMIII. Courtesy of Illustration House, Inc.

other authors of Victorian fiction. Since in those stories of the vicissitudes of love and courtship, the heroine was the dominant character; she had to be depicted as beautiful and desirable. "Wenzell's girls," as they came to be known, were, and they had a huge popular following. Their hairstyles and dress helped to set the fashions and brought him a constant flow of fan mail. However, in a full-page illustrated story in *The New York Herald* on February 14, 9004, titled "The Wenzell Girls," the artist is quoted, "I resent the phrase 'Wenzell Girls.' It is a catch phrase, which indicates but a fragment of the work I am trying to do. She was not conceived, believe me, with that sort of conquest in view." "I draw from many models," Wenzell continued, "It is often extremely difficult to get the right one. Now I do not know if there is any interest in thus revealing the pulleys and mechanism as it were—the bare mechanical difficulties of my art—but you are welcome to them. I particularly desire in my models a good head—a well modeled head,

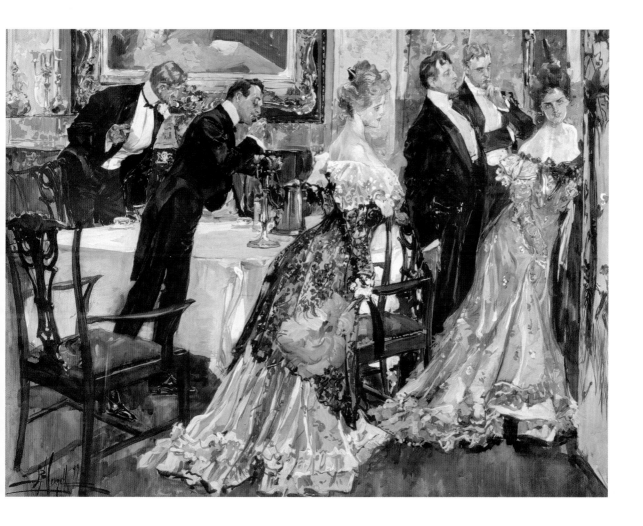

that is . . . once secured, I try to draw my model closely. My critics frequently discover characteristics in the finished drawing, its being a type and all that, which to say the least, I have not anticipated."

Wenzell also expressed strong views about the state of American art, "It seems to me, after many years spent abroad, with the consequent opportunity for comparison, that American art has advanced amazingly, further than is generally appreciated at home or abroad. The average American, for instance, admires the drawing of American girls by American artists, but he rarely goes abroad to have his portrait painted.

"American artists excel, it seems to me, in color. There are half a dozen men here now—I don't refer to several well known American artists living abroad—no, there are New York men whose work is not familiar, but whose talent is of the first order. It is most unfortunate that our home talent is not more appreciated and encouraged. I have little sympathy with the idea that an artist must live abroad in some so-called art centre. If a man be an artist it makes little difference where he lives."

In reviewing Wenzell's picture subjects, whether by his own choice or by those of his art editors, he keeps closely to his class. There are no examples to be found featuring the common man or woman, nor evidence of privation or poverty. While he was presenting a record of his times it was a very selective slice of it.

By the date of his death from pneumonia in 1917, the era of wine, women, and song was over and he would soon be virtually forgotten. Yet despite the ephemeral quality of his subject matter we must admire his great technical skill and appreciate the artistic spirit that motivated it.

WALT REED
Illustration House

Hall of Fame Laureates

[1958–2005]

1958 Norman Rockwell
1959 Dean Cornwell
Harold Von Schmidt
1960 Fred Cooper
1961 Floyd Davis
1962 Edward Wilson
1963 Walter Biggs
1964 Arthur William Brown
1965 Al Parker
1966 Al Dorne
1967 Robert Fawcett
1968 Peter Helck
1969 Austin Briggs
1970 Rube Goldberg
1971 Stevan Dohanos
1972 Ray Prohaska
1973 Jon Whitcomb
1974 Tom Lovell
Charles Dana Gibson*
N.C. Wyeth*
1975 Bernie Fuchs
Maxfield Parrish*
Howard Pyle*
1976 John Falter
Winslow Homer*
Harvey Dunn*
1977 Robert Peak
Wallace Morgan*
J.C. Leyendecker*
1978 Coby Whitmore
Norman Price*
Frederic Remington*
1979 Ben Stahl
Edwin Austin Abbey*
Lorraine Fox*

*PRESENTED POSTHUMOUSLY

1980 Saul Tepper
Howard Chandler
Christy*
James Montgomery
Flagg*
1981 Stan Galli
Frederic R. Gruger*
John Gannam*
1982 John Clymer
Henry P. Raleigh*
Eric (Carl Erickson)*
1983 Mark English
Noel Sickles*
Franklin Booth*
1984 Neysa Moran
McMein*
John LaGatta*
James Williamson*
1985 Charles Marion
Russell*
Arthur Burdett Frost*
Robert Weaver
1986 Rockwell Kent*
Al Hirschfeld
1987 Haddon Sundblom*
Maurice Sendak
1988 René Bouché*
Pruett Carter*
Robert T. McCall
1989 Erté
John Held Jr.*
Arthur Ignatius Keller*
1990 Burt Silverman
Robert Riggs*
Morton Roberts*
1991 Donald Teague
Jessie Willcox Smith*
William A. Smith*

1992 Joe Bowler
Edwin A. Georgi*
Dorothy Hood*
1993 Robert McGinnis
Thomas Nast*
Coles Phillips*
1994 Harry Anderson
Elizabeth Shippen
Green*
Ben Shahn*
1995 James Avati
McClelland Barclay*
Joseph Clement Coll*
Frank E. Schoonover*
1996 Herb Tauss
Anton Otto Fischer*
Winsor McCay*
Violet Oakley*
Mead Schaeffer*
1997 Diane and Leo Dillon
Frank McCarthy
Chesley Bonestell*
Joe DeMers*
Maynard Dixon*
Harrison Fisher*
1998 Robert M.
Cunningham
Frank Frazetta
Boris Artzybasheff*
Kerr Eby*
Edward Penfield*
Martha Sawyers*
1999 Mitchell Hooks
Stanley Meltzoff
Andrew Loomis*
Antonio Lopez*
Thomas Moran*
Rose O'Neill*
Adolph Treidler*

2000 James Bama
Alice and Martin
Provensen*
Nell Brinkley*
Charles Livingston
Bull*
David Stone Martin*
J. Allen St. John*
2001 Howard Brodie
Franklin McMahon
John James Audubon*
William H. Bradley*
Felix Octavius Carr
Darley*
Charles R. Knight*
2002 Milton Glaser
Daniel Schwartz
Elmer Simms
Campbell*
Jean Leon Huens*
2003 Elaine Duillo
David Levine
Bill Mauldin*
Jack Potter*
2004 John Berkey
Robert Andrew
Parker
John Groth*
Saul Steinberg*
2005 Jack Davis
Brad Holland
Herbert Paus*
Albert Beck Wenzell*

Hall of Fame Committee 2005

Chairman
Murray Tinkelman

Chairman Emeritus
Willis Pyle

Former Presidents
Vincent Di Fate
Diane Dillon
Peter Fiore
Judy Francis
Al Lorenz
Charles McVicker
Wendell Minor
Howard Munce
Alvin J. Pimsler
Warren Rogers
Eileen Hedy Schultz
Shannon Stirnweis
Steve Stroud
John Witt

HAMILTON KING AWARD
[1965-2005]

1965 Paul Calle	1980 Wilson McLean	1991 Brad Holland
1966 Bernie Fuchs	1981 Gerald McConnell	1992 Gary Kelley
1967 Mark English	1982 Robert Heindel	1993 Jerry Pinkney
1968 Robert Peak	1983 Robert M. Cunningham	1994 John Collier
1969 Alan E. Cober	1984 Braldt Bralds	1995 C.F. Payne
1970 Ray Ameijide	1985 Attila Hejja	1996 Etienne Delessert
1971 Miriam Schottland	1986 Doug Johnson	1997 Marshall Arisman
1972 Charles Santore	1987 Kinuko Y. Craft	1998 Jack Unruh
1973 Dave Blossom	1988 James McMullan	1999 Gregory Manchess
1974 Fred Otnes	1989 Guy Billout	2000 Mark Summers
1975 Carol Anthony	1990 Edward Sorel	2001 James Bennett
1976 Judith Jampel		2002 Peter de Sève
1977 Leo & Diane Dillon		2003 Anita Kunz
1978 Daniel Schwartz		2004 Michael Deas
1979 William Teason		2005 Steve Brodner

Steve Brodner seeks the truth. In search of that truth through satire, he has exposed hypocrisy and skewered politicians, corporate fat cats, and pop culture. As a visual journalist (a neglected art form seemingly kept alive by Steve), he has covered political campaigns and conventions as well as shed light on the plight of the underclass. Steve has even ventured beyond the printed page into the world of documentary filmmaking with drawings. I have no doubt he will excel in this endeavor as he has done wherever he applies his exceptional talent.

While most of us are content to work out our creative obsessions in the relative comfort and security of our studios, Steve is out pursuing stories that spark his passion. That quest has taken him all over the United States and, for *Outside* magazine, a considerable distance up Mt. Fuji. He takes the initiative with an entrepreneurial drive and finds magazines willing to publish his stories. Armed with notebook, tape recorder, pens, and laptop he can work anywhere. It's not unusual for Steve to finish a piece and e-mail it from a hotel room on the road.

These days, so much is in question about the future of our business. In the face of such doubt, Brodner holds firm with conviction and idealism to a belief in the power of illustration. He is that rare breed of artist who has something important to say and the ability to express those ideas in a concise way. In addition, he also has the chops to make that idea come to life on the page with great drawing, design, and humor. These qualities, along with Steve's warmth, generosity, and sincerity, have earned him the respect of the illustration community. There was nothing more moving than when the entire audience at ICON 3 in Philly gave Steve a standing ovation at the showing of his film about families of 9/11 victims.

Brodner is not only about moral outrage and compassion; he's also about stretching a face to the extreme, and leaving it still recognizable. His art is a swirling pot of Nast and Daumier, Hirschfeld and Steadman, with a dash of Chuck Jones—all paint splatter, brush, and pen lines in sweeping motion.

I first became aware of Steve's work in the mid-eighties when I saw his cover for *The Progressive* about the radio commentator Paul Harvey. The illustration showed a middle-American family gathered around a radio that had the face of Harvey spouting patriotic fireworks. It was a black-and-white tonal drawing set against a dark background. The piece was executed with such draftsmanship, yet completely stylized and distorted. It was unlike anything I had ever seen before and made a lasting impression on me. I knew this was an artist to watch. We met at a party about a year or so later and quickly became friends. Steve and I are very close in age and have had common experiences growing up in New York, he in Brooklyn and I on Staten Island. Over the years, we've reminisced about things that have shaped our pop cultural consciousness: local New York TV programming in the '60s, *Mad* magazine, and our admiration for caricaturists like Mort Drucker, Bruce Stark, Jack Davis, and David Levine. We also share a love of jazz and have spent some enjoyable nights at clubs listening to live music.

Steve is always thinking and always drawing. In a restaurant, a napkin or a tablecloth will suffice if no paper is handy. In his early days, he honed his drawing skills and keen eye by doing caricatures at bar mitzvahs. That practice served him well in later years whether he was giving a demonstration before an audience, or drawing under the glare of TV studio lights. I watched in amazement as Steve, articulate and at ease, sketched while giving an interview on national TV during his book tour. I often refer to Steve as the hardest working man in the illustration biz. One can hardly pick up a magazine without seeing a Brodner somewhere on its pages. His output is phenomenal and he often sacrifices sleep in the process. It's a very full career to be one of the top editorial illustrators working today, as well as being *the* contemporary master of caricature, but Steve doesn't limit himself to that. He juggles art journalism, teaching, filmmaking, and lecturing in addition to family time spent with his wife Anne and daughter Terry. To young illustrators he is generous with his time, complimentary and insightful. Steve even took time out of a schedule that would make most illustrators dizzy to travel from New York to Florida to go door to door on foot with people from all over the country to get out the vote.

More than anything, Steve is a political animal and it is fitting that the Hamilton King award was given for this particular image. The piece was done for *Rolling Stone*'s "National Affairs" section, to which Steve is a regular contributor. The "Four Horsemen of the Apocalypse" was an idea that publisher Jann Wenner had had in mind for some time. The article, "The Curse of Dick Cheney," seemed like an appropriate time to use it. Although

The Curse of Dick Cheney for *Rolling Stone,* watercolor and ink.

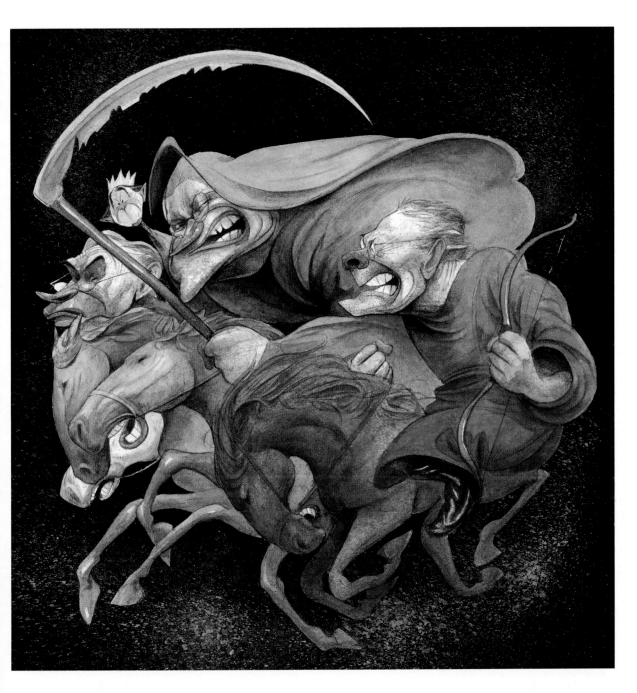

the concept may not have been entirely Steve's, the solution is uniquely Brodner. It's a powerful image, beautifully composed, and expertly executed. As always, he nails his subjects.

This award is the perfect cap to a year that saw the publication of *Freedom Fries*, an impressive retrospective of Steve's political work. Perhaps Ralph Steadman says it best in his comments in Steve's book: "Beneath Steve Brodner's imposing style there lurks a powerful draughtsman—the heart of an outraged fighter with a strong moral sense. One does not invent that kind of thing. One has either got it or one hasn't. Steve has the force— in bucket loads ... Steve Brodner is one of the great Captains of an art, which

few are truly blessed to wield as a weapon. As you wander through this book at your leisure, spare a thought for the blood, sweat, and tears of a master of his own choices, in the knowledge that inside his own rhythmic acrobatics, it never gets any easier, because he is at the cutting edge of personal opinion and expresses it in a way that can never be said in words."

Although Steve is too modest to expect to receive such recognition for his type of work, this is truly a well-deserved honor. Congratulations to you, Steve. I'm proud to call you my friend.

Joe Ciardiello

EDITORIAL

CHAIR

| ROBERT NEUBECKER | NATALIE ASCENCIOS | TIM BOWER | NICK DEWAR | TOM FLUHARTY |

ILLUSTRATOR

From Oshkosh, Wisconsin, Robert Neubecker attended Parsons School of Design. He started out at *The New York Times* at age 21 and was a regular contributor there for ten years. He was a founding member of Inx. Inc., a collective of political illustrators. In the 1980s he began freelancing for *Newsweek*, *TIME*, *BusinessWeek*, *The Wall Street Journal*, *Esquire*, *Sports Illustrated*, *The Washington Post*, *Forbes*, *Fortune*, *Barron's*, and others. He has taught at the School of Visual Arts and Brigham Young University. He moved to Utah and in 1996 joined Slate.com. He has won awards from *American Illustration*, *Communication Arts*, the Society of Illustrators, and the American Institute of Graphic Arts. He has several children's books in print and others in progress.

ILLUSTRATOR

Natalie Ascencios attended the New School for Social Research at Eugene Lang College and the Parsons School of Design NY/Paris. Her paintings can be seen in the various annuals of the Society of Illustrators, *American Illustration*, *Communication Arts*, and she is a regular contributor to *The New Yorker* magazine. She has won awards at the Society of Illustrators and in puppetry. Interviews appear in the *Pro-Illustration* vol. II, *Print* magazine (1999 January/February), and in *Communication Arts* (January 1999). She teaches at the School of Visual Arts, gives talks on painting, and has had exhibitions throughout the country and abroad. On permanent display at the Algonquin Hotel in New York City is her work, *A Vicious Circle*, and her 1920s *Round Table* is at the Brown Hotel in Louisville, Kentucky. Clients include: *The New Yorker*, *Entertainment Weekly*, *New York*, *GQ*, *Esquire*, *TIME*, *Rolling Stone*, the U.S. Postal Service, Penguin Books, Simon & Schuster, Paramount/Viacom, and Blue Sky 3-D Animation Productions.

ILLUSTRATOR

Tim Bower has been a freelance illustrator for 14 years. His work has been included in the annuals of the Society of Illustrators, *American Illustration*, *Communication Arts*, the Society of Publication Designers, and the American Institute of Graphic Arts. He lives and works in New York.

ILLUSTRATOR

Nick Dewar was born in Scotland and grew up in a small fishing town on the east coast. Since attending art school in Glasgow, he has lived in Prague, London, New York, and on a sheep farm in Cumbria. Illustration has been his sole occupation from the time he left art school over 10 years ago and indeed it is doubtful that he could actually hold down a proper job if asked.

Nick's work has appeared in magazines, on billboards, in books, and next to the telephone. He has been published in countries as far-flung as China and Iceland, but most of his work comes from Americans. He admires the work of E. McKnight Kauffer, Earl Oliver Hurst, and Ivor Cutler. However, inspiration mostly comes from crackly music and wandering about in a perpetual daze. His spare time is spent putting lint into strangers' pockets.

ILLUSTRATOR

"Thomas Fluharty?" said the editor holding Tom's portfolio under his arm as he opened the door. "Don't ever bring this crap around here again ... Come on in." Immediately Tom was ushered in and was walking down the hallways of *MAD* magazine, where he would be awarded his first cover in 1995. Other magazine assignments followed and so began his freelance career.

After moving from New York City to Minneapolis, *The New York Times* called and things took off from there. Clients include *The Village Voice*, *TIME*, *Der Spiegel*, *Entertainment Weekly*, ESPN, *Sports Illustrated*, *The Los Angeles Times*, *The Weekly Standard*, Fisher Price, and Coca-Cola.

His work has been selected by the Society of Illustrators in New York, the Society of Illustrators Los Angeles, and *Communication Arts*. Tom recently won a Gold Medal for his portrait of Hillary Clinton in Spectrum, the best in contemporary fantastic art. He has a *TIME* cover that hangs in The National Portrait Gallery in Washington, D.C., and currently has five covers in the show "The Art of *Der Spiegel*, Cover Illustrations Covering Five Decades."

CAROL KAUFMAN

ART DIRECTOR, THE LOS ANGELES TIMES BOOK REVIEW

Carol Kaufman attended California Institute of the Arts and the Boston Museum School of Fine Arts. As a designer in *The Los Angeles Times* Feature Department, Carol is currently art director of The Book Review. Previously, she was responsible for the "Life and Style," "Calendar," and "TV Times" sections of the paper. Her honors include Awards of Excellence in 2004 and a Silver Award in 2003 from the Society of Newspaper Design, and a Gold Medal from the Society of Illustrators 46th Annual of American Illustration. Her work has been included in the Society of Publication Designers 39th Publication Design Annual, and in Print Magazine Regional Design Annual 2004. She has been exhibiting her work in solo exhibitions in the Kiyo Higashi Gallery in Los Angeles since 1996 and in group shows in California and Boston. She loves dogs and has rescued many from the streets of L.A.

NANCY HARRIS ROUEMY

THE NEW YORK TIMES MAGAZINE

Nancy Harris Rouemy has worked at *The New York Times Magazine* almost as long as she lived in her hometown of Pittsburgh. After graduating from Penn State University, she worked at *Esquire* and *Harper's Bazaar*. Nancy's editorial design work has won gold and silver awards from the Society of Publication Designers and the Art Directors Club. She received a Publishers Award from *The New York Times* along with awards from AIGA and the Society of Newspaper Design. Nancy's other design work includes corporate identities and signage for a New York restaurant, a handbag designer, a jewelry company, and a private investigative firm. Nancy lives in Riverdale, New York, with her husband, Isaac, and their children, Israel (age 3), Shirel (age 2), and Ariel (6 months).

NANCY STAHL

ILLUSTRATOR

Nancy Stahl studied illustration at Art Center College of Design. When she moved to New York City to begin her freelance career, she continued her studies at the School of Visual Arts.

Nancy's illustrations have been reproduced as large as a billboard of Elvis's finger pointing to Graceland for the city of Memphis and as small as postage stamps for the United States Postal Service. Her recent work has appeared in *The New York Times* and *Der Spiegel* magazine, on calendars, in a book for Workman Publishing, and in publications for Sappi Papers. She has created packaging and identity illustrations for companies including Dreamery Ice Cream and Stonyfield Farms. Nancy recently worked as artistic director on an animated television commercial for M&Ms.

Nancy was chair of the Society of Illustrators Annual of American Illustration in 2000. She has taught illustration at the School of Visual Arts and the Fashion Institute of Technology and is an instructor at the Independent Study Masters Degree program at Syracuse University.

MINH UONG

ART DIRECTOR, THE VILLAGE VOICE

Minh Uong has been the art director at *The Village Voice* since 1995. He was born in Vietnam and came to the United States as a boat person at the age of 11. After graduating from Pratt Institute with a BA degree in communication design, he freelanced as a graphic designer and illustrator for such clients as *New York* magazine, Asian CineVision, Trainor Associates, Camera 3 Productions, Random House, Whispering Coyote Press, and *The Chicago Tribune*. Minh was the principle designer and partner of TM Studio, specialized in printing and selling T-shirts. He has illustrated two children's books and is currently writing as well as illustrating a kids' picture book.

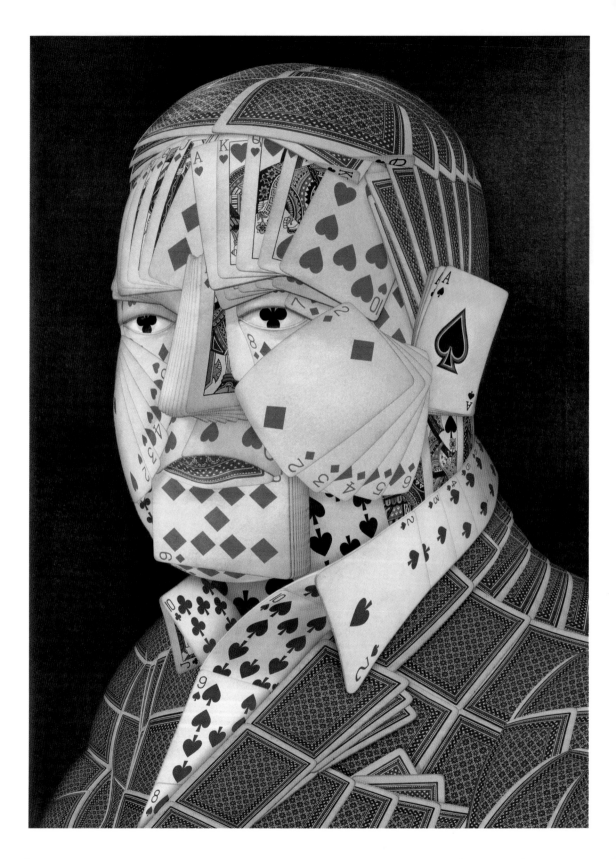

GOLD MEDAL WINNER
JOHN CRAIG

I had a commission some years ago to create a collage portrait of Henry Ford out of car parts. Using old magazine ads, I made it the old way, with paste and an X-acto knife. *Esquire* art director John Korpics remembered that piece and wondered if I could do a portrait in playing cards—a poker face. With a weathered deck, Photoshop, and a template portrait, I was able to manipulate the cards in ways that I could never have done years ago. Thanks for the recognition.

This image is now the most awarded of all the images I've done so far, thanks to Joan Ferrel, the art director, not only because she's the one who entered this piece in every contest, but also because she rejected my first sketch. As I recall, she rejected it not because it would have been that bad, but she wanted a stronger editorial point of view. For the second sketch, Joan proposed that I show the "measuring and/or comparative " aspect of the story. It was the one she chose.

When I was working on the final piece and painting the eye, I got a bug—I couldn't help making it gloomy. Was it the opinion I had about the story or the character that I couldn't help expressing? I changed the eye at some point, thinking it would never be accepted, especially since it wasn't clear on my sketch that it would end up with this look. Just before I put down my brushes, I changed it back to the first eye. I was sure I would be asked to correct it, but I sent it in anyway. When she got it, Joan did not ask for any changes—she didn't say a word about the eye. Instead she designed an elegant spread. And now this image is the most ...

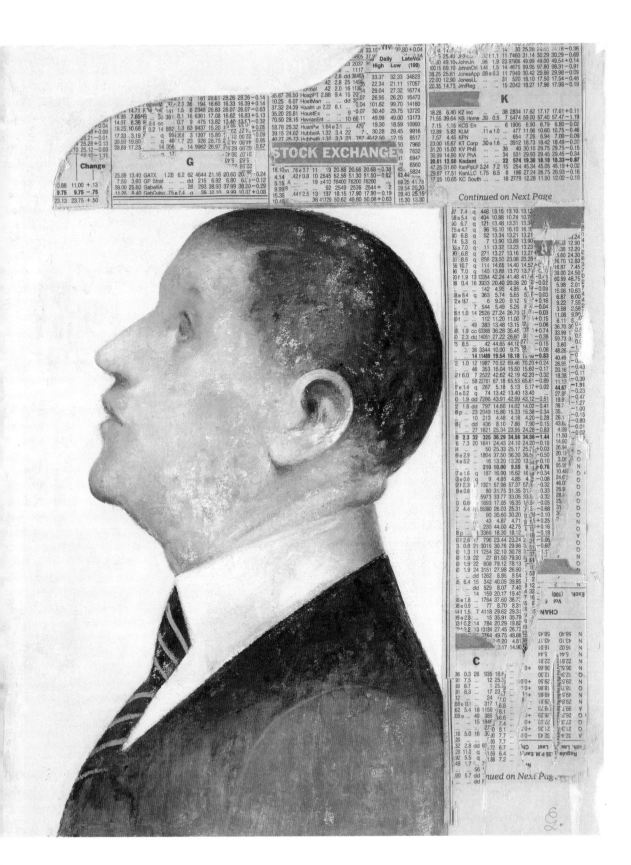

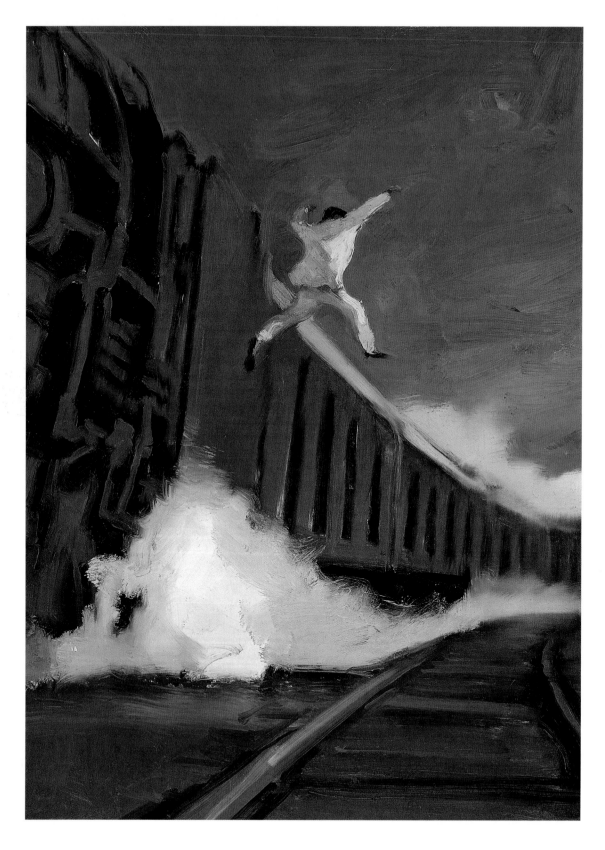

GOLD MEDAL WINNER
PETER SYLVADA

This was a feature story about the Nazi death camps and one man's story of his eventual escape.

The painting depicts our survivor in this dramatic, early morning moment as he escapes from the train on its way to Auschwitz. I painted him in the warm morning light leaping clear of the death train, which is still in the cold shadows.

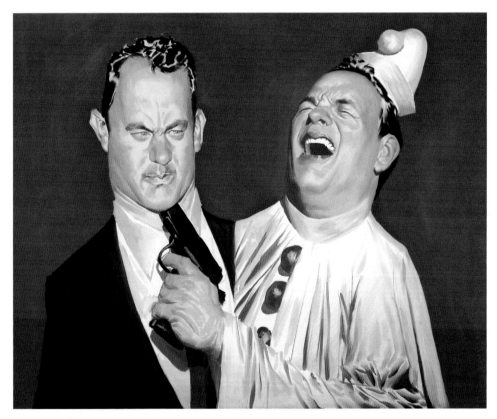

When I did this piece for *Esquire*'s movie page, Tom Hanks was moving from the *Castaway/Road to Perdition* heavy phase of his career into the frothy she-nanigans of the Coen Brothers' *The Ladykillers*. As usual, we arranged a get together with Tom, Joel, Ethan, and Condoleezza Rice in our little mountain retreat outside Geneva for the photo shoot. Condi, of course, couldn't take her hands off the gun and was the one who had the great idea to tickle Tom to get the expression we were looking for. She and art director John Korpics spent a lot of time talking about sprockets, drive shafts, and Kierkegaard, as usual. At least that's the way I remember it.

I had done a few different pieces dealing with the war in Iraq, but the story I was asked to illustrate by Chris Martinez for *Esquire* was a bit different. This was a very deep story that considered where the U.S. military was headed after toppling Iraq, and if the U.S. could police the world effectively.

Chris gave me the freedom to go in any direction I wanted, which is always a blessing. Some ideas come instantly and feel right upon reading the material, but this was not one of those instances. I felt I labored through this one. This wasn't the first concept I submitted, but my second. I wanted a simple image showing the U.S. holding the world in check and I felt this concept encompassed the main idea of the story the best. At the same time, I personally thought it might be a bit too hard to read. Chris really liked it, and, after all's said and done, I'm glad he decided to go with my crazy dog concept.

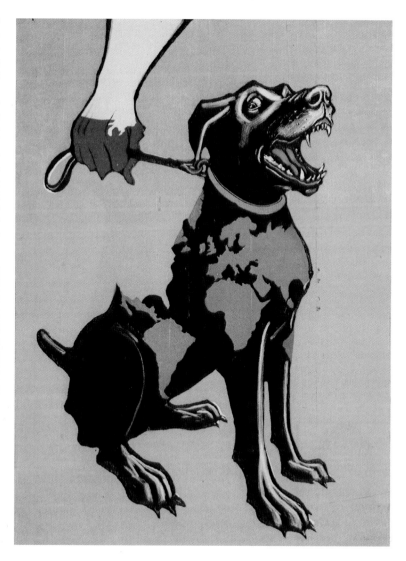

As an admirer of John Korpics's design, I had wanted to work with him for a very long time. One day I received a call from his assistant at *Esquire* who told me that John had seen my work while judging one of the Society's shows and wanted to get some samples for their files. Wanting to show him examples of my best stuff, I procrastinated on sending out the package. Some time later, John saw me at the Society and asked me just what he had to do to get me to send him some samples. After getting over my embarrassment, I immediately showed up at *Esquire* with my entire portfolio. Soon after, one of his associates, Dragos Lemnei, called and gave me this assignment, a portrait of the rap group The Roots, which ran with an article on their new album. It was done in pastel, oil-based ink, and acrylic paint on paper. I wanted it to be very bold and graphic. First job for *Esquire*, Silver Medal, not bad. I should have sent them stuff sooner. Lesson learned!

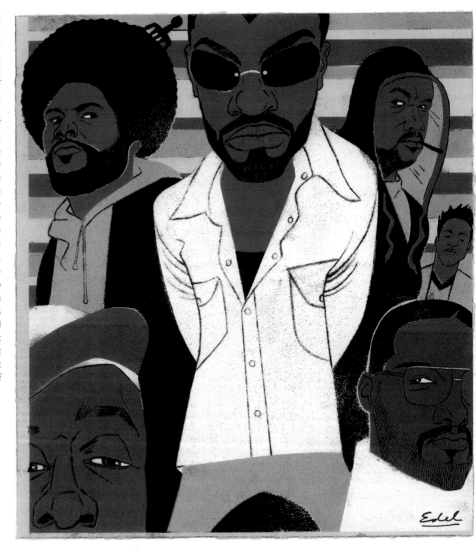

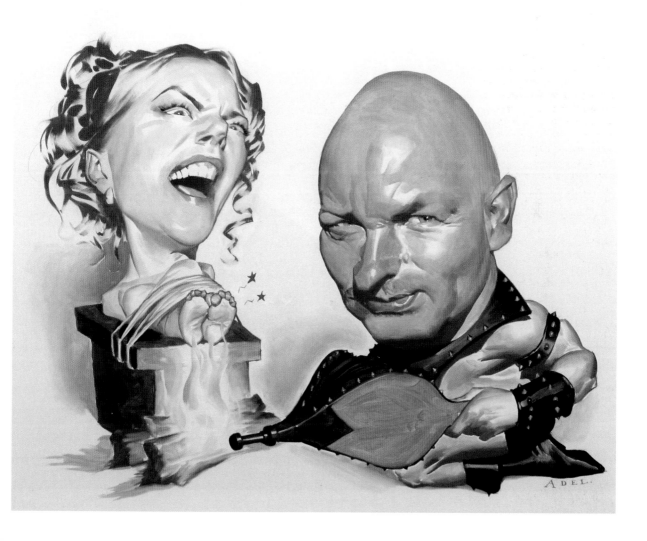

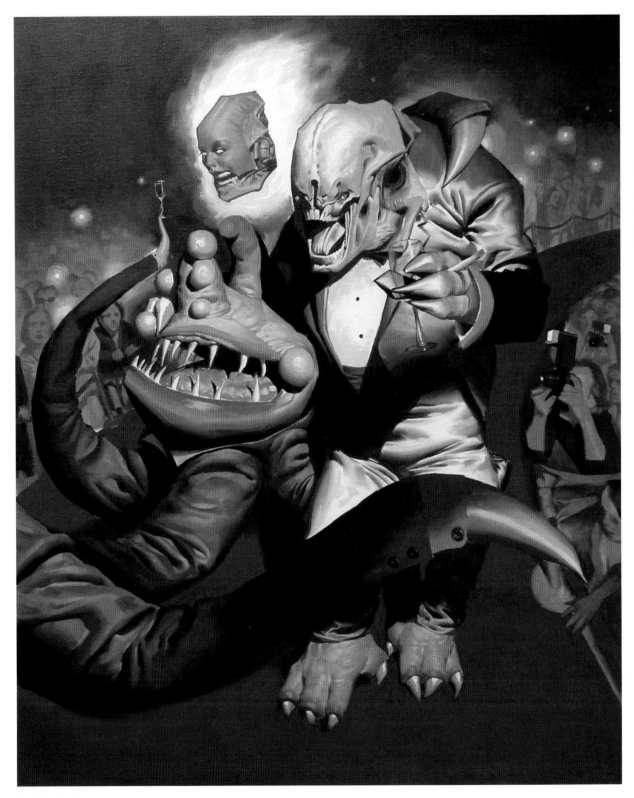

Daniel Adel

DANIEL ADEL

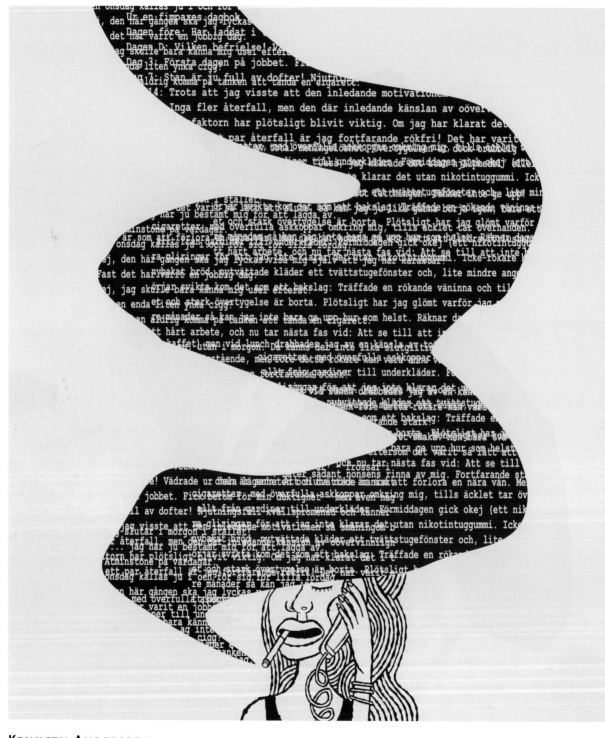

KENNETH ANDERSSON

The illustration is about a telephone line (or service) for people who want to
quit smoking. My mother always smoked when she was talking on the phone;
I thought it was fun to put words in the smoke. There were some stories from
people who were trying to quit so I used them in the text.

PATRICK ARRASMITH

This image accompanied a story by Harlan Ellison in *Realms of Fantasy*. It's an apocalyptic tale about the end of the world, filled with demons, the undead, and every other nasty element you can imagine. The main character is visited by a seductive specter. He isn't sure if she's real or not, so he touches her, sending her falling down a stairwell. The scene left me wanting to do some sort of Hitchcock/*Vertigo* image, freezing that moment in time.

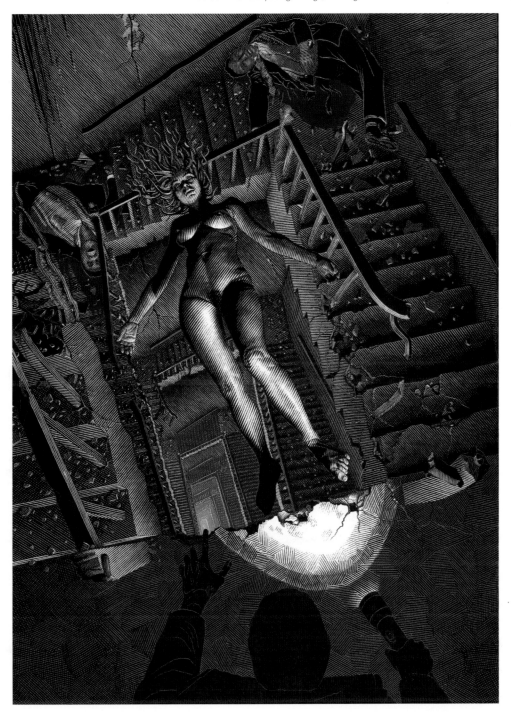

ISTVAN BANYAI

DANIEL BEJAR

This was my first assignment for *BusinessWeek*, and after reading the story I asked art director Gary Falkenstern if he had a particular direction in which he felt this image needed to go. He said he wanted something demonstrating the use of caution in a business deal. Beyond that he gave me total freedom.

The horizontal composition posed an interesting problem in that I couldn't show a figure head-to-toe. But it worked to my advantage, forcing me to crop in and concentrate on the foot of the body, taking a step forward. After that I wanted to infuse a sense of danger, so I started thinking of things that would be on the ground that could potentially cause some harm. I finally decided on rakes as the metaphor for danger because there's a light-hearted comedic danger associated with stepping on a rake and getting hit in the face.

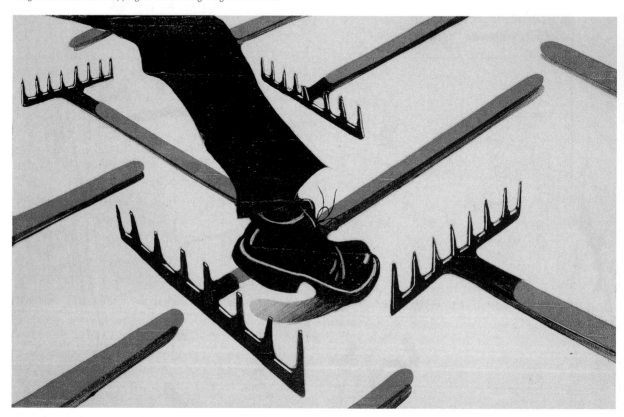

Daniel Bejar

I wasn't given more than a paragraph to read for this piece for *IQ* magazine. But that's really all it took to come up with something. Art director Sylvia Chevrier gave me the freedom to come up with whatever I wanted, and this was one of the rare instances when your first idea is dead on and you don't look back.

The story was about trying to get the front of your office to work with the back of the office to increase production. So I basically started thinking of worst-case scenarios of things that couldn't work or survive without the other half. And the logical metaphor ended up being a rowboat with rowers split in half. The ship has yet to sink, but we all know what's going to happen if these guys don't work together. It's a funny image, with dead serious undertones.

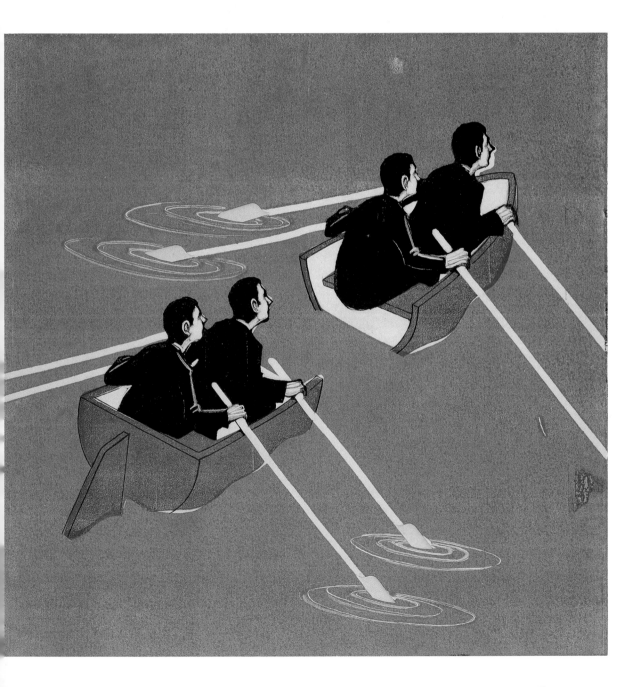

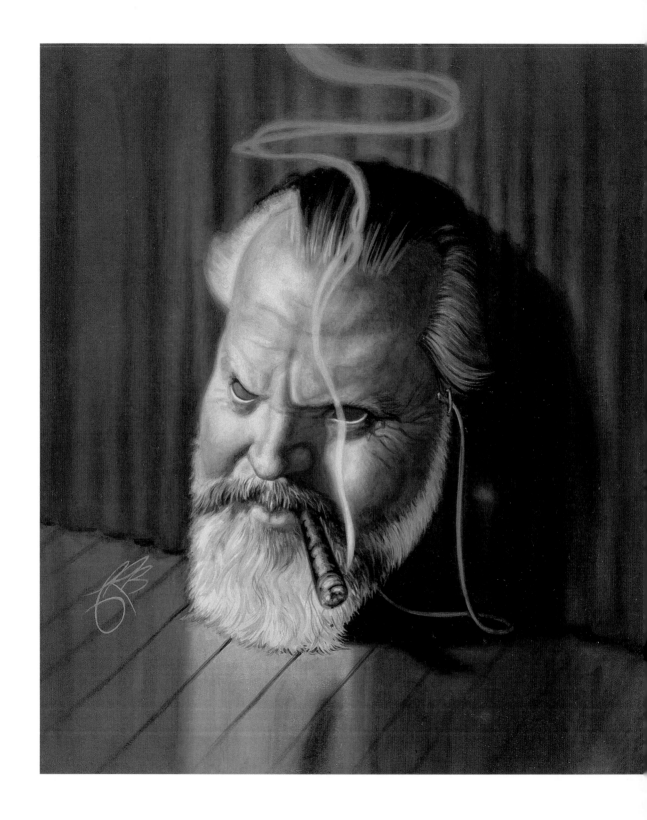

JAMES BENNETT

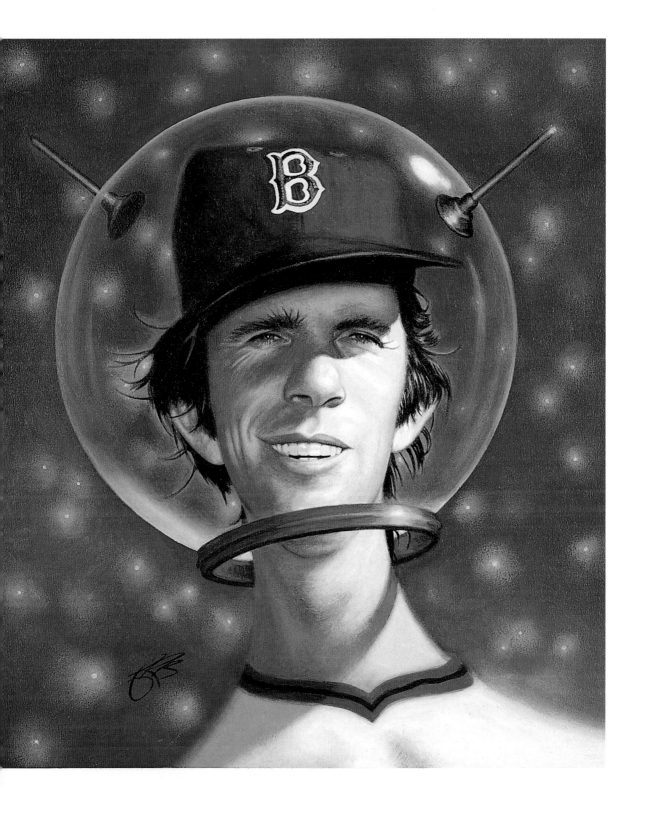

JAMES BENNETT

JONATHAN BARKAT

When Minh Uong at *The Village Voice* called me about this project for their year-end review section, I immediately started trying to find an appropriate theater to use as a location. I was looking for the rows of red upholstered seats that symbolize to me the traditional movie theater. I found exactly what I was looking for at the Roxy Theater in Philadelphia. The owner was nice enough to let me come in for some test shots and then again with a model and lights in tow. I didn't even have to bring the popcorn! Originally the image had a few 16mm movie cameras in place of the head, but this approach didn't seem quite right. After discussions with Minh and some more experimentation, I settled on using many different shots of just the camera lenses. I'm very happy with the end result and also with its inclusion in the 47th Annual.

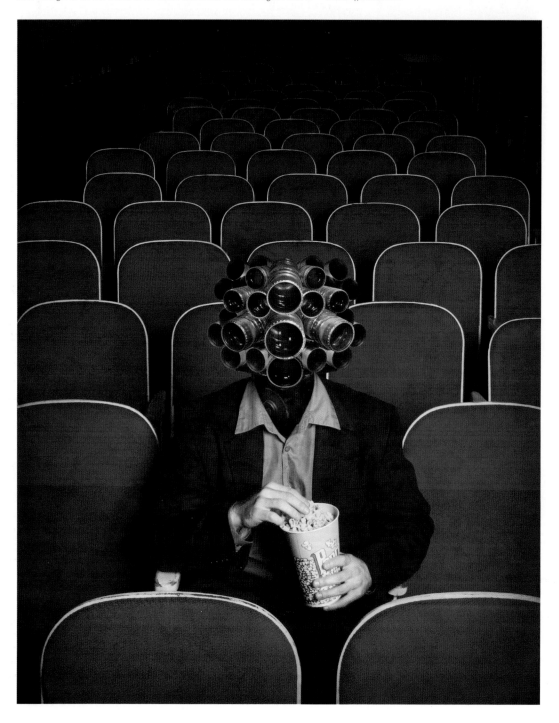

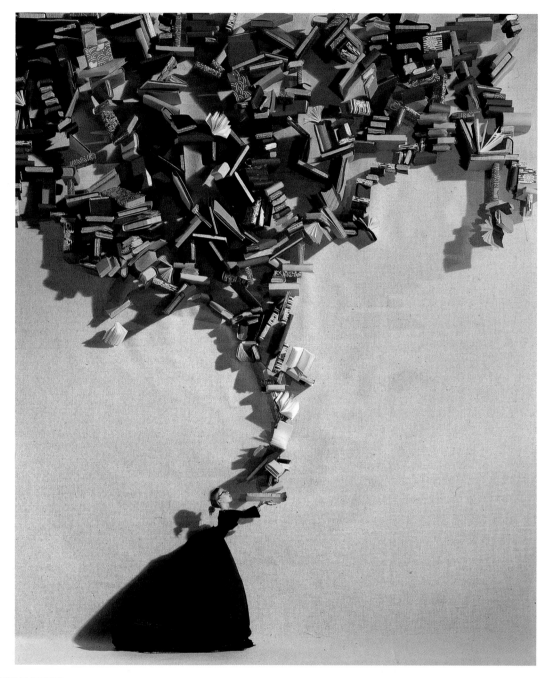

MEGAN BERKHEISER

After reviewing my portfolio, Carla Frank, the creative director of *O, The Oprah Magazine*, asked me if she could reuse one of my illustrations for a project about a French poetry instructor. The piece was originally created for *AARP* in response to a story about the decline of librarians in today's workplace. Art director Albert Toy and I worked together adapting my pre-existing illustration to fit the new story for *O*. By adding an additional remnant of fabric over the figure's skirt we were able to give my illustration a new life. The books were fabricated by wrapping bits of balsa wood in colored paper, and the figure is a combination of a photograph of my sister-in-law, printed on oak tag and hand colored with fabric wrapped around a wire armature. I shot the final images with my 4 x 5 view camera.

(p9 Note: While taking my sister in law's picture, I assured her no one would ever see her likeness in this quarter-page illustration which actually ran as a full page and has had several new lives printed in *O Magazine*, *PEI Magazine*, *Per Me Magazine*, American Illustration Website, and the following exhibitions: the Eisner Museum, the Little Art Theater, the University of the Arts, and the Society of Illustrators.)

SERGE BLOCH

I like to mix pencil drawing and photography because photography really
makes us believe that it is real. Often, only one element in a photograph
brings in the reality; the drawing allows me to play with it. To represent insults
using insects is a very common and widespread idea. I must have seen it in
the depictions of Hell in the Renaissance or in works by Hieronymus Bosch.
Myself, I own a very pretty Mexican devil that spits out snakes.

I like to start with icons, to play with the common language. As for the theme
itself—Boston's uncivil reputation—because I live in Paris, I can sympathize
with the Bostonians because the Parisians are pretty good in that field.

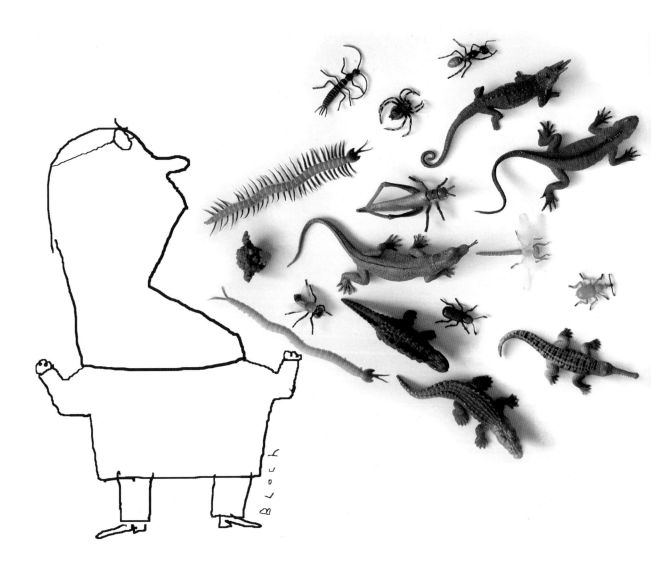

Serge Bloch

Working for daily newspapers is a real joy. You have to be quick and there is a real sense of obligation to get a good result for the art director as much as for me. I like the quality of their paper; it is not flattering and lends itself to simplicity. After having read the paper, you can use it as a straw hat, an airplane, or to wrap up fish. There was a saying in the 1970s about a satiric newspaper called *Hara Kiri*, "the only newspaper that doesn't stain the fish." Drawing for the daily press is a modest art.

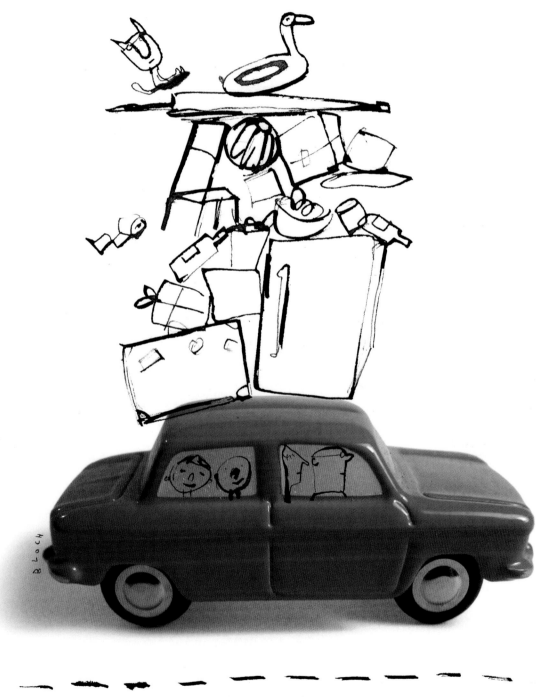

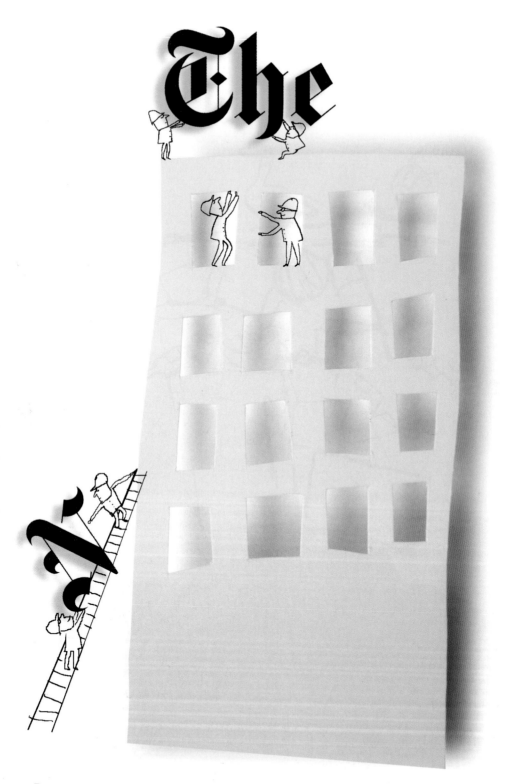

SERGE BLOCH

Another game with an icon: *The New York Times* logo that builds itself a new headquarters. Three little men, a little piece of paper and voila!

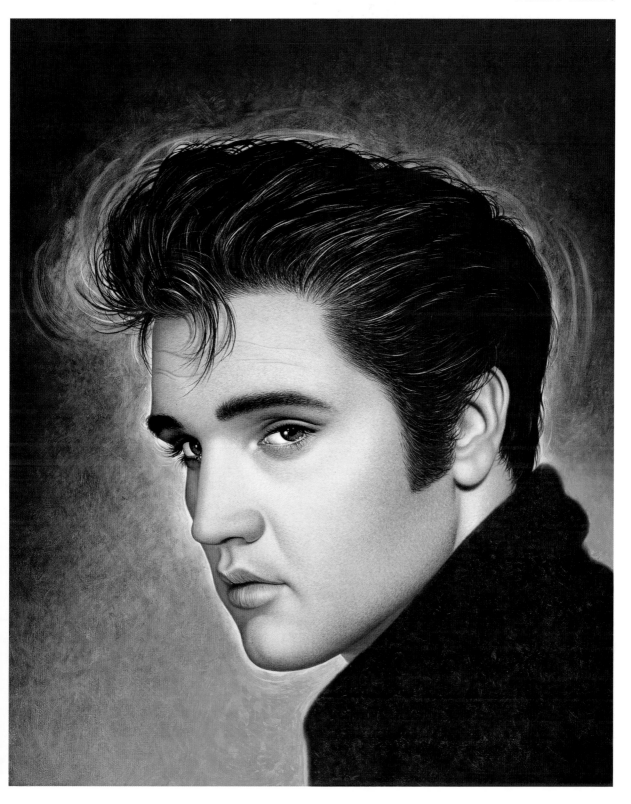

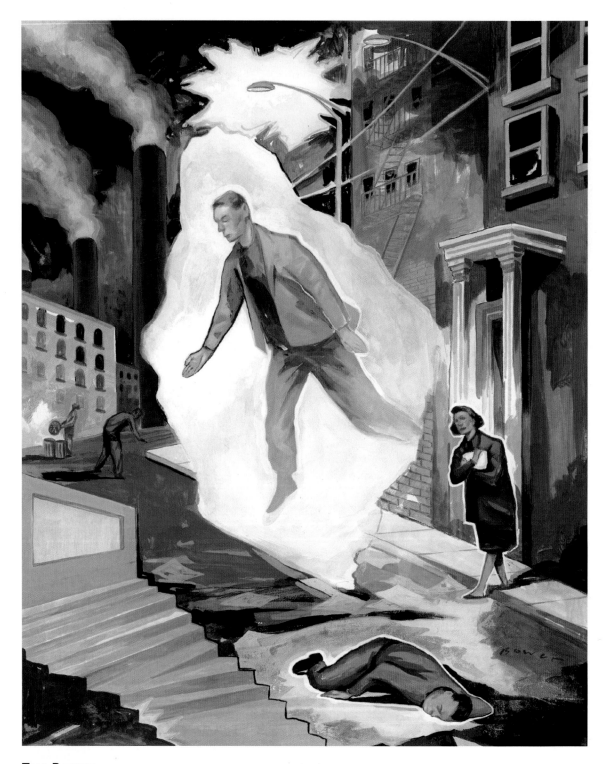

TIM BOWER

Entertainment Weekly chose *Samaritan* as the year's best fiction novel. It is the account of an altruistic man who returns to the violent housing project in which he grew up.

TIM BOWER
A cover illustration for *Forbes* entitled "Have They No Shame," about crony capitalism.

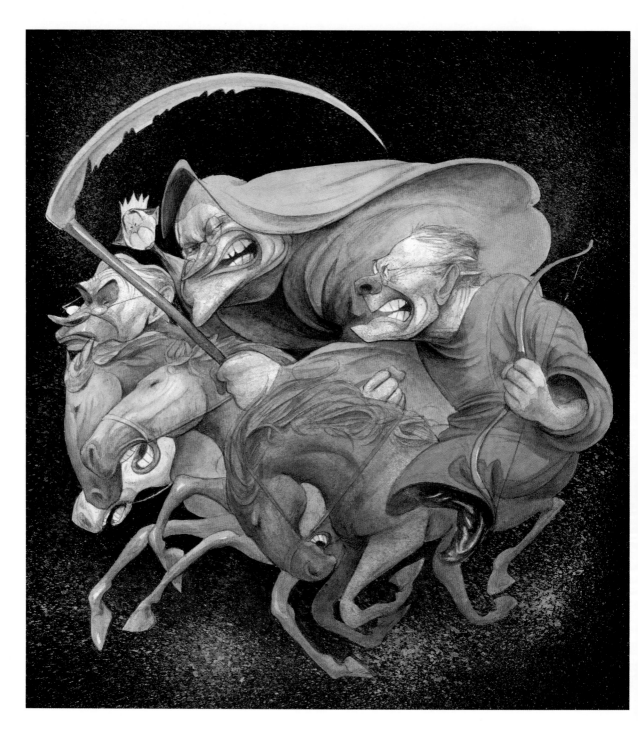

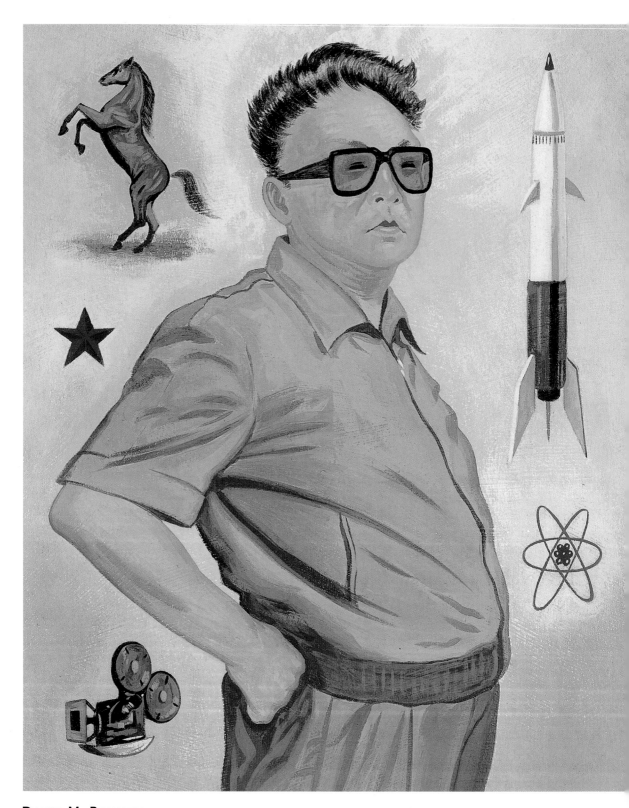

DAVID M. BRINLEY

MARC BURCKHARDT

This piece was for the cover of *The New York Times Magazine*, accompanying a feature on the Brazilian president Lula da Silva. The article explored da Silva's leadership of the nation and its evolution from an agrarian economy to a more global presence. I had about three days to complete this painting. By far the hardest part was fine-tuning the hand-lettered type. A month later it was picked up for the cover of an Italian magazine and I had to re-do the type for the Italian translation!

MARC BURCKHARDT

I was asked by art director Devin Pedzwater to create this portrait of Johnny Cash for the "Immortals" issue of *Rolling Stone* just a few months after the music legend's death. I tried to evoke the simplicity and power of Johnny Cash's music using imagery from his life and music. One of the great American music legends, it was an honor to create this portrait.

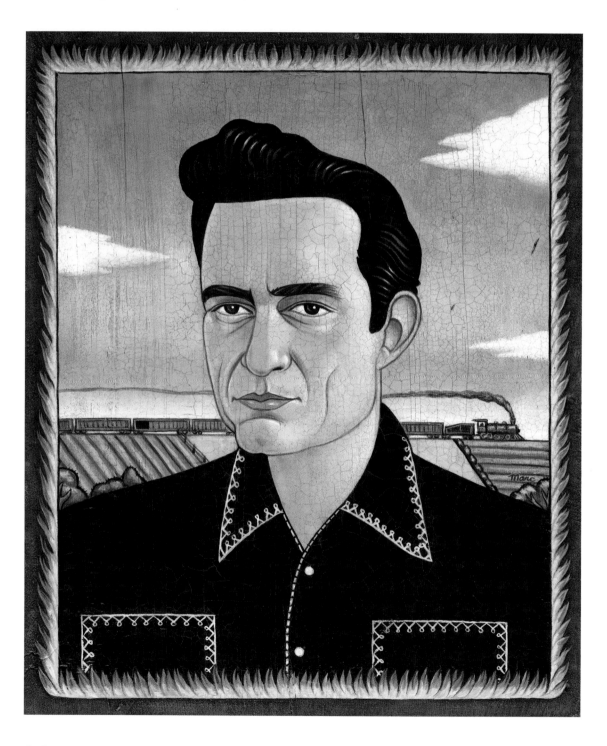

MARC BURCKHARDT

This was one of a series of portraits art director Marti Golan commissioned for *TIME*'s "100 Most Influential People" issue. I created portraits for the "Heroes and Icons" section, and this piece tried to capture the hope and pride that Nelson Mandela has inspired in so many South Africans. My favorite part of this piece was trying to capture the pattern, texture, and colors of South Africa in all the different personalities of the figures in the background.

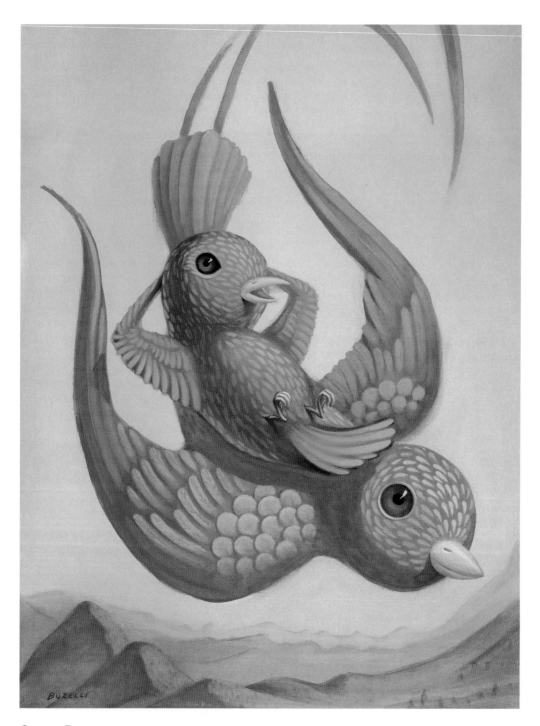

CHRIS BUZELLI

This piece was created for a great magazine, *PLANSPONSOR*. It was featured for an article regarding "Do-It-For-Me," a financial advice program. Since I enjoy painting animals, I chose birds to convey the concept. I was inspired by the art director to create this piece for myself rather than specifically for a business publication. I have since sold the oil painting at a gallery and continue to sell prints of this piece through my website.

DANIEL CHANG

The article was about alternative vacations and gave one couple's account of
their cruise on a freighter versus on a traditional luxury liner. Their experiences
were highlighted by an encounter with flying fish during sunset.

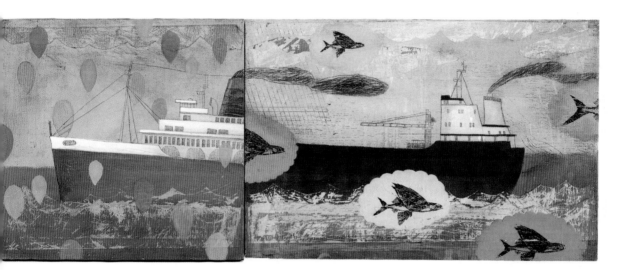

MICHELLE CHANG

TIME magazine had a feature story about the dilemma of the modern woman—specifically, about the choice to pursue a career or follow the path of marriage/family. The art director took the cue from the title of the story, "The Princess Paradox." Hence the idea to work with the iconic Cinderella figure and having her choose between Prince Charming and career. By putting Cinderella in the center, and large enough in scale, I was able to create two separate backgrounds—one modern, and one not so modern—to convey the story.

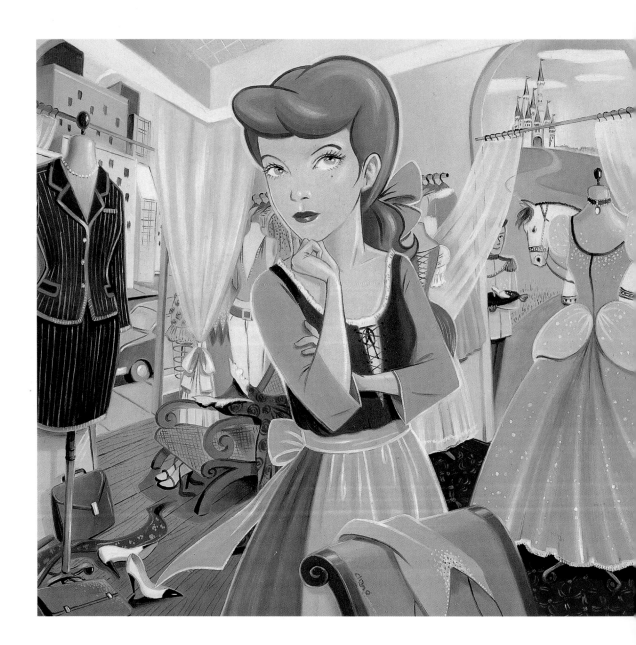

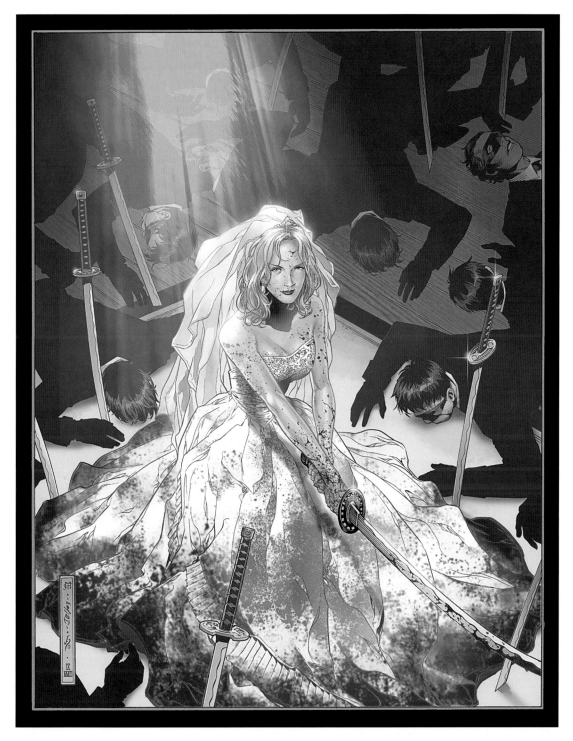

JIM CHEUNG, JOHN DELL, JUSTIN PONTSOR
This piece was produced as a cover for *The Village Voice* to celebrate the release of *Kill Bill Volume One*. The idea behind it, conceived by art director Minh Uong, was to show the Bride in action wearing her wedding gown; something not seen in the first movie.

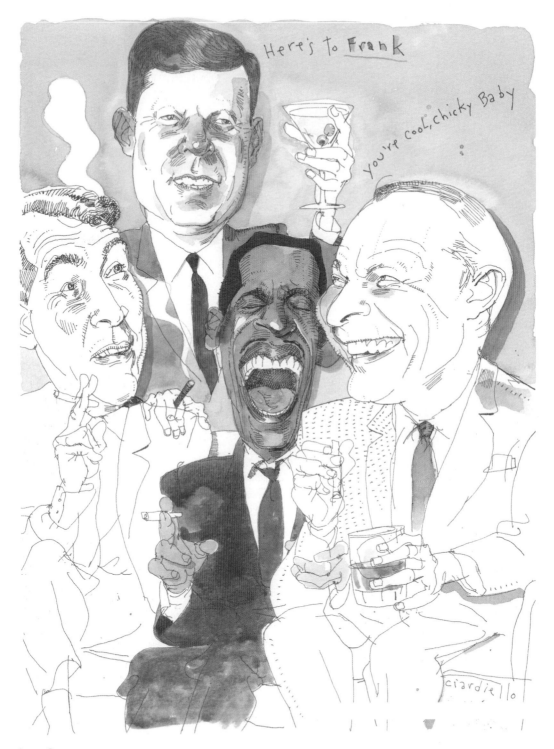

Here's to Frank

You're cool, chicky Baby

ciardiello

JOE CIARDIELLO

This story involved Sinatra's relationship with JFK. Over the years, Japanese *Playboy* has been one of my favorite clients. They allow me complete freedom with no preliminary sketch required. This ideal situation enables me to approach a job in the way I work best—drawing directly with pen.

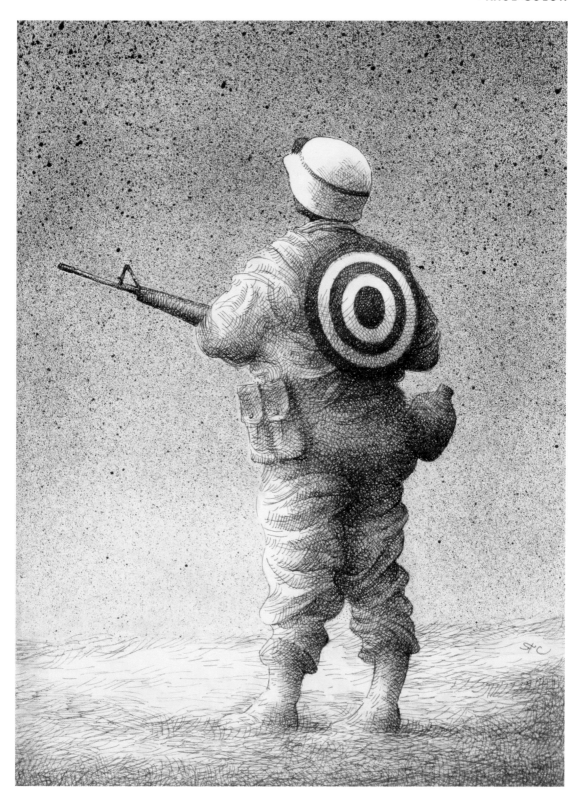

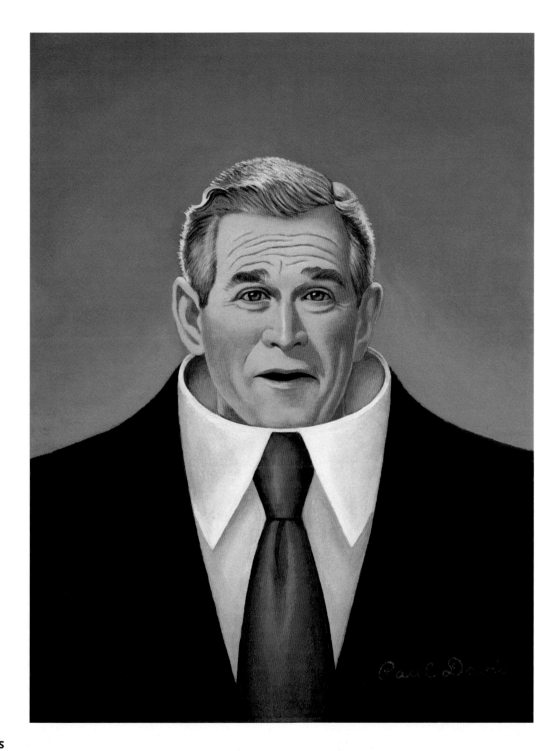

PAUL DAVIS

David Harris at Vanity Fair asked Brad Holland, Gerald Scarfe, Edward Sorel, and me to do pictures of George Bush for an article by Niall Ferguson called "The Monarchy of George II," which appeared in September 2004, just before the election. My notion was that George Bush is not really a big enough man to be president. If I could change anything about my picture today I think that I would perhaps make him smaller. I don't think that the article or the illustrations changed anybody's mind, but perhaps, in retrospect, a few more people share our view.

JOHN CUNEO

This was for an *Esquire* magazine sex advice column, addressing a question about the potential negative effects of excessive masturbation. The first sketch was a literal take on the old "... you'll grow hair on your palms" warning. It looked like a man balancing a small hedgehog in his hand.

The next sketch was more successful and led to this final. I remain trou-bled, however, by the "spanking the monkey" analogy. First off, I just don't see the resemblance. Secondly, and unless I've been doing it wrong all this time, the "spanking" thing seems ill-advised. Still, as a visual metaphor (and once you throw in a few extra monkeys), you really can't—um—beat it.

JOHN CUNEO

Here's a drawing for a *Sierra* magazine feature on the late, lamented, pro-environmental policies of the Republican Party. When art director Martha Geering describes an assignment, she often mentions an idea or two that her editors have and sometimes she'll include her own suggestion. This is always prefaced by a comment like, "...Here's what we were thinking, but I know you'll come up with something better..." But I hardly ever do—and this is no exception. Martha suggested a green elephant, which was perfect. I desperately threw in a bigger elephant and a little Teddy Roosevelt—and then claimed the entire concept as my own.

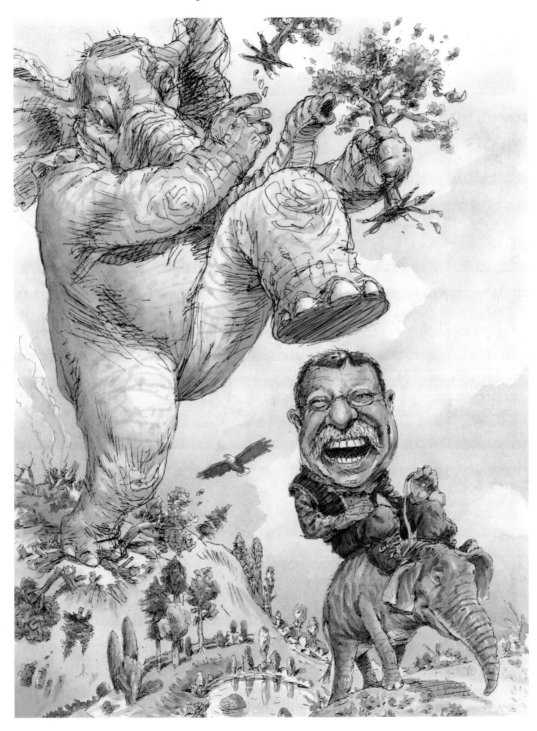

RAUL DELEO

This illustration was made for a yearly magazine/bookazine called *Dif* (from "different"). The article that accompanied this illustration was about the disappearance of terrorists and dictators. After brainstorming with the art director, we decided that a bit of humor could lighten up the topic and give it a less heavy perspective. We decided that the illustration should mimic the animated cartoon style of Walt Disney.

I wanted to try and imitate the early Mickey Mouse cartoons. But because the illustration was published in print it had to be a comic strip version. I was very busy at that time, and I only had three days to make up a story and finish the artwork. Although I only slept for a few hours in that three-day period, I truly enjoyed working on this project. With the help of my loyal computer I managed to get it all done and was pleased with the final result.

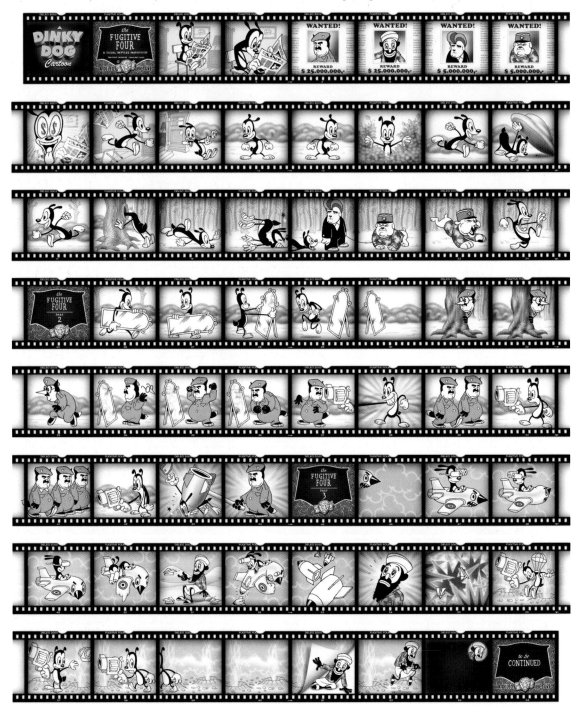

PRICE $3.95

THE

NEW YORKER

MAY 19, 2003

PETER DE SÈVE

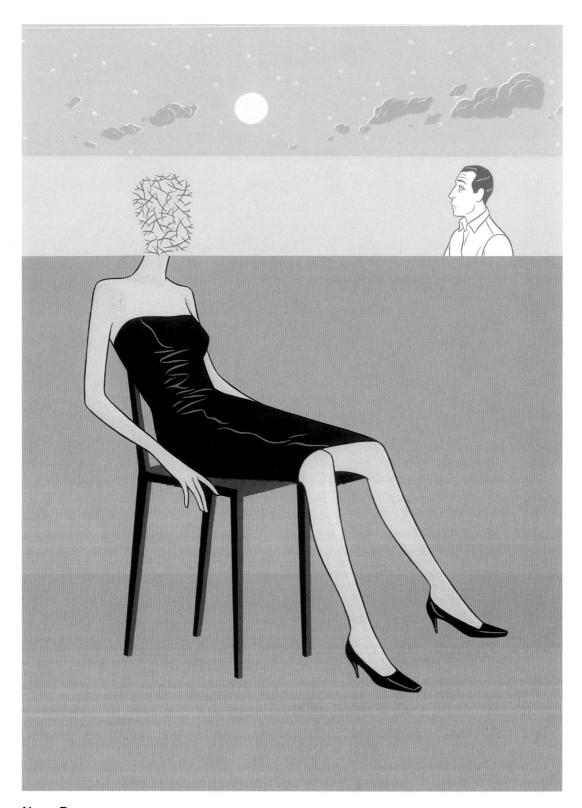

NICK DEWAR

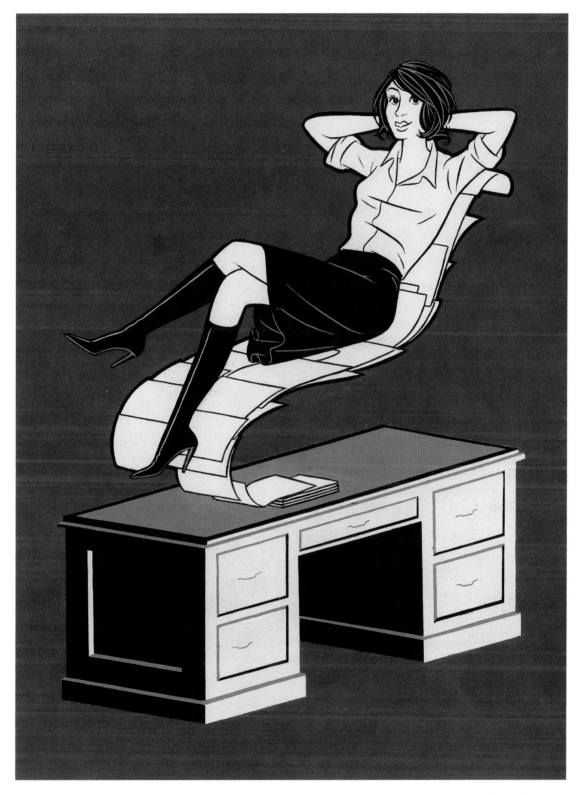

NICK DEWAR

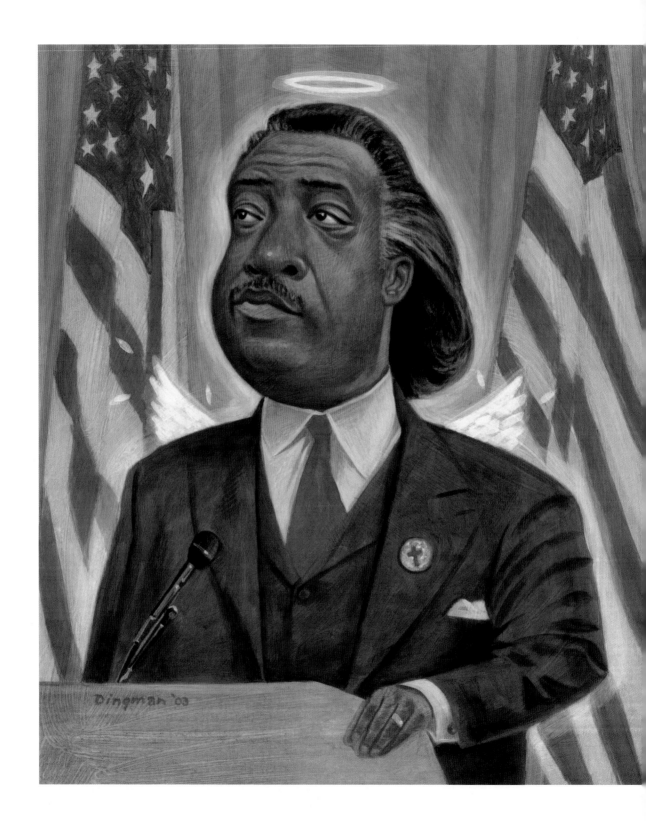

ALAN DINGMAN

GERARD DUBOIS

At first I was not so sure how I could depict the power of forgiving, the subject of this article. I first proposed a conceptual approach to the client, as I was not convinced I could express forgiveness any other way. But Vicki Nightingale, the art director, was obviously more confident than I was. She encouraged me to draw this more narrative and emotive scene.

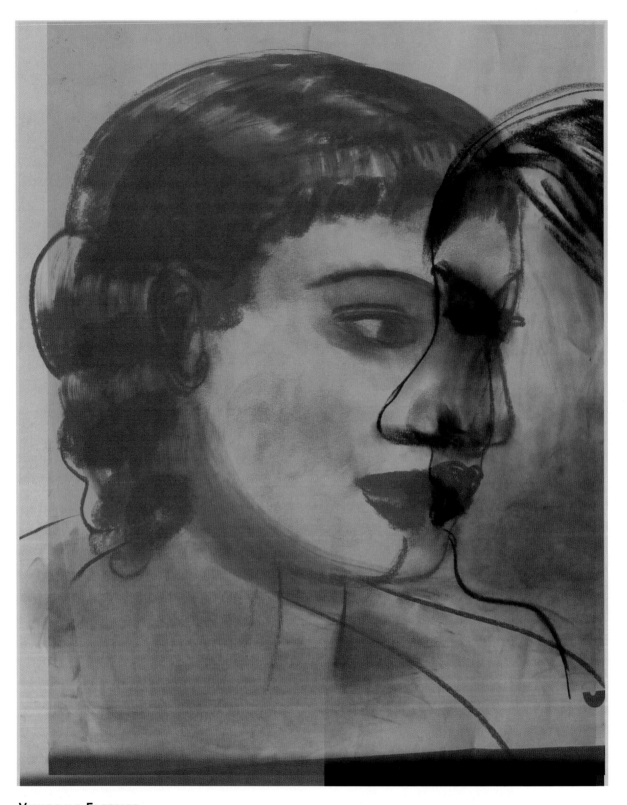

VIVIENNE FLESHER

VIVIENNE FLESHER

THOMAS FLUHARTY

Any time you get a call to draw Bush as a Boy Scout roasting Kerry like a pig on a spit, you drop everything. That's exactly what I did for this job. It doesn't get any better than this for a caricaturist. It's unbelievable that I get paid, too! The hard part was envisioning Kerry's gesture when he was tied up. I actually wrapped real duct tape around his painted body, but it didn't read well enough, so I had to settle for black cord. *The Village Voice* always gives me great concepts. Thanks Minh Uong and Ted Keller.

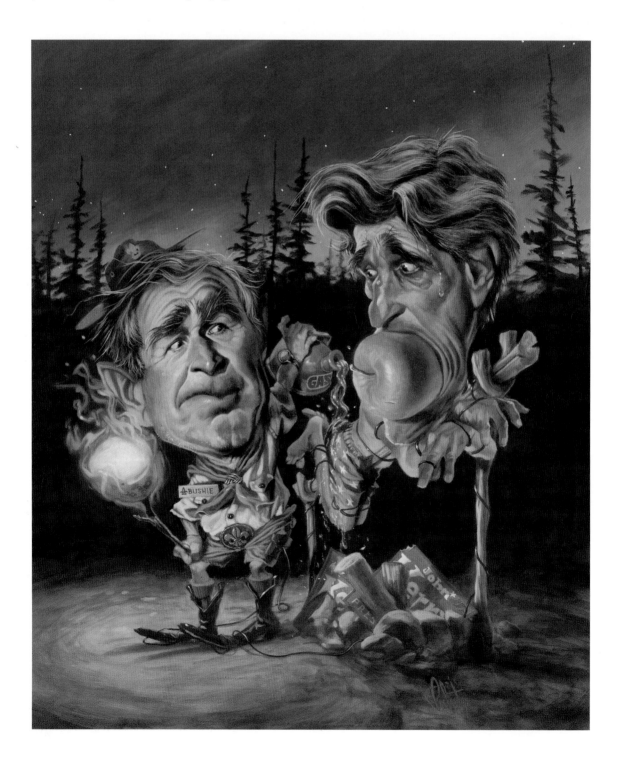

THOMAS FLUHARTY

I immediately got excited about this piece. Portraying a 50-year-old guy who refuses to grow up is something I can really identify with. All of the props I got to draw were of major interest to me, from my first *MAD* magazine cover on the chair to the Bart Simpson doll. I completed several sketches for this assignment. My first sketch wasn't the right approach—it was a close-up of the guy wearing a knitted skullcap with braces and playing with Bart. It's rare that *The Weekly Standard* has me do a second sketch but they wanted me to tell more of a story within the office environment, so I decided to pull things back to tell a bigger story than just this guy's face. It definitely worked better and keeping Bart in the sketch was a no-brainer. *The Weekly Standard* always gives me great liberty and creative freedom to "go off" on any given week. A huge thanks to Lev Nisnevitch and Richard Starr.

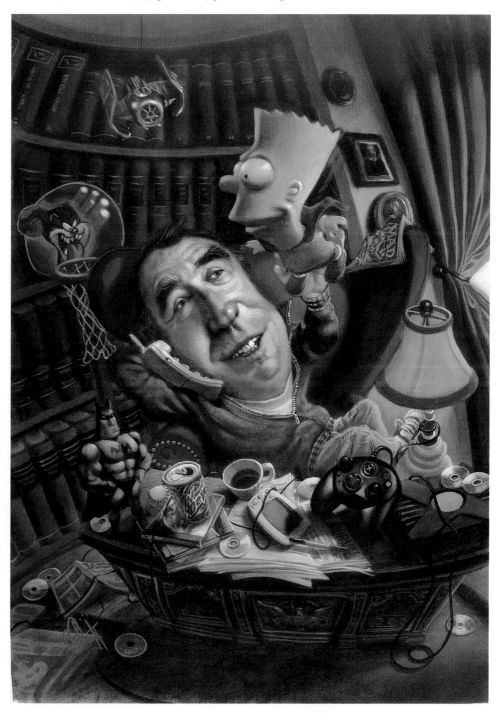

JOSEPH DANIEL FIEDLER

I have a very good working relationship with the client, *Arizona Highways* magazine, and especially with art director Billie Bishop. I'm not exactly sure why, but I'll posit a guess: the articles have been very good poetic reflections on nature. I am fascinated by the natural world. I lived in the Southwest for over eight years. I get to draw birds (in this case a mule deer) and nobody interferes with the creative process. Each experience produces work that I am happy with and it's not often I can say that! I'm happy. The client is happy. Everybody's happy.

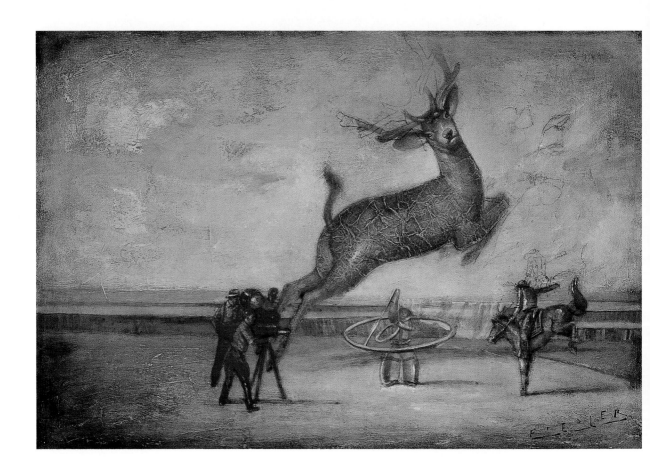

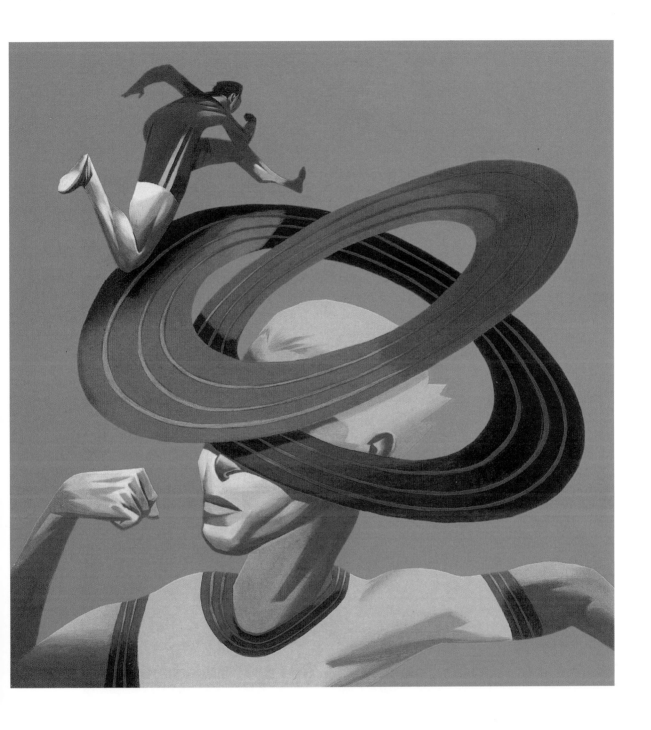

THOMAS FUCHS

This is a piece about "runner's high." Basically, when a person runs long enough and past a certain point of exhaustion, the brain emits stimulants that cause a natural high. This image is simply a runner's version of the little chirpy cartoon birds that would circle a character's head after something (like an anvil) dropped on it.

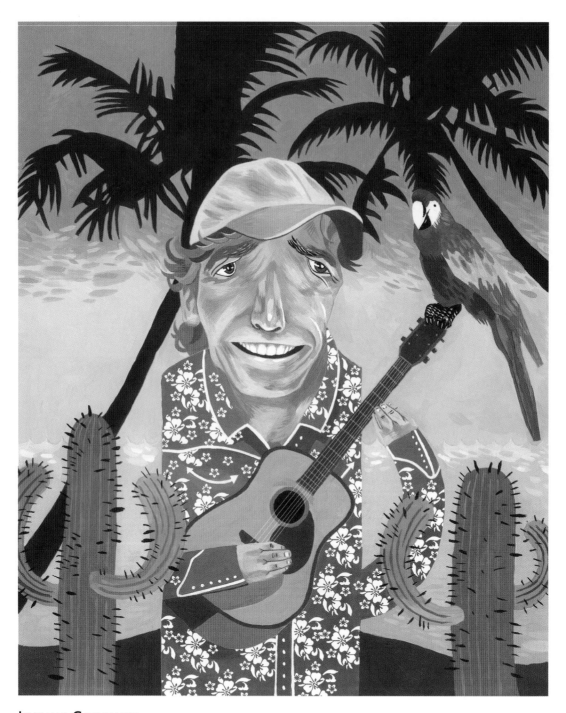

JOSHUA GORCHOV

This painting accompanied the review of Jimmy Buffett's album, "License to Chill." The album featured interpretations of old cowboy songs, a departure from Buffett's folksy Floridian style that beach bums around the globe have come to know and love. The idea was to create a conceptual portrait, weaving these two genres together. I put some cacti on the beach, a tropical floral pattern on his cowboy shirt and then mixed up a shade of pink I've never dared to mix before.

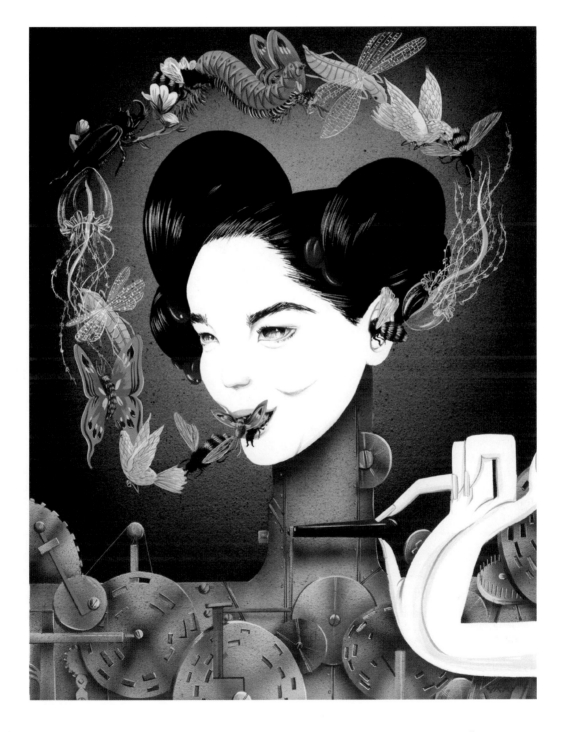

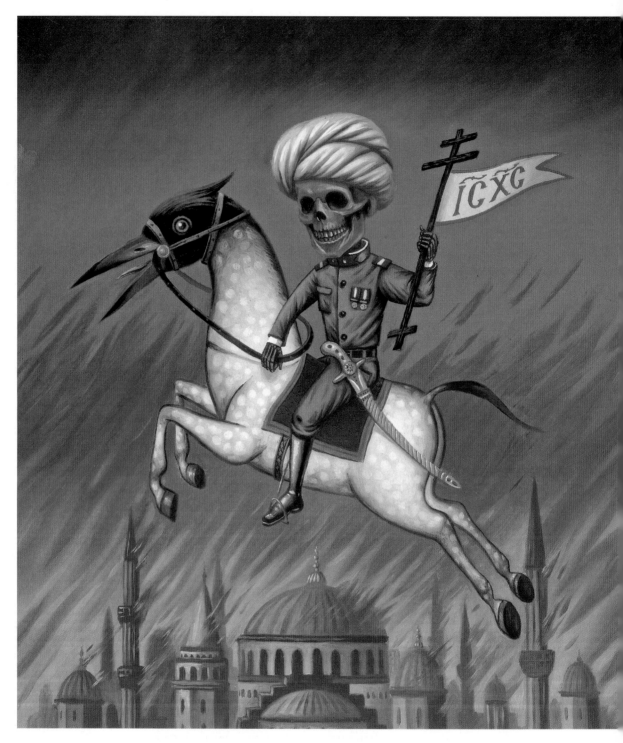

ALEX GROSS

This was done for *The Los Angles Times Book Review*. It was a review of a book that covered a lot of the history of Constantinople, later known as Istanbul, and the coexistence and later collision of Christian and Muslim cultures there. The actual title of the book is *Birds Without Wings*, hence the main image. I tried to combine elements in this image. The demonic-looking soldier is wearing a turban and a Turkish uniform, yet his banner holds the Byzantine abbreviation for Jesus Christ.

TOMER HANUKA

This former CIA agent goes to Iraq on his own and starts a Scout movement with the local kids. He becomes a central figure among teenagers who lost everything. They call him Abu Ali. Under the former regime the Scout movement was outlawed. Now they are back with a vengeance.

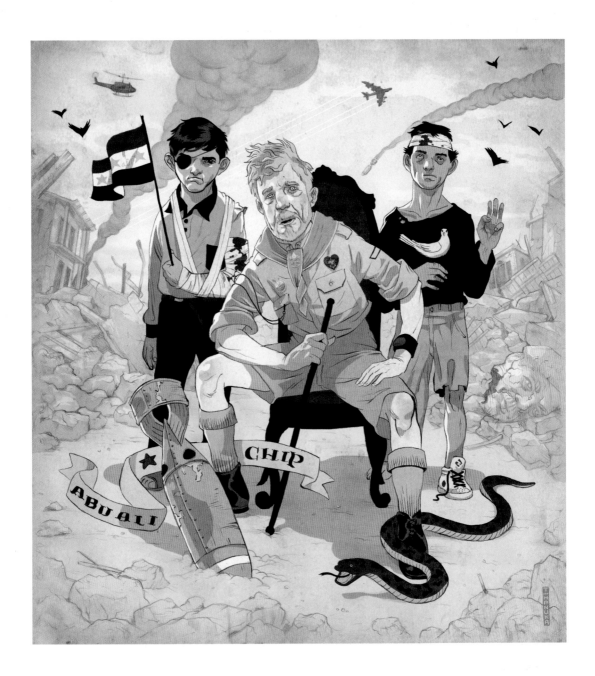

TOMER HANUKA

This image was made to accompany a short story called "Indignity." The plot revolves around a violent act performed by a group of teenagers. The story is being told in the past tense by one of the kids who took part in this shameful act and is still dealing with the guilt years later.

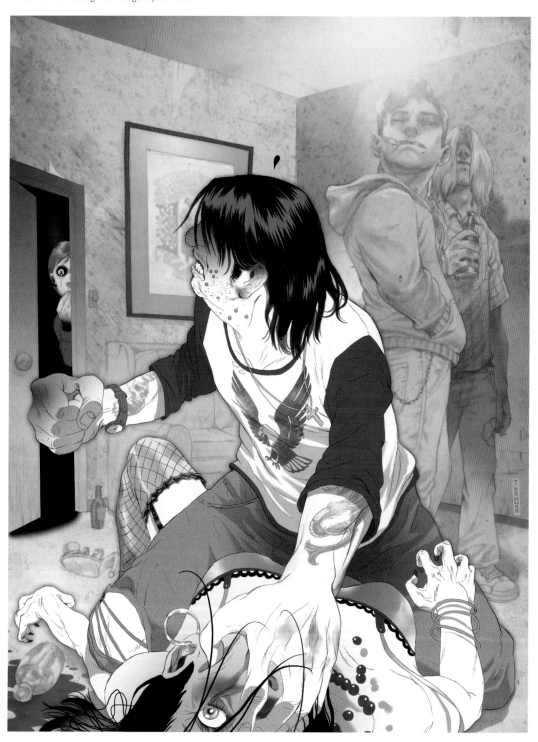

TOMER HANUKA

In the brilliant movie *Eternal Sunshine of the Spotless Mind*, Jim Carrey's brain is being wiped out so he can forget a former lover. The movie goes back and forth in his memory as certain parts are being erased. The white spots are "memory holes," missing parts of his former reality.

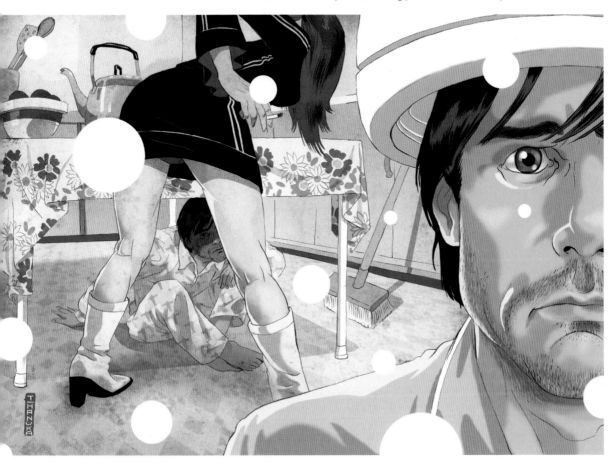

JODY HEWGILL

This was *Entertainment Weekly*'s first style page in their "End of Year" issue. I was asked to do a portrait of Sarah Jessica Parker in the dress she wore to the Emmy Awards. I loved all the soft folds of the dress, it reminded me of tulip petals. The crown and doves were added to complete the air of whimsy.

ODY HEWGILL

Rolling Stone magazine asked me to do a couple of portraits in a classical style for their "Immortals" issue. While I adhered to this direction for my portrait of Bowie, I strayed a little with Jerry Lee Lewis. I just had to paint him screaming and playing the piano with flames erupting. In hindsight, I wished I had portrayed him pounding the keys, but I think I got distracted by how beautiful and delicate his hands actually were.

JODY HEWGILL

This portrait of Halle Berry was commissioned for the "Power" issue of *Entertainment Weekly*. Her film, *Catwoman*, was due for release in a few months' time. The contoured lines of the catwoman mask were etched into the painting.

BRAD HOLLAND

This was supposed to be a painting of four Indian kids who had been sacrificed by their tribe and roamed the desert as spirits. But this isn't the painting I did first. At first I did a picture showing the kids in human form and Indian dress, silhouetted against a blue and pink sky. The image came out great but it seemed too pleasant to me and the colors were too beautiful. Beauty wasn't what I was trying to convey. So I asked the art director for more time to do it over. This time I tried to imagine the children as four candle flames flickering in a black window.

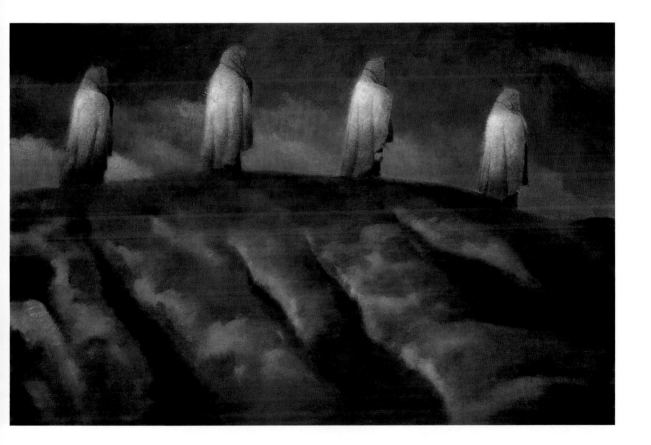

DAVID HOLLENBACH

This was done for the *Utne Reader*. It was an illustration for an article about taking on too much at work. Out of several different rough idea sketches this concept was chosen. Posed as if in an employee identification card, the man carries his burden in note form. Not only a burden, the Post-its hide his face and his individuality. This makes the work his identity.

DAVID HUGHES

Well, I watched the first series of "The Office" and I watched the second series and I can't remember my thought or work process except that I was gripped by an overwhelming energy to produce a masterpiece. Such was my cynical and despairing feelings toward the wretched art of illustration. I think it worked, I even think the designer didn't have to see a sketch; a sketch is the kiss of death.

MIRKO ILIĆ

This illustration was done for the cover of *The Los Angeles Times Book Review*. The issue was about Thomas Curven's novel *Little Scarlet*, which deals with the aftermath of the LA riots. The word "scarlet" in the title reminded me of blood. I thought of a black person "crossed-out," or crossed away from society. Meanwhile, the "x" is also becoming the X for Malcolm X, and the red-scarlet color is associated with tribal colors used to paint warrior faces. The red also reflects blood. To add more drama, I made the illustration perfectly symmetrical, except the drips of the paint/blood are irregular and thus throws off the symmetry.

MIRKO ILIĆ

This illustration for the cover of *The Los Angeles Times Book Review* was about K.C. Cole's book, *The Fabric of the Cosmos*. (The title "Writing Science" was added after the illustration was done.) The idea came about when thinking about space and cosmos, which got me thinking about black ink. If we are cosmos, and everything is cosmos, then ink is also cosmos. The blackness of it reminded me of the outer space. Since ink is also space, the illustration is about writing using space. To get the point across clearly, we added a few actual photographs of the planets of the solar system into the bottle.

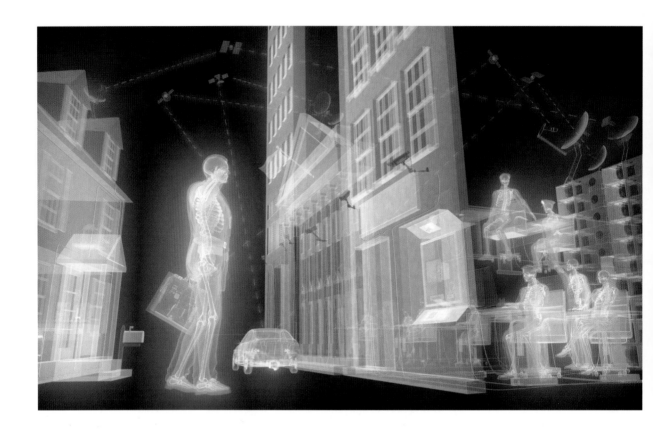

MIRKO ILIĆ

This illustration done for *National Geographic* magazine was about the issue of security. I had the opportunity to do a gatefold on the subject of scientific achievement used to track people's personal information. Indirectly, it is almost like living in Orwell's novel, *1984*, because with new technology, everything is transparent: the person, his house, car, belongings, and everything else. Even the people who are watching him—government, police—are also transparent. Among themselves, they are exchanging information and handling papers. This was a complex illustration for which my associate, Lauren De Napoli, needed not only to create the environment and objects, but also the inside of these objects, bodies, etc. This is almost like overlapping three totally different illustrations together.

STERLING HUNDLEY

Art director Karen Nelson gave me as much freedom as an illustrator could want on the Othello book. This particular work illustrated the scene just as Othello has been told by Iago that Desdemona has committed adultery. He falls to his knees and swears to kill her. Thanks to my friend Adam Johnson for his help on the series.

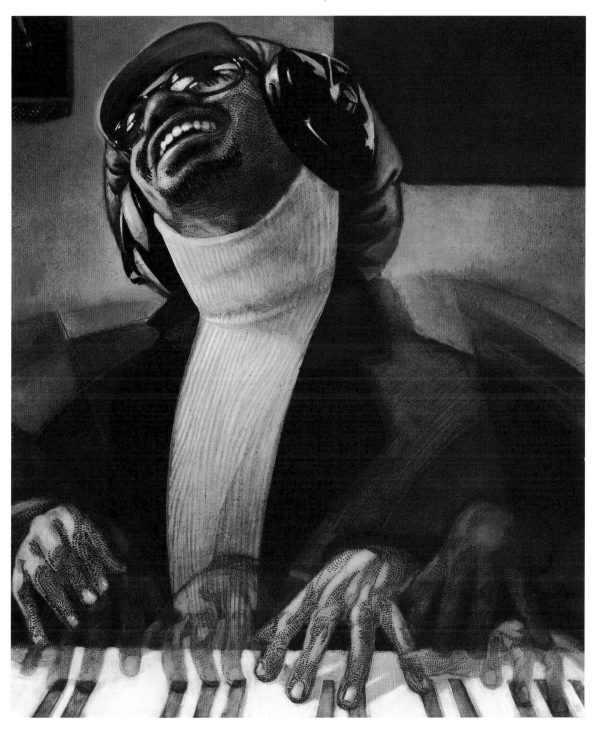

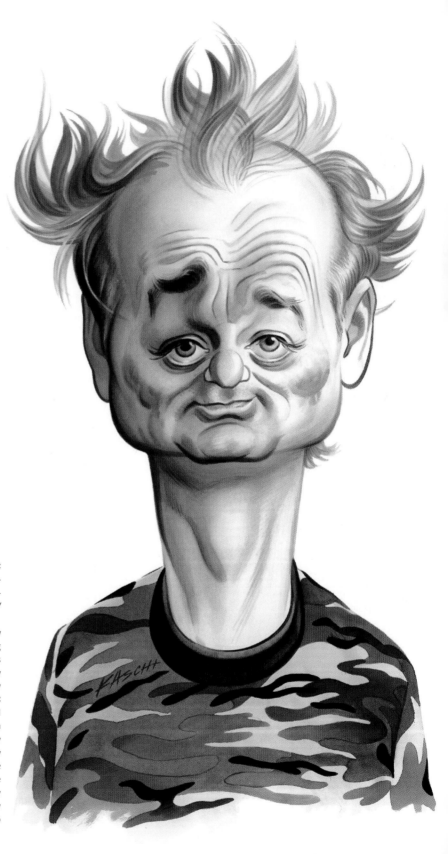

JOHN KASCHT

Since its inception 15 years ago, *Entertainment Weekly* has provided a showcase for caricature—and steady employment for caricaturists, even in lean times. I love *EW* for that.

I've done enough work for EW to know they prefer a caricature that is "doing something" rather than standing on its own as an interpretive portrait. When they commissioned a caricature of Bill Murray to illustrate their review of the movie, *Lost in Translation*, I knew right away that I wanted the concept of the piece to begin and end with his bemused, world-weary expression. I worked out an especially tight sketch so the editors wouldn't have to make a leap of faith—hoping that the expression could carry it. They liked it very much, and agreed with me that Bill Murray making his Bill Murray face amounted to having him doing something.

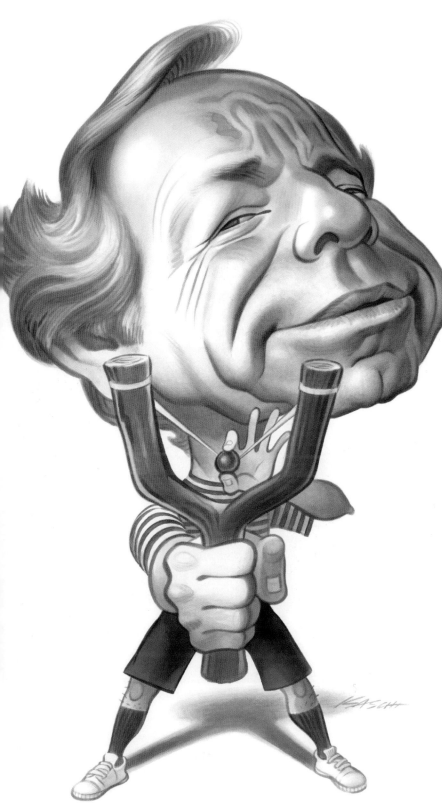

JOHN KASCHT

I hate trying to capture a likeness from un-detailed, inkjet-printed, web-resolution mug shots. I like to see wrinkles and pores and eyelashes. I'm not really old enough to be an old fart yet, but I hear myself complaining about change. You know, "Back in my day..." magazines used to supply excellent prints, transparencies and tear sheets to draw from. Or you could rent a decent scrap file from Reference Pictures in Manhattan, now out of business. These days, you're on your own.

Anyway, I was thrilled to get this *Village Voice* cover assignment because I happened to have a dozen excellent photos of Joe Lieberman who had recently been profiled in several magazines. It was such a pleasure to draw from good photos and not have to guess at the details.

JOHN KACHIK

Marco Rosales contacted me via the telephone, after reviewing my work on my web site. Like all really good art directors, he was able to see something in my work that didn't exist yet. He had the insight to know my illustration style would fit his editorial needs. He wanted a double-page spread illustration to go with a story in *Nexos* magazine. The topic was the Golden Age of Mexican Cinema, and Marco wanted the focus of the art to be the beautiful but stern woman as seen on vintage Mexican cinema posters circa 1936 to 1956. He directed me to a book titled *Cine Mexicano* for inspiration and reference materials. After a few hours with the text I was able to find a vocabulary of imagery that seemed typical of that period and cinematic movement. A sketch was made and approved. The final art was completed in Photoshop, scanning hand-drawn line-work and textural painted background.

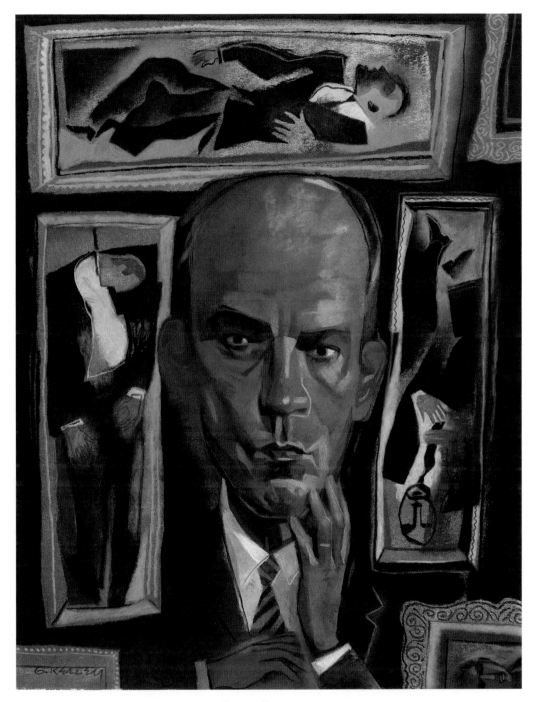

GARY KELLEY

In this film review art, Tom Ripley is battling Soviet secret agents and recruiting the picture framer in his small Italian village to help him destroy the enemy. The framer, terminally ill with nothing to lose, becomes Ripley's hit man in a kind of spy-versus-spy mayhem. The connection between framer and victim prompted my concept of bloodied bodies enclosed in picture frames, framing the portrait of a slightly twisted, definitely devious Tom Ripley—John Malkovich.

JON KRAUSE

The article this painting accompanied took a serious look at teenage obesity and its causes and ramifications. This idea was my first—my best—and the art director's and editor's favorite. Needless to say, I exalted in this rare occurrence.

JON KRAUSE

This was a cover assignment for an *America Lawyer* supplement that focused on splitting the roles of CEO and chairman of the board. The catchphrase was "too much power lies in too few hands." I agreed with that statement, so I retained the CEO status of my own business, and relegated chairman duties to my beagle Pickle, who quizzically stares at me for hours when I paint.

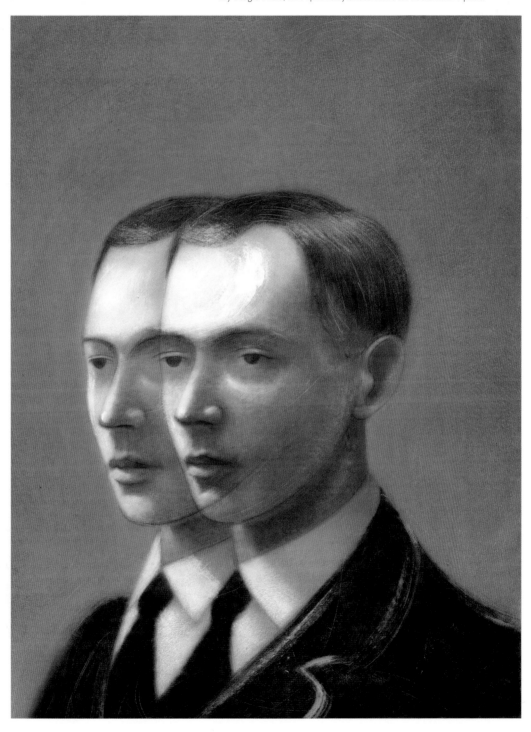

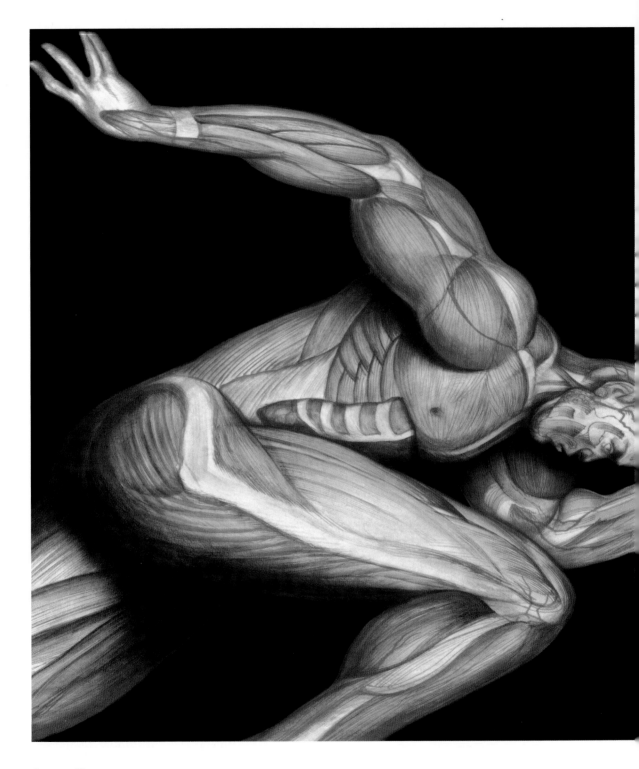

ANITA KUNZ

This was for an article about performance-enhancing techniques and drugs (including steroids) that athletes might use, and the legality of these drugs. The idea was to do a powerful cover with a larger-than-life athlete. I had to make up a good deal of the medical information in the image and was glad that no real medical illustrators took me to task for any irregularities!

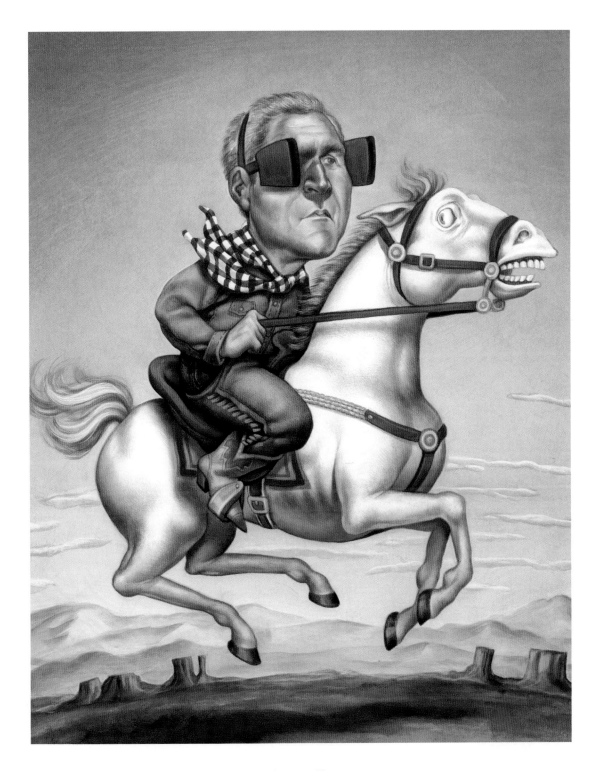

ANITA KUNZ

I was grateful to *The New Yorker* for publishing this image, thought by many to be controversial. It illustrates the idea of a rush to war in Iraq by using Texas imagery.

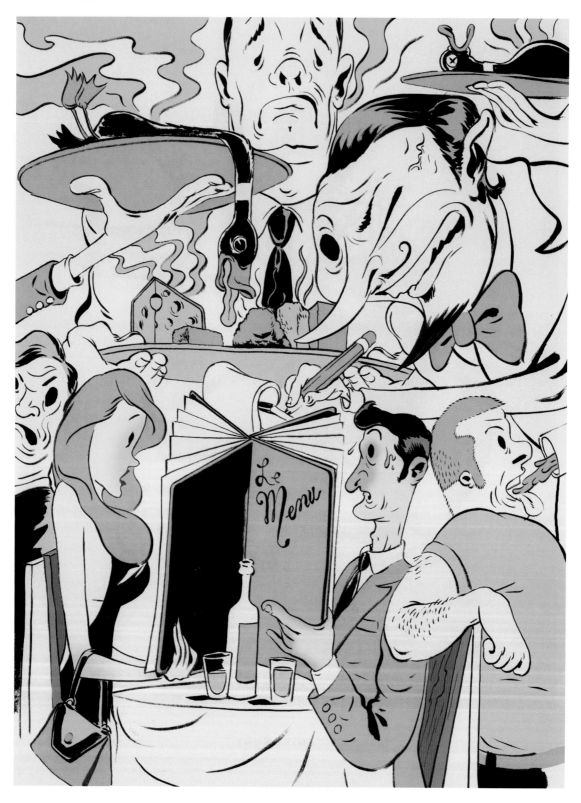

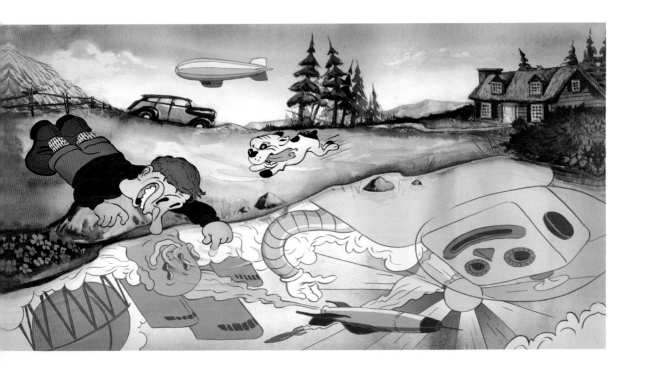

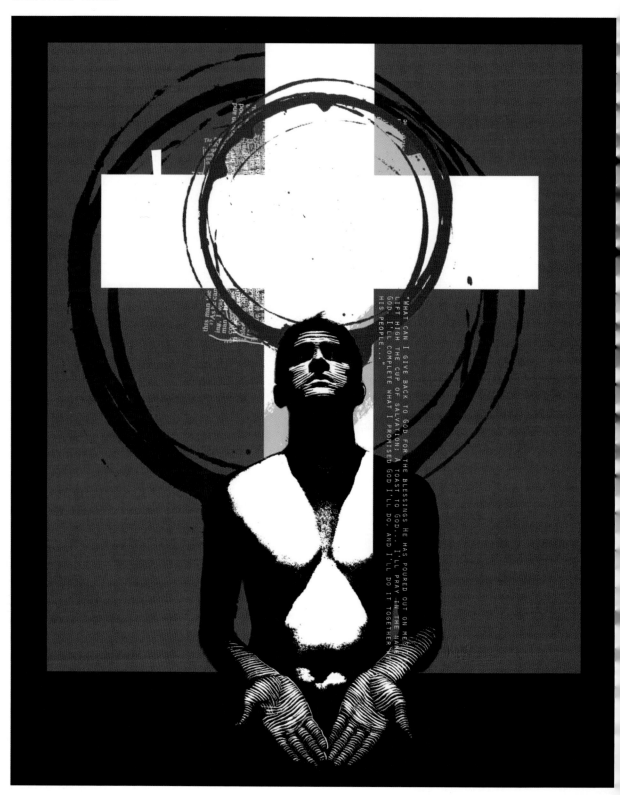

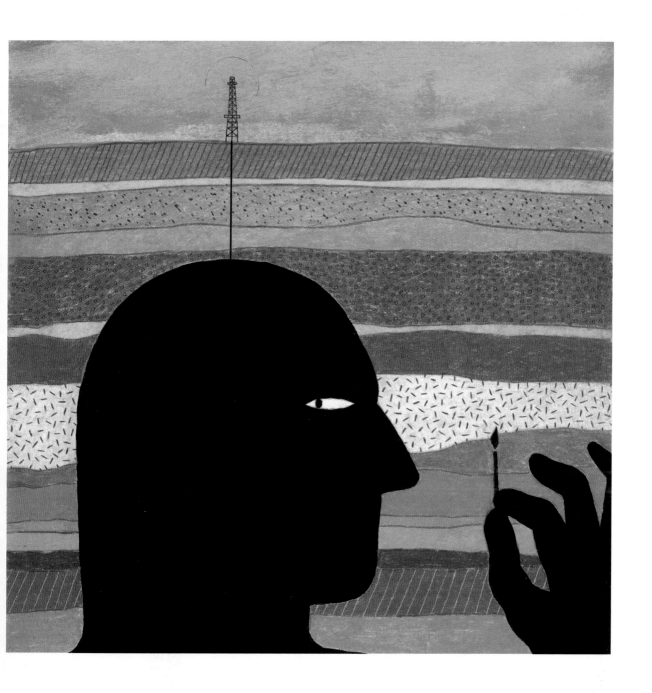

DAVID LESH

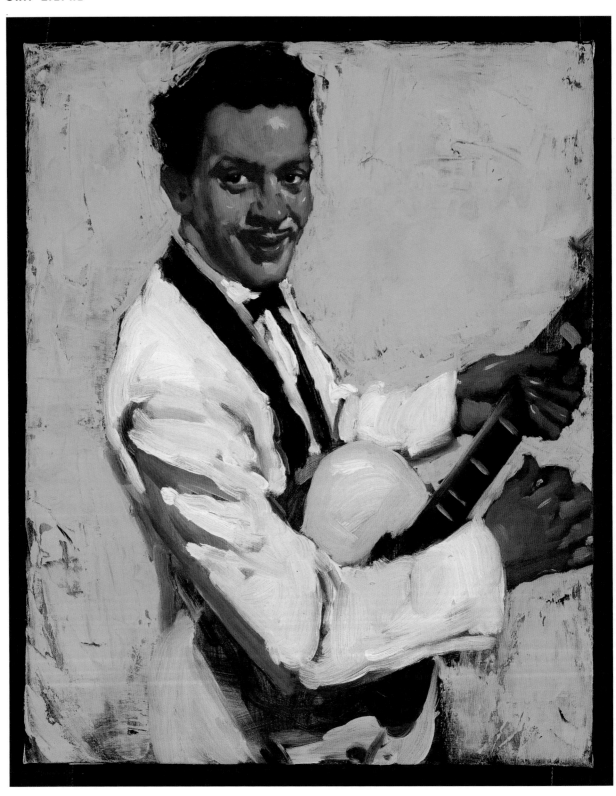

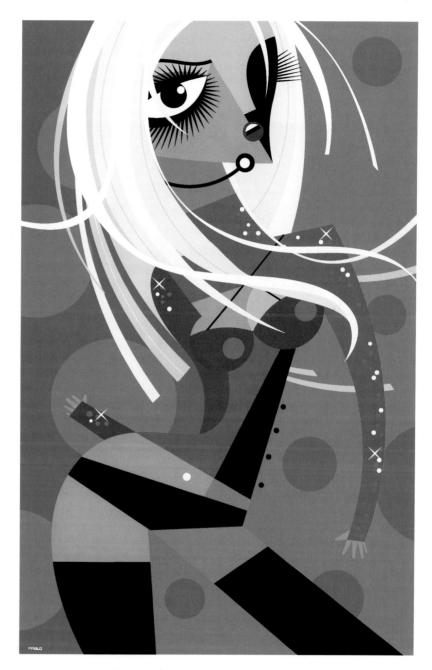

PABLO LOBATO

Rolling Stone chose Britney Spears as one of the hottest artists of the year, and they asked me to do an illustration of her. There are two things I consider important when doing a portrait: the likeness and the attitude of the illustrated. I thought the best way to do Britney was dancing in a sexy hot outfit showing her belly button and shaking her blond hair. I used reference pictures (a lot of them) and videos. I usually spend more time watching and studying the subject than actually drawing. I did the sketches in pencil and when one was approved I traced it with a vector software.

LIZ LOMAX

My *dream* job! Created for *Rolling Stone*'s "Rock's Rich List," which profiles the richest rock stars in the world. The Rolling Stones topped the list. To emphasize how wealthy they are I put them on a golden stage, dressed them in gold, furs, jewels, and gave them gold instruments. I used gold leaf, gold velvet, glitter, and rhinestones. Devin Pedzwater did a great job art directing this series as he really pushed me to go over the top with the outfits and

jewelry. I recall him saying "F*** Yeah!" when I asked him, "Is it really okay if I give them fur coats and gold chains?" It was a frenzy of gold paint and glitter in my studio as I only had ten days to make the Rolling Stones, 50 Cent, Christina Aguilera, and Toby Keith. The figures are made of wire, packed with tinfoil and rendered with Super Sculpey on top. They're baked in the oven, painted with oil paints and photographed digitally.

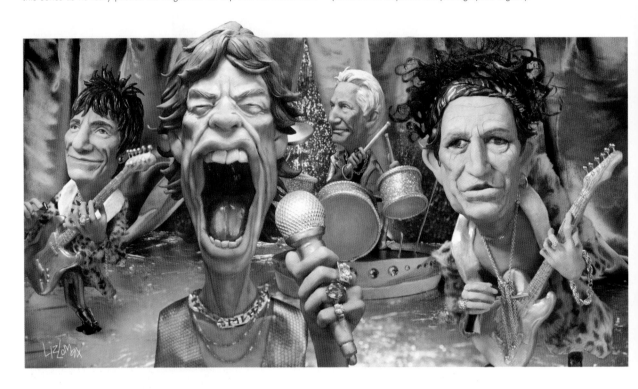

Liz Lomax

This piece was especially tricky because it was Devin Pedzwater's favorite musician on the list—serious pressure. I had to show that 50 Cent is loaded, so I made his bulletproof vest (which he wears, having being shot nine times) in gold. I made him a fur coat, threw some gold chains on him, and made him a throne from foam core with Sculpey and rhinestone details. 50 has a wire armature that functions as a skeleton. I packed tinfoil on top of that to build up the bulk of the figure. Next, I rolled out layers of Super Sculpey, covered the tinfoil, and rendered it with clay shapers until his likeness was achieved. Finally, I popped him in the toaster oven for 15 minutes, painted him with oil paints and photographed him digitally.

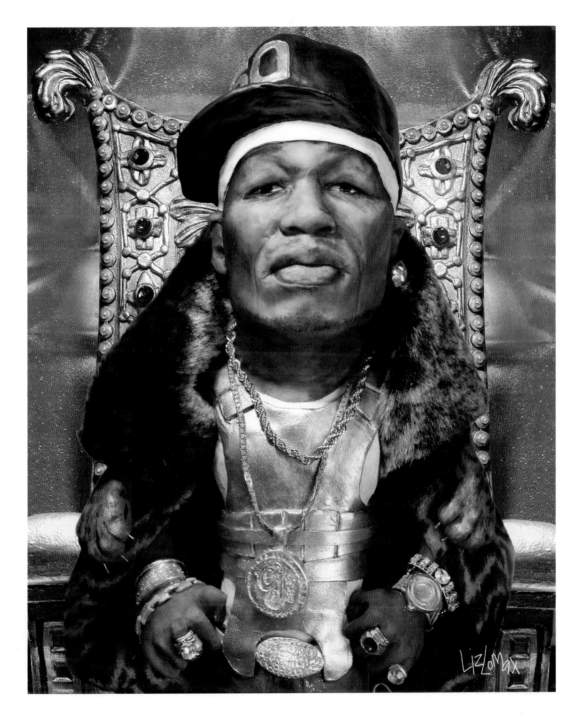

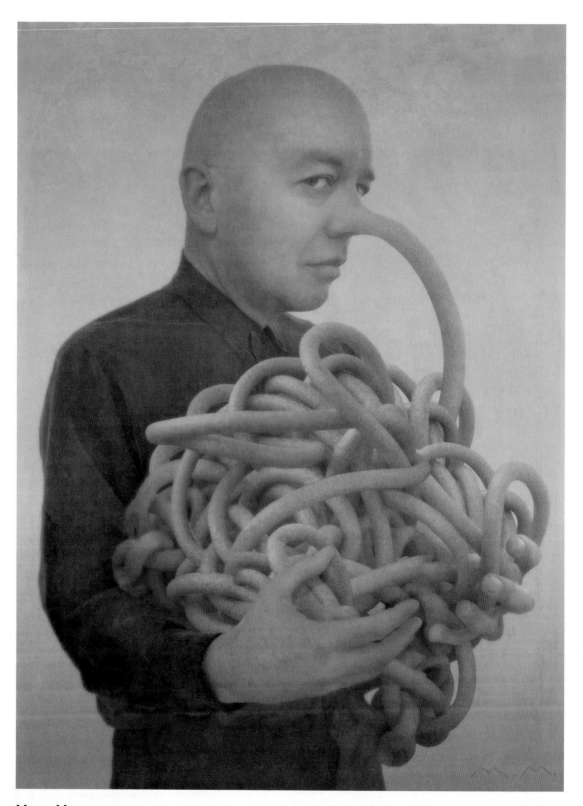

MATT MAHURIN

GREGORY MANCHESS

When the *National Geographic* called with this project they were hoping to have me paint from the sketches Herb Tauss had started for the story illustration before his untimely death. Ultimately, we redesigned the piece, so I did new sketches and it became my own. I had my son-in-law and granddaughter pose for some of the figures. It is a sad piece on so many levels for me: the tragedy of the slave trade, Herb's death, and my son-in-law battling cancer. A tragic painting for a tragic time, then, as now.

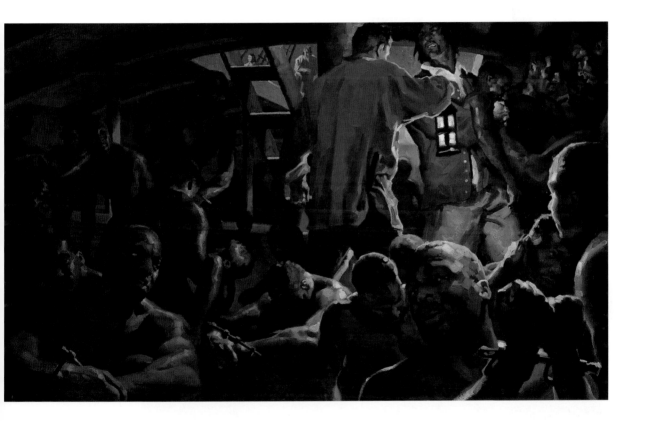

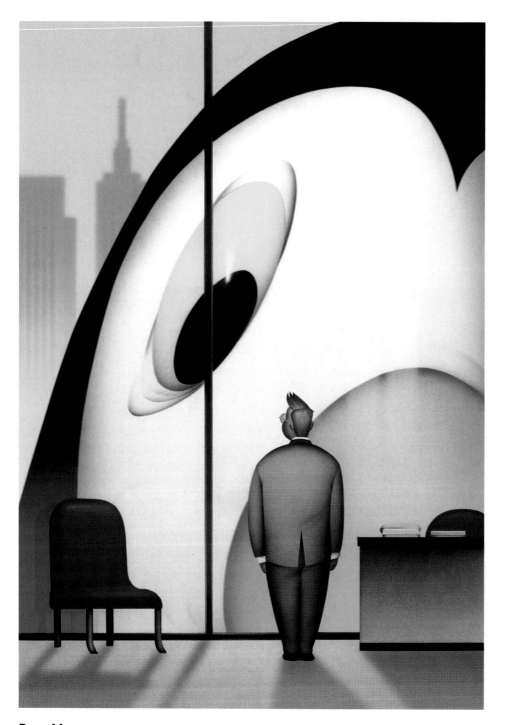

BILL MAYER

This is one of several illustrations in a lead story for art director Andrew
Danish of InfoWorld which all followed a universal theme borrowed from that
1933 classic, *King Kong*. I just wished there was a way to bring Fay Wray into it.
The other illustrations included the giant footprint and the penguin high atop
the Empire State Building. This illustration, set in an uptown office looking out
at the penguin looking in, was my favorite.

BILL MAYER

I wish I could say this was my idea but when Minh Uong called from *The Village Voice* I just couldn't say no. They decided to stay a little distanced stylistically from the *Curious George* book illustrations and put him on a stage instead of the typical vignette on a yellow background. George looked so cute in his flight suit; you know he makes quite a respectable monkey.

ADAM McCAULEY

When Joey Rigg called me to illustrate the cover of *San Francisco Chronicle*'s Top 100 Bay Area Restaurants, I knew it demanded a good strong image. As anyone who lives or has visited here knows, the Bay Area hosts some of the best restaurants in the world, and this issue of the magazine serves as the year's bible of where to go. Fortunately for me, Joey's style as an art direc-tor happens to be my favorite kind: she trusts me completely and leaves me alone to have fun ... which I did. An added bonus was that one of the most fancy restaurants in the issue traded me an incredible meal for two in exchange for the use of the image on their flyer. This is the kind of job that makes me glad I became an illustrator!

ADAM McCAULEY

Scott Feaster at *Boys' Life* called for this assignment, a fiction piece about a creepy road-stop attraction. For the opening spread, all he had to do was suggest circus signage and snakes and I was doodling before we finished the conversation. I'm not sure Scott knew this, but I love to draw snakes, and bugs, and creepy guys, and circus lettering. So I had a good time. Enough years of doing this have taught me this much: having fun generally makes good images. Thanks for the gig, Scott!

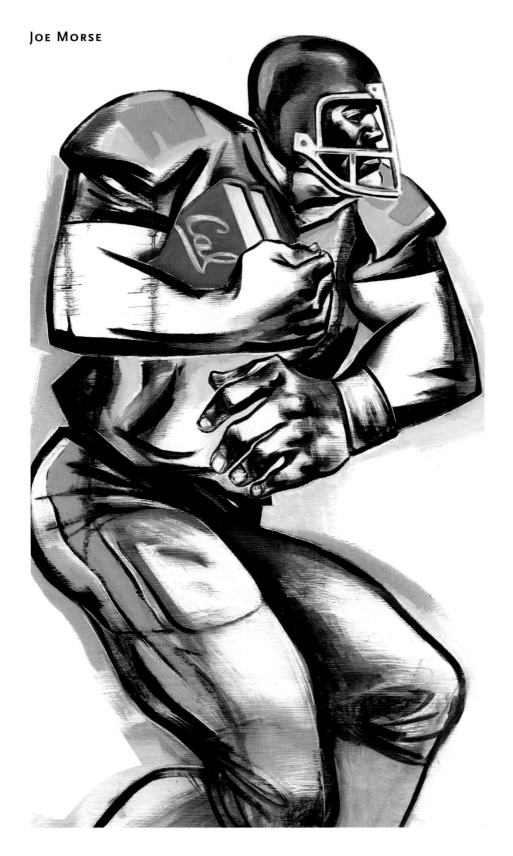

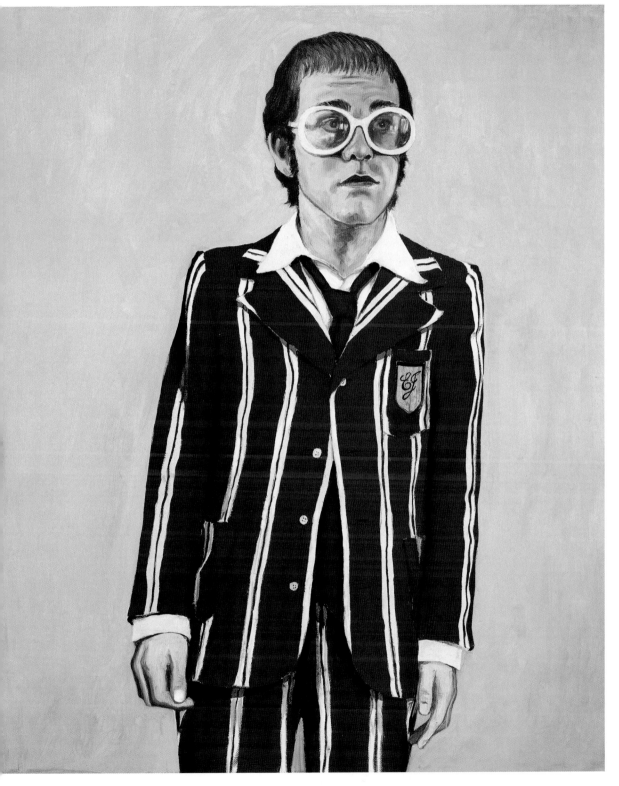

CHARLES MILLER

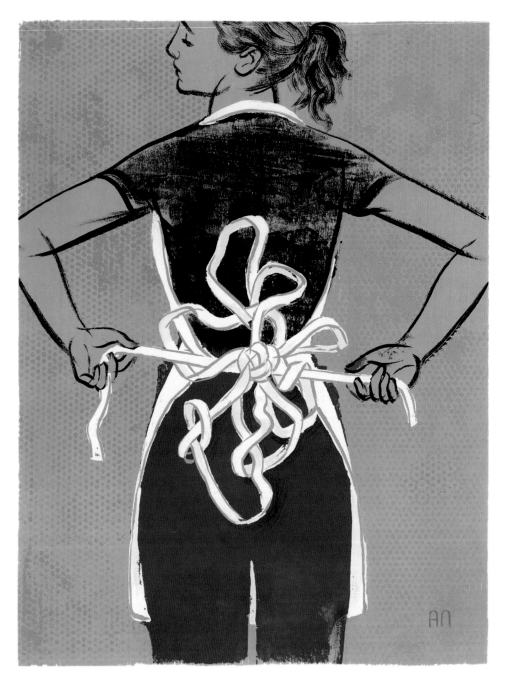

ALEX NABAUM

Concept was the homemaker as seen through the TV lens, from June Cleaver and Claire Huxtable to "Desperate Housewives." Did five different rough ideas.

1. Mother spooning colors out of a TV into apron.
2. Stirring dough, with shape of dough missing from figure.
3. Floating with apron ties forming wings.
4. Figure formed out of steam from rising roast held by oven mitts.
5. Chosen image, only thing I changed was a tighter crop for a better composition.

Usually I draw from my head and pose myself, but not being in the mood to cross-dress, Shayna (my desperate wife) posed for a quick sketch, which helped the line quality. Taking the most time was the messy string, which took a half dozen redraws to make confusing and believable. Color is always a struggle for me, but in this case I knew I wanted a pink-and-white apron to contrast with a darker background and figure. So with that starting point the colors came together with much less muttered swearing than normal.

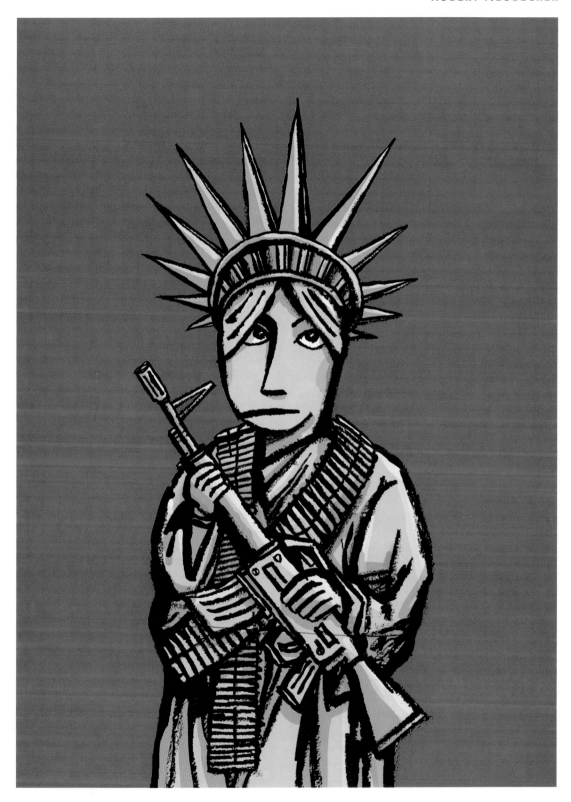

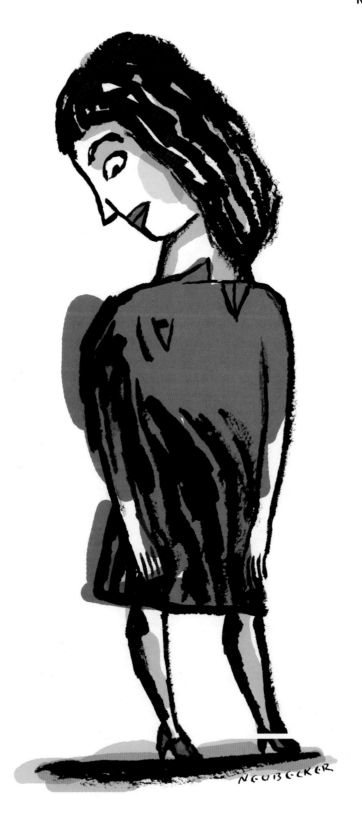

TIM O'BRIEN

The challenge of this assignment was capturing a likeness of a revolving likeness. Surely Michael Jackson's musical legacy was worth noting, but it had to stop around 1983 (my opinion). I had to force my mind to forget Anita Kunz's Michael Jackson/mouse illustration (in my opinion the best Jackson portrait), and go for sincerity. I found a series of images of Michael just before he hit it big on his own. The sky indicates the storms to come.

TIM O'BRIEN

This piece was for an article about the possible consequences of altering genetics. A great assignment with fun possibilities. This painting was a breeze and took about eight hours. Oddly, at the opening of the Editorial and Book Exhibition at the Society, a few people told me they liked my Bill Maher portrait. I guess if you cross a human with a kangaroo you get the host of HBO's Real Time.

TIM O'BRIEN

Like Michael Jackson, Little Richard evolved into a sort of cartoon character of himself. My goal was to get back to the initial Richard Penniman: strikingly handsome and beautiful at the same time. The palette was a bit of a departure for me. I tend to lean towards golden tones yet the illustration had to have the look of the '50s.

DAVID O'KEEFE

The caricature of Bill Murray looking somewhat inebriated was created for *The Village Voice's* New Year's Eve cover naming *Lost in Translation* 2004's Best Film. Props included some borrowed dress clothes and a case of Cold Duck that art director Minh Uong refused to reimburse me for.

DAVID O'KEEFE

Hillary's Mushy Middle shows the distinguished senator from New York dripping with sweet, gooey apple pie filling. That's a home-made pie, not some store bought one. The art spoiled within days.

KEN ORVIDAS

Steve Banks at *The Los Angeles Times* sent me a story about how contemporary classical musicians were continually performing the works of only five notable composers. As listeners, that's all we hear. Performers began researching the works of obscure composers. Some of them had greatly influenced the famous five, yet we don't know about their music.

While sketching thumbnails I drew the treble clef. The shape is curious and I began to rotate it. At the moment it was inverted I got the idea of it hanging, long forgotten, in an old closet with a single light bulb illuminating the scene as if it was just discovered.

KEN ORVIDAS

Working for the Op-ed page is fast, furious, and fun. The article is about a Japanese-American writer living in New York City reminiscing about a childhood trip to Japan with her mother. The language was different. The customs were different. The living was different. Even though the girl looked the same, she felt as if she didn't belong. One day, while watching kids at play, a boy swung on a huge wisteria vine and called, '"ta-zan" to the girl. She understood! She ran, grabbed the stout vine and swung, yelling at the top of her lungs, "Tarzan." The idea was to stylize a traditional Japanese painting and replay the scene in the woman's black hair as if the memory was being extracted from the deep past while melding the two cultures together.

CURTIS PARKER

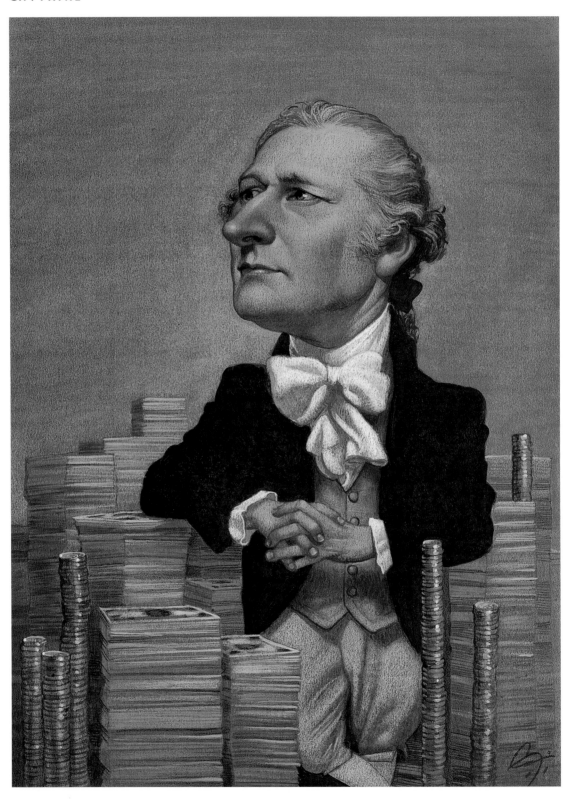

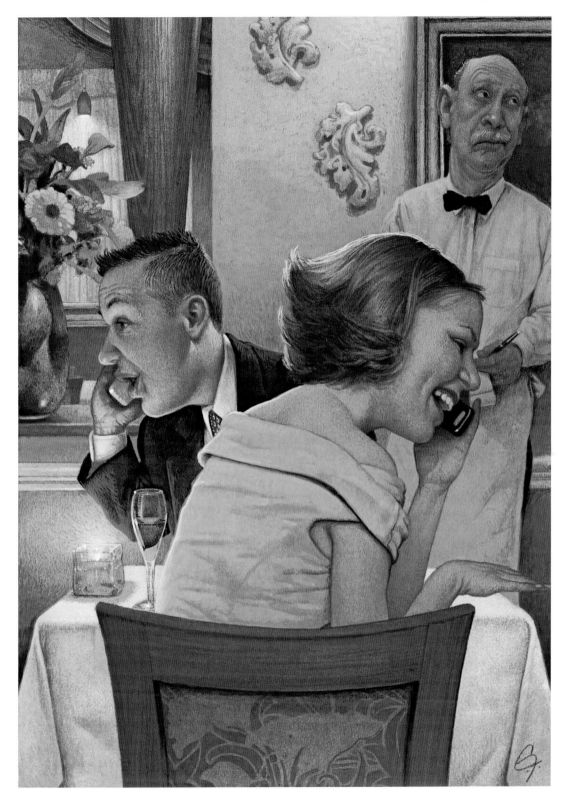

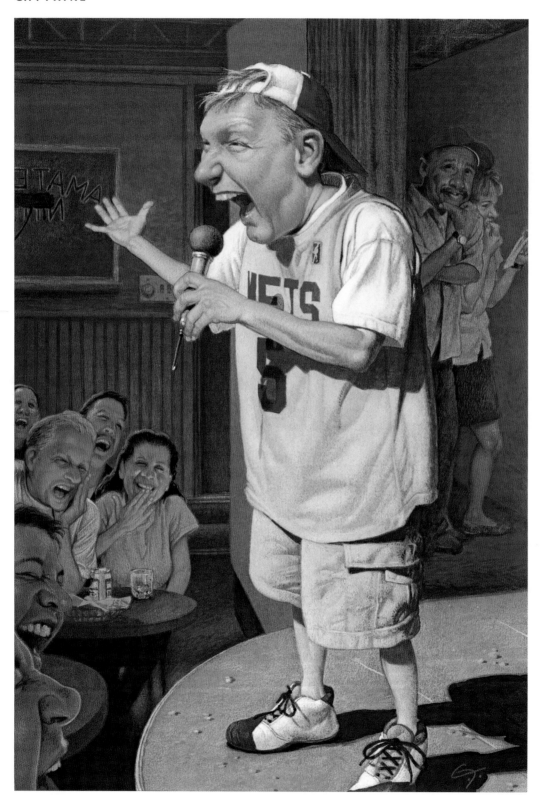

Andy Rash

Senator Joe McCarthy was one of the most devious characters in American politics. He gained power by vilifying minorities and spreading baseless accusations. He exploited the worst instincts of the American people. His tactics, however, remain effective and widely used. This portrait was drawn in pencil and manipulated with a computer to add texture and color. The image was commissioned by Steven Heller, art director for *The New York Times Book Review*, and was created to accompany a review by Geoffrey Wheatcroft of the book *Reds: McCarthyism in Twentieth-Century America* by Ted Morgan. Senator McCarthy is depicted in black and white, as most Americans saw him, and surrounded by red, as he saw himself.

HANOCH PIVEN

This piece was done for *New York* magazine right after the campaign of Howard Dean in the Democratic primaries started to fall apart following his out-of-control angry shouting in an election rally. I tried to gather elements that suggest breaking, hitting, violence, craziness. The broken light bulb was to symbolize the great idea or ray of light that went away.

The way I work is by throwing all the relevant objects on a white sheet and then moving them around, sorting the ones that work better. Once a likeness seems to be appearing, I draw the sketch around the objects. So, in a way, I first draw with the objects and only then with a pencil or a brush.

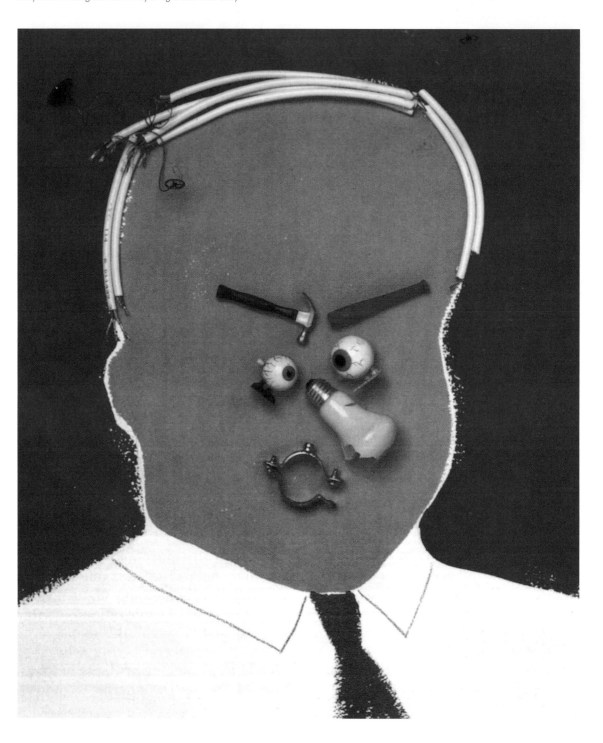

HANOCH PIVEN

This piece is really special for me because it is the only illustration in which I managed to include my middle finger. (Yes, that is MY middle finger there) and if I can claim any achievement, it is perhaps being the only illustrator ever that managed to "give the finger" in a national magazine. But being more serious, for every portrait that I make, I try to connect to the attitude of the person I'm drawing. Kid Rock has this type of attitude. Middle fingers are part of the visual language used in the design of his CDs, so in a way that was an obvious solution and, as always, what is left then is to make it work visually.

I love to play with cans and bottles and see the different mouth expressions that they can simulate. This beer can just happened to have the right expression to go with the attitude.

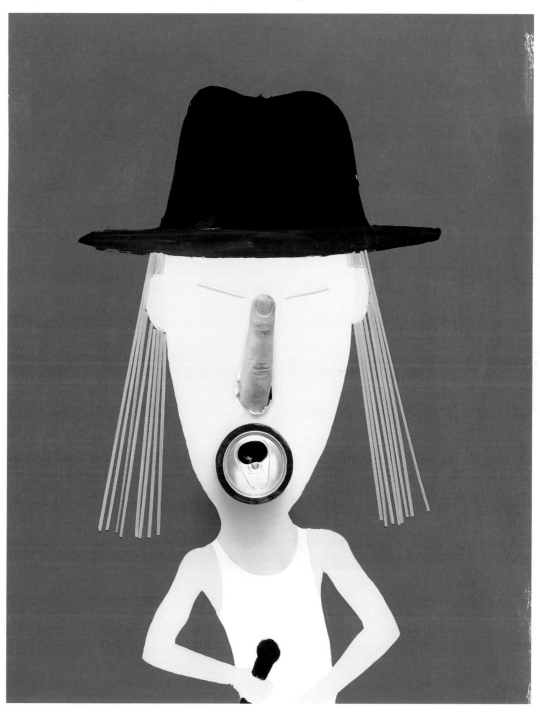

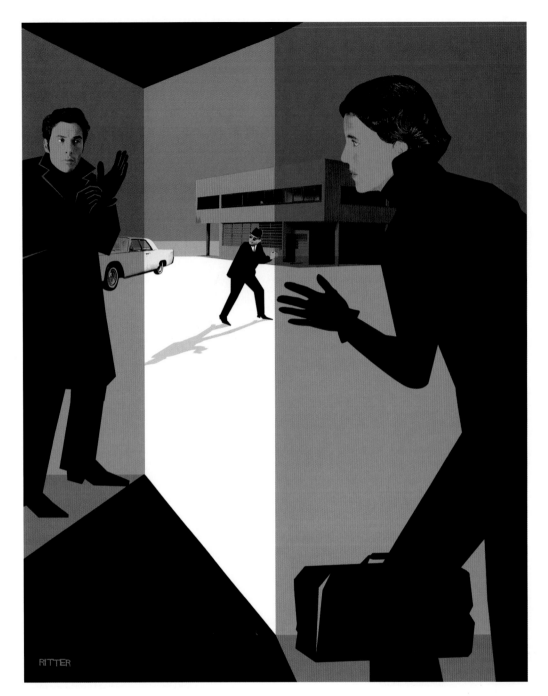

JOHN RITTER

This illustration accompanied an article in *American Lawyer* magazine that focused on a law firm that represents operatives of the Central Intelligence Agency and other intelligence organizations. Art director Joan Ferril requested a solution that addressed the sinister nature of the piece. We discussed pulp fiction poster art of the 1960s as a possible direction for creating a mood. The story revolved around two main characters: a pair of attorneys who handled most of the cases. They became the "spies" who are juxtaposed with the CIA.

To create the image, I began with a series of rough digital sketches,

which were based on photos of a model and me. Once the illustration's narrative was established, I began to collect reference material. The final piece was constructed in layers using Adobe Photoshop. Each subject was photographed separately with a digital camera. Faces were then manipulated using contrast adjustment, paintbrush, and eraser tools. The bodies were drawn freehand with the pen tool. Color was added, subtracted, and adjusted until a sense of visual depth was attained. The image layers were flattened before final art was delivered to the client via e-mail.

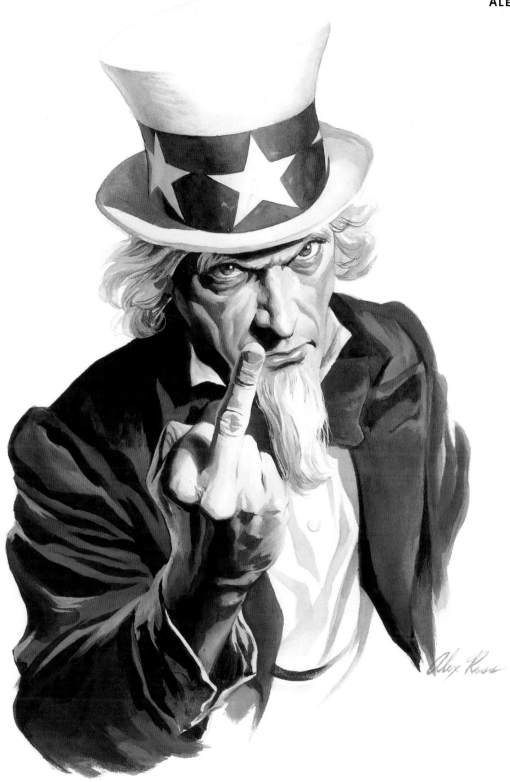

EDEL RODRIGUEZ

This image accompanied an article on the outsourcing of American jobs to countries such as China, India, and Mexico. I wanted to show someone who had been carefully cultivating something for many years, and is then made to stand by helplessly as his or her hard work is suddenly ravaged or destroyed. I've been planting shrubs and trees recently and from time to time they show up in my conceptual work.

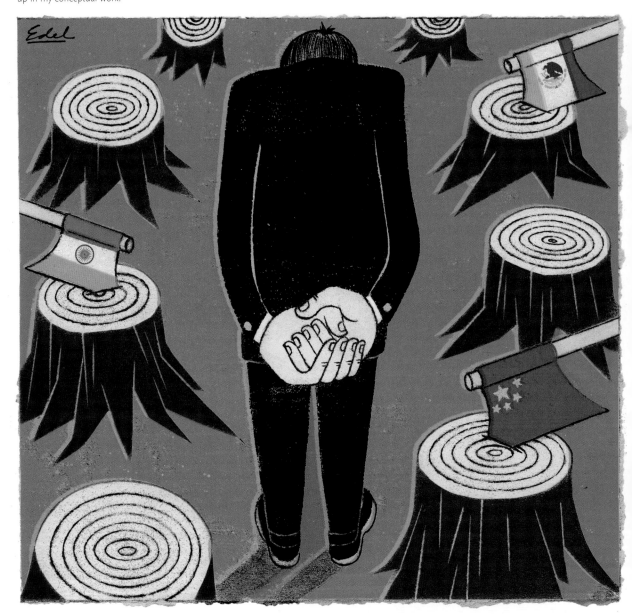

EDEL RODRIGUEZ

This is a drawing of a play at Lincoln Center titled "Nothing But the Truth," about a family coming to terms with years of apartheid in South Africa. Sent to the theater by *The New Yorker*, I made many sketches in the dark as I watched the play unfold, and composed the final from those roughs. The final art is pastel and oil-based ink on paper.

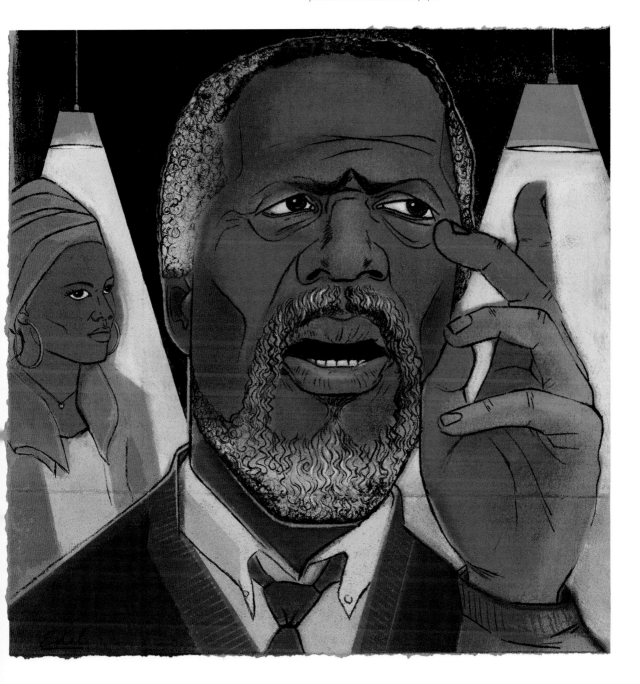

JOSEPH SALINA

Comparing President Bush's exit strategy and the ongoing situation in Iraq to the adventures of Curious George, the mischievous character created by H.A. Rey, was an idea favored by the good people at *The Village Voice*. I was intrigued by the idea and felt the comparison appropriate. A number of other ideas were explored and discussed with art director Minh Uong, but the one you see before you emerged as the strongest.

I was surprised by the re-election of President Bush.

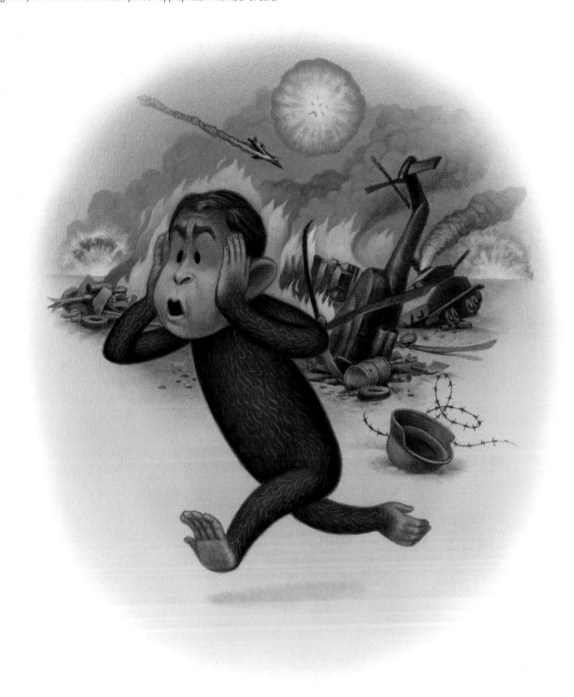

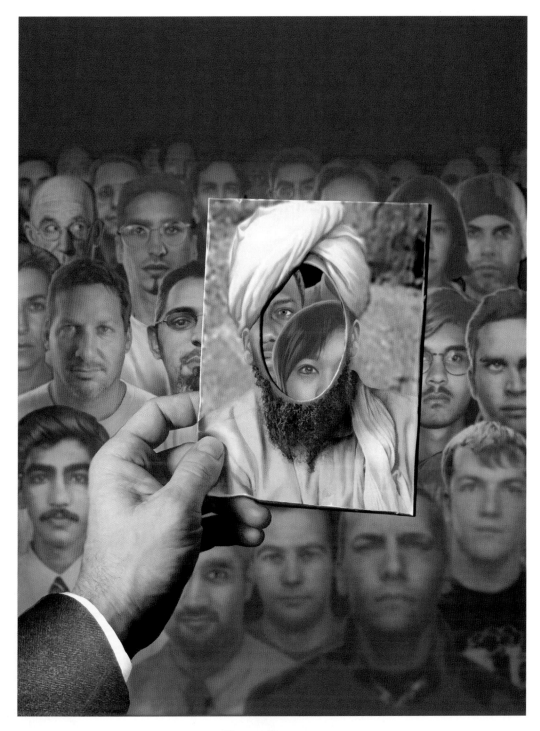

PETER SCANLAN

The concept for this piece for *The Village Voice* was to show how anyone can fall under suspicion in the climate of fear that we find ourselves living in. In the background, I included the husband from *American Gothic*, taken from a *Voice* cover featuring paranoia in America, which I'd done several weeks earlier. It seemed appropriate.

JASON SCHNEIDER

YUKO SHIMIZU

The client wanted to feature rails that were just becoming popular among snowboarders, but they couldn't find any photo good enough for the cover because the rails don't generally photograph well. They provided me with a whole bunch of photos to work from, but they wanted it more dramatic and graphic, something more believable and exciting than actual reality.

Red Nose Studio

I remember getting the call from Minh Uong of *The Village Voice*; he wanted to know "had I ever built a bomb before?" After talking about the story and the concept and then going through a few roughs to get the right bomb, I took my sketch and went down to my junk piles and rummaged through until I came across an old car horn that I had been saving for a few years. The horn had a metal dome that worked just right for the nose of the bomb and it grew from that.

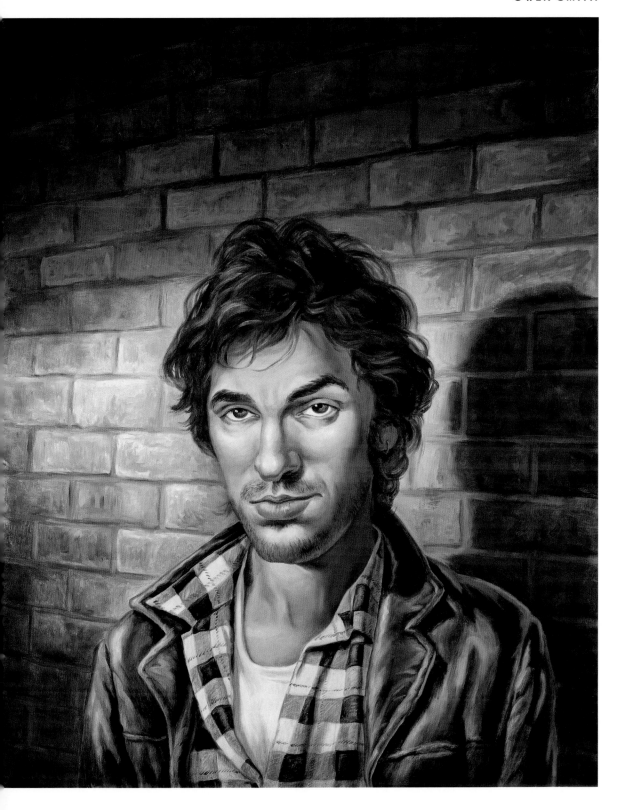

JEFFREY SMITH

JEFFREY SMITH

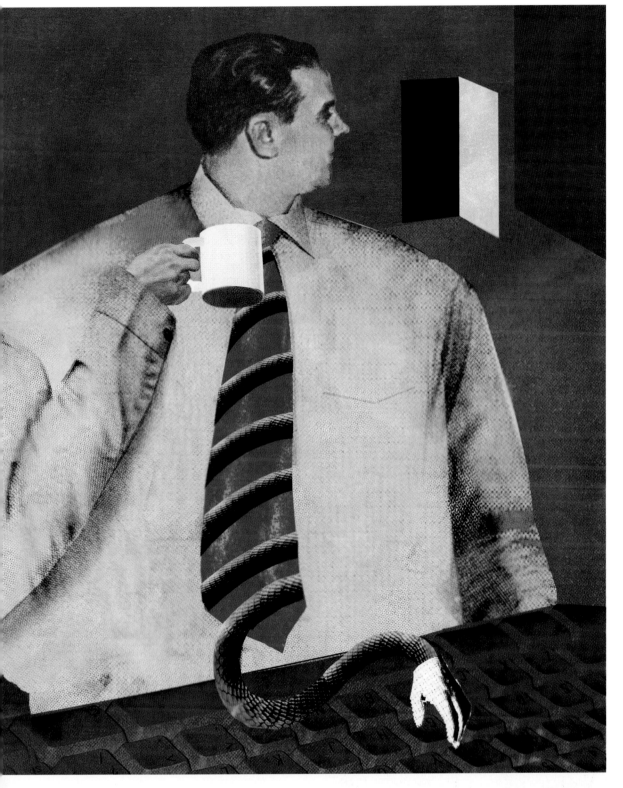

BRIAN STAUFFER

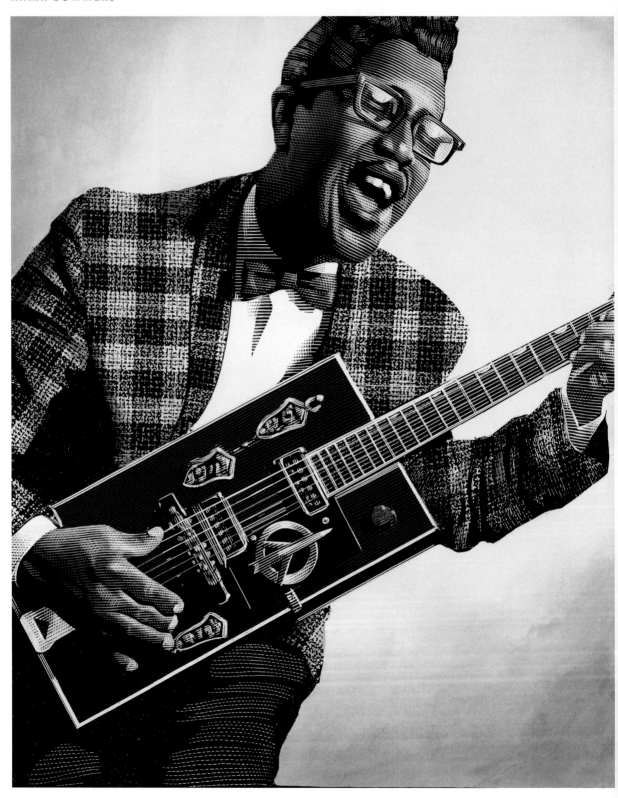

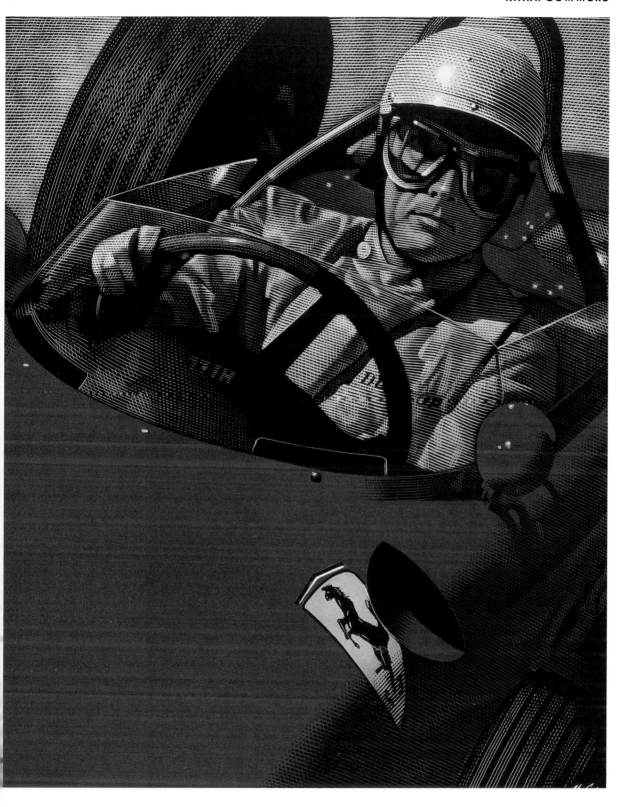

ZACH TRENHOLM

This caricature of Steve Jobs is from the April 2004 issue of *TIME* magazine's annual "100 of the World's Most Influential People" and is one of five individuals portrayed for the section titled "Builders and Titans."

I recall there was a great deal of back and forth involved on this project, much of it because it was the first time I had worked with Marti Golon, *TIME*'s Special Projects art director. It was three weeks of daily contact, numerous conceptual sketches, and, of course, a few last minute revisions.

Although it was a lot of work, in the end I was very pleased with how it turned out. I liked how Marti had incorporated into the overall design of the section what I had done for her—from sampling my palette, to using rounded boxes (like the ones I'd used to frame the portraits) to house copy and shape the additional photos.

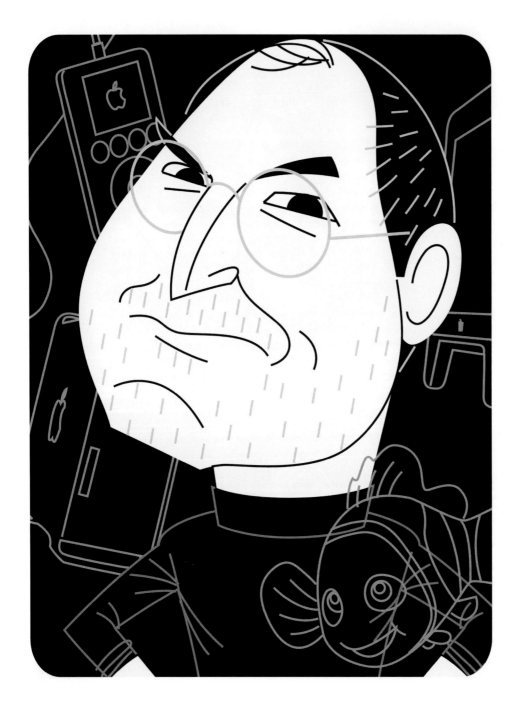

ZACH TRENHOLM

This portrait of Quentin Tarantino was part of a larger assignment for the February 2004 *Premiere* magazine article on movie directors and the films they did in 2003.

Initially, I thought that because of the concern and emphasis being made (as well as the size of the art being requested) that the portraits of Peter Jackson, Ridley Scott, Robert Altman, as well as Tarantino, were intended as the main art for the piece. Maybe at one point they were, but somewhere along the line they became far smaller and pretty much over-shadowed by the half- or full-page photos of the other directors I later saw included in the article. Oh well...

There was a lot of latitude, though. Depiction was up to me as long as it coincided with the films being discussed. This one of Tarantino ended up being my favorite from the bunch. Along with posing him à la Uma Thurman from *Kill Bill 2*, I took a poke at his somewhat goofy persona by having the sword subtly pass through his ears. It's something one doesn't usually catch at first glance.

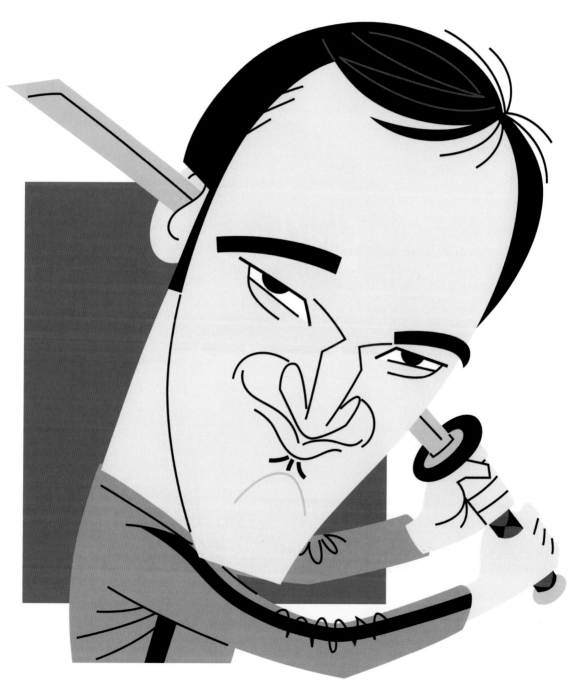

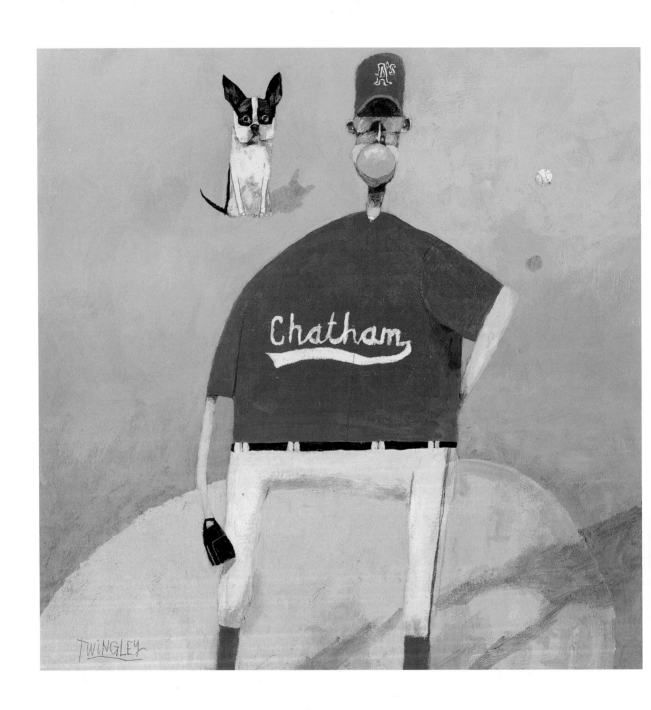

JONATHAN TWINGLEY

MARK ULRIKSEN

Sometimes the dictates from the art director make an image come alive in your head while you're still on the phone getting the assignment. Wesla Weller asked for a portrait of rocker PJ Harvey for a calendar item about her appearance at a rock 'n roll film festival in L.A. Could I somehow incorporate a reel of film into the image? The guitar shape took care of that. For me the fun part was using stills of Mick Jagger from the *Exile on Main Street* LP for the neck of the guitar. A tad subtle, I know.

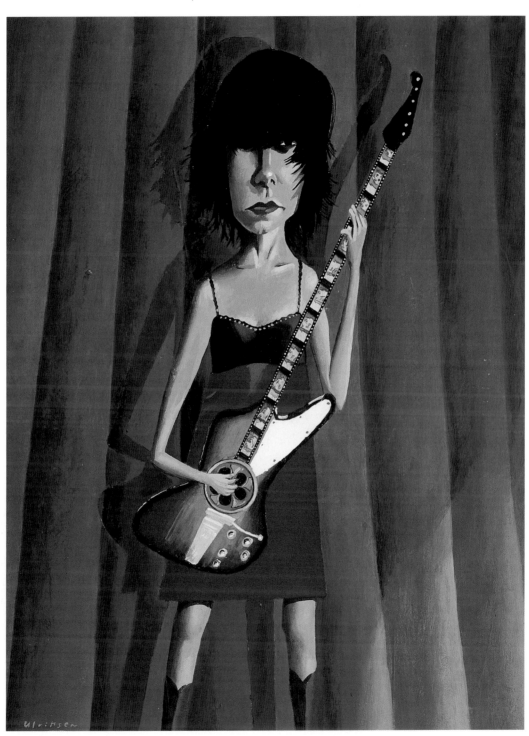

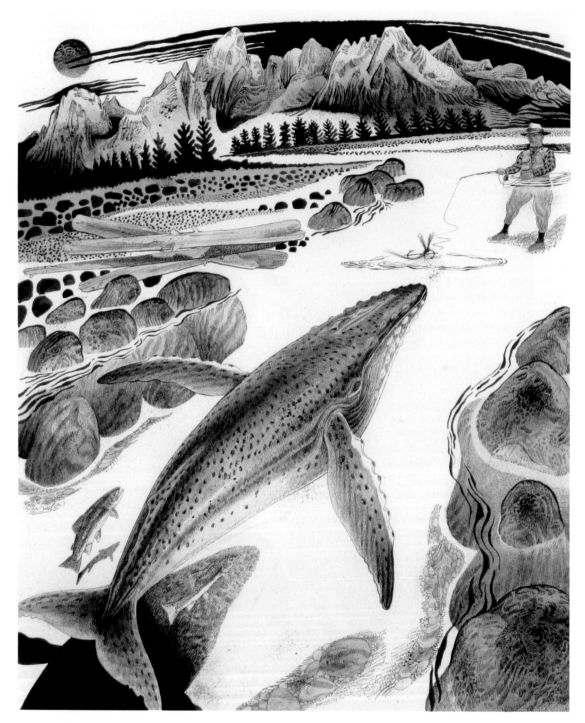

JACK UNRUH

Opening day of trout season and hope springs eternal. Yep, it's the same for Fisherpersons. We are all fishing for the big one. Willie Nelson has the line, "telling all tales, fishing for whales." Seemed like the visual image of the verbiage would make a fun solution. Looks like this fisherman found his.

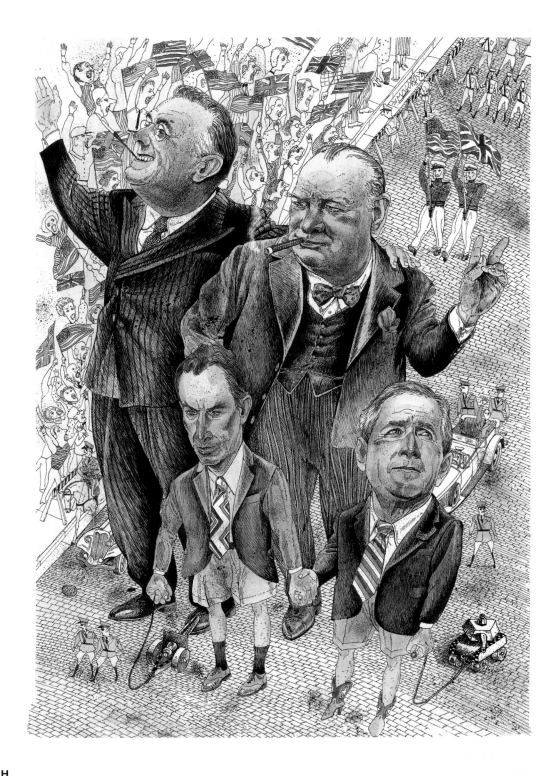

JACK UNRUH

What we have here is George W. and his little buddy, Tony (the one with the funny accent). The story is about the traditional alliance that has existed since FDR and Churchill. So I chose to show the men and the boys leading a victory parade. But I couldn't help myself, for here was a wonderful opportunity to demonstrate the difference between the great old heroes and our current wannabes. It wasn't in the narrative, but the art director and the editor evidently saw some humor in my interpretation. God bless America!

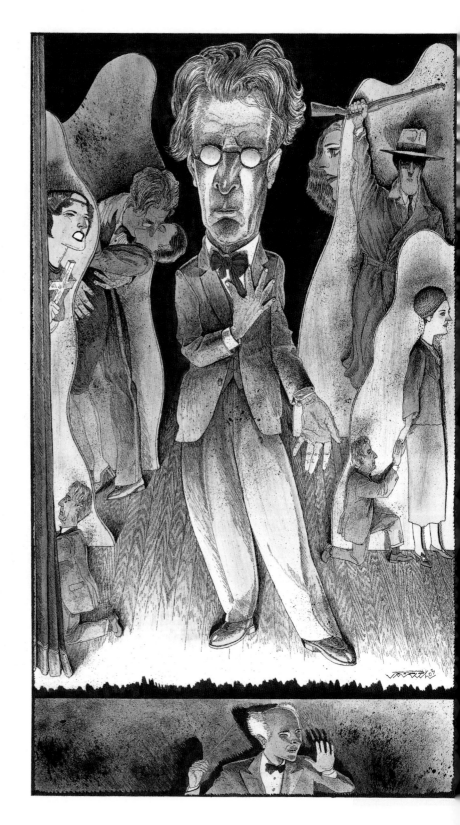

JACK UNRUH

A biography of a man who has had a pretty active life. I decided to show the stages of his life.

Jonathan Weiner

KENT WILLIAMS

For this nonfiction piece for *Playboy* entitled "Why The Military Never Learns," the idea was to put a deadly spin on the classic playground sandbox image by bringing the toy soldiers to life. Taking this very serious subject and playing it in a lighthearted fashion amplifies the horror of the message. It's a mixed-media piece, primarily consisting of watercolor and oil, painted on paper mounted on wood panel.

NOAH WOODS

BRAD YEO

This image, titled "Quitting the Paint Factory," is one of four quarter-page-sized works that ran with an essay in *Harper's* magazine. The essay takes a critical look at the "live to work" ethic that has become a moral standard and way of life in America. In this essay the author presents a positive critique of idle time as something grossly undervalued. Idle time is needed in developing the democratic mind, a mind of independent, critical thought and reflection.

Each piece in the series addresses a key message in the essay. "The Church of Work" is a phrase used by the author to describe our steady willingness to stick to the program, to work tirelessly, righteously. My interpretation is one of self-sacrifice, as the image represents the giving over of one's hands to this purpose without question.

HONGNIAN ZHANG

DANIEL ZAKROCZEMSKI

This was for a newspaper book club package, which included editorial art, promotional posters, and bookmarks. Iconic Paul Newman is an easy pick for the subject of this illustration for *Empire Falls*. Even when in rags and whiskers and given a bottle of cheap liquor to sip on, he still manages to look distinguished.

DANIEL ZAKROCZEMSKI
This was for a story about Schwarzenegger's first year in office and his transition from movie star to governor of California. Arnold smiles happily as he straddles the political emblem of the state flag bear as easily as larger-than-life movie action figure.

CALIFORNIA REPUBLIC

Advertising and Institutional

CHAIR

TIM O'BRIEN

ILLUSTRATOR
Tim O'Brien creates intricately detailed illustrations and portraits from his studio in Brooklyn, New York. His art can be seen in *TIME*, *BusinessWeek*, *Esquire*, *The Atlantic Monthly*, *Rolling Stone*, *National Geographic*, and many other publications. Other clients include book publishers such as HarperCollins, Penguin, Scholastic Inc., Simon & Schuster, and a variety of advertising agencies. Tim has taught at Paier College of Art, Syracuse University, and is a professor at the University of the Arts in Philadelphia.

Tim is a founding member of the Illustrators' Partnership of America; he was on the board of the ICON 3; he is on the Illustration Advisory Board of the Norman Rockwell Museum, and is currently vice president of the Society of Illustrators and chairman of its Scholarship Competition.

His awards include over 75 works in Society exhibitions since 1987. His work has been featured in *Communication Arts Annual*, *Graphis*, the Society of Publication Designers, American Institute of Graphic Arts, *Art Directors Club Annual*, and *Print*.

CHRIS AUSTOPCHUK

SONY BMG MUSIC ENTERTAINMENT
Christopher Austopchuk has been in the design field for the past 32 years, 25 of which he has spent in the music industry, first at CBS Records, then Sony Music, and now Sony BMG Music Entertainment. A graduate of Cooper Union, he has had a varied career which has included work for Pushpin Studios, Condé Nast, *Rolling Stone*, and various consulting positions. In addition to this, he has been a graphic design professor at the School of Visual Arts for the past 30 years.

He is the winner of over 300 professional awards.

CRAIG FRAZIER

ILLUSTRATOR
Craig Frazier is an illustrator who has had a distinguished career as a graphic designer since 1978. In 1996, he shifted his career emphasis from graphic design to illustration. His experience as a designer and communicator has contributed to his simple and conceptual style of illustration. Today, he is commissioned internationally for his editorial and corporate illustration. His work is frequently published in *Communication Arts*, *American Illustration*, and the Society of Illustrators annuals. He has been the subject of articles in *Communication Arts*, *Critique Magazine*, and *Graphis*.

Craig has published a 176-page monograph titled *The Illustrated Voice* (Graphis Press, 2003). He has also published two children's books: *Stanley Goes for a Drive* (Chronicle Books, 2004) and *Stanley Mows the Lawn* (Chronicle Books, 2005).

Craig is married and has two children. He lives and works in Mill Valley, California.

ADAM McCAULEY

ILLUSTRATOR
Adam McCauley has illustrated for magazines, advertising campaigns, CD covers, business collateral, and all sorts of other fun and interesting stuff. He also illustrates kids' books, including Jon Scieszka's Time Warp Trio series, Louis Sachar's Wayside School series, and numerous picture books. Adam is also the author and illustrator of *My Friend Chicken*. Clients have included Apple, Viking, United Airlines, Seybold, Microsoft, Bon Marché, *TIME*, *Kiplinger's*, and many others. Adam's work has been consistently recognized by *Print's Regional Design Annual* and the Society of Illustrators annuals, as well as *American Illustration*, *Communication Arts*, and *Graphis*.

He is a member of the artist cooperative, Picture Mechanics, made up of 40 of the world's top illustrators. His work has been included in group shows in New York, Nashville, Los Angeles, San Francisco, Osaka, and Tokyo. His animation, *Fast Food*, is in the permanent collection of the San Francisco Museum of Modern Art.

Adam works out of his home in the Mission district of San Francisco.

CHRISTINA McCORMICK

ASSOCIATE ART DIRECTOR, MAJOR LEAGUE BASEBALL
Christina McCormick's interest in graphic arts began while watching her father, a commercial artist, at work in his studio. She trained at Kutztown University, where she received a degree in communication design. Her first job was as a junior designer for General Media Publishing Group at *Penthouse* magazine, in New York. She eventually accepted a job with Gruner and Jhar USA Publishing, as a designer for *McCall's* magazine. After being promoted to senior designer for *McCall's*, Christina accepted her current position as associate art director for Major League Baseball Properties, in the publishing division. She helps to produce and print annual publications such as the All-Star Game Program, League Championship Series Program and the World Series Program, along with specialty projects, which include annual Little League Baseball magazines and all of the Washington Nationals 2005 inaugural season's publications. She received the Young Alumni Award from the Kutztown University Alumni Association in 2001.

JOSÉ ORTEGA

JIM RUSSEK

FELIX SOCKWELL

ILLUSTRATOR
José Ortega received a BFA from the School of Visual Arts in New York City. He has been featured in magazines such as *Graphis* and *Advertising Age*. José's work has been used for magazine illustrations, Bloomingdale's shopping bags, and numerous textile designs. His work *Una Raza, Un Mundo, Universo*, was dedicated to his mother.

CREATIVE DIRECTOR, SERINO COYNE, INC.
Jim Russek began his advertising career at Case & McGrath in 1975 after working for four seasons as a production assistant on The Ed Sullivan Show and then full time in major political campaigns in the roaring '60s. After a significant stint with Hall of Famer Julian Koenig, Jim started his own ad agency in 1983 with illustrator Paul Davis, whom he met while managing six years of breakthrough advertising campaigns for The New York Shakespeare Festival. The short-lived Davis & Russek became Russek Advertising in 1984 and Jim began 20 years of campaigns for Lincoln Center Theater including *Anything Goes, Six Degrees of Separation, The Sisters Rosensweig, Carousel, The Heiress*, and *Contact*. He continues today working with Lincoln Center Theater as a creative director at Serino Coyne, Inc.

ILLUSTRATOR
Felix Sockwell, a naturally hot-headed, 35-year-old native Texan, cut his teeth as an art director at DDB, then The Richards Group, and later as co-founder of the Brand Integration Group at O&M, NY. Upon leaving there in 1998 he became renowned as an illustrator with a knack for identity design and a penchant for slamming down phones (mostly on calls from ninnies and thrifty losers in advertising and corporate communications). After meeting the girl of his dreams, he was all smiles. He started listening to Art Blakey and the Jazz Messengers. He married, moved to Maplewood, New Jersey, and fathered many children. Is he smiling in this picture? He should be.

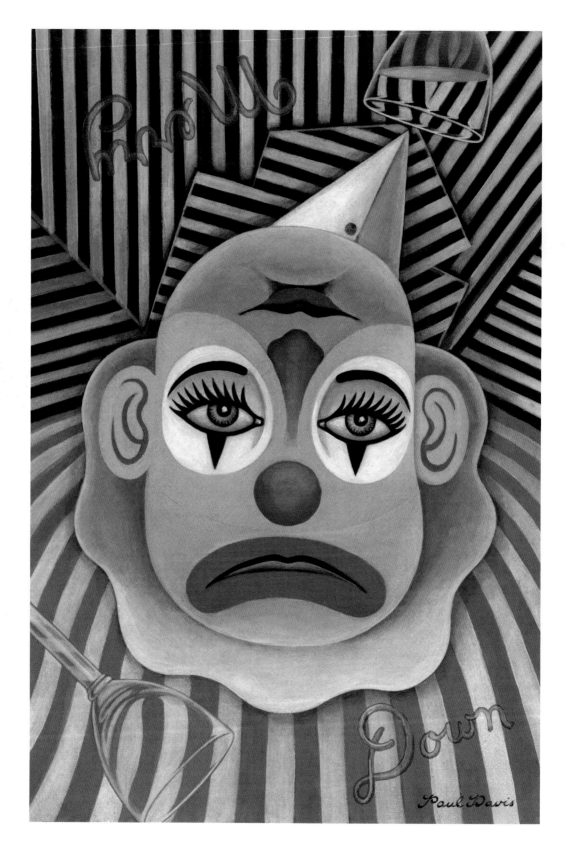

Paul Davis

GOLD MEDAL WINNER
PAUL DAVIS

Dave Dye of CDD London asked me to create this upside-down poster for Merrydown, a cider which is sold in pubs in Great Britain. The campaign has been very successful and more than 25 illustrators have created versions of this concept. It was a very open assignment in that I was given the freedom to create any kind of image of the drinker that I chose. He or she had to be merry in one direction and down in the other. The most unusual thing that happened on this project was that a couple of weeks after I had completed the art, the managing director of Merrydown, Chris Carr, called to say how much he liked the painting. It warmed my heart.

GOLD MEDAL WINNER
ANN FIELD

The challenge and the glory of working in watercolor is one I enjoy. It is a bit of a gamble. You have to be ready with your idea, sure of yourself, and completely in the moment. Sometimes the image reveals itself immediately; as the years go by, this has been the case. Sometimes you have to work at it more; for instance, one of these images took a few go-rounds to get right. By that I mean, starting from scratch every time, and not making alterations. I like the immediacy of the effect—immediacy achieved in a moment through years of practice and error. I have noticed that the client subconsciously responds in the affirmative to the freest of the images, the ones that look as if they just took a minute to do, and everything is perfect. I think it represents a freedom of spirit, a freedom that we would all like to feel.

The choice of watercolor for this particular project, Bloomingdale's Bridal Registry, seemed very logical to me. Your wedding day is one of the happiest days of your life. What it represents is fulfillment. The drawings had to embody a completeness and also that joy. The instantaneous effect of the watercolor and the pooling and blending of color could be read as symbolic. Yet again, the paintings are so free and loose they are instantly appealing and communicate a lightness and happiness. They are also spare and minimal. I purposely limited the palette and the composition. This is a style choice. Fashion is a statement and the image had to act as a brand while communicating an emotion. The painting became a graphic device that was used on all registry materials and promotion. Such is the power of illustration.

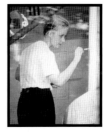

GOLD MEDAL WINNER
SERGE BLOCH

Of course I am very proud of this award, but I only deserve it half way. I have to share it with the designers and the art director of the agency. They imagined what I could do with their message and trusted me. I believe that what they saw in my work is the research of simplicity to get the idea through.

In fact, I think with my pencil and I draw with my head (at least I try). Or maybe it is my pencil that thinks alone; I am the movement. And I watch. If it is funny, if it's talking, if there is an idea, I keep it. Otherwise, I throw it away. No idea, no drawing.

I like to mix pencil drawing and photography because photography really makes us believe that it is real. Often, only one element in a photograph brings in the reality; the drawing allows me to play with it.

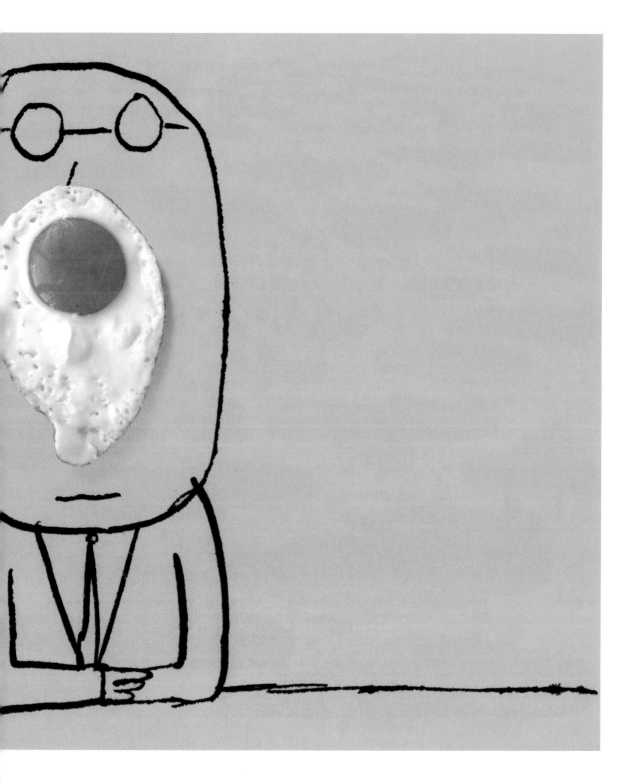

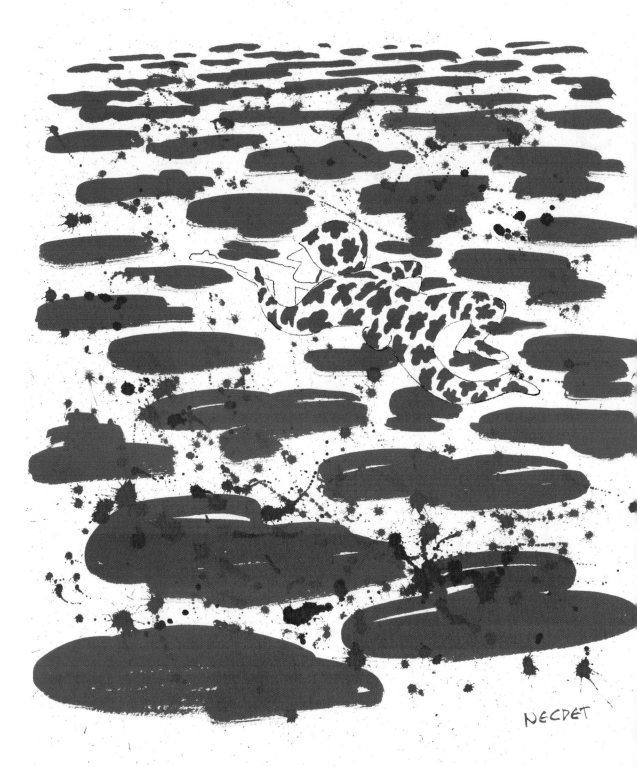

NECDET

I wish I could spend my days just drawing colorful flowers, lovable doggies, and furry kitties; I would be perfectly content. Unfortunately, the world makes this pursuit difficult. Although I am thousands of miles from the Middle East, I am deeply affected by the Iraq War. While brainstorming on ideas for the Aydin Dogan Caricature Competition, I came upon a picture of a camouflaged soldier in Alan Fletcher's book *The Art of Looking Sideways.* Wars are so bloody that they change the landscape. Battlefields lose all of their natural vitality and color when they are coated in red. This soldier... My soldier headed back to New York for the Society of Illustrator's 47th Annual Exhibition. I think he was happy to be away from the violence of war. His Gold Medal and month of safety was what he needed. I hope all soldiers head back to their countries and turn their backs on war forever. So that I can go back to drawing my colorful flowers, doggies, and kitties...

This assignment came from Nancy Coyne at Serino Coyne. She asked me to make a portrait of Tonya Pinkins, the star of *Caroline, or Change,* which was moving to Broadway. I had already seen the show downtown at the Public Theater but I went back that night to experience it again. I usually like to make my own reference photos but in this case that was not possible. The ad agency sent me a selection of pictures, which I felt were not enough so they sent along several CDs with a much wider variety of images. After I delivered the painting there was some discussion about whether Caroline should be portrayed with a more cheerful attitude. It is very difficult to change the mood of a painting. Usually, when that is necessary, I prefer to start over. Fortunately, in this case that wasn't necessary and the painting was used the way I had painted it.

SILVER MEDAL WINNER
JODIE HEWGILL

It's easy to be inspired when you're working with a great script. I have done 28 posters for Arena Stage, and I recognize that the material you have to work with can make a world of difference. *M. Butterfly*, by David Henry Hwang, is a play with the great theme of love and betrayal. Set during the cultural revolution in China in the mid '60s, a French diplomat, René Gallemard, falls in love with Song Liling, a singer in the Beijing Opera, whom he comes to call Butterfly, his fantasy of the perfect woman. Unfortunately, unbeknownst to him, Butterfly is a man masquerading as a woman, and is working as a spy for the red Chinese government. She's good. She's delicate, coy, and very passive/aggressive. Song sets René up and has him arrested for treason. At the end of the play, while René sits in jail, he implies that after their 16 years together, he never knew Song was a man.

I wanted to portray the intimacy of their relationship with Rene's desperate clinging embrace, and at the same time allude to Rene's ignorance by placing his head in close proximity to the loins in question. I purposely left his right eye in shadow to imply his blindness to Song's true identity. I wanted to introduce elements of Asian art without changing my style radically from my other three illustrations included in the brochure. Besides including the fan, the shoshi screen, and the robe, I illustrated the hair in a style similar to Asian prints.

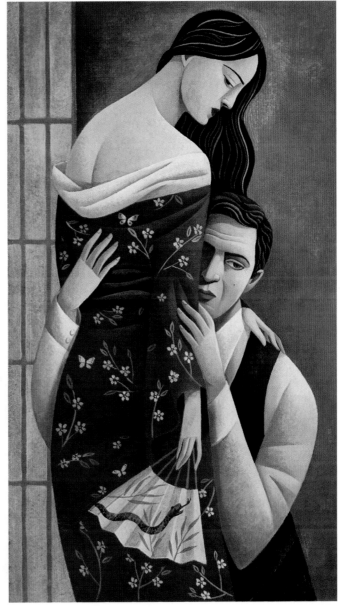

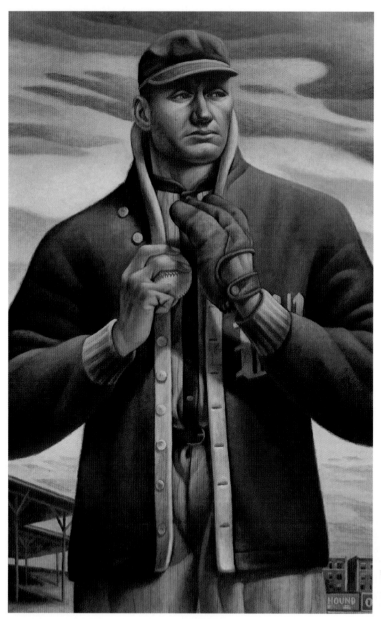

Walter Johnson is believed by some to have been the hardest thrower ever. He was one of the game's true gentlemen and he often feared that one of his fastballs could possibly kill a man. He was nicknamed "The Big Train" so I set out to create an intimidating figure wearing an oversized warm-up sweater of the era and set him against an ominous sky.

This is the 13th illustration from a baseball campaign I have been doing for Bob Beyn at Seraphein Beyn Advertising. Throughout the year we discuss certain ballplayers we might like to illustrate. The criterion is that they are from the first half of the 20th century and that they are or should be in the Hall of Fame. Negro League players are also considered. I start by suggesting Goose Goslin every year, which predictably gets denied, then we mull over names until one will click for both of us.

The project gets more difficult every year as I try to find a new approach yet still keep the overall consistency of the campaign. With Walter Johnson, and all the past players, I want to create a static image with an undertone of melancholy and sadness. I think of these players in terms that these are the happiest days of their lives and they know it won't last forever. I try to avoid any cliché baseball card poses or settings, and I use many references. My ultimate goal is to create a bigger-than-life feeling without too much distortion.

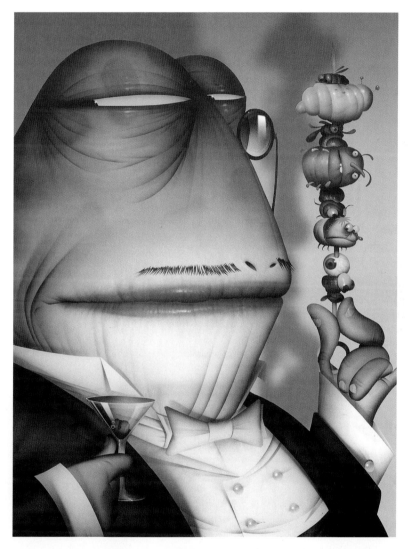

think this is my seventh illustration for Jim Burke and Dellas Graphics. All of which have been in the Society's annual shows and several have won medals. How can you go wrong with an illustrator for an art director and a client who basically lets you do anything you want as long as it has a frog n it? Sometimes that can make it difficult to settle down to one idea. This illustration was one picked out of the probably 50 ideas I came up with. The frog with the dirty martini and the shish kabob of nasty bugs and eyeballs is set in a kind of contrasting style reminiscent of J.C. Leyendecker Arrow Shirt illustrations, which, when combined, make a rather ironic happy frog.

Scott Anderson

This piece was commissioned by Ensemble Theatre Company for their production of *The Goat* by Edward Albee. The executive director was nervous about directly addressing the actual content of the play (a man having an affair with a goat), so we settled instead on depicting the bucolic scene where the lead character first lays eyes on his future love. I tried to make her as, um, "appealing" as possible. The idea was to give theater patrons a solid visual image of the goat, as she is constantly referred to but never actually seen until the very end of the play. Unfortunately, there was a switchover in theater management mid-season just as the poster was about to go to print, and the author subsequently pulled the play.

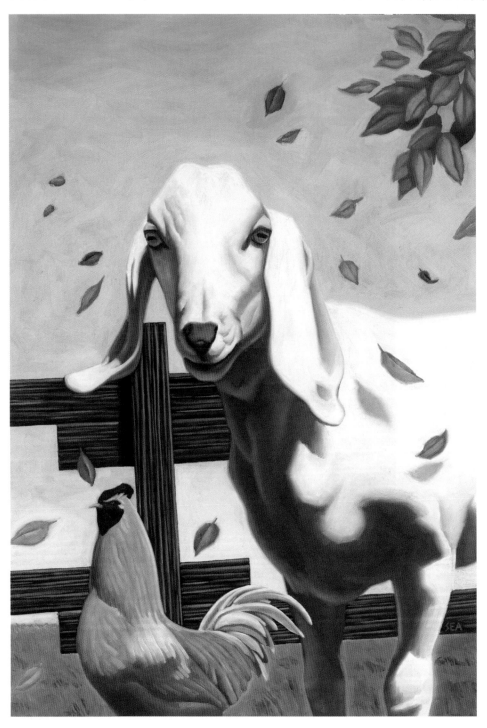

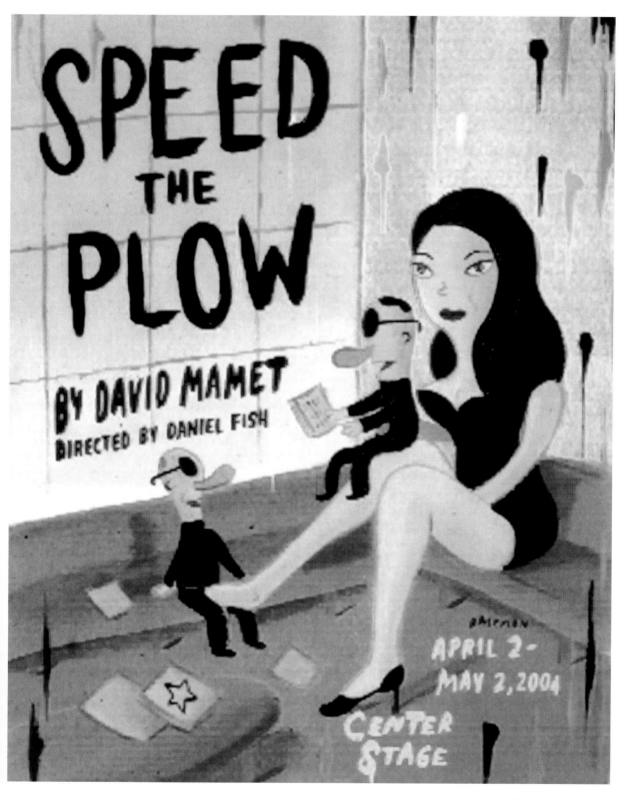

GARY BASEMAN

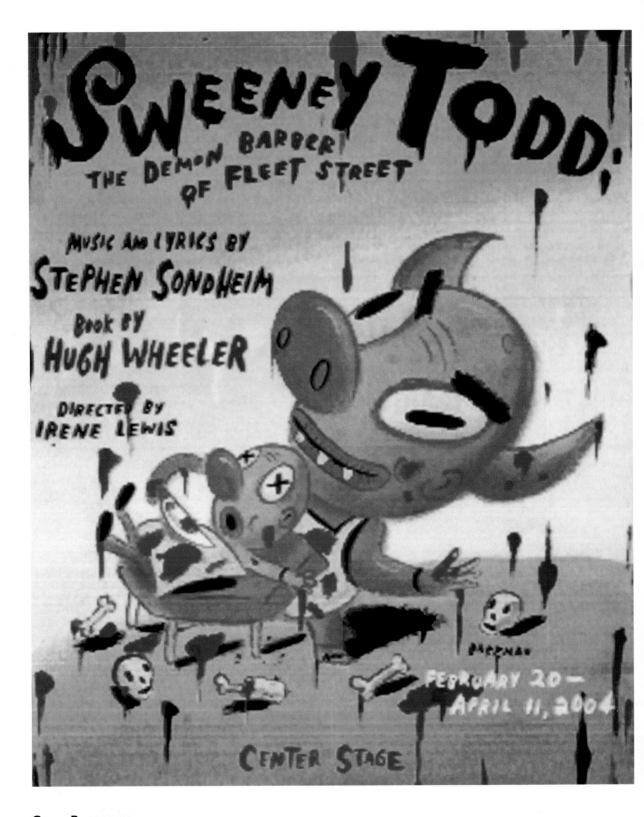

GARY BASEMAN

GARY BASEMAN

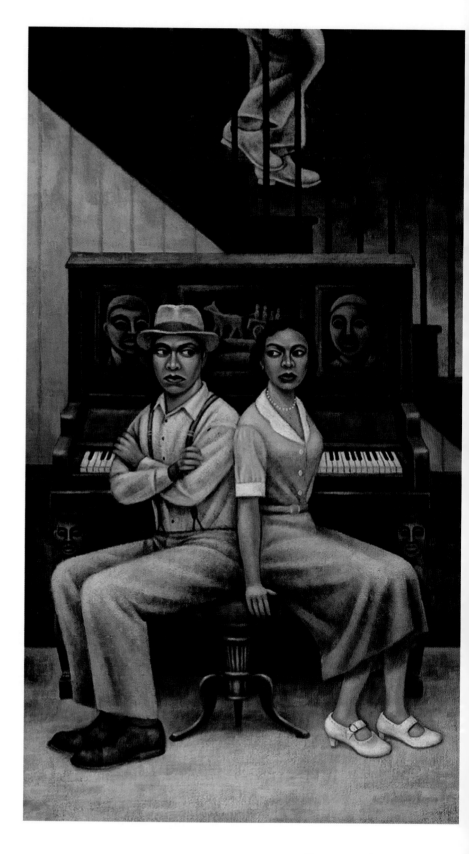

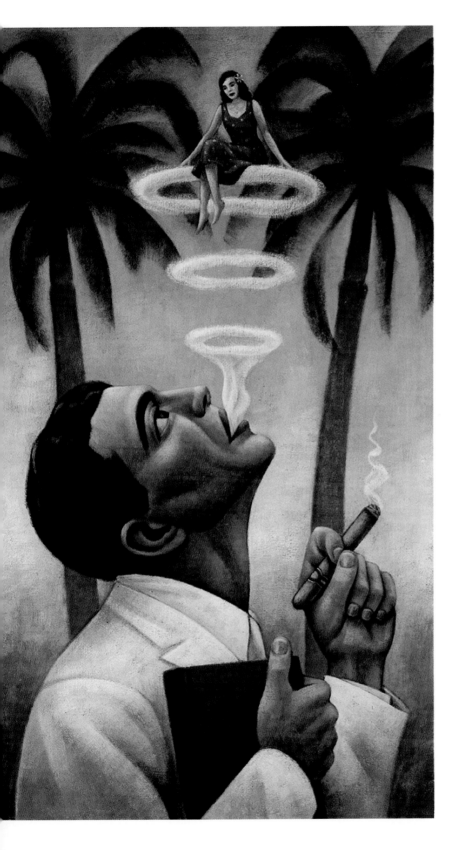

MIKE BENNY

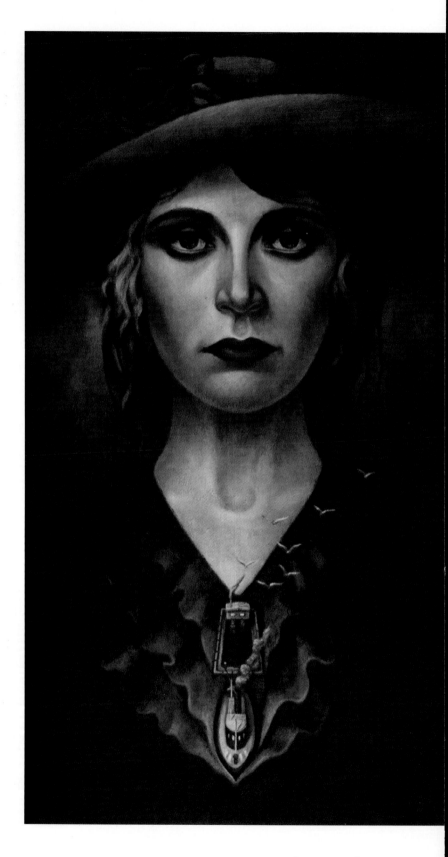

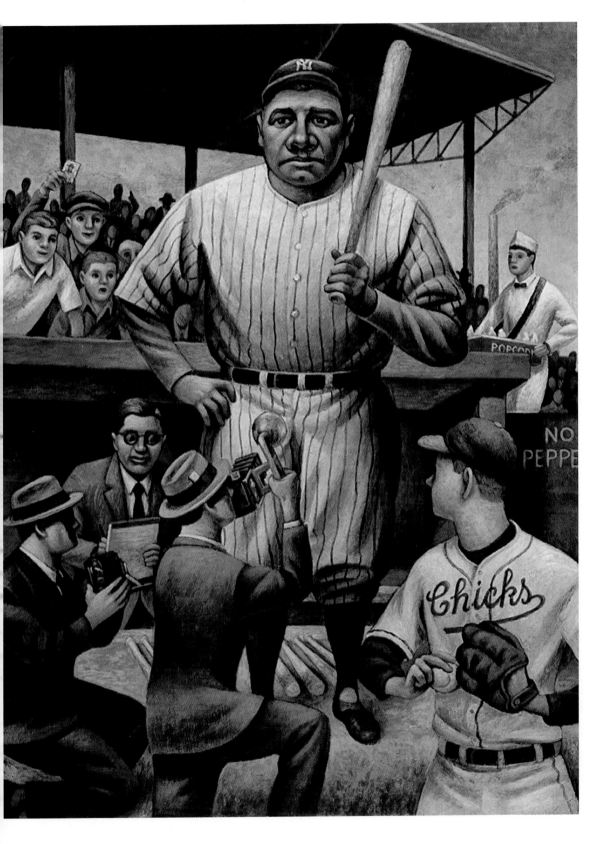

MARC BURCKHARDT

This project was a wonderful chance to work with one of my favorite subjects—music—and my hometown icon, Austin City Limits. The piece was commissioned as a limited edition, collectible poster, and program cover for the event, which featured over 130 bands. An added bonus to this project was getting backstage access for the concert and the opportunity to meet the likes of Elvis Costello, Ben Harper, The Pixies, Wilco, and the one-and-only Beatle Bob.

MARC BURCKHARDT

This painting was created for Merrydown's Vintage cider, a special brew in their beverage line. While the upside was that the wider campaign has a hook, the downside was that all their artists had to work with it. However, the Vintage line gave me the opportunity to add an extra dimension to the picture. By giving the piece an old signboard look, I was able to evoke the feeling of a traditional pub environment. CDD gave each artist complete freedom and the results are a very successful and effective campaign.

WILLIAM CARMAN

Coming up with titles for CDs has been fun. Summer rain in the mountain desert sure smells good. This title just looked better with one "r." Sometimes I wonder if the computer has made me more cowardly. Instead of doing line work right on a painting, I'll often do it separately and combine images digitally. It can rob me of that incredible feeling of risk as pen or brush touches painted surface.

WILLIAM CARMAN

I did the first cover for this group of musicians pro-bono—most of the proceeds went to charity. The cover was a success and I have been doing at least two covers, including packaging, for them each year for about five years. The great thing now, aside from being paid, is that the relationship has progressed from: "Here are our ideas," to: "Our ideas are lame, do what you think is cool." One problem with this cover has been printers wanting to fix the title so that it reads correctly.

PAULA SANZ CABALLERO

GREG CLARKE

Ed Pagor, the winery owner, was open to a non-traditional approach to his wine label. I wanted it to be a conversation starter—something imbibers could read things into and speculate about the social dynamics occurring in the wine bar setting. It was also a rare opportunity to do something graphic with three solid colors and no screens.

DAN COSGROVE

This is the third in a series of posters I did for Audi. For me, this was a great project because I really enjoy any illustration that involves racecars. Especially one as interesting and historic as the Audi Silver Arrow. When I did my preliminary design, I used the mountain as a background element to frame the car. After I sent the design to Keith Greenstein, he informed me that the Silver Arrow had actually raced at Pikes Peak. Sometimes things just work out.

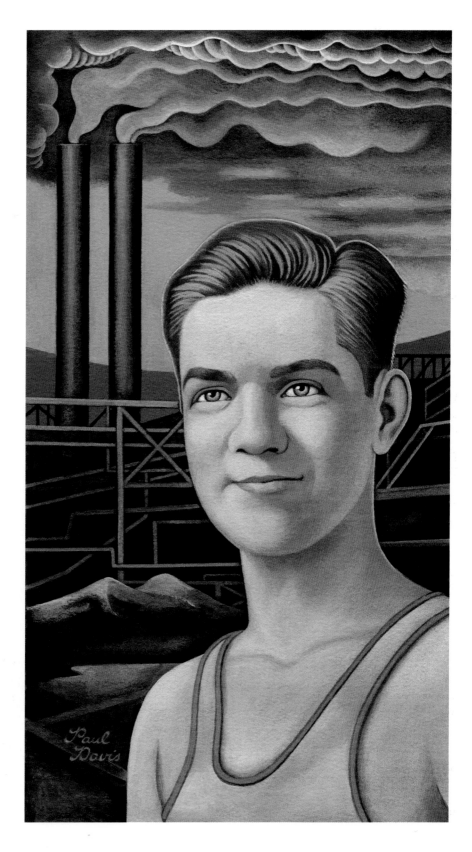

ETIENNE DELESSERT

Brad Holland and Chris Payne of Illustrators' Partnership of America asked me to create an image to contest the use of stock pictures by an army of hare-brained, uneducated, weak art directors. I believe that art directors, copywriters, and editors have had absolutely nothing to say since the crash of 1987, when they began to understand that they could lose their jobs in a minute. They hid in their shells and gave up all creative power to the Attilas of marketing, for whom the best new idea has to reflect the last success of the competing brand.

In this case, some courageous guys at Leo Burnett dared to put their necks under the knife.

Needless to say, the IPA campaign is a desperate attempt to change the situation, the last battle before being slaughtered.

The work is done with watercolor and pencils on paper.

LA GALERIE DU CHÂTEAU À AVENCHES

ETIENNE DELESSERT

DES ANGES

du 6 novembre au
5 décembre
2004

Ouvert du mercredi au dimanche de 14h à 18h

ETIENNE DELESSERT

ANN FIELD

Quiksilver is a great client. They allow total artistic freedom because they are hungry for the new and interesting. At the same time, the California spirit has to be communicated and the democracy of their brand maintained. This piece is a portrait of a surfer, appropriately, in watercolor. The life aquatic.

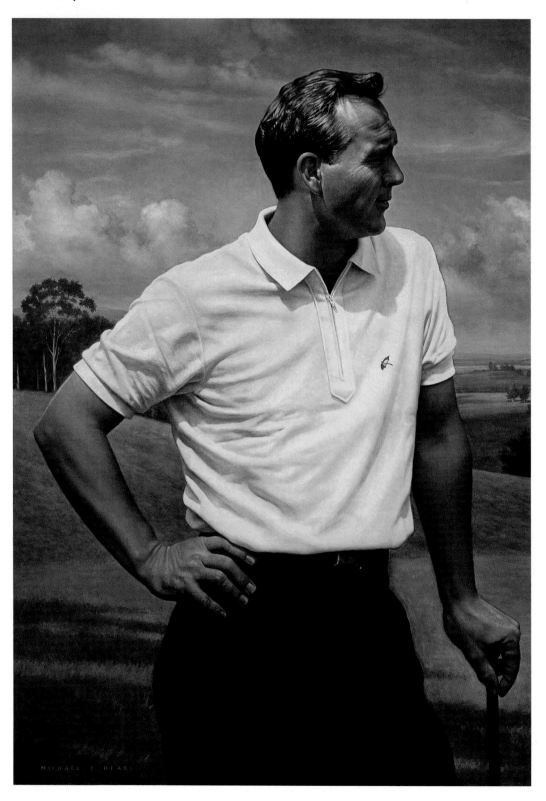

DOUGLAS FRASER

This assignment came from Eleven inc., in San Francisco. The client being Ameristar Casinos. The subject being an image to promote the Super Bowl. The image had to function as a poster, outdoor board, and other formats. It would be cropped somewhat differently for each application. Also, it was still not known which teams would be in the final game. After reviewing my preliminary sketches, Eleven inc. requested that a number 11 be applied to the player scoring. No team logos were used. With the red of Eleven inc. (San Francisco) scoring, the defending team became blue, for contrast. The background was kept a monochromatic yellow-ochre for a complimentary color, as well as text usage.

THOMAS FOWLER

The poster was created to announce an upcoming performance of the opera *Rigoletto*. It was done on a pro-bono basis with the understanding that the designer/artist would have total creative freedom as the tradeoff. The opera is basically about Rigoletto, a court jester, and the loss of his daughter, Gilda, through a tragic case of mistaken identity. The graphic image of the jester's hat with a typographically imposed frown works together to give the impression of a pathetically sad face.

The art was created digitally in Adobe Illustrator 8.0. It represents one in a series of three posters created for the 2005–2006 opera season. All three in the series were done using very simple bold graphic images with the same color palette to achieve a cohesive appearance.

THOMAS FOWLER

One of a series of three posters produced for the Connecticut Grand Opera & Orchestra's 2005–2006 season. It announced the upcoming performance of the opera, *Don Giovanni*.

Don Giovanni was the great seducer, always casting an eye to love and seduction. The obvious visual solution was created digitally in Adobe Illustrator 8.0. Bold, simple graphics and a color palette common to all three posters in the series created a cohesive connection

CRAIG FRAZIER

I frequently wrestle with communicating the notion of collaboration, as it's gotten harder to represent it with much novelty anymore. The subject of this ad was Boeing and their partners in space technology, so I cast them against a night sky doing the impossible.

Beppe Giacobbe

This job was done last year along with five other subjects for a United Airline's advertising campaign. The subject was the time schedule of national and international flights. I conceived the illustration as an abstract vision of flyers going everywhere, and I composed a puzzle with a traveler among the puzzle pieces. I wanted to maintain simple shapes to let the color and surface communicate the meaning. As I often do, I did not submit a sketch but went directly to a color finish using a Corel Painter brush. The job was enjoyable and very easy for me. The client approved it without asking for revisions.

DAVID LANCE GOINES

When I was a boy, the distinction between the genteel home and lesser dwellings was the presence of a piano. Preferably a piano in the parlor. This room was not actually lived in the way a bedroom or kitchen or even a living room was lived in, but was reserved for special occasions: When the minister visited, he was entertained in the parlor. Daughters sat in the parlor with their beaux—under, or at least uncomfortably near, the vigilant parental eye. A piano and a parlor were in the same important class as lace curtains. They marked you as a member of the middle class, or at least of the rising working class. The next step up would be cut flowers in the house—even though no one was dead. We never went that far, as I recollect.

David Lance Goines

The cherubic Athos model for this poster was two-and-a-half years old when he watered my vegetable garden. His reward for his labors was that he got to keep the watering can.

Athos will probably not remember much, if anything, of early visits to my print shop, or playing at Totland, or our trip to the zoo. He loves watching movies and may have fairly good recollections of *Toy Story*, *Pinocchio*, or *A Bug's Life*, each of which he has watched about a million times and can

quote at length. As language develops and consciousness emerges, it is a mixed blessing. Memory, too, will lock in, and he will begin to form permanent recollections of times we spent together, of the joys and tribulations of childhood, of birthdays, Christmas, and Easter egg hunts. But the image of watering the garden on a summer afternoon will not remain.

Here, grown-up Athos, is a picture of you watering my garden in the summer of 2004. I have remembered it for you.

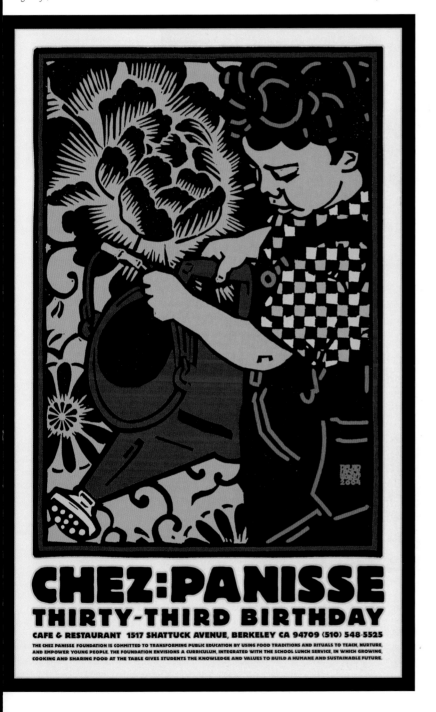

MICHAEL GIBBS

Friedrich Durrenmatt's play, *The Visit*, concerns an economically blighted town whose residents await a visit by a woman who fled 50 years earlier, shamed and destitute, after being betrayed by her lover. Now fabulously wealthy, she offers the townspeople $100 million—but only if they execute her former lover, a shopkeeper in town. They initially reject the offer, but slowly capitulate as greed begins to overtake them.

The woman is glamorous but compassionless, an eccentric character with artificial body parts and a quirky entourage that includes two mute bodyguards, one of whom plays guitar.

The fall leaves symbolize the decay of the townspeople's morals, the approaching end of the shopkeeper's life, and the woman's advancing age. She's made partly of stone, suggesting her stone-cold, unyielding demeanor. Her cane points to a lone red leaf, representing the murdered shopkeeper.

EDDIE GUY

This is one of several upside-down posters commissioned by CDD of London for Merrydown Cider. The premise was to illustrate the words "Merry" and "Down" in the upside-down poster. It was great fun to work on a graphic idea I was familiar with but had never seriously considered. The hope to make the poster emotionally happy/merry and angry/down, made the dual face notion compelling to me. I experimented with many kinds of faces but finally I choose this man and woman because I liked the way the hair worked as hair or beard.

MICHAEL HAHN

The exhibition, with the bible-like title "Do not be afraid!," was a retrospective of my sketches for posters made in the years from 2000 to 2005. Many who saw the posters but didn't understand them were furious. People don't necessarily love my work.

MICHAEL HAHN

The art director of the festival, "Musical Spring," which takes place every year in a small castle on the river Elbe, was looking for a new motif and chose my sketch that related to the classical program and the unique natural environment of the location.

MICHAEL HAHN

The illustration directly takes up the main character of Pam Gem's popular theater piece: Piaf rising from a shabby street singer to a famous star. The special atmosphere in the Paris quarter of Montmartre, accordion, and birds tuning into a mood of longing and melancholy.

JODY HEWGILL

This is a poster for the play *Intimations for a Saxophone* by Sophie Treadwell. Set in the jazz age, the heroine, Lily Laird, finds herself trapped in a loveless marriage and bored to tears. All around her, young Americans are learning to shed their Victorian mores for a more exuberant lifestyle.

JODY HEWGILL

When Mark Murphy commissioned me to do the cover of *The Directory of Illustration*, he asked me to create a piece on the theme "Seasons," and to give it a feminine feel. My piece shows two women: one represents spring and summer, the other autumn and fall. I created the art so that it could be inverted when used inside the book and, for the same reason, so that it could represent the two different hemispheres.

BRAD HOLLAND

This idea came because I wanted to do a picture with a lot of yellow in it. I first proposed it a couple of years ago to a different client who had asked me to do a poster. I was enthusiastic about the idea but once I got into it, the yellow began to overwhelm everything else. I messed around with it for a day or two, but with a deadline to meet, I abandoned it and gave the client something else.

Then, last year this assignment came along and I decided to try the picture again. This time I think I got it right.

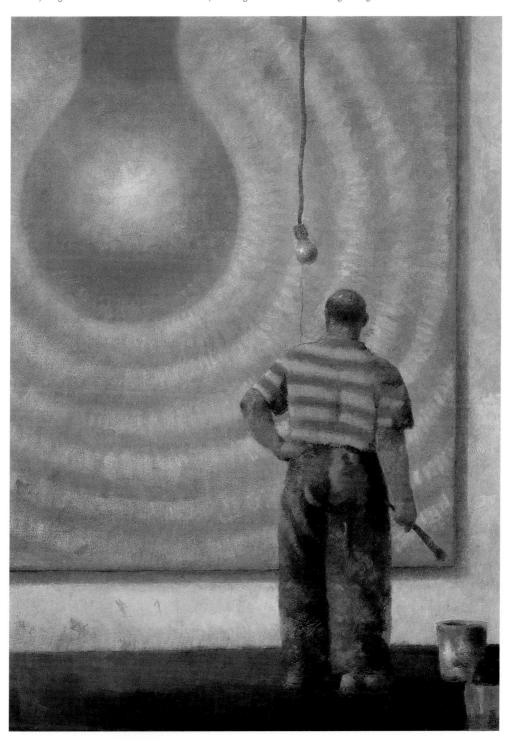

BRAD HOLLAND

The first time I did this picture I made an awful mess of it. The sky looked like a muddy palette and the lightning strike looked like a crack in cement. The second time I got the sky under control and I reconceived the lightning bolt as a kind of Japanese character. That gave me the abstraction I was looking for, although sometimes it looks more like the mark of Zorro. Somebody asked me if the artist is being touched by lightning or is painting it. That's a good question.

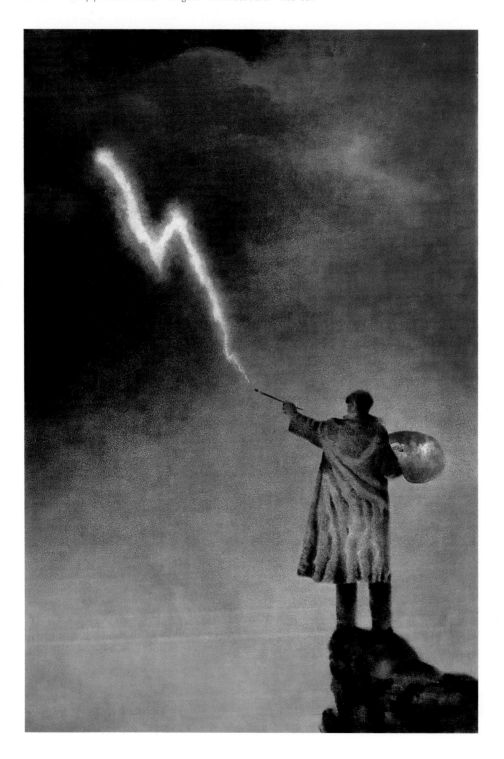

BRAD HOLLAND

I did two versions of this poster. The first version was a nocturnal picture in blues and greens. I favored it, but I also liked the idea of doing a sundown version, so I did this one, too. When I was finished I sent both paintings to the theater and let them pick the one they wanted to use. It's supposed to be a fool following a wise man. Or maybe it's the other way around.

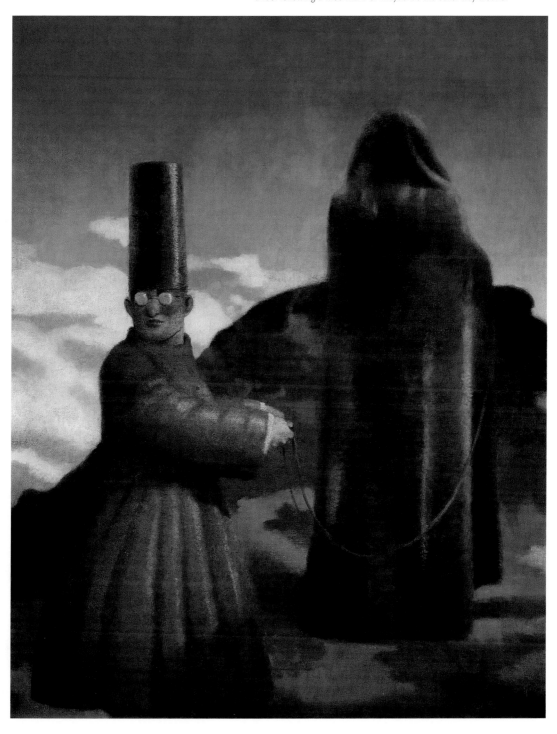

PHIL HULING

For this CD the jazz musician Dan Block was exploring the early arrange-
ments of Irving Berlin. Specifically, when Irving was known as Izzy Baline
and lived on the Lower East Side of New York in the early 1900s. So I chose
to approach this cover with a portrait of the young Izzy with the characters
and pushcarts of the tenement slum. The tone had to be lighthearted in
keeping with Baline's music.

 I met with Dan Block to show him a few sketches, which included full-
figured Izzys with alternate facial close-ups. I also brought along a George
Grosz Dadaist watercolor, which incorporated some collage, to propose a
possible avenue of technique. To my complete surprise, he informed me that
George Grosz's son was playing guitar on the CD. The agreed-upon sketch
approved by the art director was a stylized headshot of Izzy within a humorous
streetscape. In executing the finish I used an oil wash over a duotone print of
a tight pencil rendering, then further tinted the finished art with colored inks.

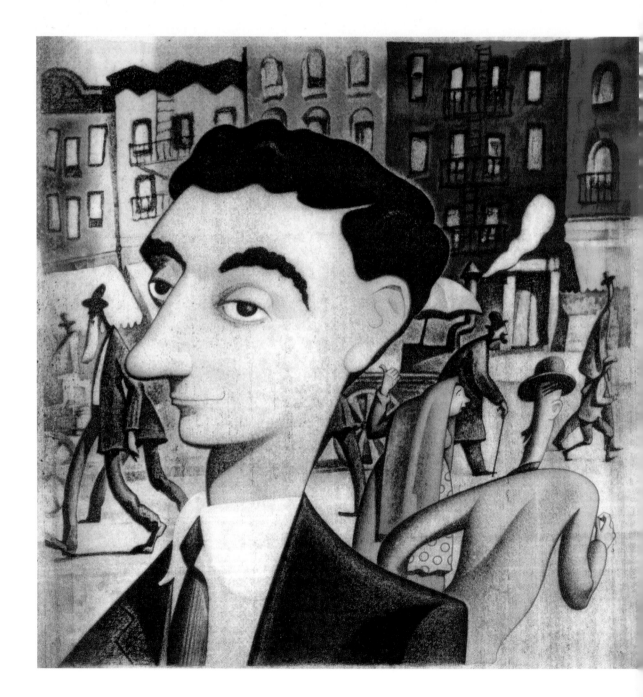

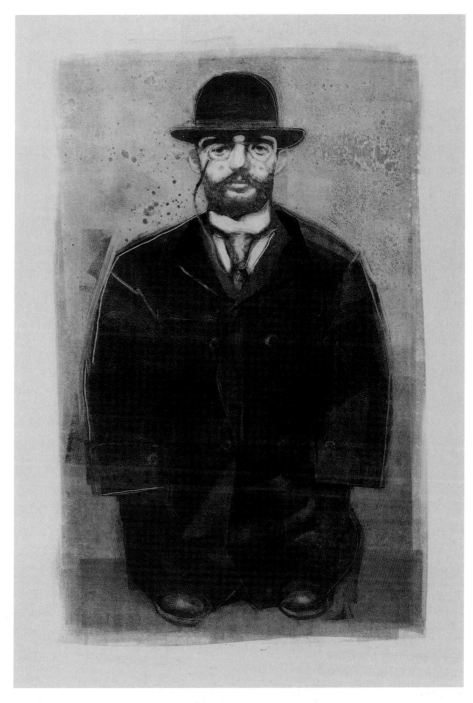

GARY KELLEY

The challenge here was to create a poster to promote an exhibition of 100 posters paying homage to Henri de Toulouse-Lautrec. I wanted to suggest the artist's physical stature without too much of a visual cliché and to render his portrait in an expressive medium not so often associated with illustration—printmaking. I love the organic and accidental effects that come off my press when I'm doing monotypes like this one. After years of perfecting my craft in other mediums, I find the unpredictability of monotype exciting and refreshing.

STERLING HUNDLEY

I've had the privilege of working with Kiera Alderette on a number of assignments. They continue to be of the most intriguing assignments that I get to work on. The summary of Kiera's direction on this illustration was to make it "sexy." The storyline is based around the relationship between a man and his wife. The wife makes a wager that he cannot steal the purity of a young virgin before she is to be wed. Much of the story is explained through correspondence in the form of handwritten letters. A classic roll-top desk was used as a symbol for the woman who the man is trying to seduce through his writing.

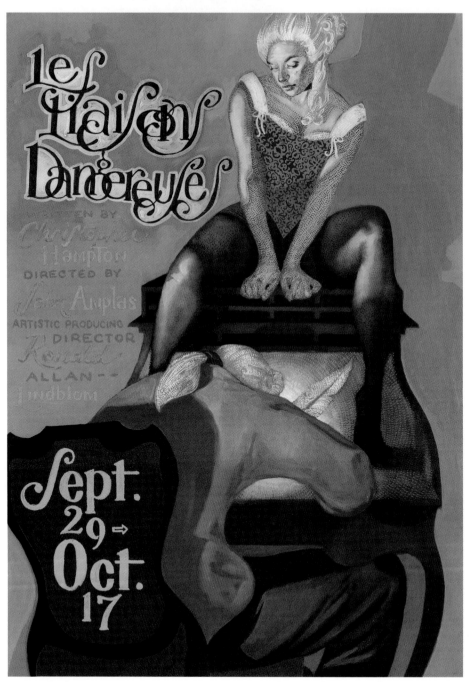

STERLING HUNDLEY

Kimberly Akimbo is a story about a young girl who suffers from Progeria, an illness that ages the body four times faster than normal. Kimberly's greatest ambition is to travel to the zoo to see the animals, especially the monkeys. In this illustration, I wanted to emphasize that Kimberly was just a child, even though she looks much older. I like the juxtaposition of a child's youthful, soft face between two aged, wrinkled hands. Her lunch box is open and the animal crackers reference the fulfillment of her ambition to go to the zoo.

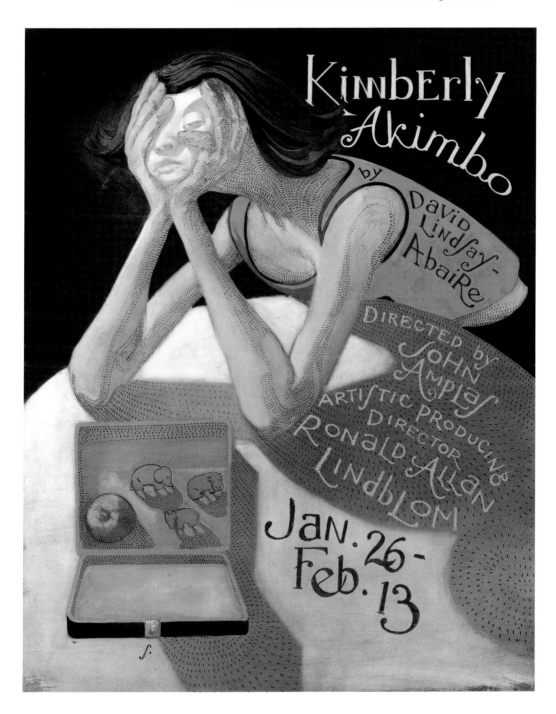

Tatsuro Kiuchi

For this presentation poster piece, I was asked to come up with something completely new, not just a traditional travel poster. The poster is meant to convey Amtrak's website, Amtrak.com, as the destination. I used the graphic shape of a hand and fingers to imply pointing and clicking. This shape also served as a bridge to futuristic cities. What I wanted to say through this piece was that fantastic travel experiences to new worlds on Amtrak is just one click away. This was an assignment with a very tight deadline, and the brief was very open. I worked digitally in Photoshop for this assignment and also did the type treatment.

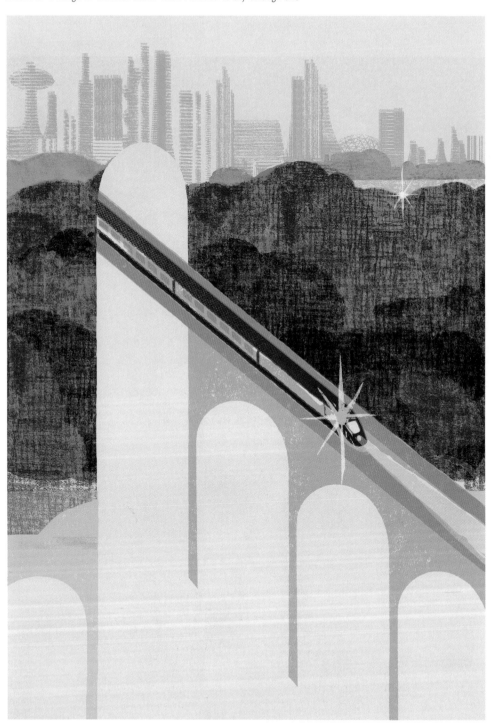

Coco Masuda

nited Air Lines, with Stanaszek Goodwin Design Partnership, was work-
g on a series of travel posters using illustrators who reside in each area
f destination. Originally, I was a candidate to do "New England" (I live in
ew York), but I also proposed to work on "Hawaii," where I have a vaca-
on home, and "Japan," where I was born and spent my childhood. Well,
was chosen to do only the "Hawaii" poster, but if I hadn't thought of the

proposal, I might not have done any.

Out of the three ideas I presented, this image with the banyan tree was
chosen. I have always been overwhelmed by the tree's immense size and
beauty. I depicted a Ukulele-playing mermaid to add dreamlike quality to
the image.

BILL MAYER

Irma Vep is a strangely macabre play complete with vampires, werewolves, and bloody murders. In this poster illustration for Hartford Stage I was trying to catch a rather comic sense of fright with a raised meat cleaver reflected in a giant eyeball.

BILL MAYER

This illustration for Bill Keighbalm at Integer in Dallas is the inside of a foldout poster promotion for the agency that poses the age-old question one more time. Should you play in the traffic or stay on the sidelines? Regardless, we had a blast creating this little group of strange friends.

John Mattos

At this event pedigreed, vintage cars leave from the Fairmont Hotel in San Francisco and drive a thousand-mile course modeled after Italy's famous Mille Miglia race. The client, Martin Swig, chooses the secret route, reviews petitions for entry, and selects 60 cars. At the start of the project, my friend, bon vivant and obstructionist art director Dan Radowicz, pointed out this was my second Mille poster, and that the second car to win the Italian Mille was an Alfa, a red Alfa, but that I should do whatever I thought appropriate.

Later, when reviewing my sketches, Dan observed that a great illustrator like Ken Dallison could draw an Alfa, a red Alfa, really well. Upon submission of the finished art, during a lively discussion about the appearance of spoked wheels in motion, Dan opined, "Dallison could have pulled it off."

GRADY McFERRIN

If you dig deep enough into any good song lyrics, themes start to appear, and visual symbols get stuck in your head that aren't easily shaken. If you're lucky, those symbols come together in a structure or composition that is as unique as a song itself. My favorite element of this poster is the farm equipment in the left oval (seed drill) and right oval (mechanical reaper).

GRADY MCFERRIN

The art director and I agreed that it would be too easy to riff on the band name, so we steered clear of anything "keys" related—no keyboards, key chains, typewriters, or keyholes. The black keys are a guitarist and drummer from Akron, Ohio, who play stripped-down Bluesy, garage Rock ... perfect for the Fillmore. I incorporated a few Victorian elements to reference the "classic" Fillmore poster aesthetic, while using the crudely posted-up Xeroxed type to keep it feeling raw and gritty.

GRADY McFERRIN

Bill Graham Presents is a wonderful client who allows me to explore abstract concepts, often taking lyrics which are elusive and poetic and translating them visually.

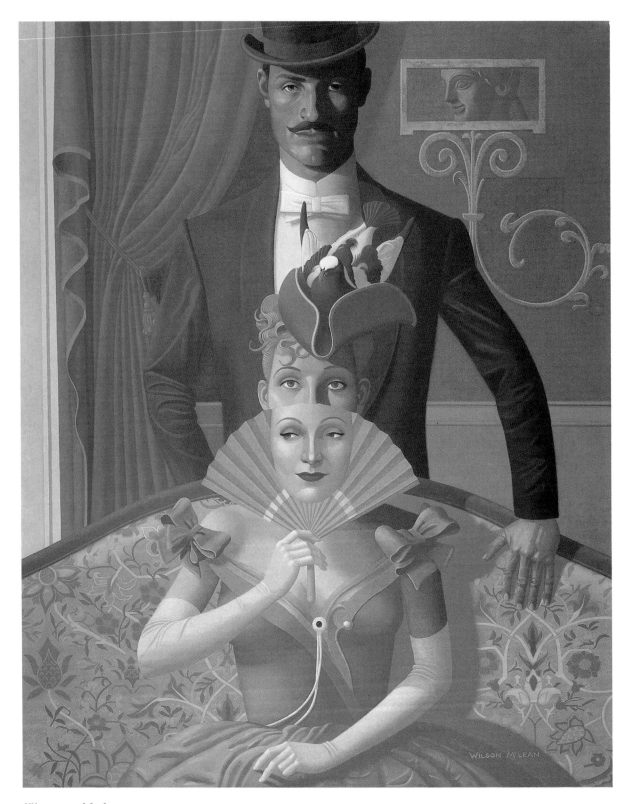

WILSON MCLEAN

JAMES MCMULLAN

In this portrait of the actor Christopher Plummer, I tried to get both the heroic intensity of the character of Lear and, in the gesture of his right hand, the sense of his vulnerability. The calligraphic strokes of his robe were what I most enjoyed painting in the poster.

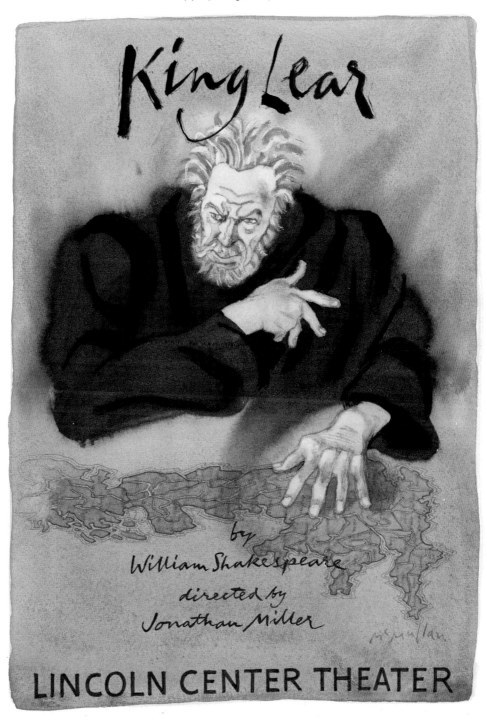

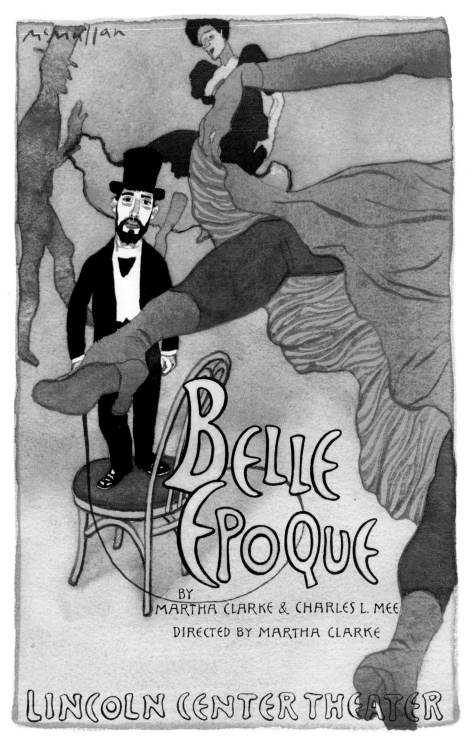

JAMES MCMULLAN

The theater piece that this poster advertises suggested to me, in an oblique way, the Fellini movie *8 1/2*. I saw the Toulouse Lautrec character in *Belle Epoque* at the center of the play like a ringmaster directing the action, just as Fellini's central character did in the last scene of the movie. My concept involving Lautrec standing on a chair holding a whip didn't actually reflect a specific moment in this production, but Martha Clarke, the co-author and director, went along with my conceit.

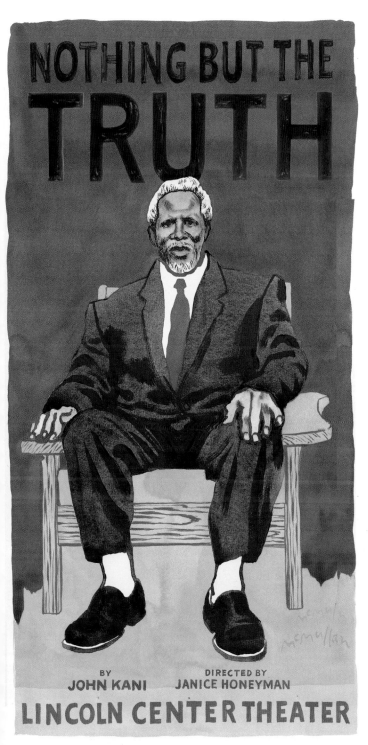

JAMES McMULLAN

John Kani was both the author and the principal actor in this play. I sent him (in South Africa) a pencil sketch that I had done, imagining the pose, and asked him if he might have a photo of himself taken in the same position. He agreed and, using the subsequent photo as reference, I painted the portrait in the poster. The background orange wash created the basic shapes of the image, including the loop that defines the head, and the simple drawing of the hands and chair. Doing it felt very edgy.

RENÉ MILOT

Merrydown, a cider company from England, already had in place a series of images by several illustrators based on the Merry vs. Down concept. All these concepts had to be seen both upside and downside. When contacting me for the "Vintage" products, the creative director asked for an "antique" approach to their concept. The idea was to create a painting with a familiar look to it that would set it in an historical period. After exploring several eras, it was decided that the Flemish/Dutch look would fit the requirements of the product well. The interesting part of creating the image was finding elements of clothing of that era that would fit in the upside-down version. Working in oil on canvas in the style of the era, creating a wooden frame suitable for a 17th century paintings, aging it with gold leaf, crackling, peeling paint, etc., gave it an overall vintage look.

JOE MORSE

CHRISTOPHER NEAL

"Love Crimes" is an abstract dance piece that combines expressionistic dance and contemporary music to portray a medley of tragic love stories. Though there is no distinct narrative, the universal concept of anguished love drives each performance. Longtime friend and designer Michael Signorella and I wanted to convey a very human experience, with some sort of human element. At the same time, we did not want to imply anything specific about the characters including age, class, time period, etc. By focusing on the hands and referencing an expressionist style in the art, we were able to create an image devoid of specific details and focus on the concept in a broad sense. Michael and I worked for three years as a design team in Colorado working on various collateral and web-based projects. This was our first project together as art director and illustrator since my transition from designer to artist. I think it went well and the poster has been well received.

KADIR NELSON

This image was used for the cover of a new video game about street football with NFL players. It had to be one of the most tedious paintings I have ever painted because there were so many stages to get through before I was able to put paint to canvas: 20 or so sketches. Mercy. But in the end, I think we got a nice painting. The guys at Electronic Arts respected me for trying to keep the integrity of my work while trying to accommodate all of their needs. And I respected them for allowing me to be heard. After all, we as illustrators are hired for a reason, right?

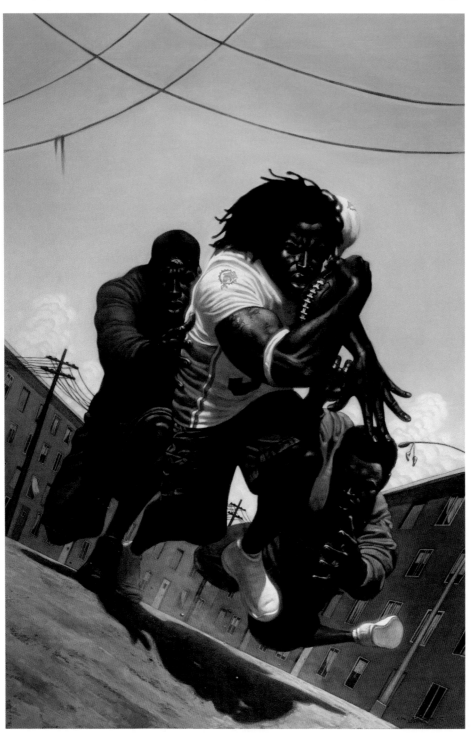

ROBERT NEUBECKER

When I got the call from Fox Searchlight's creative director, Stephanie Allen, I thought I'd never see a finished poster for *Sideways*. Movie posters are almost always photos and surely the boardroom suits would never approve an illustration, certainly not one like mine.

The director, Alexander Payne, and the producer, Michael London, had seen my cover for *The Los Angeles Times Magazine* about overcrowding in Southern California. They felt that I had perfectly captured the sense of alienation portrayed by Paul Giomatti's character and wanted that for the poster.

My agent, Tammy Shannon, set up a deal where I was paid an escalating fee for each stage of development: sketches, finished art, and a premium for the poster itself. Then I set about convincing the suits. I ignored the specified number of sketches in the contract and did every possible visual permutation of two drunks, a bottle, two women, and bad judgment. Then Christian Struzen, son of Drew, who has a design firm specializing in movie posters, sent over more ideas, which I also did. In all, I sent in at least 40 sketches. I really, really wanted to do a classic, simple image movie poster harking back to the fifties and sixties.

Two weeks later Stephanie Allen called. I had the poster! Payne and London had brought the studio on board. I couldn't wait to start. Stephanie said, "No, it's done. It's already printed." Christian had designed this lovely poster around one of my sketches and so there it was. We won a Key Art Award, the movie industry's design Oscar, for best comedy poster of 2004.

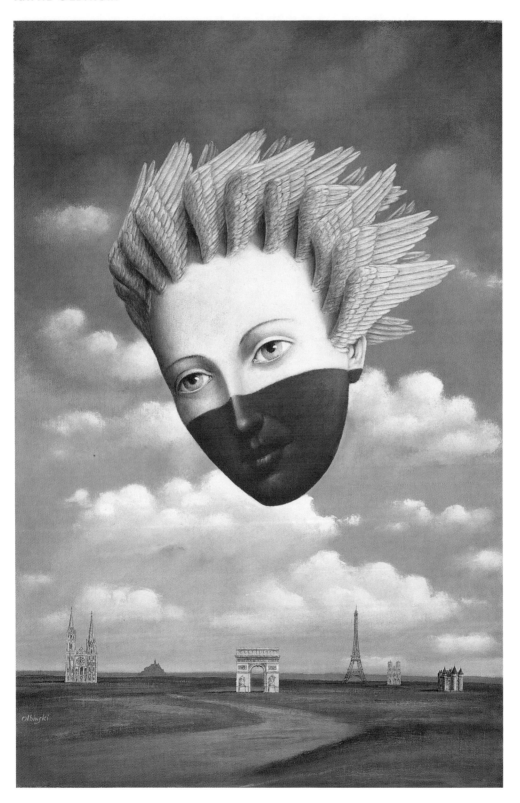

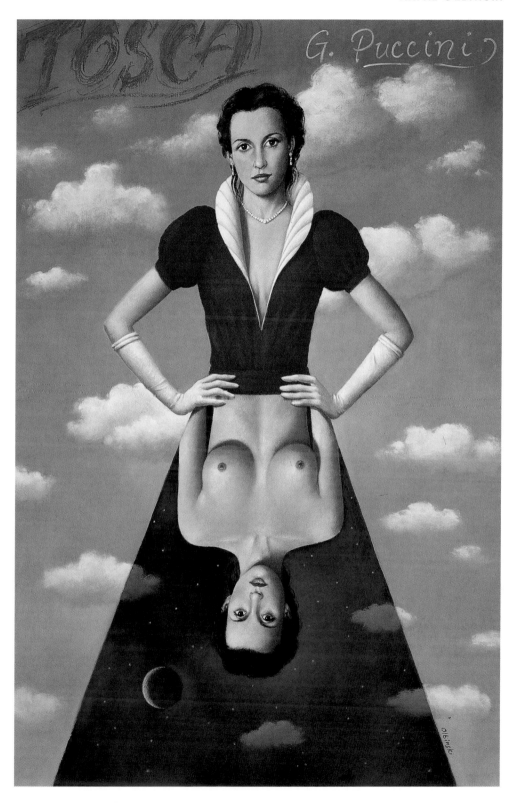

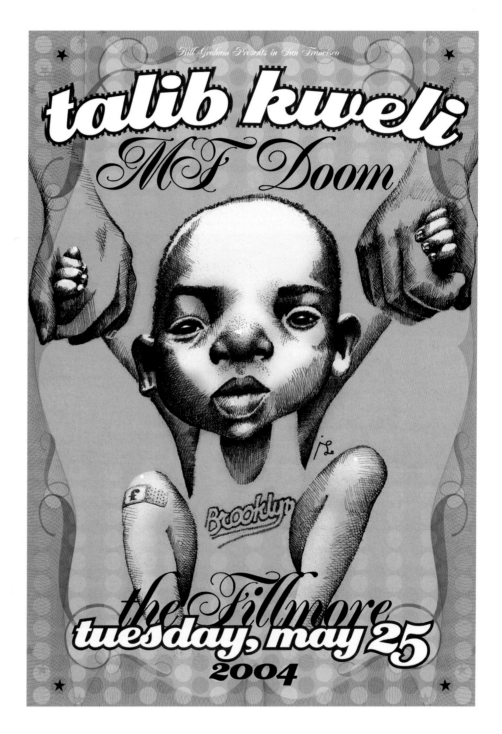

JUSTIN PAGE

Being a fan of both artists on this bill, I was very excited at the opportunity to do the poster. My first inclination was to do something with a positive message. I also wanted it to feel nostalgic while tipping my hat to the band's hometown and culture. The central drawing is ink on illustration board while the type and border treatment are done in Illustrator. I com- bined them and added some additional color in Photoshop. I enjoy the combination of hand drawn and digital elements and am pleased at the outcome of this poster. This project went smoothly with minimal changes and I recall the art director was pleased as well.

JOYCE PATTI

When I got a call to design a tea box for Celestial Seasonings' Persian Mint Tea I was thrilled. It was a job I thought I was perfectly suited for and had waited a long time to get. Celestial Seasonings wanted something that was a throwback to the time of the Arabian nights and the Persian miniatures. One of their suggestions was a camel caravan, as they have many animals depicted on other boxes. Other imageries were people having tea, garden scenes, and flying carpets. They also wanted whimsy and fantasy. I researched and purchased a beautiful book on Persian miniatures, which helped me immensely. After submitting, I believe, four solid design ideas, they went with the two women in the garden having tea, which seemed to be the most engaging. It was their idea to change the buildings into teapots, as they always want that little bit of extra whimsy in their designs, which made it more magical. I was glad they chose this design as it was my favorite also, and I went on to a color sketch and finish.

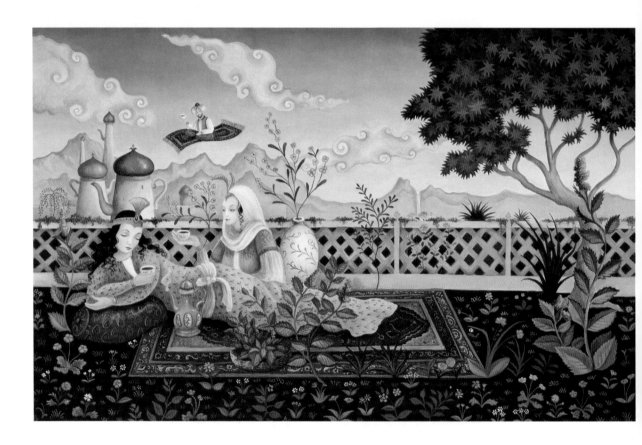

DAVID PLUNKERT

This poster art was created for a non-partisan voting campaign. Who'd trade a voting box for a cage? The initial inspiration for my book, *Sticks and Stones*, came from a comment by the artist Andy Goldsworthy. In the documentary *Rivers and Tides*, he talks about his realization that so much of what we consider to be solid and permanent—like mountain ranges—are far from it. Though they appear stationary they have moved miles and changed shape over time.

In this same regard, empires—from the Roman to the British—that once seemed perpetual, have crumbled. The superpower status the United States now enjoys, with an alarming level of hubris, may also prove to be another part of this continuum.

I decided an allegory would best describe this cycle since it transcends individual politicians or countries. Also, I couldn't bring myself to draw George W. Bush for 128 pages! I made *Sticks and Stones* wordless so it would be accessible beyond language barriers and, echoing hieroglyphs, would use pictures as a language of their own. The art was created by cutting stencils and spraying them with enamel paint. The speckling from the spray paint gave the whole book the texture I was aiming for. I added watercolor, colored pencil, ink, and white acrylic to finish the drawings.

I am honored to receive this award and thankful to live in a country where (as of this writing at least) free expression brings more than just a prison sentence!

STEFANO RIBOLI

This is my fourth assignment for Qowaz, a German beer-based drink, so I knew all the client's requests, and some of the most difficult problems had been solved successfully in the previous illustrations. For those reasons, I was able to work completely without stress, concentrating on the goal of recreating a pin-up style that didn't seem outdated, but on the contrary looks modern and fashionable. Many thanks go to the girl, Erica, who posed for the reference photos, and to the art director, Marc Leitmeyer, who created a fantastic layout: nothing was left to chance. I hope I will have the opportunity to work on "the past" as a starting point, and I hope to have an assignment in the field of realism. I know it's not easy, but it could be a very original point of view in the days we are living.

EDEL RODRIGUEZ

This image was originally done for a calendar put together by Pepsi in celebration of a variety of African-American music genres. I was asked to draw my interpretation of Jazz and this composition came to me rather quickly. The image was later chosen to appear on the cover of the 2004 *Communication Arts Illustration Annual.*

CHRIS RUBINO

A port city. That image is what came to mind instantly after reading John Patrick Shanley's *Sailor's Song*. I thought of Havana and New Orleans, I thought of the climate in each, the streets and the dancing made famous in those cities. The drawing captured all of that for me. I was even happier with it after seeing the play and how well the drawing coincided with the staging.

Tracy Sabin

Biscotti: crisp, twice-baked cookies typically used to dunk in a café latte, made originally in Italy.

Looks like... an orange wedge? a moon? a boat?
boat... Italy... boat... Italy...
gondola...
gondolier on a biscotti as if it were a gondola in Venice...
No, not in Venice—in a cup of café latte.

Yes, I think so...

CHRIS SHEBAN

Technologically (embarrassingly), my electric pencil sharpener remains the most advanced upgrade I've made in years. Sadly, with a drawing like this, basic knowledge beyond my "1-k" computer abilities may have made it easier to create the "crashed through" logotype. Instead, I cursed my way through hand-drawing it incorrectly a number of times.

CHRIS SHEBAN

This was a cover for a Lands' End catalog issued during election season. Unintentionally, and for reasons I can't explain, the jolly fellow on the "right" looks remarkably like my father-in-law, a dyed-in-the-wool Democrat.

LASSE SKARBOVIK
Cover for a brochure with information about prizes and how to advertise in the magazine *FastighetsTidningen*. The magazine is for and about homeowners in Sweden.

RYAN JACOB SMITH

This project was a CD cover for a compilation titled "Depressed? Stay Depressed." The CD contained depressing yet beautiful music from twelve different musicians. I wanted to capture the wit of the title and the depression and beauty of the music.

One thing I came up with was an anvil, a symbol developed from a childhood of watching cartoons. Anvils were usually dropped onto characters with humorous results, but in real life it would be tragic. So, rendering a realistic anvil in a cartoonish situation created a witty yet tragic mood.

I painted an old record cover beige. I wanted to use a limited palette to create a simple, quiet mood. The girl and anvil were painted on separate pieces of illustration board, then I cut them out and pasted them on the painted record cover. Then I distressed the piece by chipping off paint, spilling ink, and ripping part of the painting. Giving the piece a worn-out yet admirable look.

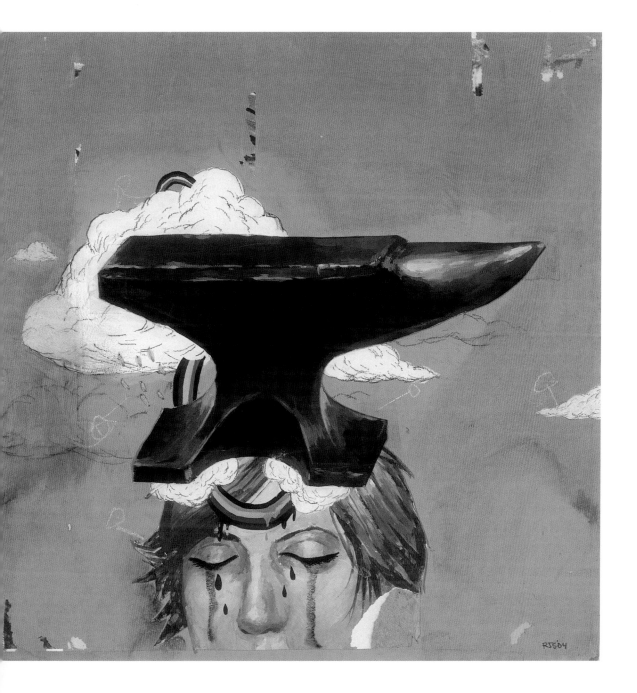

Felix Sockwell

This poster was a pain. First, I went to the bookstore and bought up all the Blue Note jazz photo books. Man, I love that stuff. Photos come in handy for detailed jobs. "Don't make them too black," requested one account person. Heh. Well, I finally got something I liked—this one—but couldn't manage to sell it so we all bitched and moaned, eventually settling by printing a gold version that was less detailed. I hated that version. Despised it. This one was printed but never sold. The best part of the whole deal was becoming friends with the art director, who called me "playa," "boss," and "pimp," and later gave me a big Ford assignment for the Freestyle. I finally met him at the opening for this event at the Society.

FORD DETROIT INTERNATIONAL JAZZ FESTIVAL

JAZZ MASTERS CLUB LIMITED EDITION 2004 *Ford*

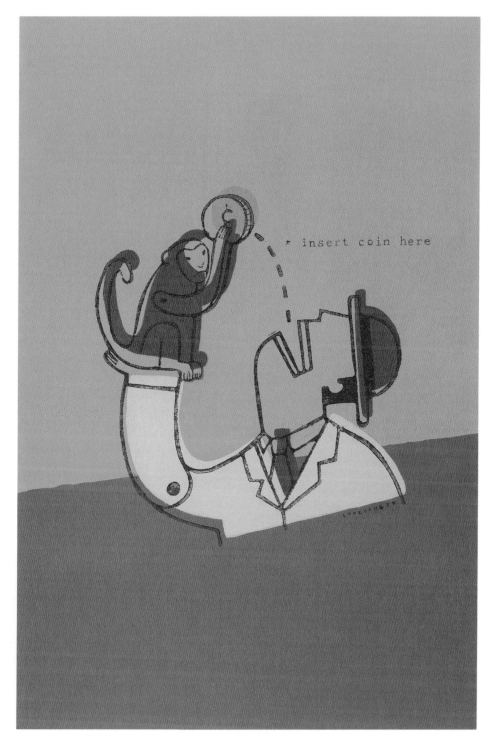

insert coin here

CAREY SOOKOCHEFF
This was one of six theater posters for the Theatre Pass Mauraille's 2004–05 season. *Small Returns* is a play about two workers in a small claims collection agency. I wasn't given much more information than that about the play, which made it easier to suggest the content of the play without giving it all away.

PETER SYLVADA

This is one of a series depicting a young girl's life on a cotton plantation and the camaraderie she has with the other women there. For this painting, I chose to depict the women working, even during off hours, in their tiny cabin, where they are interrupted by the girl who comes calling.

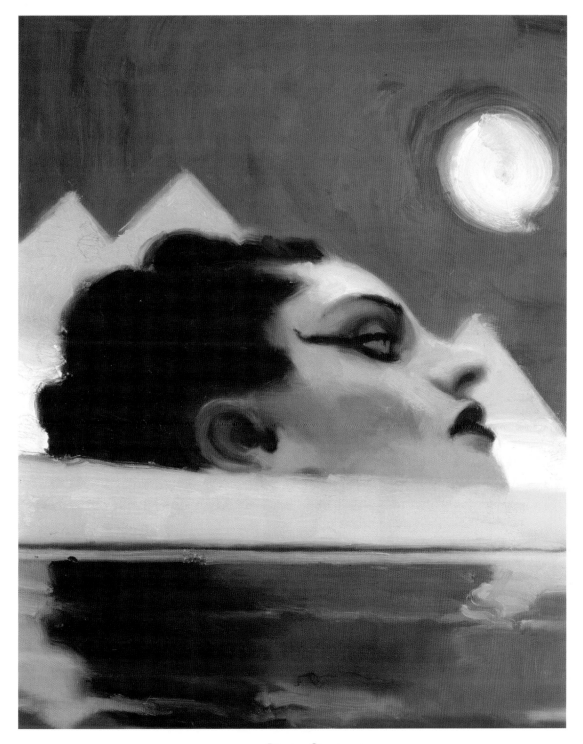

PETER SYLVADA

The opera *Aida* tells a story of a love greatly divided. Aida, an Ethiopian princess, longs for home while deeply in love with a great Egyptian soldier. This is a story of monumental characters in the land of the greatest monuments.

DUGALD STERMER

After a couple of decades of striving for accuracy in my illustrations of animals, birds, reptiles, insects, people, and even lower forms of life, it was refreshing to draw a myth. But an ostrich hiding its head in the sand is not only entirely fictional; it's also a cliché. The challenge was to make it fresh and even intriguing. To that end, I tried to make the illustration feel factual by exaggerating the look of 18th century natural science engravings.

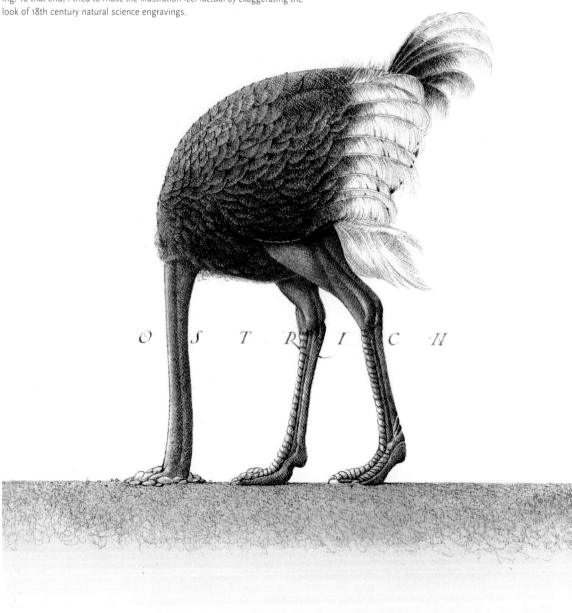

O S T R I C H

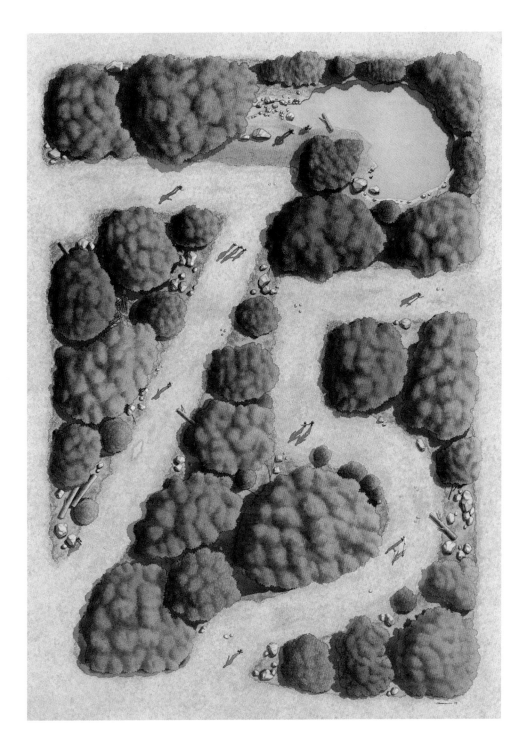

BILL THOMSON

This illustration was created to serve as a limited edition poster for the Connecticut Forest and Park Association commemorating the 75th anniversary of the Blue-Blazed Hiking Trails. Designer Peter Good provided me with a wonderful concept of a path with a numerical shape. Having grown up in South Carolina, my childhood was spent exploring the woods and trails around my home with my brothers. I wanted this illustration to reflect the rich textures of nature that I recalled from my youth with the numerical component somewhat hidden in the image. I worked much larger than usual so the detail would translate to the large format of the poster. This painting is actually the largest thing that I have ever done. I didn't use any reference materials (unusual for me) and relied strictly on childhood memories for this nostalgic little trip back to the woods.

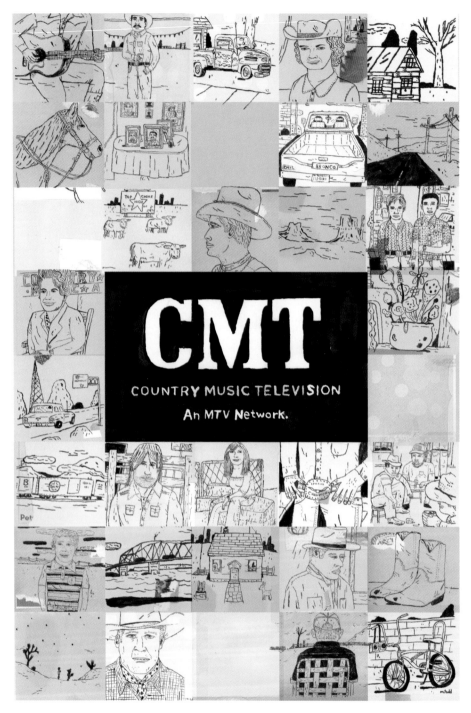

MARK TODD

Working with Country Music Television on this ad was one of those great jobs that are so much fun to work on, where the creative director just lets you go and gives you a lot of creative freedom. I was able to work like I do with my personal projects: from the hip, few sketches, a huge stack of paper, ink, and brush. CMT wanted to capture the feeling of country music in a young and fresh way, helping to introduce new talent in the industry, while giving a nod to icons like Loretta Lynn and Johnny Cash. Each image was drawn separately, digitally laid over collaged backgrounds and pieced together into a grid. That way, certain panels could be pulled, rearranged, or featured, depending on the type of ad. The art was also animated for television and for CMT DVD title openers that went into music stores.

POL TURGEON

Working for a CD cover is always a pleasure. This is my favorite piece of the package for the band CD kit. It was used on the inside of the CD case where the disc sits; when removing the disc from the case this image is revealed to the eyes. The designer did a fun little animation using the cover art for The Calling web site. It was so interesting to see my image in movement. One day, I'll definitely push the animation side of illustration. Really too joyous!

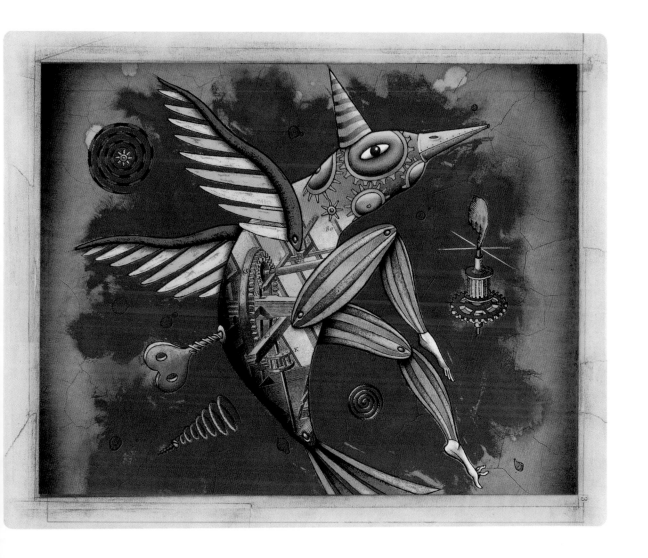

JACK UNRUH

This ad draws the parallel that bees build their hives near flowers, which is why you might want to build your next major manufacturing site at Port Freeport. They also like that the bees have an efficient transportation system near a deep-water port they call home. The headline sums up the benefit: "Time is Honey."

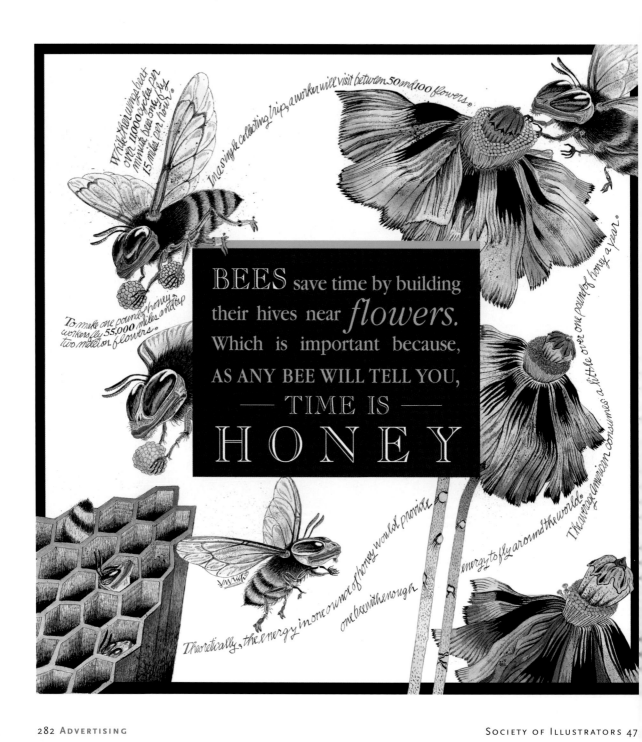

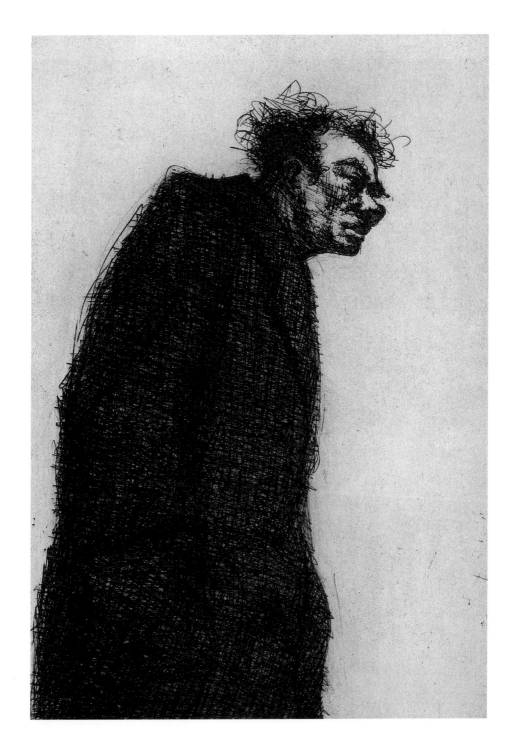

Bruce Waldman

This piece is an etching. It was created with traditional etching techniques and processes. The image was drawn with a metal etching needle onto a zinc plate, and then soaked in a bath of nitric acid so that the image could be permanently engraved and fossilized into the metal.

The assignment was to create a desperate, disheveled, and threatening figure, in the suggestion of a ghetto, urban environment (actually in New York City). I used a dynamic perspective, looking up at the figure to make him appear menacing and larger then life, and I left a gray plate tone in the background to make it feel like dusk, or nightfall, to create an atmosphere that is threatening and ominous.

The assignment was done for the New York Society of Etchers, and the subject was New York City.

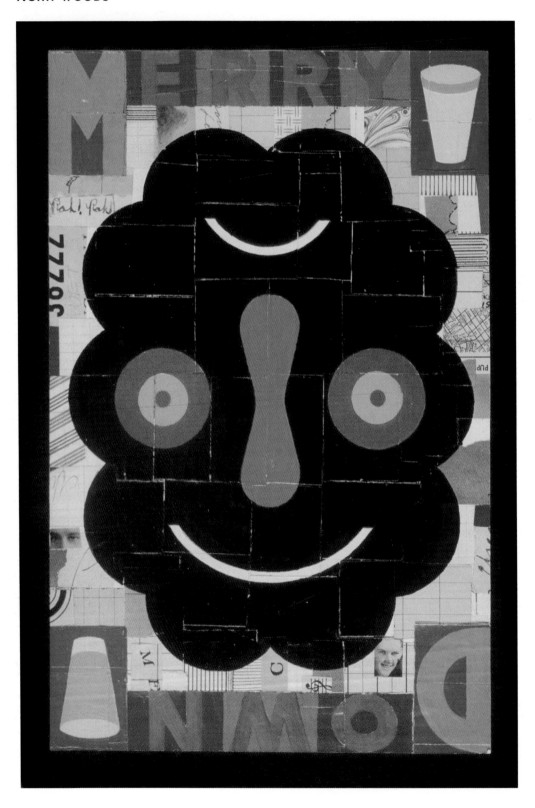

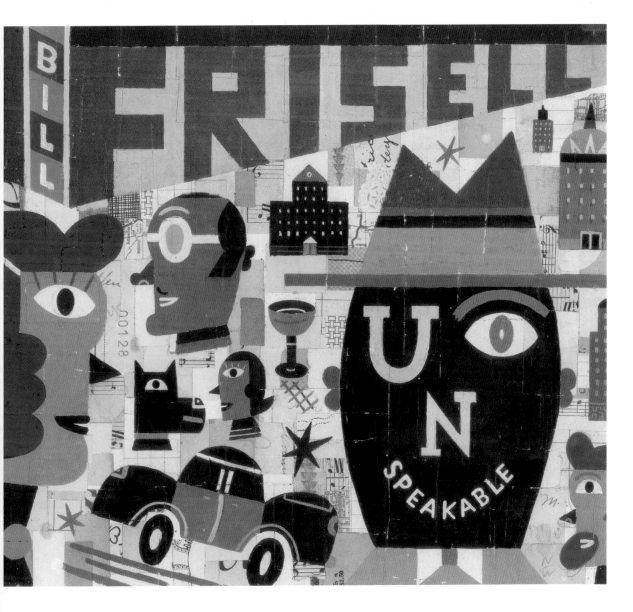

HIROSHI WATANABE

This is a magazine advertisement with the concept: "We want to send a smile." I've recently been drawing a lot of animals. I want people to be happy when they look at my pictures. I've long dreamed of having my work in the Society's annual book and am very happy to be included.

Green Consumer Niigata

TAKASHI AKIYAMA

This illustration is for an eco-campaign poster of "Green Consumer" (Niigata Prefecture). The purpose is to urge the viewer to become a "Green Consumer." The character "Green Consumer man" (the leaf that loved nature) was born. "Refuse, reduce, reuse, recycle" is important.

TAKASHI AKIYAMA

This illustration was used for the notification poster of Icograda, world graphic design conference in Nagoya. The theme is Visualogue. My image shows "The eyes speak as much as the mouth."

TAKASHI AKIYAMA

This illustration was drawn for the exhibition "Homage" to honor professor Jun Tobohashi. To show respect for his creation, I drew the Ukiyo-e "crane and turtle." Ukiyo-e was the people's art born in the Edo period and it has molded the aesthetics of Japanese illustrators to the present day. "Crane and turtle" means "long life" in Japan.

Kayo Aiba

Kayo's artistic uniqueness lies in the method of her creative expression, utilizing a textile canvas, thread, bits of fabric, and a sewing machine. The finished work resembles a sketch in progress, with numerous layers and long ends of the threads purposefully left on the canvas to create the "seeping" effect, giving the illustration a dynamic and lively atmosphere. This multi-dimensional "sewing art" has a very warm and approachable feeling.

NATALIE ASCENCIOS

I was asked to create a series of wine labels from Italy. I was already familiar with the regions and did a variety of sketches. A more conservative sketch was chosen and I simply went to final in oil on canvas. The others will be executed in the coming year.

NATALIE ASCENCIOS

The new owners of the Algonquin Hotel appreciated my first painting that was commissioned by the previous hotel owner. Once new management came in, the first painting was then taken to the Brown Hotel in Louisville, Kentucky. I had two months for the whole commission, including orchestrating the specialized lighting, custom stretchers, framers, professional hangers, photographer, and movers. I came up with two sketches. One was chosen. From there, I did a color study within the week and then the final. It is on permanent display at the Algonquin Hotel in New York City and now is considered the hotel's property.

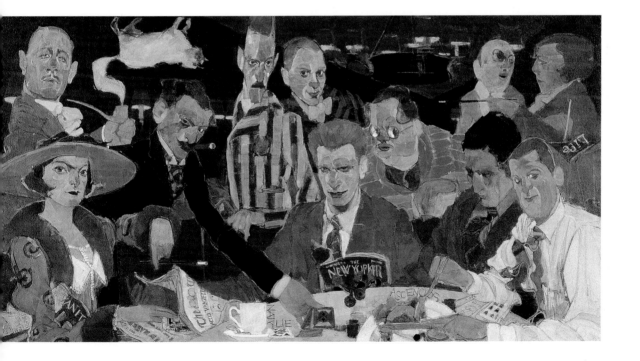

THOMAS LEE BAKOFSKY

This piece was commissioned to conclude an issue of the *CalTech Undergraduate Research Journal*. My hope was that a whimsical, hand-made image would provide welcome relief from the requisite charts, graphs, and diagrams that constitute the bulk of the publication's pages, while simultaneously encapsulating the underlying spirit of exploration that drives the research.

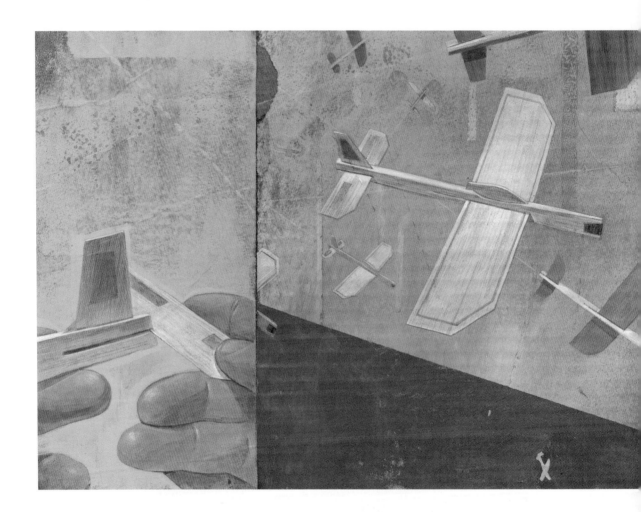

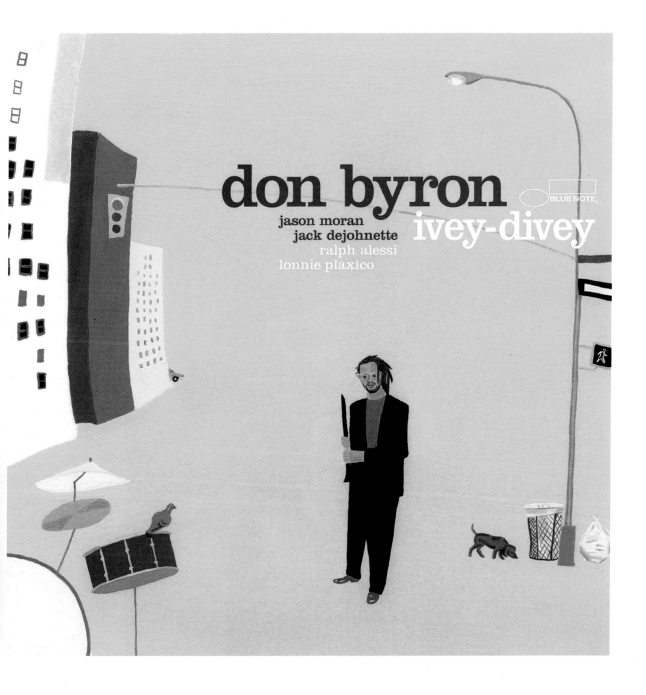

don byron
jason moran
jack dejohnette
ralph alessi
lonnie plaxico
ivey-divey

BLUE NOTE

JULIETTE BORDA

A 1946 album by Lester Young inspired Don Byron, a jazz clarinetist. It was requested that the new art should somehow recognize Young's original album cover. I nodded to that cover by using a similar palette (though different proportions of the colors) and the man-on-the-street idea. The two covers really look nothing alike, but I do like the idea of both the music and the art being inspired by the same source.

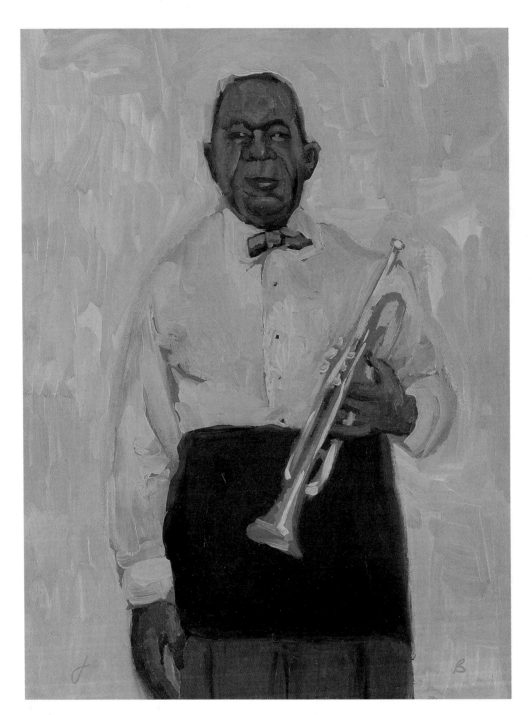

JIM BURKE

This painting of Oscar "Papa" Celestin was created for a promotional poster for the printing company Dellas Graphics. "Papa" (1884–1954) was a very influential figure in New Orleans Ragtime as the leader of the Original Tuxedo Brass Band from 1911 to 1925, which featured many leading musicians during the formative years of jazz, including an up-and-coming coronet player nicknamed "Satchmo."

I had a blast with the limited palette and buttery texture in this oil painting. Studies from many of my heroes' works (Sargent, Duveneck, Sloan, and Manet) prompted me to loosen up and just have fun.

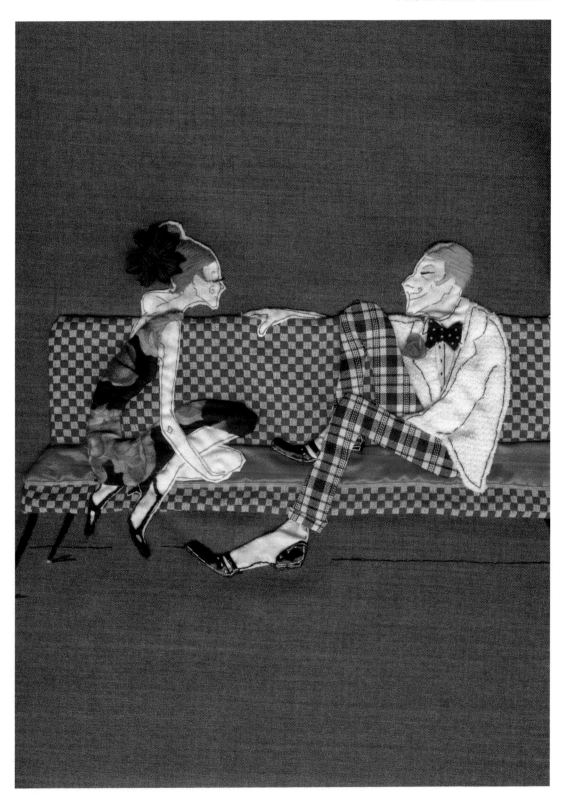

Daniel Chang

This piece was for the musical *Elliot and the Magic Bed*. The story was filled with so much rich imagery it was a pleasure to illustrate it.

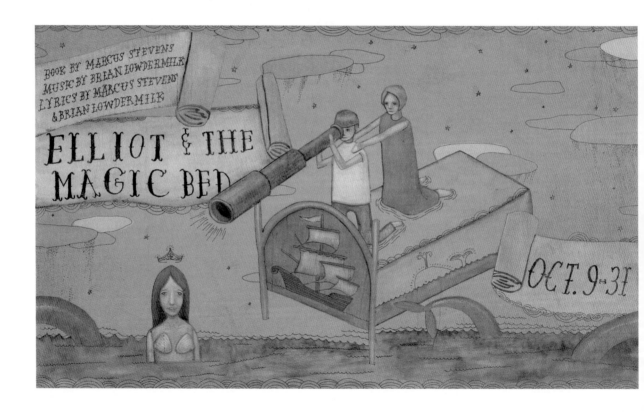

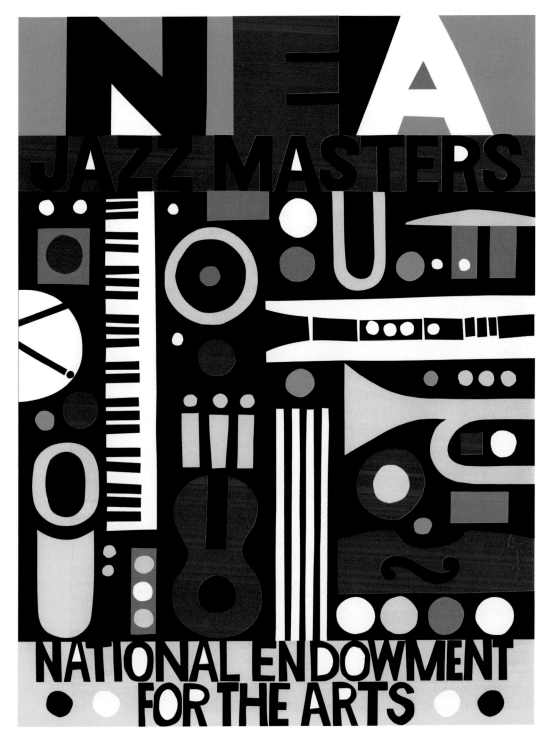

van CHERMAYEFF

he assignment was to celebrate the liveliness and exuberance of jazz
America. The image combines the name (NEA Jazz Masters) and the
ponsor (The National Endowment for the Arts) in a single tapestry of jazz
mages and color, while the words and the images are all in one handmade,
ut paper, visual language.

The intention was that the combination of the whole be usable for a
poster, a press list, stationery, and all other varied communications in print
and on the air.

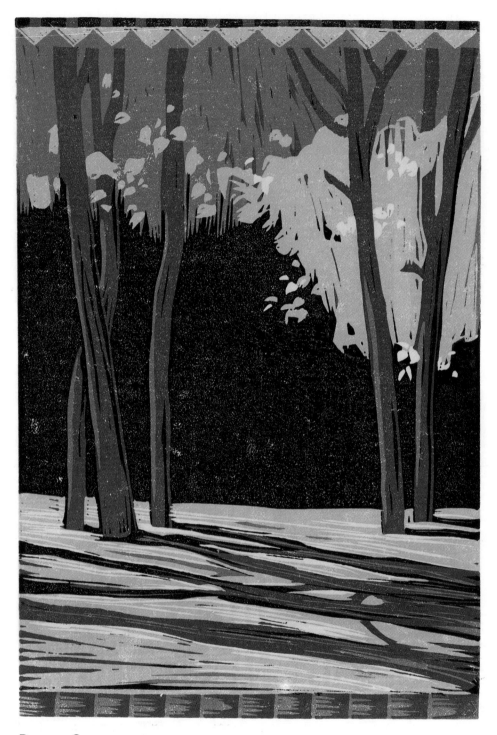

DANIEL CHRZANOWSKI

The intention was to create an image that depicted a late afternoon quality of light with long dramatic cast shadows that would look very tonal without being rendered in much-used oils, and water-soluble pigments and inks. I generally use three to five tonalities in my relief prints. When one changes the viscosity in the various inks, shapes are created that are both flat and graphic, but that also suggest a very textured, tonal quality. Plus, you g the unexpected results that are achieved by working in the reductive reli printing process where one color is printed over another, keeping the col chord active and alive.

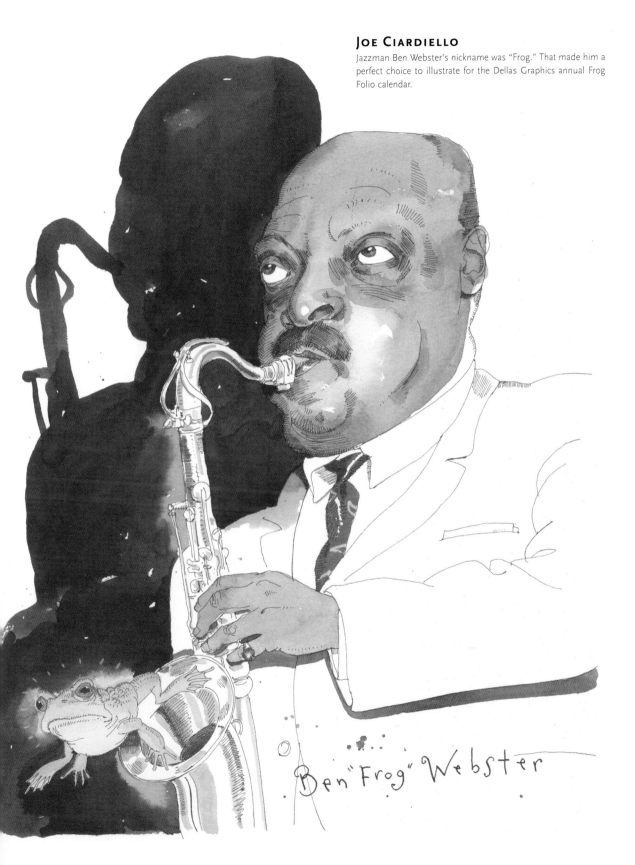

Ben "Frog" Webster

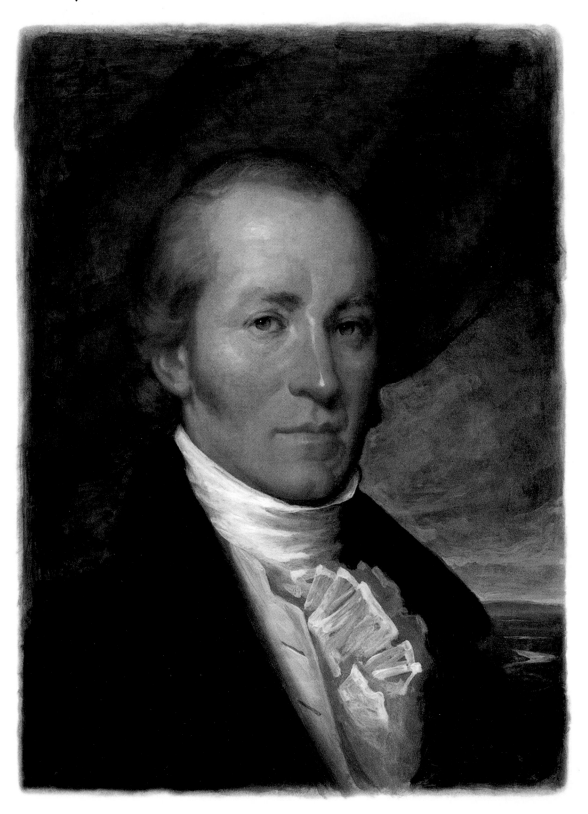

RAOUL DELEO

These drawings were made for a showcase of Dutch designers, called Dutch Design 2004/2005. The issue consists of two volumes. With the help of a graphic designer, I developed the "design army" concept. We wanted the two books to come across as a complete strategic plan of conquest. All the fields of design are represented by armies and are lined up so they mark their own territory, their own creative space. We created the soldiers and their particular skills, designed the armor, and made the maps of the areas to be conquered. We wanted to fill the pages of the books with an overload of visual information about the armies and their skills and strategies. The whole project took more than six months to complete.

SOCIETY OF ILLUSTRATORS 47

INSTITUTIONAL 303

ETIENNE DELESSERT

I always choose a theme for an exhibition, for example: "The Little Lights of Paradise," "Birds of Prey," or "Prophets and Pretenders." Last year I explored the concept of Angels. I went from butterflies to winged creatures, and since I am not really sure they exist, I presented my angels as old, wrinkled, a bit cranky, wise characters that I would like to meet to talk about life, death, and the affairs of the world, far from the botoxed angels we see in the Renaissance paintings.

As some people become angels before grammar school, I started th image as the face of a sweet little girl. But nothing worked, and soon I onl kept her little round nose—my nose. The painting would become one o only three self-portraits I have ever done.

It is painted in acrylics on wood.

DAVID DE RAMÓN

The original intention of the client was to develop a simple poster, mostly just typographical in design. The design studio AzulFaroDiez convinced them to use an illustration "with character" that would lend credibility to the Festival and transmit a solid and impressive image on the various surfaces wherever they publicized it.

The result was a generic illustration about the blues. It was personalized within the context of the Menorcan culture (it's a small island in the Mediterranean Sea), with the sea inside the guitar.

Based on just a thumbnail sketch, the client approved the idea at once, and I started work immediately. I thoroughly enjoyed working on this illustration and when I left the studio, on my way home, I suddenly remembered why I do this.

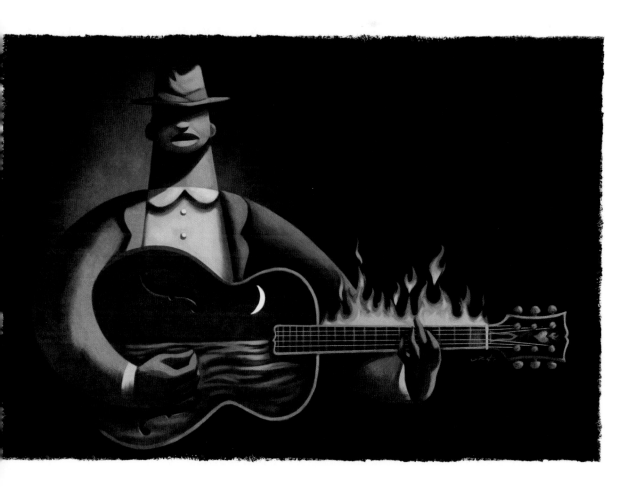

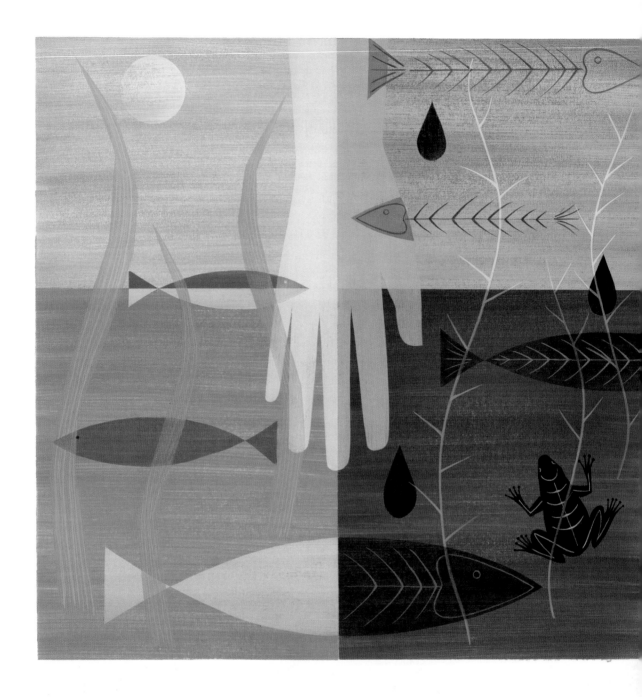

SANDRA DIONISI

The wars in the future will be fought over water. A small town in the Dominican Republic is forced to deal with a shortage of water brought on by diversion dams, deforestation, and climactic change. The magnitude of the problem is felt across the whole of the community and creates struggle in every aspect of life. This was the subject of an article entitled "Water" in the book *Saving Lives Millions at a Time*. I tried to show the relationship between water and humanity as one of fundamentals, and approached the subject as an exercise in archetype. If water is life, the human hand represents a choice between drawing on that life or wiping it out.

GERARD DUBOIS

Working from a text, a quote, or, in this case, a legend you've read and liked and chosen can prove to be harder than initially expected. From all the legends submitted to the participating artists of this calendar, this one attracted me most. However, I had great difficulty trying to draw something I liked. It was such a mess that for a while I even thought of stepping away from the project. Ultimately, as often happens, after taking a break and with a fresh mind, I took a look with a new perspective which enlightened the whole story differently and allowed me to come up with an idea that made sense to me.

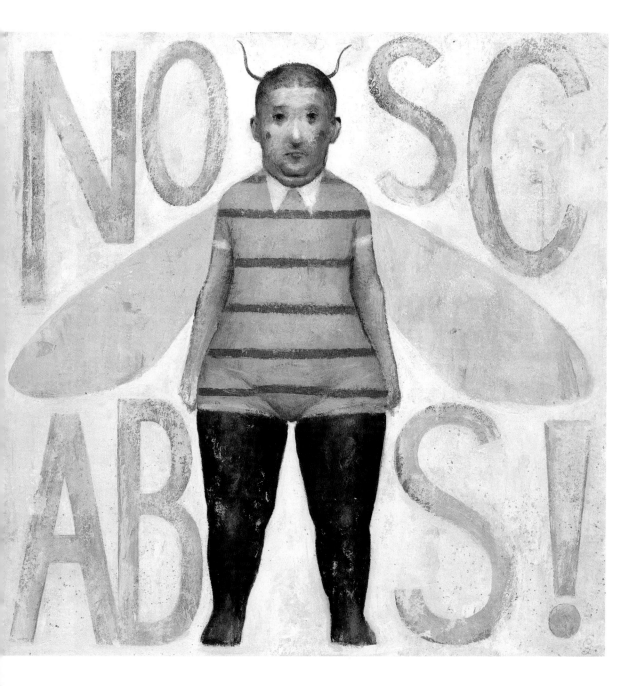

Maria Eugenia

I have many drawings and paintings of musicians and singers. The client saw some of these images and asked me to do some pictures for their greeting cards Jazz Line. I had complete freedom and I think it was an assignment any artist would like to have.

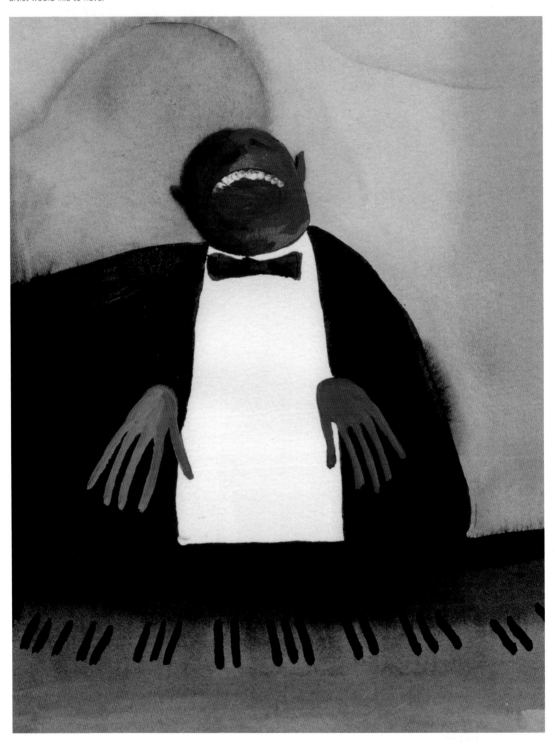

MARIA EUGENIA

The client, Teca paper products, saw an illustration I had done for a newspaper article and asked me if I could do something similar for a celebration greeting card.

MARIA EUGENIA

The client, Teca paper products, created a line for kids with my illustrations. In the beginning it was difficult because they thought some of the images were too strange and scary for babies, but I didn't want to do something very different from my style, so the art director suggested that the kids, like this one, should look funny and at the same time tender. The soft palette of the watercolors helped a lot.

Douglas Fraser

Jacques Lamarre of the Hartford Stage offered this assignment. The subject was a graphic image for the Shakespearean classic, *Othello*. I wanted to keep the image simple and subtle. The racial difference between the female and male character was to be softened by the direction of Jacque Lamarre. The approval of one of my sketches led me to execute the final in a digital vector approach. I wanted a more contemporary feel to the image. The male hand both cradles and threatens the reclining female hand. The radiating black lines speak to the external forces on the male protagonist.

CRAIG FRAZIER

I drew this image for a poster I designed for my own speaking event at Philadelphia University. I consider these assignments tough because I can do absolutely anything I want and I'm never quite sure what I want. I chose to work strictly in respect to the poster with a lot of scale and contrast, and a little detail. As a poster promoting a lecture, I felt its primary responsibility was to be graphic, evocative—and my style.

CRAIG FRAZIER

Faced with a traditional problem, he avoids the rules of the game and plays a new game.

THE HEADS OF STATE

In this poster for folk artist, Iron & Wine, we wanted to show the complexity of his music while still addressing the eerie, back porch melodies that are ubiquitous in his recordings.

The Heads of State

A part of a series of posters for Wilco, this was more an experiment in found objects than anything else. An enlarged, blown-out picture formed the texture of the figure, and a dying plant of some sort sitting in my apartment lent itself to be used for the lungs.

Vivienne Flesher

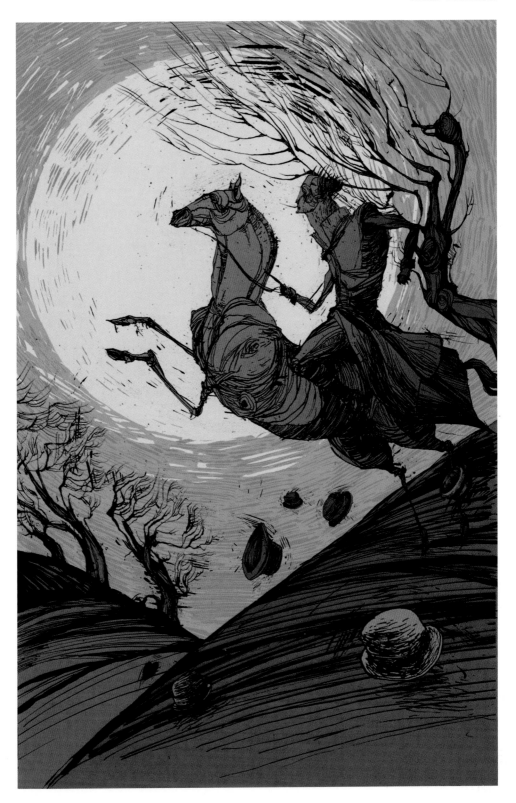

Lars Henkel

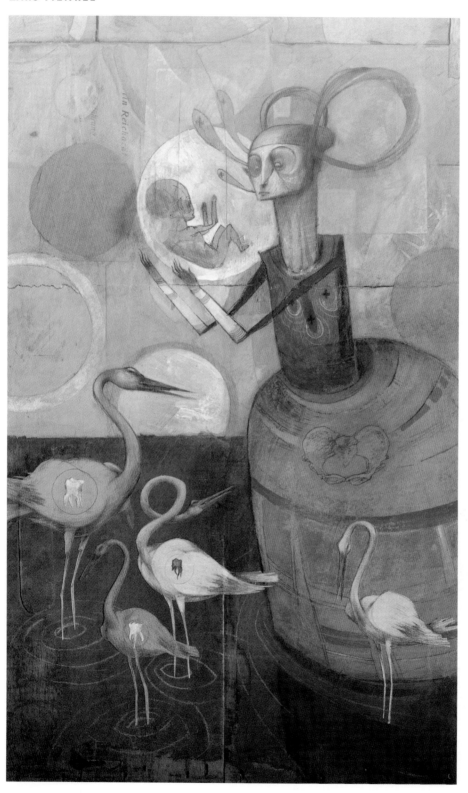

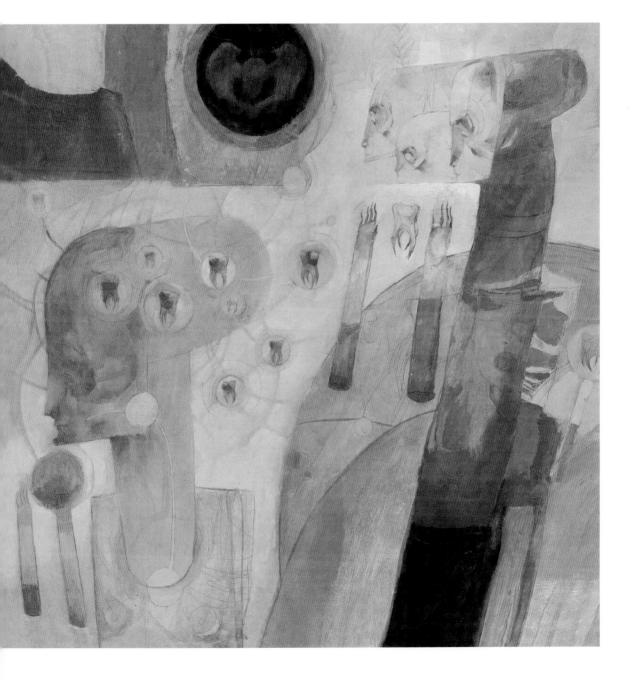

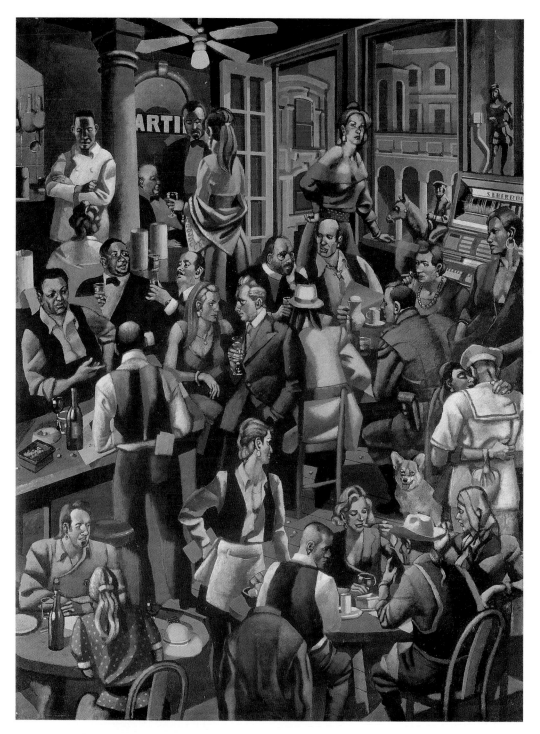

JOHN H. HOWARD

This painting was originally an ad I had done for a famous beverage pur-
veyor and it was filled with mid-generation, middleclass coffee drinkers
in a suitably pleasant and homogenous environment. It had been kicking
around my studio for about a year and I began to imagine it being taken
over by what seemed to be extras from a Fellini film set. As I started to re-
paint it the surroundings changed accordingly. Deciding later it was th[e]
bar of Mario Vargas Llosa's *Casa Verde*, it really fit the bill when a loc[al]
restaurateur asked for a mural that would provide a backdrop for the cultu[r]
ally diverse clientele he hoped to attract. The painting was photographe[d]
enlarged, and printed digitally to fit his wall.

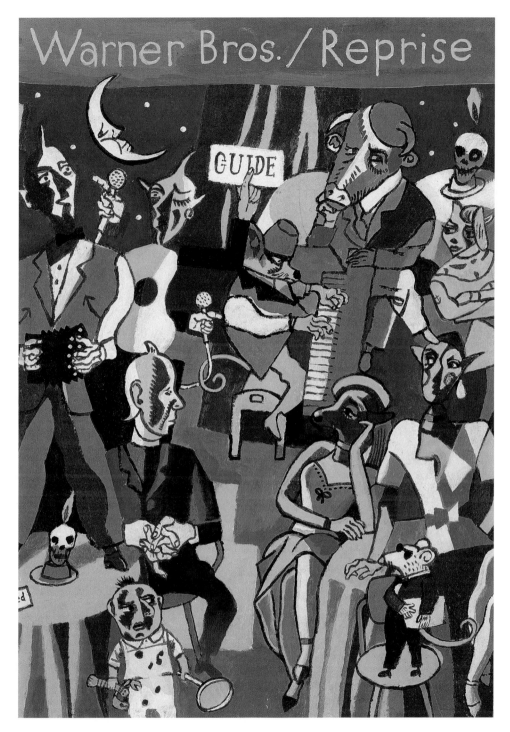

JOHN H. HOWARD

his commission was for the cover of a bi-monthly catalogue for Warner ros/Reprise Music. It was to be non-specific in terms of music or musians but had to show the company's name and logo. I checked out their ebsite and was impressed by the intensity and variety of the art. With the encouragement of art director Michael Diehl, I felt free to do something really personal. I spent about an hour breezing through my notebooks and guided more by intuition than thoughtfulness, I chose to paint this piece, with a little adjustment.

SATOSHI KAMBAYASHI

This is from a set of stamps I was asked to design for the Royal Mail in the United Kingdom. This issue was titled "Occasions," but would actually focus on light social communication, rather than specific occasions. They were after something generic, cheerful, and bright. Thinking up ideas is the best part of any project, and after deciding to use an envelope as a common motif for the set and a symbol of postal communication, I just had fun with it. For this one, I focused on the similarity of a diaper and an envelope. I tried to make the image as simple and fresh as possible. The Royal Mail always commissions several different people (illustrators, photographers, etc.), and design firms for variety of interpretations on the same project, so it was a bit like the Wimbledon tennis tournament. It was very exciting to be selected for the final design!

SATOSHI KAMBAYASHI

This is also from the set of stamps entitled "Occasions" commissioned by the Royal Mail in the United Kingdom. They were for consumers looking to send mail stamped with cheerful postage, which would put the sender and receiver in a positive frame of mind. They were looking for a solution with a generic, cheerful, and bright treatment. To this end I started to think up some ideas, and this one was in fact the starting point for all the others in the final set. The idea came to me when I associated the flap of the envelope with a smile. Initially, it was a grinning Cheshire Cat, which I developed further to make a design of a boy holding up an envelope that doubled as a smiling mouth. This and the "Baby" formed the initial pitch to the Stamp Advisory Committee.

SATOSHI KAMBAYASHI

This, again, is a part of the set of stamps commissioned by the Royal Mail in the United Kingdom entitled "Occasions," which would focus on light social communication. They needed it to be suitable for a broad range of events from birthday cards and anniversaries to fun social "pick-me-up" post. The "Baby" and "Smile" solutions gave something of a direction, so I decided to have more fun using the envelope as a common thread. One of the resulting ideas was this duck image. Royal Mail also liked the pun of "sending a bill" and "a duck bill, "although it was not intentional!

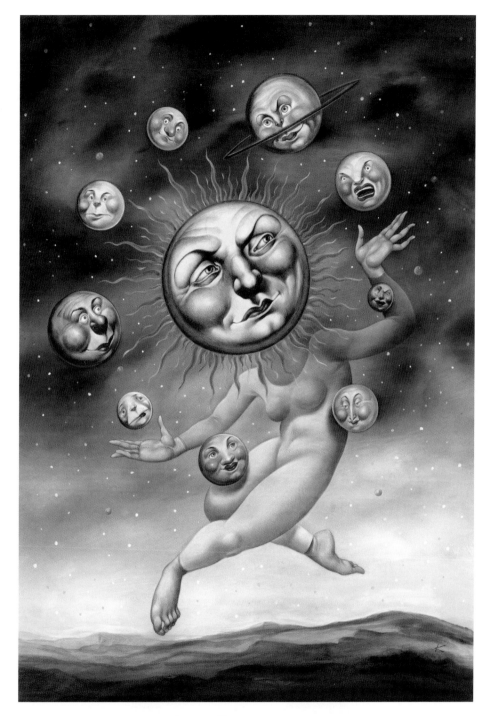

ANITA KUNZ

John English's Illustration Academy has used a juggler image a number of times to promote the school. I was asked to give my interpretation of a juggler, and I wanted to somehow incorporate the idea of the teacher/student relationship in the image. I used the solar system as a metaphor, with the planets representing the variety of students, and the sun as representing (I hope) the energy (and information) source.

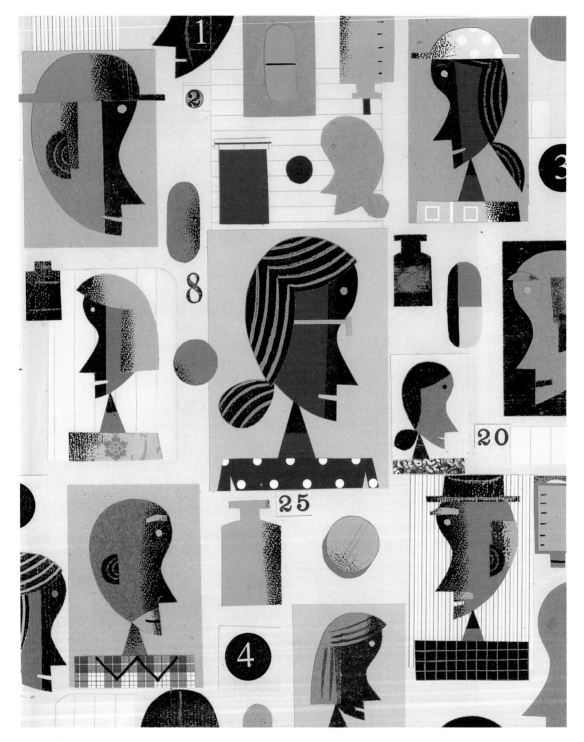

RICH LILLASH

This illustration was done for a story about getting seniors to participate in clinical trials. When the subject matter is difficult, I try to go for a more decorative solution. This simply shows a variety of seniors with pills and drugs in a "wallpaper" pattern.

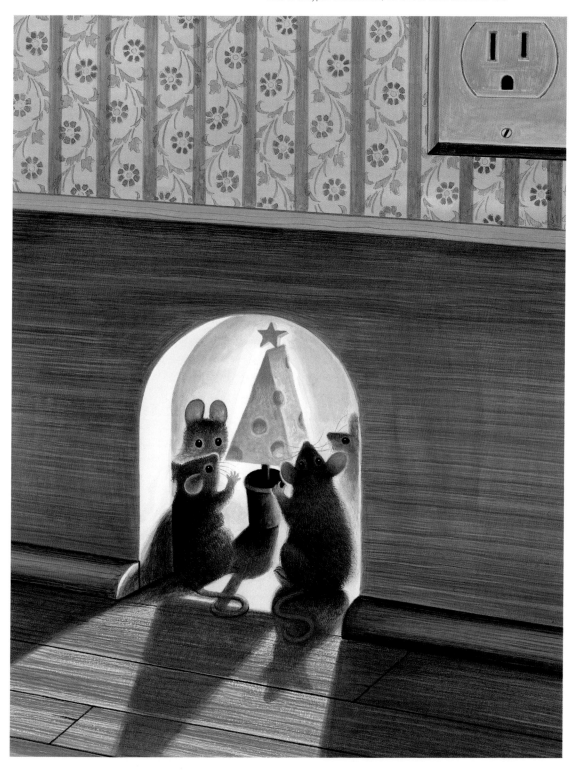

KEN ORVIDAS

The commission was to illustrate the 2003 wpp annual report from front to back. Wpp is the London-based parent company of ad agencies, design firms, PR firms, brand firms, etc. Even though I needed to address designated themes in the book, I decided to treat the book as one large piece of art. Rob Lamb, the creative director, agreed. After about a month and a half, I had done 100 or more images. Some were printed just as they were, small pencil doodles, while others were developed into full-page and spread images. "Share ownership" is a section of the book that is a global report on overall stock ownership. Shares of stock are like owning bits of the company. The idea of one, wholly functioning dog being comprised of several different species seemed to drive the point home.

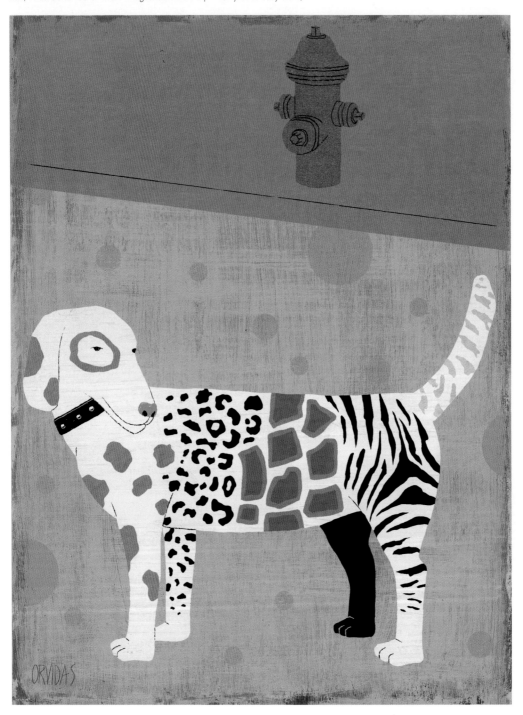

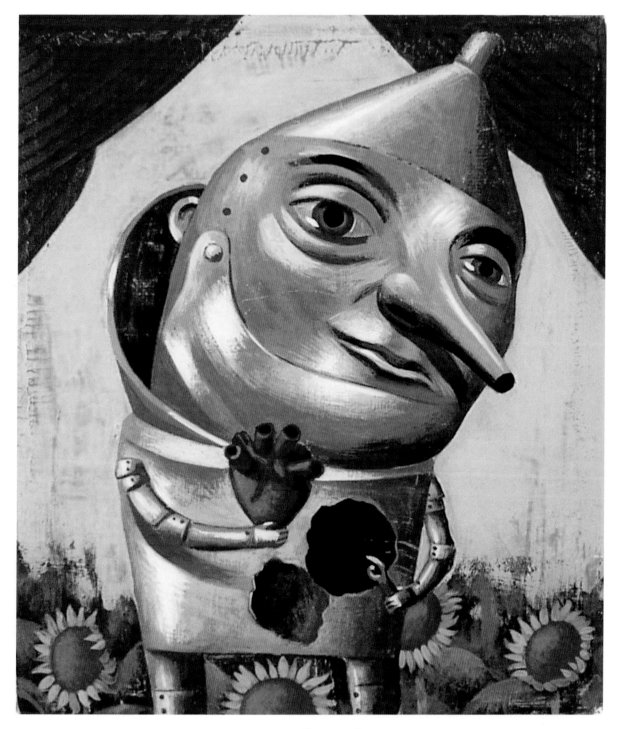

CURTIS PARKER

This was done as a promotional piece for my rep group to celebrate 21 years in business and "coming of age." I wanted to resist the typical drinking and party age thing, so I chose this classic metamorphosis of the Tin Man. He was definitely the favorite character from Oz for this. I don't think the scarecrow getting a brain would evoke that warm fuzzy feeling.

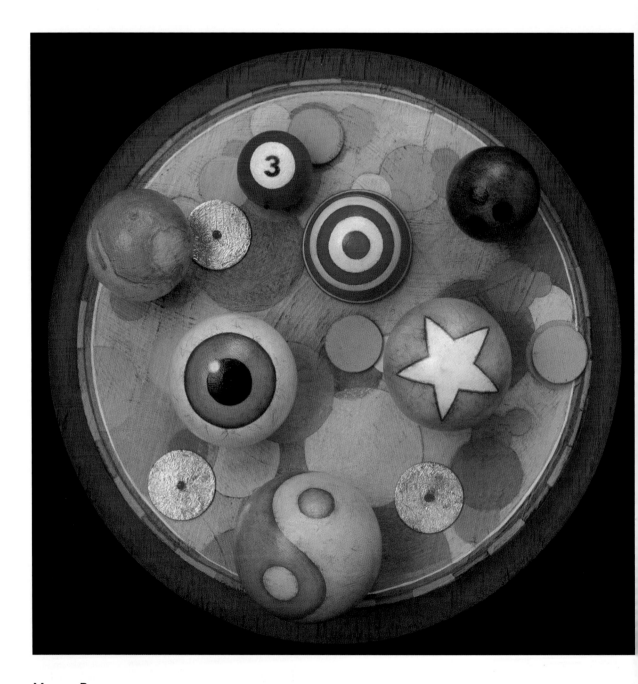

MARIA RENDON

This is the kind of project I love to get. A letter came in the mail describing the
project. "The theme is 'well-rounded'; the format is round; the final product
is a calendar/set of drink coasters placed into a tin container; and you can do
anything you want." I was one of 12 illustrators, designers, and photographers,
each one responsible for one month, who were invited to collaborate in this
promotion piece for Ventura Printing.

　Since my work is three dimensional, I often find myself using objects as
canvases; in this case spheres and circles were the natural choice. I decided to
paint icons that represented the theme "well-rounded" onto these surfaces.
Everything about this piece is round.

Kunio Sato

I was inspired while seated in front of the family altar after the death of my father.

The image of the light emanating from and radiating around the Buddha on the hanging scroll was impressive. Also the image of a beautiful lotus flower, which emerges from the depths of a murky pond, fired my imagination about the great cyclical power of nature. To express such a concept with a person would be rather overbearing, so I used a cat to bring some levity to the scene.

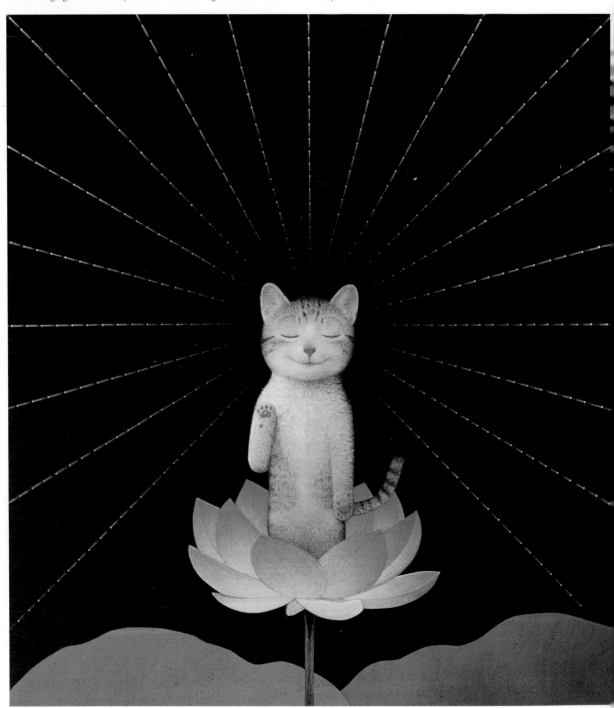

Team Tryouts

schill

GEORE SCHILL

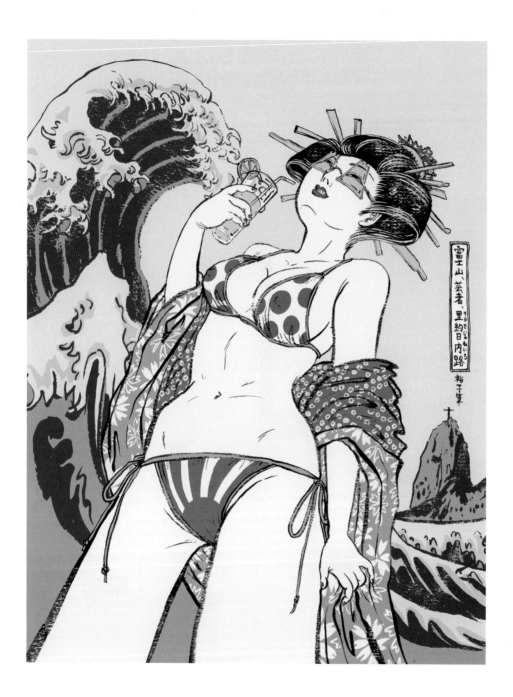

YUKO SHIMIZU

This image was published in a design conference catalog in Australia. I had total freedom as long as it fit on the page. Back then, for some reason, a lot of Brazilian design magazines and websites were featuring my work, which was encouraging. I decided to dedicate this image to those Brazilians as a "thank you" for supporting my work.

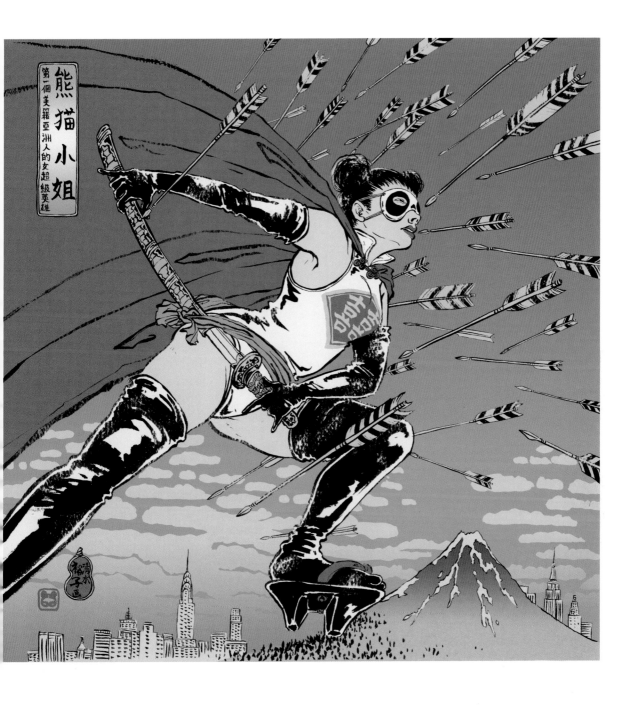

YUKO SHIMIZU

For the artists' calendar book, *Artistic Utopia*, we were allowed to create any image using the theme of artistic utopia. For "Panda Girl," I decided to create an Asian American Super Heroine incorporating all the common stereotypes, misunderstandings, and misconceptions average Americans have about Asian people.

MIRIAM TROOP

When I heard the National Portrait Gallery might be interested in a drawing of caricaturist Al Hirschfeld, I dropped his agent a note. A few days later my phone rang: Hirschfeld himself (then almost 98) was inviting me to visit him that very afternoon.

When I arrived, my subject was sitting at his drawing table in his famous barber's chair. He looked up from his work, smiled, and indicated where I might sit and proceeded to ignore me completely. He became so absorbed in his work that he barely moved for the better part of an hour. Hector, the family cat, settled in for a nap and with no time wasted on small talk, I soon had the sketches and notes to finish my project at home. When I got up to leave, Hector rose and stretched. And Hirshfeld jumped: he had forgotten I was there. We both laughed. The drawing he was completing with such concentration was featured in *The New York Times* the following week.

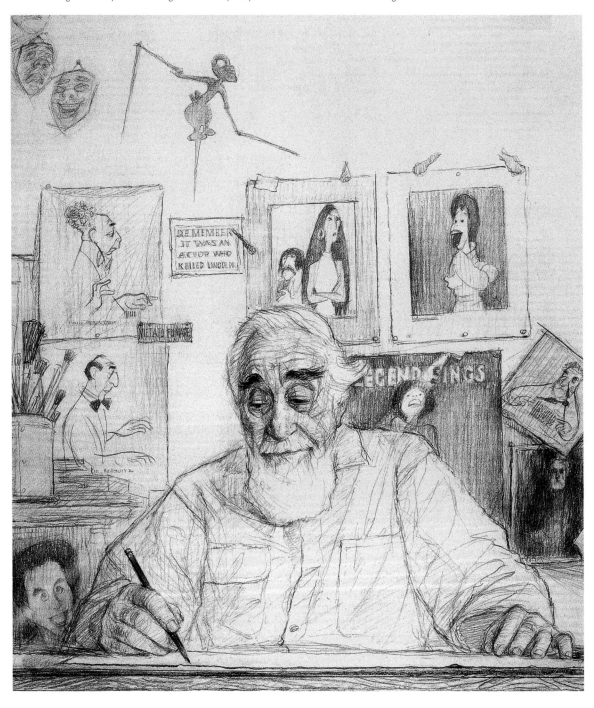

TOMASZ WALENTA

Water gives life to all. In the imagination of the Australians, the source of rain was personified by the rainmaker. My interpretation of this myth is a humanized cloud. I hope that I managed to give life to this piece the way the rain gave me life.

JACK UNRUH

Oil companies work in some fairly remote areas. To show the extent of their exploration, we create illustrations that depict that terrain. My "weed file" comes in handy when these assignments come around. I carry a camera when I'm fishing and hunting to take photo reference shots of rocks, weeds, bushes, and other things of interest. I then use these little bits to put together images like this. Example: the decaying fish and beach area.

POL TURGEON

Astrological signs have always fascinated me with their symbolism and eso-
teric meaning. Being able to execute illustrations for the twelve astrological
signs represented for me an infinite source of delight. Already the research
into the multiple representations for the signs was, for me, captivating. Like a
child who is offered a panoply of fabulous toys, I enjoyed penetrating the world
of occidental astrology in order to generate a personal version that would be
captivating. It was a marvelous game, pushing certain images to the limit of
what is acceptable in a world that sometimes is too sanitized. To my great sat-
isfaction the client was magnificently open, ready to endorse a type of imagery
that surpassed a superficial representation of those millennial signs.

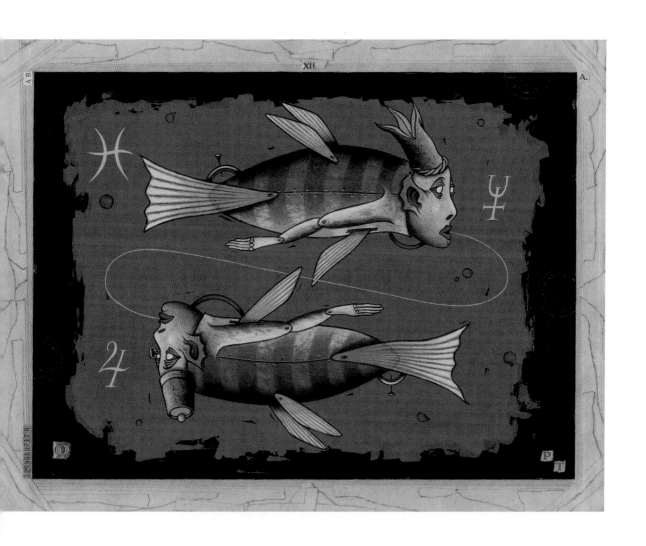

KYLE T. WEBSTER

The North Carolina School of the Arts School of Filmmaking is making waves in Los Angeles and New York. Their annual student film screenings have drawn larger and larger crowds with each passing year.

For the 10th anniversary of the screenings, a special poster was commissioned to draw attention to the event. The image I created was painted in four days and is based on an approved concept sketch no bigger than a postage stamp (usually the case with my work—I need to sketch bigger). This was the first time I used hand-painted type in a poster. Now I'm hooked, and the last three posters I've created all make heavy use of handwriting as a design element in the image. The background of the poster is made up of about eight color-corrected layers of the same photograph of the painted wood ceiling in our studio. The pattern in the light coming from the film projector (or "head") comes from an old handkerchief. I'm pleased to announce that the client liked the poster so much they repainted their offices in the colors from the poster and made it the centerpiece of their reception area.

JONATHAN WEINER

Dan Yaccarino

I was delighted to receive a call from Peaceable Kingdom Press to create an illustration for a baby card. I wanted the image to be for either a boy or a girl and very sweet, but still have my sense of humor shine through. It was a fun assignment.

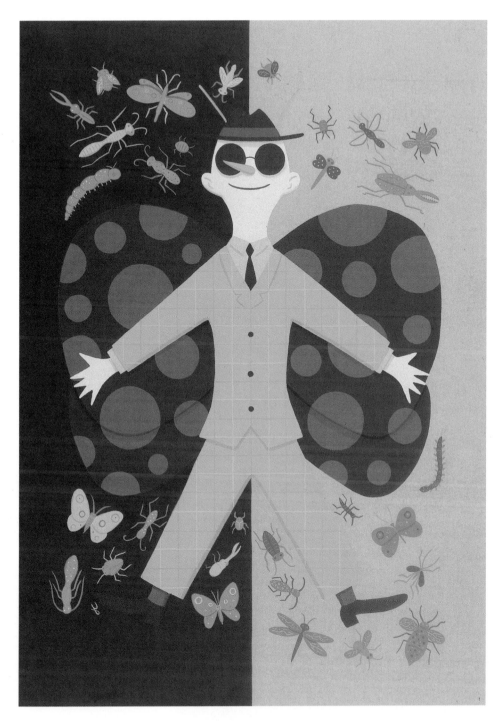

DAN YACCARINO

Spur Gallery approached me to exhibit some of my work. I was charged with the task of coming up with a poster for the show. It's funny how you spend most of your time illustrating for clients and grumbling about the usual restrictions, but once you have the opportunity to create something without any, you can't seem to think of a thing! I went back to my sketchbooks and found several images that would make a great poster. I decided that the Bug Man would be a lot of fun.

BOOK

Society of Illustrators 47
Book Jury

MARY GRANDPRÉ

ILLUSTRATOR
Educated at the Minneapolis College of Art and Design, Mary Grandpré began her career as a conceptual illustrator for local editorial clients. As her style developed, she attracted clients such as Ogilvy & Mather, BBD&O, Whittle Communications, The Richards Group, Neenah Paper, *The Atlantic Monthly*, Random House, Berkley, Penguin, Dell, and McGraw Hill. She has had a *TIME* magazine cover featuring her work for the Harry Potter series and also worked on visual development for the Dreamworks animated film *Antz*. She has received recognition from the Society of Illustrators, *Communication Arts*, *Graphis*, *Print*, and *Art Direction*. She has been featured in *Step-by-Step Graphics* and *Communications Arts*. She has illustrated seven children's books.

MICHAEL ACCORDINO

ART DIRECTOR, SIMON & SCHUSTER
Michael Accordino has worked in the publishing world since 1984. He started at New American Library in the promotion art department designing brochures and sales pieces for mass-market paperback books. A few years later he moved to the cover department designing paperback covers. Shortly thereafter, he was hired by St. Martin's Press, where he eventually became art director of the trade art department working on a large list of hardcover and trade paperback titles.

He left seven years later to work as an art director at Penguin USA but was soon hired by Simon & Schuster where, for the last ten years, he has been working as an art director.

His book jackets and covers have been seen in various publications and shows including *Print*, The Type Director's Club Annual, and the New York Book Show.

JULIETTE BORDA

ILLUSTRATOR
Juliette has created gouache paintings for Coca-Cola, Lands' End, *Real Simple*, *O* magazine, Purity Organic Juices, *Glamour*, Penguin-Putnam, and *BusinessWeek*, among many others. Her work is represented in the United Kingdom by Eastwing.

Juliette's work is featured in the following recently released books: *Handwritten: Expressive Lettering in the Digital Age* by Steven Heller and Mirko Ilic, Thames & Hudson; *The Big Book of Illustration Ideas*, Harper Design International; *Illustration Now*, Taschen; *A Book of Noisy Outlaws, Evil Blobs, and Some Other Thing That Aren't As Scary, Maybe, Depending On How You Feel About Lost Lands, Stray Cellphones, Creatures From The Sky, Parents Who Disappear In Peru, A Man Named Lars Farf, and One Story We Couldn't Quite Finish, So Maybe You Could Help Us Out...* with stories by Nick Hornby, Neil Gaiman, Jonathan Safran Foer, and many more. Introduction by Lemony Snicket," McSweeney's, release date September 2005. (purchase at store.mcsweeneys.net)

CALEF BROWN

ILLUSTRATOR, PAINTER, WRITER
Since graduating from Art Center College of Design Calef Brown has worked as an illustrator for *TIME*, *Rolling Stone*, *Newsweek*, *The New York Times*, and numerous other newspapers and magazines. He has created art for advertising, CD and book covers, murals and packaging, and has written and illustrated four books for children. His paintings have been exhibited in galleries in New York, Los Angeles, and San Francisco, and his work was included in "America Illustrated," the inaugural exhibit at the new National Gallery of Modern and Contemporary Art in Rome. Calef lives and works in Pasadena, California.

JEFFREY DECOSTER

ILLUSTRATOR
At a young age, Jeffrey was attracted by the immediate, expressive potential of the drawn or painted mark. His earliest artistic memory involves "embellishing" the pattern of his mother's new wallpaper with a big red crayon. In his current illustration and painting, he claims the same attraction, despite the grownup trappings of the business. "It is still about the charm of watching something bold and colorful and unexpected appear before your eyes, made in part by chance, and in part by hand. The only difference is now I don't get sent to my room."

Since graduating from Art Center College of Design in 1989, Jeffrey's work has been published in many national magazines including *Rolling Stone*, *The New Yorker*, *Forbes*, *Harper's*, and *The Atlantic Monthly*. He has also produced images for theater posters, CD packaging, annual reports, and print advertising. A two-time winner of the Gold Medal from the New York Society of Illustrators, his work has been featured regularly in both the *American Illustration Annual* and the *Communication Arts Illustration Annual*. He currently lives in San Francisco.

LOREN LONG

ILLUSTRATOR

Loren Long was awarded two Gold Medals from the Society of Illustrators and has been frequently selected for their annual. His work has appeared in other juried exhibitions including *American Illustration*, *Communication Arts*, *Step-by-Step Graphics*, and *Print*. His clients include *TIME*, *Reader's Digest*, *Forbes*, *The Atlantic Monthly*, Lands' End, *Sports Illustrated*, and HBO. He has illustrated book covers for Penguin, Simon & Schuster, HarperCollins, Houghton Mifflin, Candlewick Press, Henry Holt, and the National Geographic Society.

Recently, Loren has concentrated on illustrating books for young readers including *I Dream of Trains* by Angela Johnson, which received the 2003 Golden Kite Award for picture book illustration presented by the Society of Children's Book Writers and Illustrators. Madonna chose Loren to illustrate her book, *Mr. Peabody's Apples*, a *New York Times* #1 bestseller. Loren's book, *When I Heard the Learn'd Astronomer* by Walt Whitman, won the 2004 Parents' Choice Gold Award and the Golden Kite Honor.

GREGORY MANCHESS

ILLUSTRATOR

Creating a moment that communicates emotionally with the viewer is the essence of Gregory Manchess's artwork. After two years as a studio illustrator with Hellman Design Associates, Gregory began freelancing in 1979. His paintings have since appeared on the covers of *TIME*, *The Atlantic Monthly*, and special commissions for the movie *Finding Forrester*, The History Channel, and an extensive project for the Abraham Lincoln Library and Museum.

Gregory was included in Walt Reed's *The Illustrator in America: 1860-2000*. His paintings have been featured in *Artist's Magazine*, *Communication Arts*, and *Step-by-Step Graphics*.

Gregory has worked for the National Geographic Society on many occasions, including a river trip for an article about David Thompson, "The Man Who Measured Canada." His illustrated children's books include *To Capture the Wind*, *Nanuk: Lord of the Ice*, and *Giving Thanks*.

In 1999, he received the prestigious Hamilton King Award, and in 2000, the Stevan Dohanos Award, both from the Society of Illustrators. He lectures at universities and colleges nationwide.

KATHY OSBORN

ILLUSTRATOR

Kathy Osborn is from Rochester, New York. She was voted most daring and most artistic (a dubious honor, sounds phony) in high school, but is really a big chicken. She went to Rhode Island School of Design as a painting major because everything else required note taking. It turned out that painting required note taking, too, and she was frightened!

Her work has appeared in *The Washington Post*, *The Harvard Business Review*, *Travel and Leisure*, *The Boston Globe*, *The New York Times*, *GQ*, *The New Yorker*, *American Prospect*, *Rolling Stone*, *The Chicago Tribune*, and, yes, *Supermarket News* and *Barbie* magazine. She has done five kids' books and is currently working on her sixth.

Her work has been chosen by the Society of Illustrators, *Communication Arts*, *American Illustration*, and *Print*.

DAVID SAYLOR

VICE PRESIDENT, CREATIVE DIRECTOR TRADE BOOK GROUP, SCHOLASTIC INC.

David Saylor is vice president, creative director for the Trade Book Group at Scholastic Inc. He left California on his 21st birthday and has lived in New York City ever since. David's first job was for Lettering Directions, a photo-lettering type house. After working in the production and manufacturing departments at Marcel Dekker, Random House, and Farrar Strauss & Giroux, he studied design at Parsons and switched careers in 1987. David has worked as an art director for HarperCollins Publishers, Ticknor and Fields Books for Young Readers, and Houghton Mifflin Children's Books.

At Scholastic Inc., he is responsible for the art and design of trade hardcover and paperback books. He has won awards from the Society of Illustrators, the Bookbinder's Guild of New York, the American Library Association, and the American Institute of Graphic Arts. He was nominated in 1998 for an LMP Award and again in 1999, when he received the LMP Award honoring excellence in graphic design for his work in children's books.

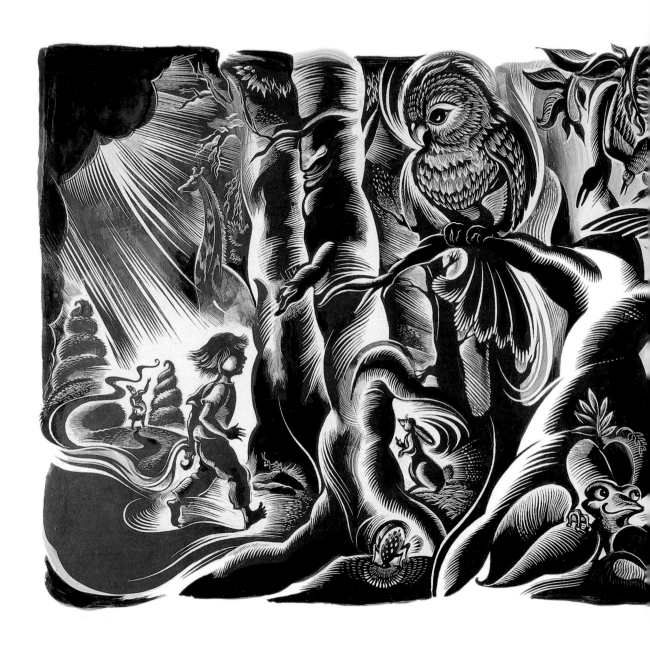

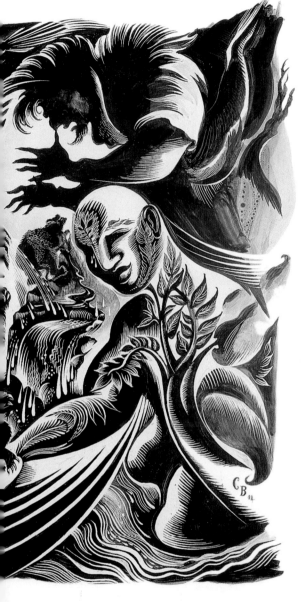

This illustration appeared in a book entitled *Dialogue: The Fine Art of Conversation*, a theme-based art book curated and published by Mark Murphy and Murphy Design. The assignment was to translate a handwritten narrative into an imaginative visual narrative. I chose a letter from my mother, written at a time when my oldest daughter was three years old. I was inspired by two things in the letter. First, the stationary itself had a charming image of a bear at the top and I incorporated the little bear into the painting, as well as its color palette. Secondly, the main focus of the letter was about raising children; my mom emphasized how important it was to discipline children without breaking their spirit. This served as a basis for the storytelling of the art. She also made many comparisons to how bears mother their children. In the painting, the little bear's ability, once he has left the forest of life, is able to stand up to the meanies. The assignment served as a pivotal piece in my development as an artist. Perhaps it was the personal nature of the subject or where I began working on the piece. The sketch was executed in front of hundreds of children because, at the time of the assignment, I was an artist in residence for a grade school. The title was inspired by the figure lifting up the bear at the lower right. The Beatles' tune, "Mother Nature's Son," was playing all the while.

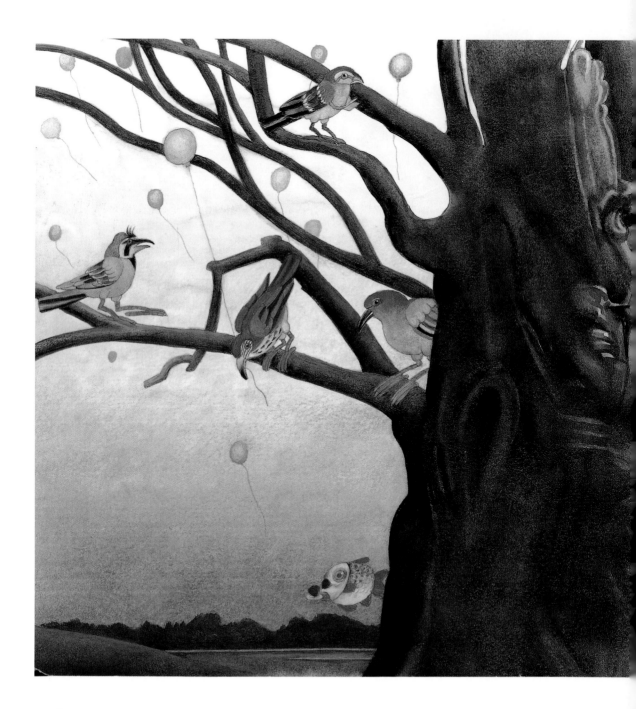

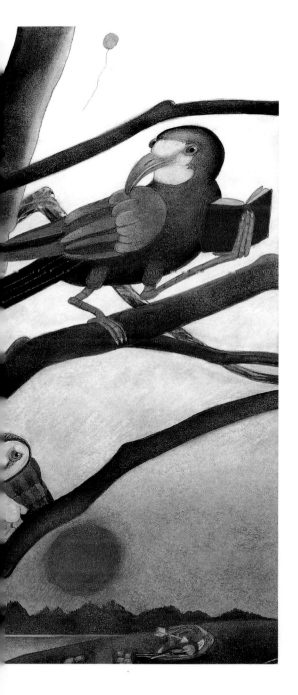

"Who Killed Cock Robin" is an English nursery rhyme that has been delighting young readers since it was published in the mid-1700s. As a modern version of a Dance of Death, it emphasizes the poem's themes of friendship and loss, with a twist: children put on masks and costumes, and they become birds or fish in a magical play.

To introduce a new generation to a timeless tale—and to remind older readers of the playfulness of youth—I walk a fine line between reality and make-believe.

Books live a long life! May children wake up to beauty and great storytelling, and change this frenzied world!

As usual I used watercolor and pencils on a hard surface, Swiss paper.

Alice in Wonderland is a story that always intrigued me. Ten years ago, when I received the commission to work on the book, I wanted to find the visual equivalent of this fantasy with its play on words where time and space, dream and reality have become completely relative. What helped me were the perspective experiments of M.C. Escher, which I developed in my own way. This gave me the opportunity to tell the story in one continuous space with visual games and illusions. For me, this works well with the style and wit of Lewis Carroll. While working on this painting I completed a few other books. Having the luxury of time allowed me to step away, look at it again with fresh eyes, and never lose interest.

The idea was to take details of the painting and put them in order with the story. This is rather unusual and a risk for the publisher. However, the benefit is that every publication that follows can look completely different. I am grateful that Dimiter Savov and Simply Read Books took that risk.

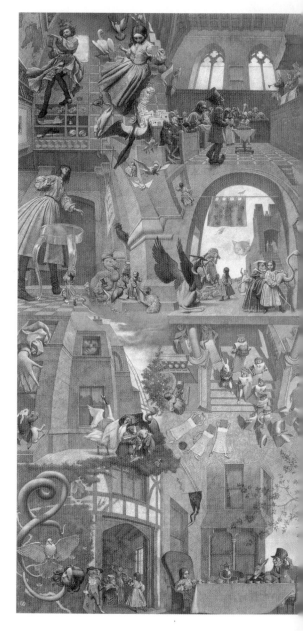

SILVER MEDAL WINNER
BRAD HOLLAND

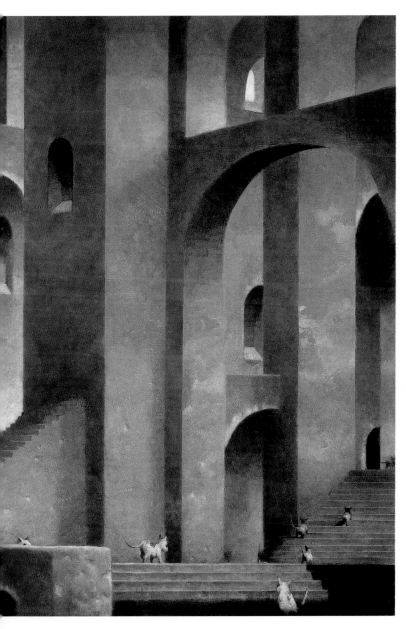

It's a well-known fact that if you give a client five sketches, he'll pick the worst one. Irene Gallo must not know this policy because I always send her a bunch of sketches and she always picks the one I'd most like to do.

In this case, she okayed an idea that had come to me one day years ago, when I was trudging around the New York State Supreme Court building, trying to clear up some Kafkaesque paperwork. I had been going in circles for several hours, visiting one room after another with no sense that I was getting anywhere, when suddenly I imagined the whole building with its marble floors and columns abandoned, like a Mayan temple, and swarming with dogs.

I never thought that anyone would ever commission a picture like this, but when a book called *The Dog Museum* came along, I thought maybe I had a match. At first I wanted to make the dogs lean and wolf-like, but this book featured Bull Terriers, so I deferred the decision and reckoned I'd put the dogs in last.

Before I could finish the picture, my mother died in Arkansas and I had to get an extension on the deadline to settle affairs there. When I came back, cutting through Washington Square Park, I spotted a man walking a Bull Terrier. This settled the issue of breeds for me. I followed the pair, sketching the dog in my head, then went home and started adding dogs to the painting.

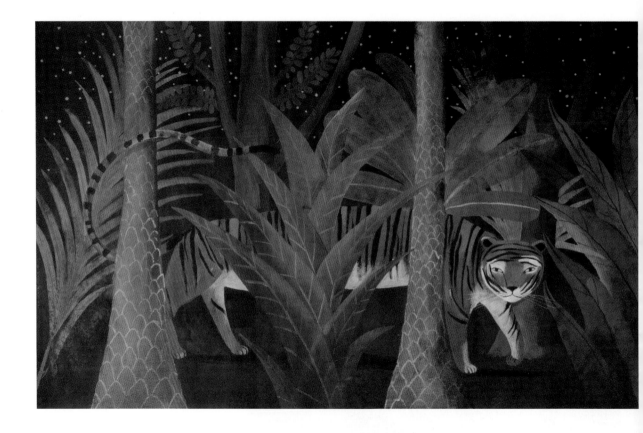

I enjoyed working on *Animal Poetry* very much. I always like drawing animals, so for that reason it wasn't particularly difficult. In fact, it took more time making sure I understood the text of the poems properly, which were in English and had to be translated for me into Italian. The art director gave me complete freedom to do the job as I liked, and I'm satisfied with the outcome, though maybe the graphic part could have been worked out better. Usually, I provide the illustration and the art director decides how it will be used on the page. In this case, Karen Nelson wanted more of my graphic participation—I'm not as confident about that as I am about the art. The work was done with acrylics on paper. Much credit goes to my husband, Daniele Melani, for translating for me.

BRIAN AJHAR

This painting was the opening scene for my book *Home on the Range* (September 2004, Dial Books) based on the popular campfire song. I chose the palette to separate two different worlds: reality and fantasy, a theme carried throughout the book. Subtle hints of what is to come lead you through the following pages. Here a hint of the West is indicated by the Remington sculpture on the right side.

My intention was to set the overall tone and mood and introduce the main character in a subtle way. I was hoping to draw the viewer into the book's underlying theme of dreaming and of always pursuing your dreams.

BIRGIT AMADORI

Genji Monogatari is an ancient Japanese novel from over 100 years ago. Making the illustrations has been something of a turning point in my drawing style because I became more interested in working with patterns. I have remained interested ever since and the use of patterns has become more complex each time I work with them. As far as *Genji* goes, I loved working with the contrast between the patterns and the simple one-color/gradient shapes. The novel itself is written in an unfamiliar and unusual style for today's readers. The protagonists remain relatively anonymous; that's why I reduced their physicality and tried to let their character shine through clothes, pattern, and color.

PATRICK ARRASMITH

The only rule I was given with this book cover was not to reveal that the title character is a vampire. Instead, I conveyed his sinister nature by giving him a big toothy grin. My neighbor was the perfect model for this character. He drives a horse carriage in Central Park wearing a top hat and trench coat. His look—especially when he flashes his sly smile—reminds me of London around the time of Jack the Ripper.

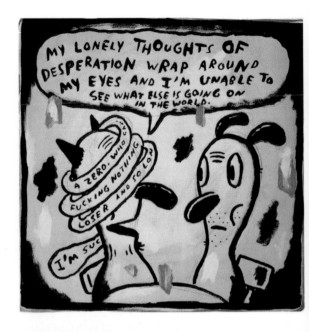

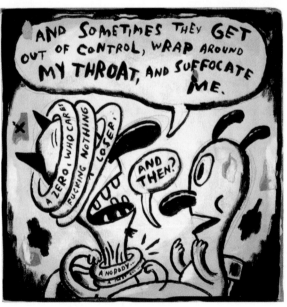

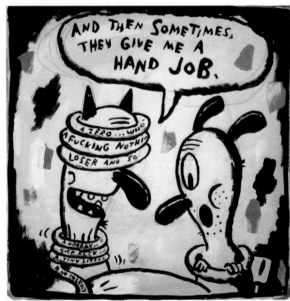

GARY BASEMAN

DOUG CHAYKA

When I first read the manuscript for *The Pink House at the Seashore*, this image came immediately to mind and I knew it was one I had to do. Here I wanted to simply show the two kids illuminated by the warm lantern light and create a sense of playfulness with the strong light and shadow shapes. I cropped in and brought the lantern to the foreground to make the space snug. The kids are sharing a moment in their new make-believe house, a tent on the site of their destroyed vacation home.

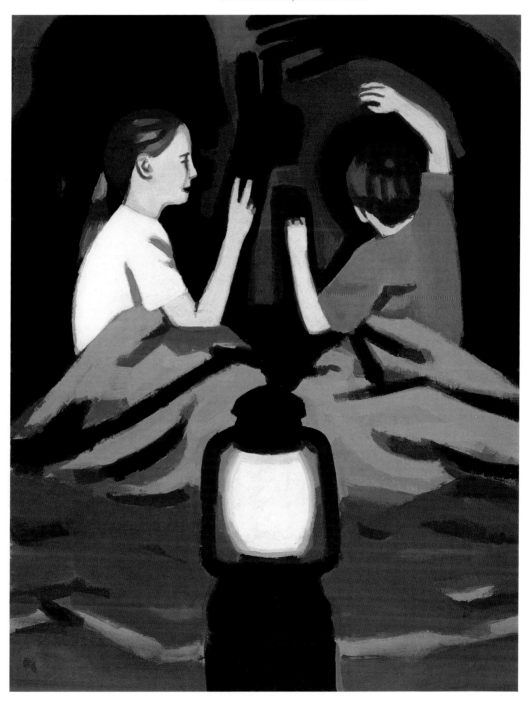

DOUG CHAYKA

This is the point in *The Pink House at the Seashore* where the reader finds out the fate of the family's beloved vacation house after a storm had come through. I hoped to provide a little shock with this double-page spread, reducing the house to a few boards, splinters, and one blue shutter. The empty landscape increases the sense of loss. The lighthouse, which is still standing, was not in the text but I felt it needed to be there as a symbol of strength and hope. Painted during the summer of 2004, images of the destructive tornadoes in the Southeast at that time were not far from my mind.

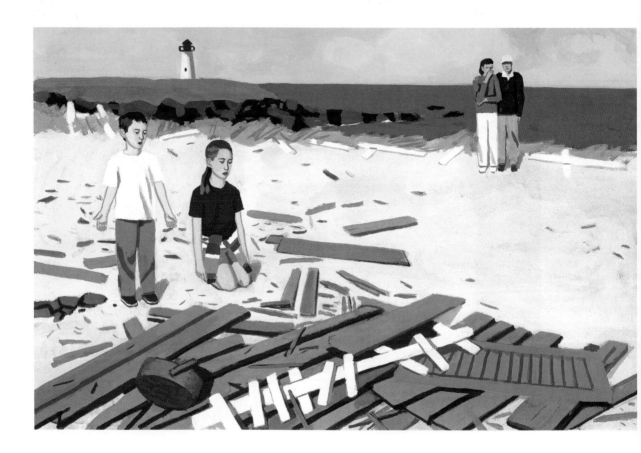

DOUG CHAYKA

This interior piece for *The Pink House at the Seashore* was fun to compose. After putting the big car shape in the foreground, I needed to break up the rest with small shapes and more active textures and patterns. I divided the picture more or less into thirds, with the horizontal lines of the porch, tent, and car to carry the eye through. The car was an old beauty that was parked outside my apartment while I was researching this book. I immediately photographed it every way possible. I have not seen it since! The book wouldn't have been the same without it.

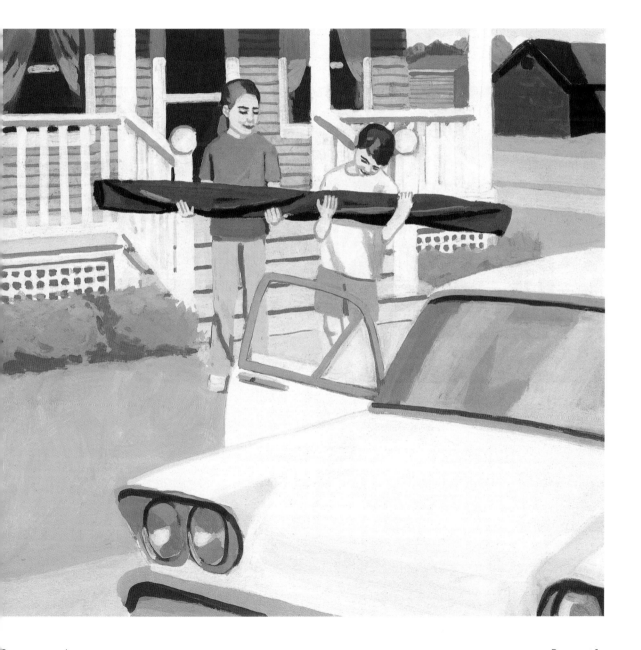

CATHIE BLECK

This piece is in a book titled *Open Spaces*. My interpretation of a space: a peninsula, which was a fond childhood playing space on the tree nursery in which I grew up. Each of the characters in the painting serves as a symbol for people who played a role in my life. I am the cat and have finally caught a golden fish. With admiration, my parents (the happy love birds) watch me with undivided attention as they turn away from their nest of hungry birds (their were nine children in my family). My grandmother, the loving squirrel, holds her precious third child, my mother (the small pinecone). My grandfather, whose aura was so present when alive and is now believed to be a spirit among us, passes through as a ghost deer from the trees he farmed so well. This piece was originally a concept for another book, *Why*, a self-promotional book for the Picturemechanics.com co-op. This book theme explored why we became artists.

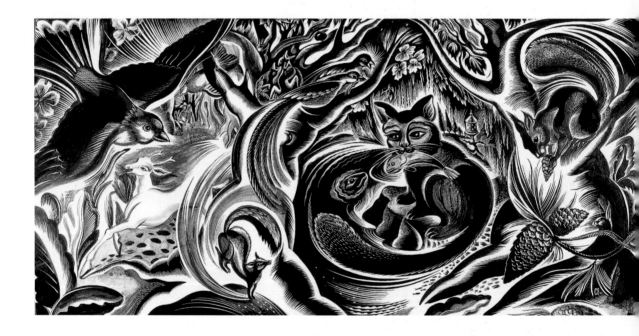

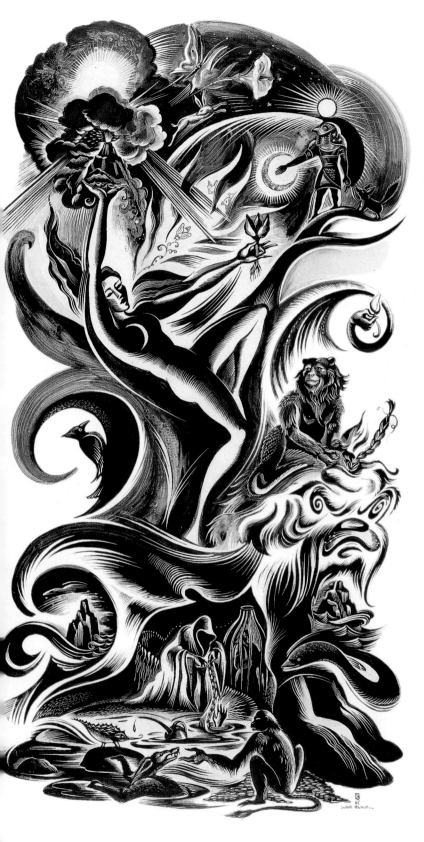

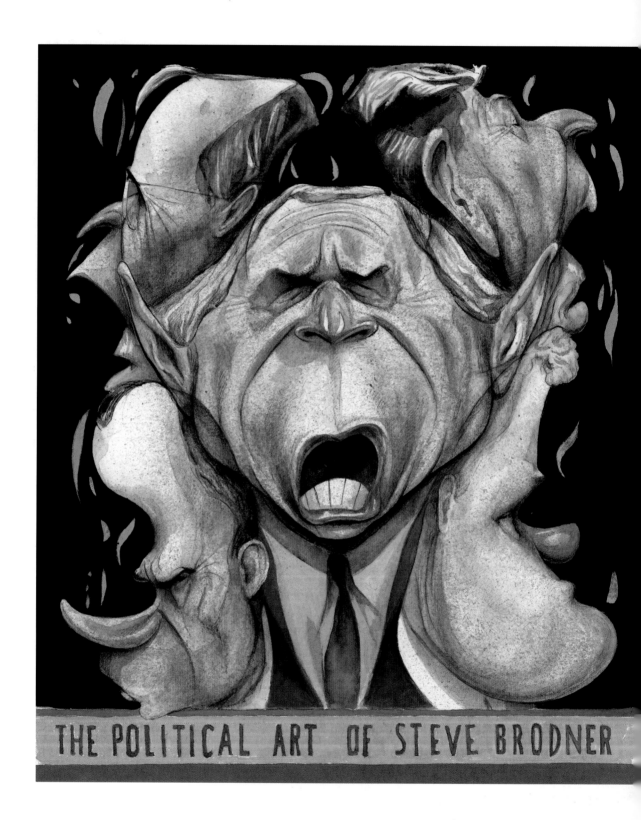

THE POLITICAL ART OF STEVE BRODNER

STEVE BRODNER

366 BOOK

MOLLY IVINS

WHO LET THE DOGS IN?

Incredible
Political
Animals
I Have
Known

WITH
MORE
BUSH-
WHACKING!

STEVE BRODNER

JOE CIARDIELLO

Rise of the Vulcans is a book about the history of Bush's war cabinet. This is a very straightforward approach to the jacket. The trickiest part was composing the piece to fit all six personalities in an oval office setting and allow room for type. Generally, I prefer more spontaneity in my drawing. However, an assignment like this requires more planning.

JOE CIARDIELLO

The French have had a fascination with flight dating back to the 16th century. This is my take on part of that journey created with a journal-like feeling. It was done for the Mark Murphy book project called *Dialogue*.

Raúl Colón

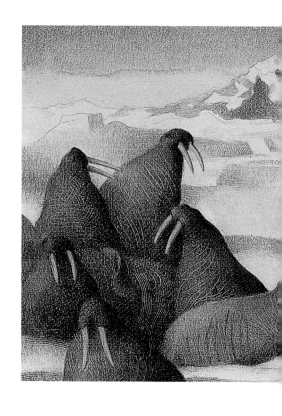

Greg Harlin

An opening spread in *Dangerous Crossing: The Revolutionary Voyage of John Quincy Adams*. I had audaciously high hopes for this one. I wanted to be Winslow Homer. I wanted to capture the power of the winter Atlantic. I wanted smell, sounds ... Then Icarus came crashing down. In retrospect, I guess it was an appropriate frame of mind for illustrating a book on an impossible chapter of the impossible American Revolution. And relearning humility is never a bad thing.

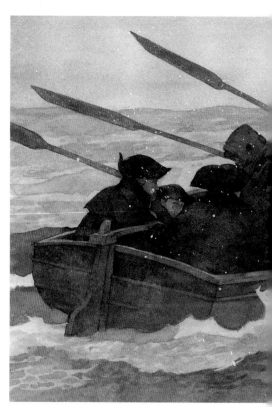

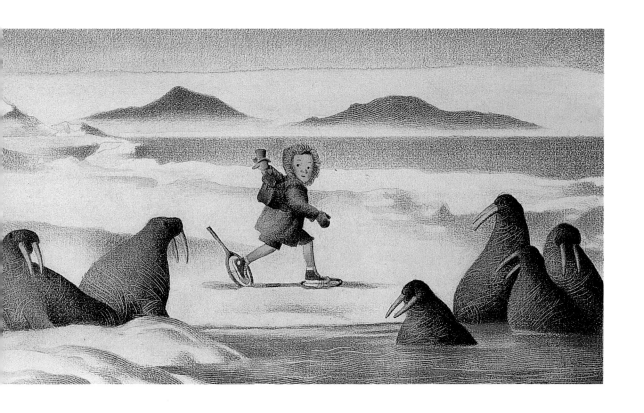

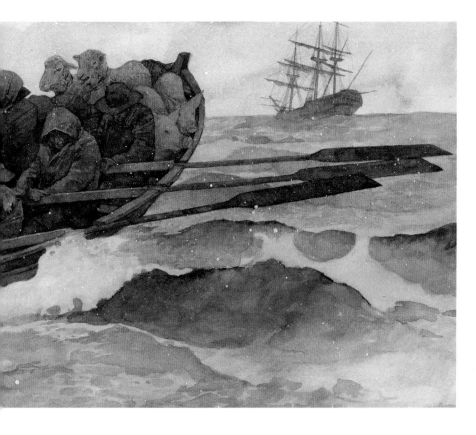

DAN CRAIG

I began the piece with the simplest direction from Tom Egner: a portrait of a cat in a fantasy environment. Having an enduring affection for Flemish painting, I wanted to lend a 15th/16th century look to the rocks, sky, and mountains, then embellish them with whatever details might enhance a sense of the fantastic. The cat engages the viewer with its direct gaze, creating a sense of a formal portrait. Flemish Masters such as Jan van Eyck, Hans Memling, and Rogier van der Weyden, among others, have left a lasting impression on my work and for this I continue to appreciate them all.

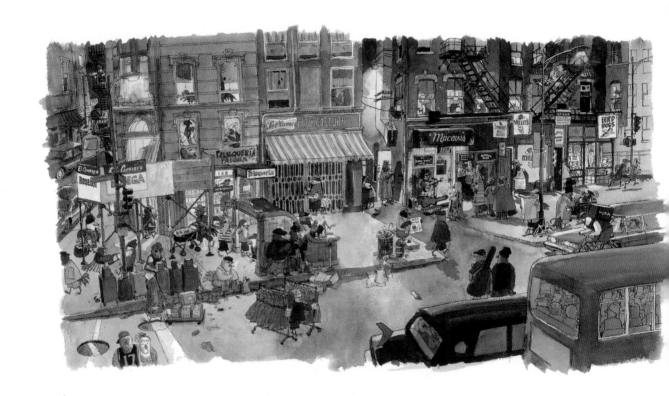

LARRY DAY

I had illustrated a piece for a demo CD cover of a bunch of birds hanging out in a Hispanic neighborhood late in the evening. It was for a music studio here in Chicago.

Monte Beauchamp saw it and asked me to do something similar for *BLAB!* I followed up with a single page. As things evolved, he saw the potential of the neighborhood growing from a single page into a spread. It became a spread. All the better for it.

I've sketched from the sidewalks of Chicago for years. I like to incorporate what I know into my illustrations. One gets to know where the well-dressed pigeons hang out.

DANIEL DOS SANTOS

Art director Irene Gallo asked if I would create the cover for a new book titled *Bonnie Loves Clyde*. Little did she know I already had a mild obsession with the couple (a picture of the two graces my living room wall).

The book is a love story written from the perspective of Bonnie Parker. The "Love" in *Bonnie Loves Clyde* is actually a heart icon in the title. I decided to play off that imagery and added the heart-shaped movie poster behind them. I felt the loving couple depicted behind them was an interesting contrast to the distant gazes of the two.

This painting is a personal favorite of mine and now hangs happily next to the other Bonnie and Clyde picture on my wall.

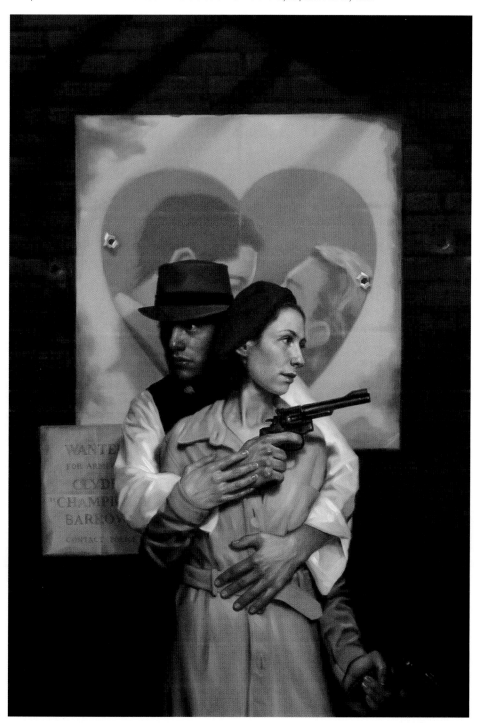

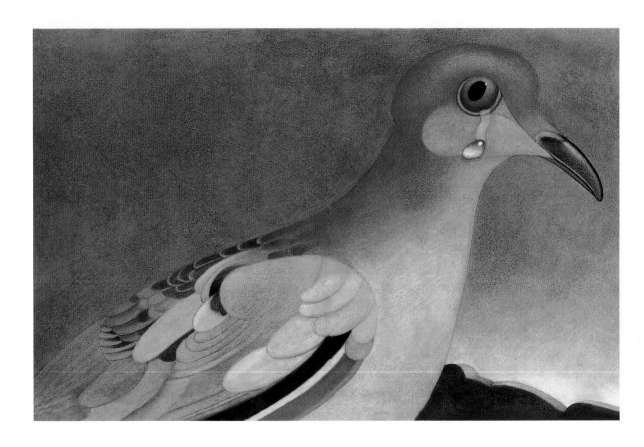

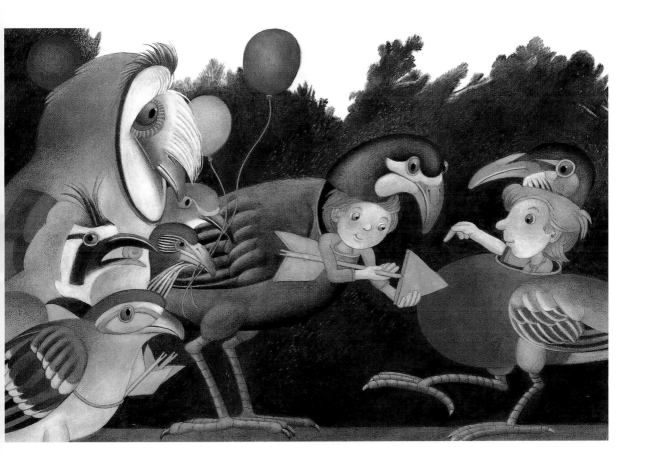

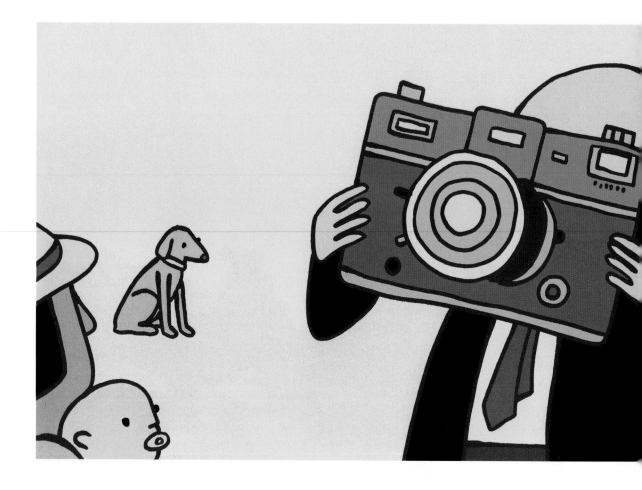

MARIA EUGENIA

The Brazilian publishing house Cosac & Naify asked me to illustrate the picture book *Coisas que eu queria ser* (Things I Would Like to Be) by Arthur Nestrovski. Usually I work with watercolors, but the art director, Raul Loureiro, wanted me to try something different and suggested using the computer. It was fun doing this book and I always like to work with new media; I think it's a good way to stay fresh.

CRAIG FRAZIER

Stanley Goes for a Drive is a children's book about Stanley and his magical ride in a '53 Chevy truck.

SARAJO FRIEDEN

For this cover of an activity journal for kids, the art director requested that I use my digital style to show kids engaged in lots of different activities and communicate the idea that this will be a very fun book to have. Since I also like to play with lettering, I am often asked to include lettering in my illustrations, as I did with the title of the book.

SARAJO FRIEDEN

This painting was included in the wonderful sourcebook *Dialogue: The Fine Art of Conversation*. It refers to a note written by my father the year before he died. I had called him from Montana, describing a run-in that friends and I had with a huge black bear while camping in Glacier National Park. Of course, the bear terrorized us for the better part of a night, but in re-visiting the memory, I imagined the bear as Smokey, stopping by for a steaming cup of freshly brewed coffee and conversation.

CHRIS GALL

Illustration created for my book *America the Beautiful*, illustrating the words
to our nation's most beloved hymn. This illustration accompanied the phrase
"O beautiful for pilgrim feet, whose stern, impassioned stress..."

CHRIS GALL

Illustration created for my book *America the Beautiful*, illustrating the words to our nation's most beloved hymn. This illustration was to capture the phrase "... thine alabaster cities gleam, undimmed by human tears ..."

CHRIS GALL

Illustration created for my book *America the Beautiful*, illustrating the words
to our nation's most beloved hymn. This illustration accompanied the phrase
"... A thoroughfare for freedom beat, across the wilderness."

VALERI GORBACHEV

he spread that was chosen for the Annual was taken from the Can Read book Whose Hat is It (HarperCollins), which I wrote and illustrated. I love he process of creating a book from beginning to end. I feel it gives me a reat opportunity to have input not only on the plot and dialogue, but the esign, layout, and even the senses involved—much like a movie or theater roduction. I like to draw animals with bold personalities and put them in a ozy, comforting world. I try to bring my characters to life through the use of proportions, composition, and dynamic poses. I also love humor and try to bring it into each of my illustrations. It helps me fill the stories with a sense of mischief and delight.

My technique is very simple and traditional. I use pen, watercolor, and ink. It allows me to maximize my drawing skills and express the feeling I try to reflect in these pictures.

RICHARD GOLDBERG

The two drawings accepted in the Annual represent an evolutionary step for me. A strong concept has always been the most important and spontaneous part of a drawing for me. In the past, when I liked the concept I would draw the final by tracing a series of refined sketches. However, with these two drawings, I drew the final in one take; it either makes it or it doesn't. If it doesn't, I will draw it again. While this technique is pretty scary when you are on deadline, it does add spontaneity and energy to the drawing (and grey hair to my head). Texture and line join concept in importance to the overa[l] drawing and are promoted to equal status with the idea.

These drawings are for the gift book *Zen Cowboy*. *Face to Face* illustrate[s] a parable titled *Be the Cow* about figuring out who you are (when you realiz[e] that you are not a cow). "Stop" is a parable about the best way to stop [a] stampede: don't let it happen in the first place.

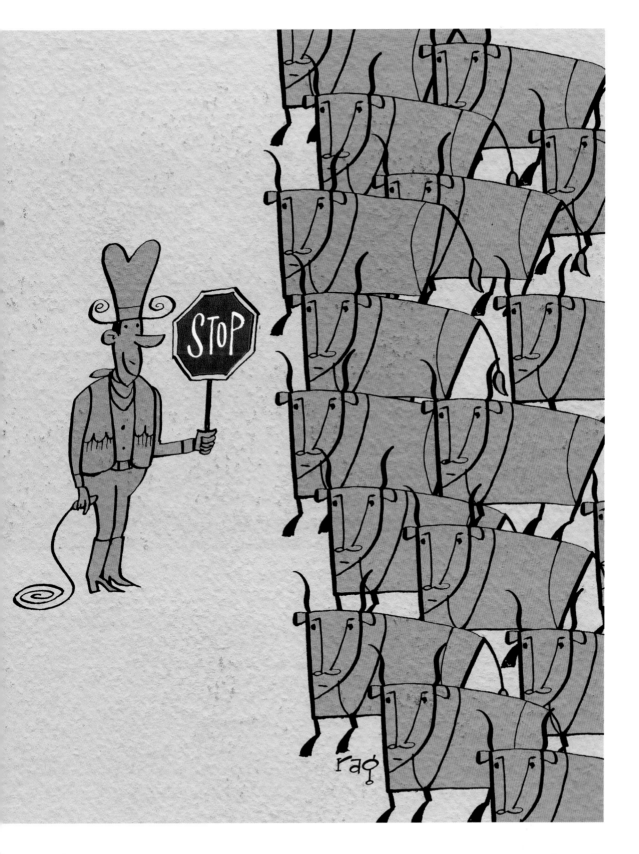

OKI HAN

Pondering over the freedom that Basho, who honestly believed in power,
value, and potential of poem or art, I asked myself:
"Who am I?"
"Where am I going?"

JESSIE HARTLAND

A scene from the author-illustrated children's book, *Clementine in the City*, published in 2005 by Viking Children's Books. In this scene, Clementine, a spry and spunky standard poodle with a mind of her own, is poring over the want ads in a dog newspaper, looking for a way out of her dull life in a small town. Among ads for lap dogs, sleigh dogs, hot dogs, and guard dogs is one placed by a big city circus looking for a performing poodle. This has caught Clementine's eye. "I'm going to get that job!" she says.

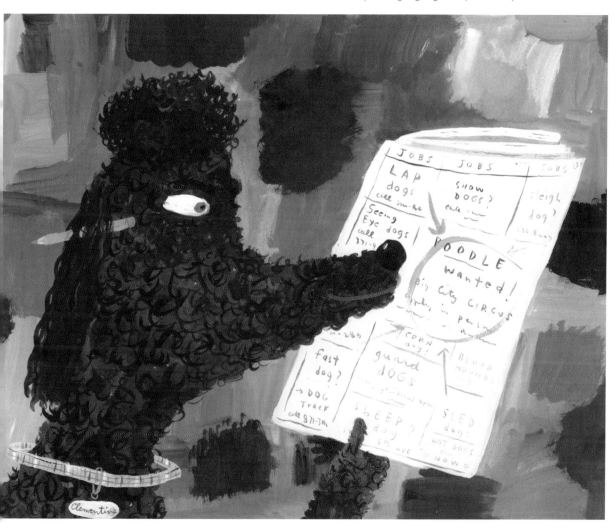

JESSIE HARTLAND

A painting from the pages of *Clementine in the City*, an author-illustrated picture book published in 2005 by Viking Children's Books. The poodle character has left a small town and moved to New York City to experience, among other things, snazzy shoes, shark fin soup, and fried chicken aromatherapy. In this scene Clementine is experiencing the low-end of canine coiffeur.

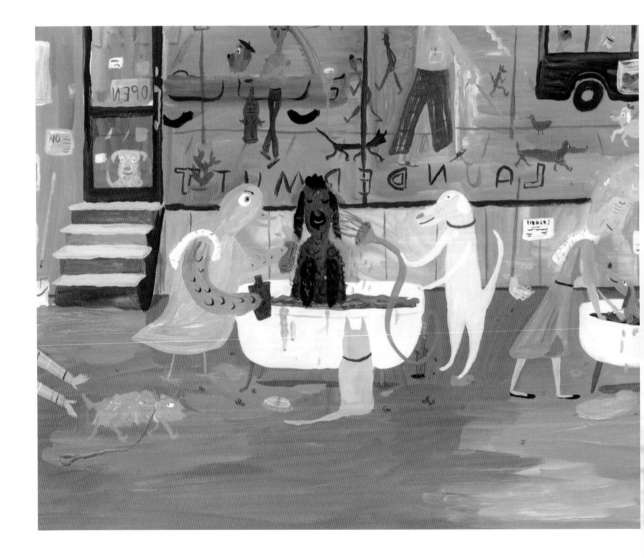

JESSIE HARTLAND

A picture from the illustrated children's book, *Clementine in the City*, published in 2005 by Viking Children's Books. In this scene, Clementine, a former small-town inhabitant, is grooving on big city life and all of its marvelous choices. She has a list of needed props for an upcoming circus audition, and a feather boa being on that list, she finds herself in the city's feather district.

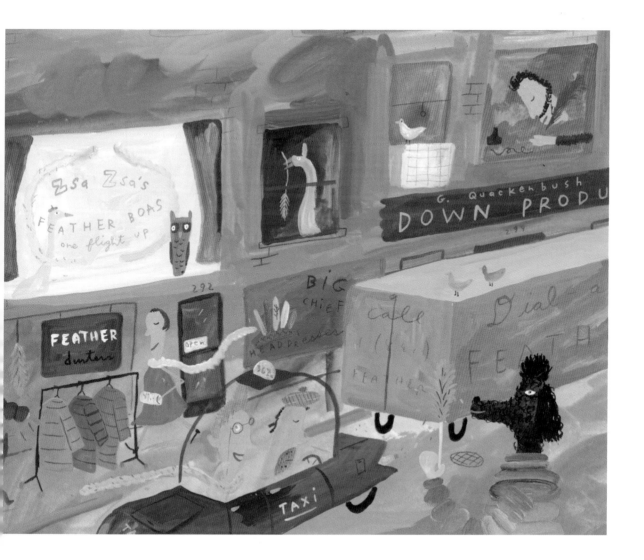

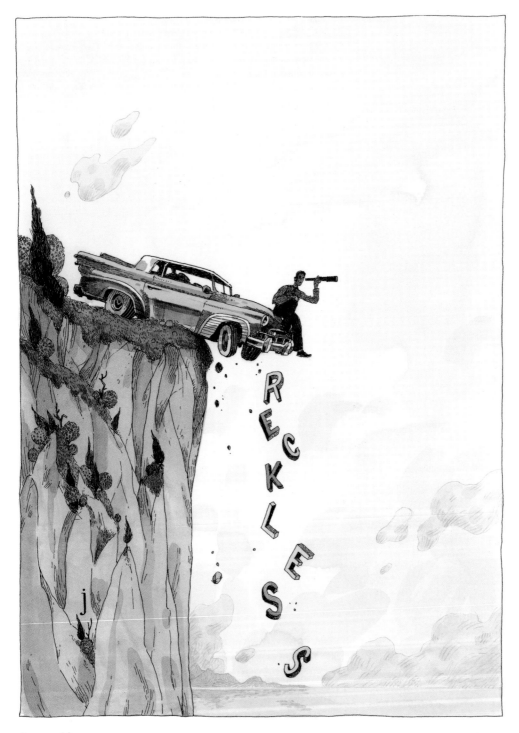

JOHN HENDRIX

This drawing was the cover image for a short story anthology series for young readers called Rush Hour. Each issue uses a different theme for the contents. In *Reckless*, most of the stories involved an element of danger and taking risks. This metaphor seemed to fit perfectly, without referencing any of the narratives themselves.

BRAD HOLLAND

A collection of science fiction stories called *Christmas Stars* gave me a lot of latitude for imagery, and since I had been wanting to do this picture for years, I proposed it. Sometimes you have to struggle with a painting to overcome the desire to control it, but this one came to me as easily as if I were putting a coat of paint on the wall.

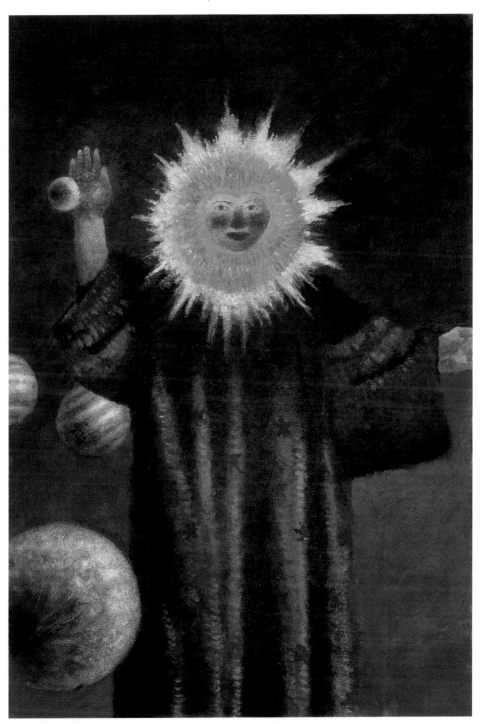

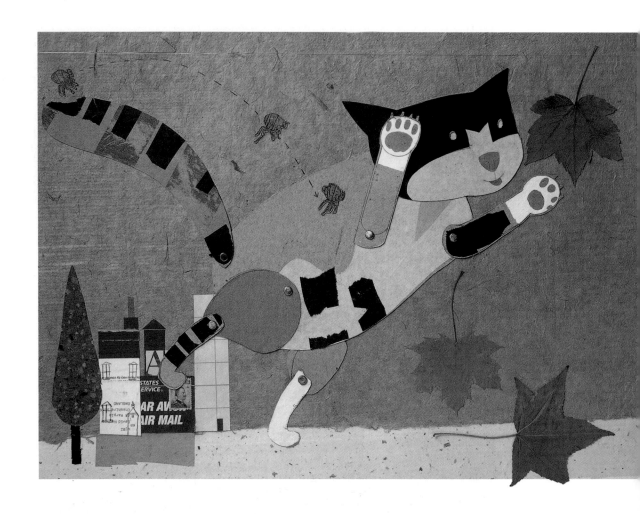

DAVID HUGHES

This is a Sandy Turner book produced after submitting a very long text to editor Caitlyn Dlouhy. She had the confidence that I could produce a stunning picture book for children.

Each piece is collage and it's a protest against the amount of digital computer illustration that is fashionable at this time. I even submit to the practice: it is very seductive, but it is also responsible for turning me into a lazy individual; I can produce so much mediocre junk very quickly. So *Cool Cat* is a return to good ol' fashion craft. It took forever; I will die from spray glue fumes and my feet stick to the studio floor like Velcro. It started as a Sandy Turner, but it ended closer in spirit to David Hughes.

STERLING HUNDLEY

Art director Karen Nelson gave me as much freedom as an illustrator could want on the *Othello* book. This particular work illustrated the scene just as Othello has been told by Iago that Desdemona has committed adultery. He falls to his knees and swears to kill her. Thanks to my friend Adam Johnson for his help on the series.

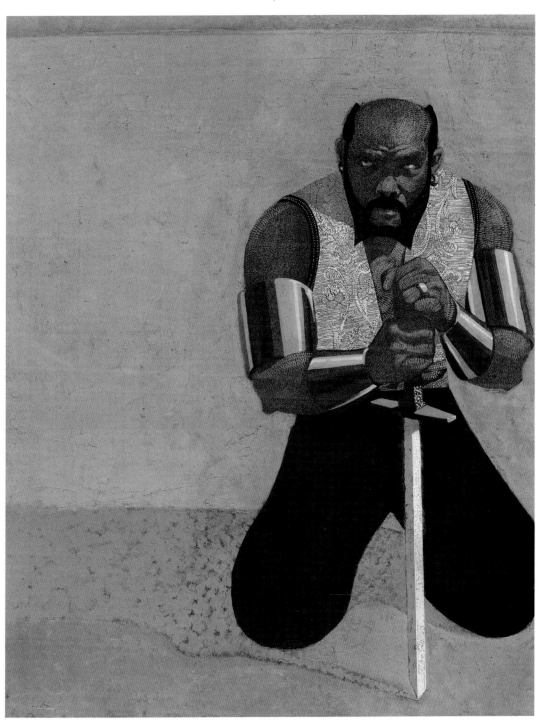

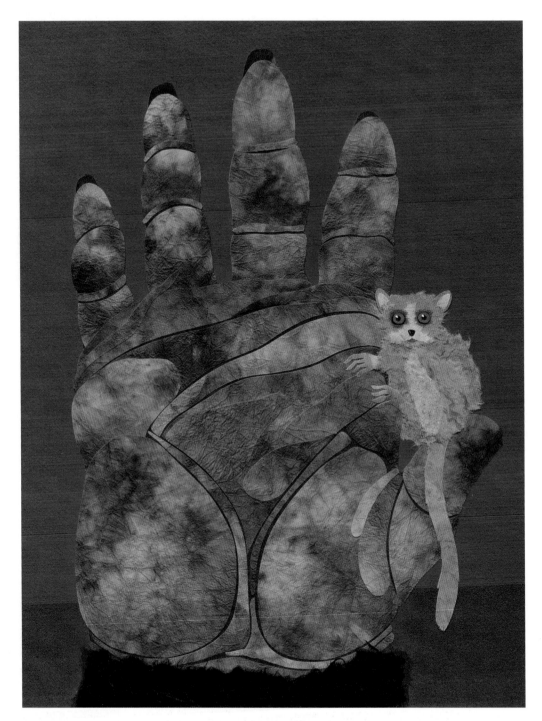

STEVE JENKINS

I've been writing and illustrating non-fiction children's books for a few years now. They're all about some aspect of the natural world. This particular book shows lots of different animals (or parts of animals) at actual size. It began with a visit to the San Diego Zoo with my son, who was 12 at the time. We spent a lot of time at the gorilla paddock, watching the gorillas watch us. In front of the moat that separated the tourists from the residents stood a metal informational plaque with a cast impression of a male gorilla's hand. It was huge. Almost every child (and most of the adults) that came by placed their own hand on the cast. On the spot, I decided to make a book showing animals at actual size, and ended up using the gorilla hand—the first illustration I did for the book—on the cover.

Steve Johnson and Lou Fancher

The paintings for *The Boy on Fairfield Street: How Ted Giesel Grew Up to Become Dr. Seuss*, developed in the usual manner: research, discussion, reference gathering, arguing (we're two artists working together, after all!) more research, sketching, reference editing, laughter and tears, more sketching, and finally, painting. We were mindful of the author's care with detail, our editor's concern with historical accuracy, and in awe of the legacy and endless creativity of the biography's subject. We decided to include a treasure trove of Ted Giesel's unforgettable imagery throughout the book's pages. If there is a solution to the intimidating prospect of placing one's art on the same page as art by Dr. Seuss, ours was to avoid imitating. We chose a softly stylized, but mostly realistic approach. The art is meant to have a classic feel, with a bit of exaggeration for fun. This particular piece appears on the cover of the book and reflects Ted Giesel's lifelong love and affinity for animals.

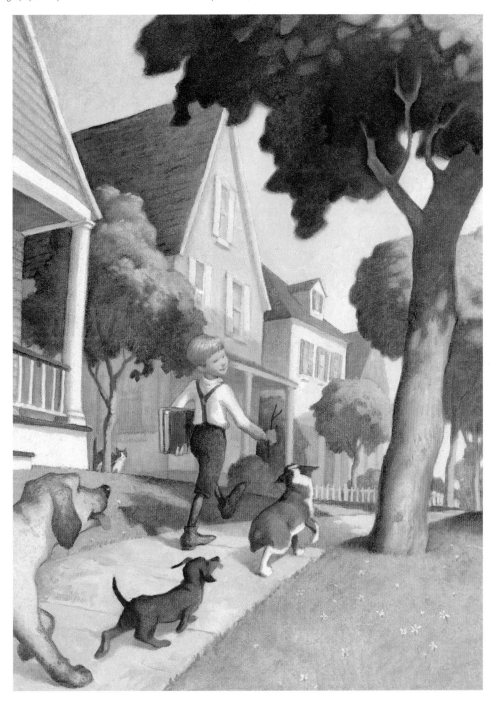

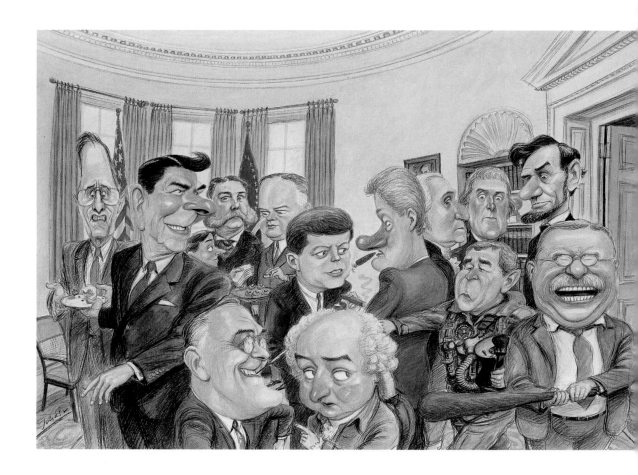

VICTOR JUHASZ

Of primary consideration when creating an image that has a number of diverse characters united only by the subject matter, is to ground them in a setting applicable to all and within which they can play off one another. The Oval Office seemed a very amenable solution for a bunch of presidents, considering that this was not originally assigned as a campaign anecdotes book. The presidents, though set in various groups, are, for the most part, focused upon and visibly reacting to the arrival of George W. Bush. The core interaction in this illustration is between W Bush, in photo-op, Iraqi Freedom flight suit smugly striding into the room, and Ronald Reagan, who, recognizing his heir apparent, abruptly passes his appetizer plate to the dismissible but put-upon Bush Sr., and turns towards the son. I deliberately contrasted W's smugness with his size in relation to the others in the room. A way, I hope, to add some subtle commentary and still make the cover viewer-friendly.

TATSURO KIUCHI

This is an illustration for a textbook cover for the radio program "Learning Basic English." There wasn't any specific theme for this cover other than a general sense of a season. This book was to be published in winter so I tried to depict the warm and relaxed atmosphere between the boy and his dog in the living room. He might be reading a book in English. I worked digitally in Photoshop for this assignment.

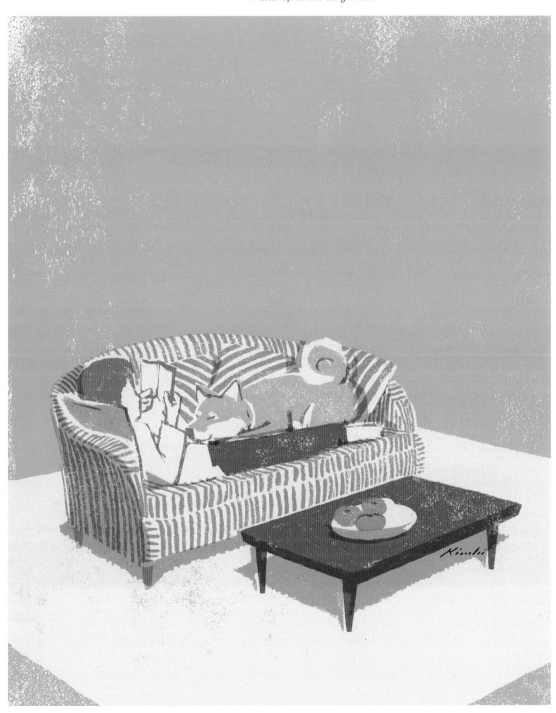

GARY KELLEY

This picture book illustration portrays Vincenzo Peruggia, the thief who pil-
fered Leonardo's *Mona Lisa* from the Louvre in 1911, contemplating his crime.
Across the Seine we see the famous museum as my research and imagination
pictured it that fateful August night nearly a century ago. I wanted to create
a sort of film noir atmosphere, using color and the body language of the
Peruggia figure. I did have some reservations, however, about depicting a man
smoking in a book for younger readers.

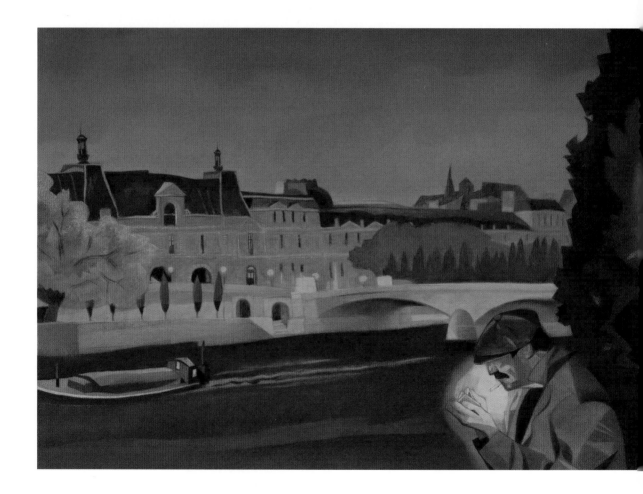

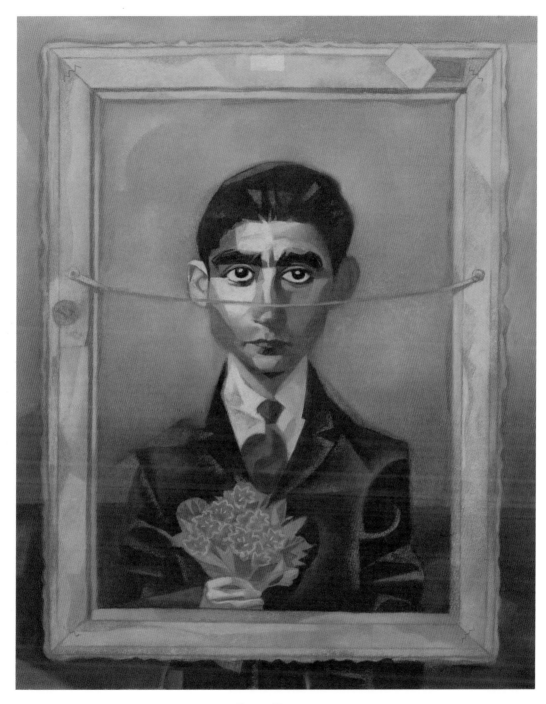

GARY KELLEY

The theft of the *Mona Lisa* from the Louvre had a profound effect on the residents of 1911 Paris, including the writer Franz Kafka. This image remembers his visit to the museum and the empty space the painting had recently occupied. Although barely a minor player in this episode, Kafka had that mystical, expressive gaze that artists love to paint. I welcomed the brief opportunity to introduce his portrait to my range of subjects employed to tell the story of *The Stolen Smile*.

At times they would roam through the woods in the daylight, with the lady riding upon the lion's back. She still loved songbirds, and the lion knew just where to find the ones that sang most sweetly.

One day news came that her sisters were to be married. The lady longed to see her family again and introduce her beloved husband.

The prince offered to have his lions escort her. "Please, come with me," she said to him. Unable to deny his lady anything, the prince agreed and they set out the next day.

LAUREL LONG

This spread is from the picture book *The Lady and the Lion* by the Brothers Grimm. The Lady is shown spending some quality time with her prince, who is a lion by day and a man at night. The story references the Red Sea, giving me the opportunity to use the perspective and design elements of Eastern Art.

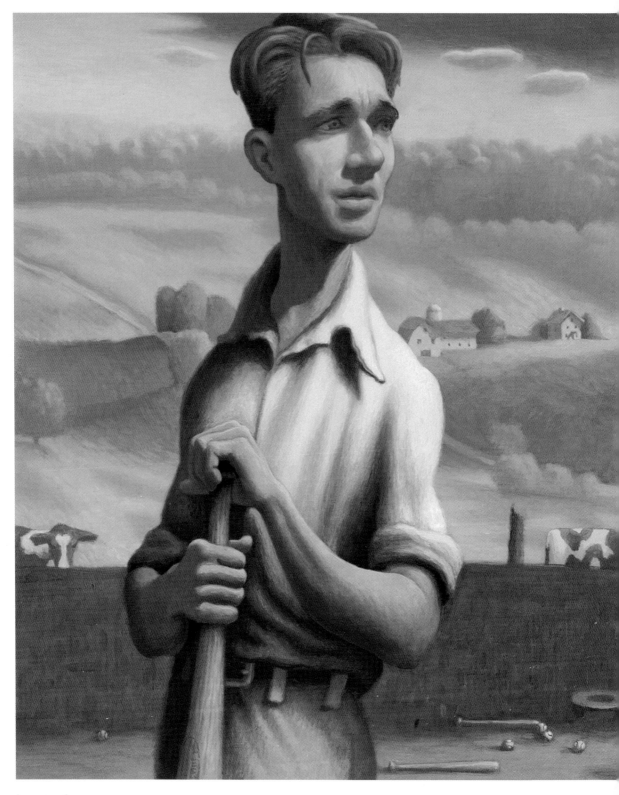

LOREN LONG

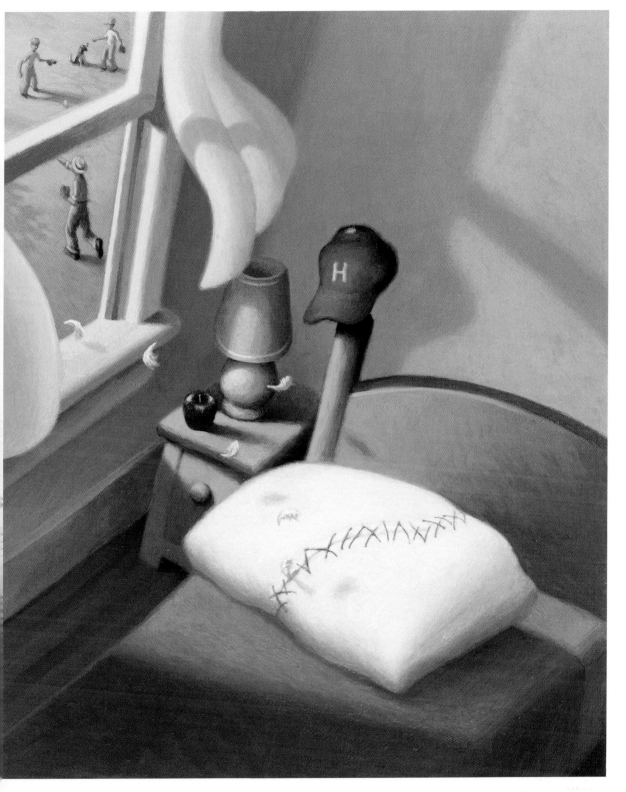

LOREN LONG

STAN MACK

The assignment for this work was given to me, the illustrator, by me, the writer, to illustrate a memoir about me and my partner. *Janet & Me, An Illustrated Story of Love and Loss* (Simon & Schuster) is the story of Janet's losing battle with breast cancer and about my role as caregiver. The setting is New York City. Since drawing, not writing, is my first language, it was natural to tell my story as much with drawings as words. I wrote and designed the book as a traditional narrative and then added drawings—over 300 and most with dialogue balloons—in precise spots within the text. I drew simply, so people could read this hybrid form easily. In this drawing Janet and I have received very bad news about her condition from her doctor and have walked from our apartment in the West Village to the Hudson River to stare out across the water and face our future.

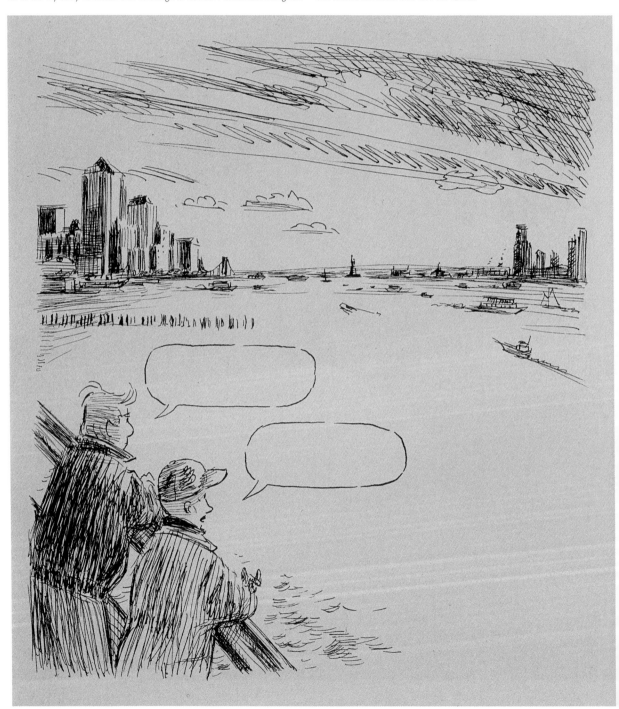

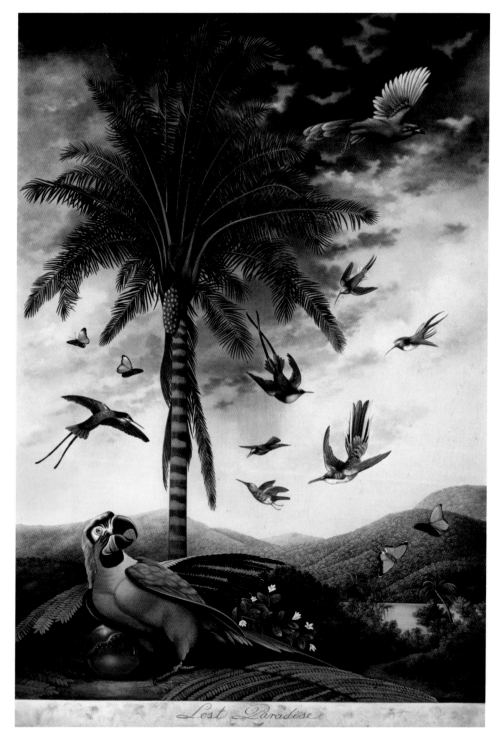

CHERYL GRIESBACH AND STANLEY MARTUCCI
The most envious assignment is for artwork that has already been created and provides the perfect image for a book title. It had originally been commissioned and sold as one of a series of paintings depicting Paradise; we were thrilled to have it reproduced (in *Darwin's Wink*), especially with the name Darwin in the title.

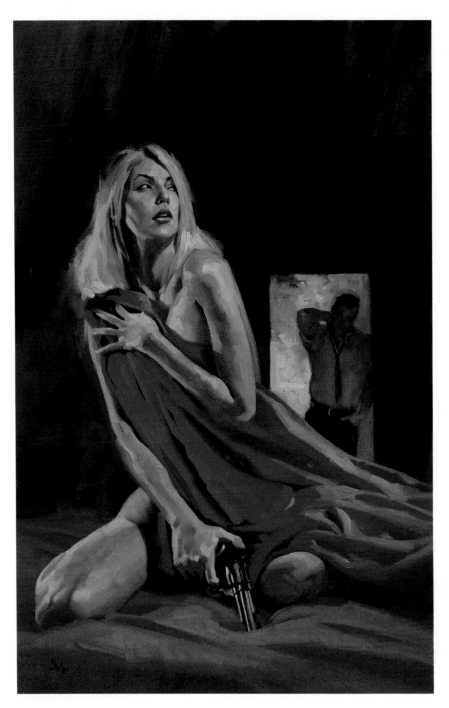

GREG MANCHESS

Art director Max Phillips had to be careful that we didn't show too much skin on the cover ... it was being sold in WalMart stores. I set up the scene to titillate and wanted to show much more skin. But the idea of the sheet came to mind and solved most of the issues around that. We had great fun playing with her cold character and added the gun. Hey, it's pulp ... whadja expect?

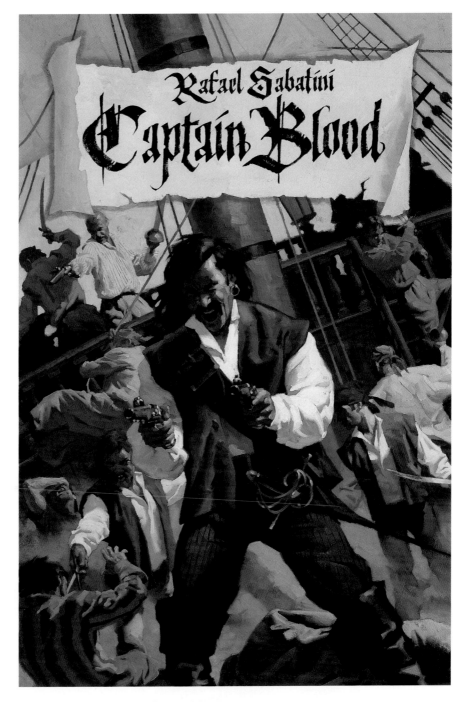

GREG MANCHESS

A call from Ingsu to do the covers of three Rafael Sabatini books from the '30s: *Scaramouche*, *Sea Hawk*, and *Captain Blood*. Who could resist? Paintings of pirates for a book cover like the old guys used to do? What a great time. I got a pair of pirate boots and pistols to work with. My friends dressed up and posed ... and I got in there, too. I designed the panel for the title space and then added calligraphy on a whim. They liked it so well they asked me to paint it in. A last bit of derring-do.

BILL MAYER

This illustration for Klutz was part of the wackiest book on ball games. With this game, you sit on the floor and roll the ball to each other with the cat in the middle. I thought this perspective of looking though the legs of the cat was appropriate, and creative cropping helped remove the offensive Walter Mondale button.

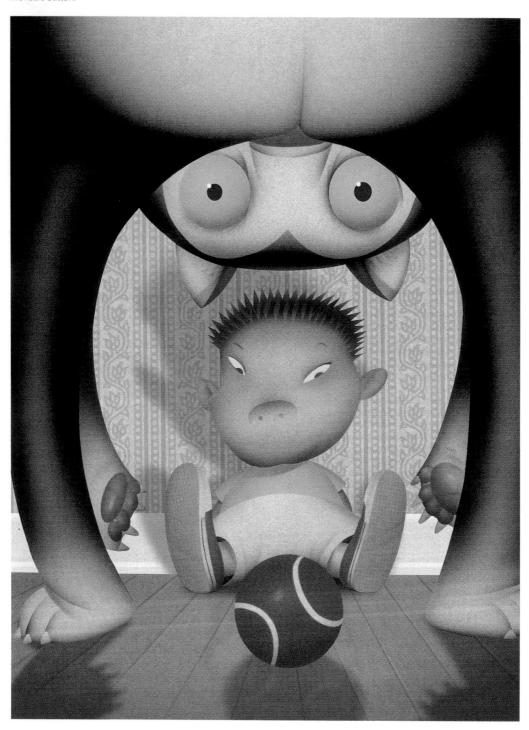

ADAM McCAULEY

This was a really fun assignment to illustrate the cover of a book about a kid who is so unassuming that he appears all but invisible to the world around him. The art director, Heather Woods, fortunately designed a cover image that had a bold, simple approach. For some reason, I thought of Ben Shahn and tried to imagine how he might approach it. Of course, it ended up nothing like Shahn's work (wishful thinking), but at least I had a lot of fun drawing Afghan hounds. Heather and company did a beautiful job with the production and design of this excellent book by Neal Schusterman, and I feel fortunate to be part of it.

SCOTT McKOWEN

Karen Nelson at Sterling Publishing called with the engrossing assignment of illustrating ten classic children's books. *The Secret Garden*, *Sherlock Holmes*, and *Tom Sawyer* are three of my favorite covers in this series. I approached the covers much as I do theater posters, by trying to distill the spirit of these familiar stories down to a single strong image. The engraved lines of scratchboard immediately evoke the 19th-century world of most

of the books. The drawing is all by hand with a sharp knife; the color was added electronically.

My wife, Christina Poddubiuk, is a theater set and costume designer and contributed advice on the period clothing for these illustrations. Most of the models were eleven- and twelve-year-olds in my small town of Stratford, Ontario. We invited them, with their families, to a book launch

party when the printed samples arrived: "Tom Sawyer, I'd like you to meet Anne of Green Gables."

Many great illustrators have done unforgettable versions of these books over the past century, and it was a particular thrill to have the opportunity to contribute to that tradition.

SCOTT McKOWEN

LUC MELANSON

This drawing is from a children's book I wrote and illustrated entitled *Ma drole de ville* (*My Magical City*). A young boy describes in rhyme the imaginative things he sees in his city, his neighborhood, his house, and even in his bath. Nobody believes him ... except his Mommy, of course.

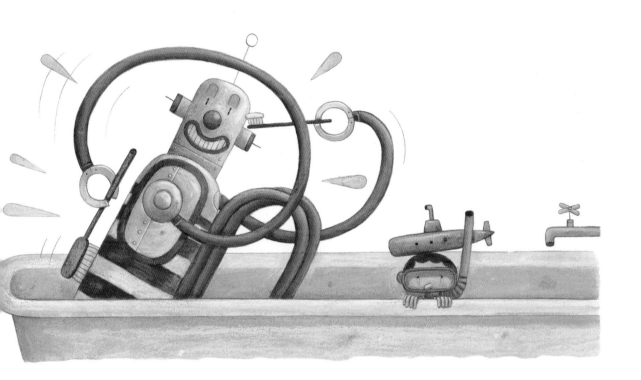

DAVID MERRELL

I was commissioned by Terry Groner to create this illustration for the cover of *Tabletalk* magazine. This image illustrated an article stating that although Christianity is called to influence the outside world, it often seems that the outside world has more influence over Christianity. Terry already had the concept in mind of depicting a dopey lamb trying to fit in with a bunch of snarling wolves. I was given complete freedom in bringing that concept to life.

I wanted to emphasize the naiveté of the buck-toothed lamb. He has relaxed yet confident posture and a grin to show he feels he is complete successful in pulling off the disguise. He also seems oblivious to the fa that he is drawing suspicious looks from the rest of the pack and that he irritating one of the wolves in particular by resting his elbow on its head.

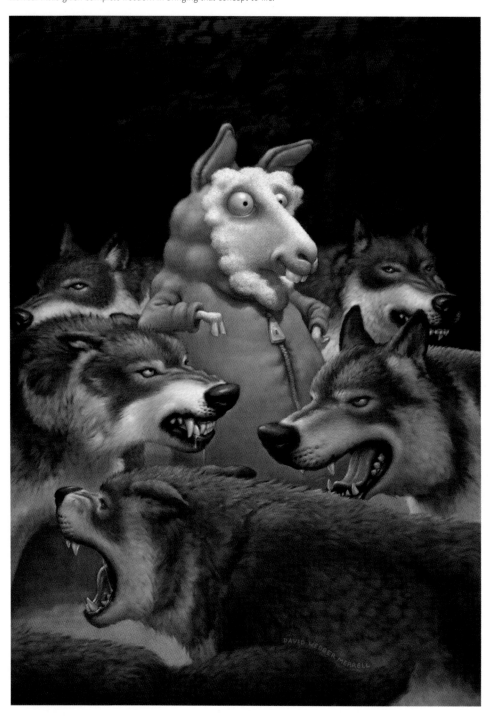

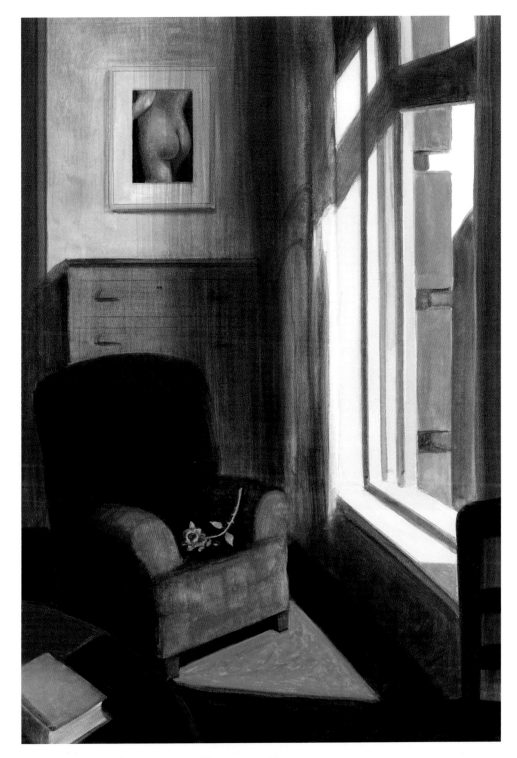

WENDELL MINOR
This painting is part of a series of covers created for Donald Harington novels. In this particular book, a parody of an Edward Hopper painting becomes the basis for telling the story.

LARRY MOORE

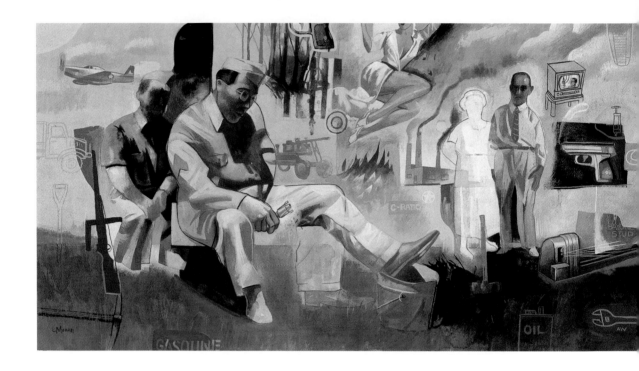

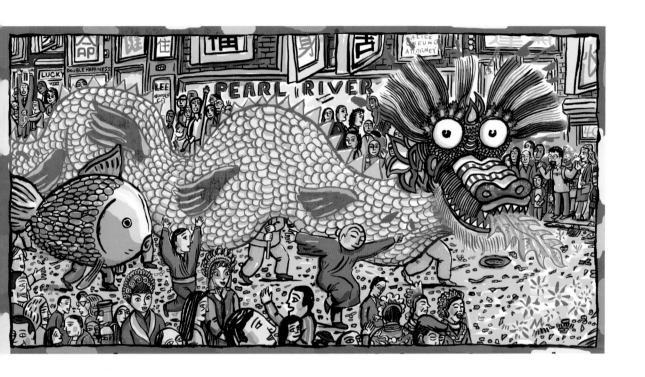

ROBERT NEUBECKER

This is a spread for my children's book, *Wow City*, which won a 2005 Notable Book Award from the American Library Association. The story idea originated with my daughter's first visit, at age two, to New York City, and how she was bedazzled by everything she saw.

It's actually an album of collected memories of my twenty years as a New Yorker, one of the most vivid being the Chinese New Year's celebration. It's done in India ink with the color added digitally, in a technique I call Photoshop Dick and Jane.

SIMONA MULAZZANI

The donkey, jester, and tiger were for the book *Joy: 45 Life-Affirming Visualizations for Breast Cancer Treatment and Recovery* by Wendy Burton. For this project I was guided more by the author than by the art director. I felt it was very important to correctly interpret her visualization. Before I started I thought it would be very difficult to work on this book, especially because of the unusual subject the book deals with; I was afraid I wouldn't satisfy the author, who had chosen me after seeing 500 artists! On the contrary, she was extremely open, enthusiastic, and gentle. She helped me a lot and I liked working with her. All works are acrylics on paper.

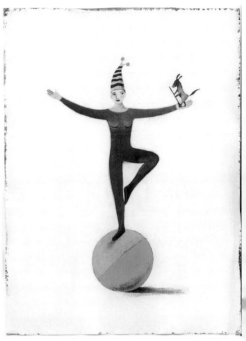

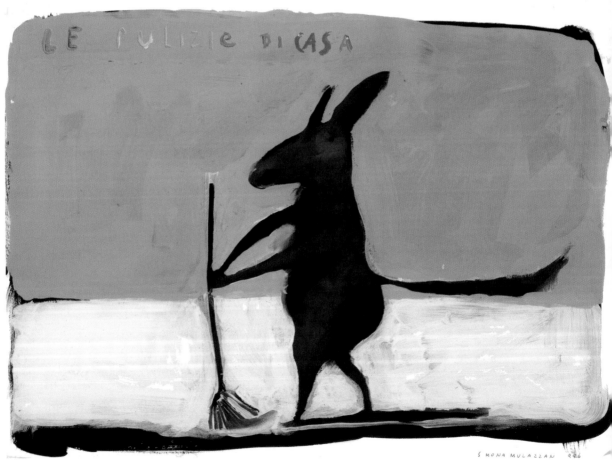

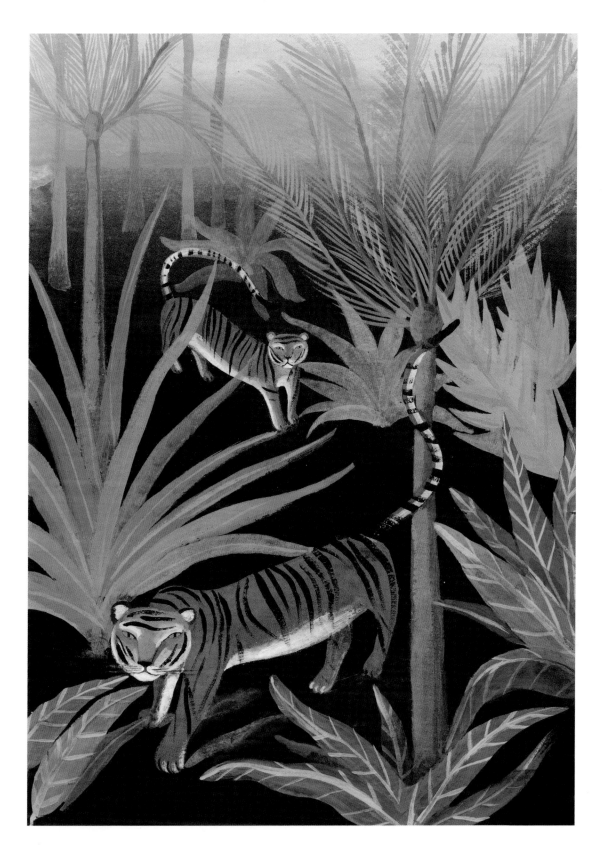

YAN NASCIMBENE

When I was offered to illustrate *Hachiko*, written by Pamela Turner, my wife and I were without a home or a studio. We were staying with a friend and I worked on his kitchen table. This might have helped with my wish to create simple images, understated and direct, somewhat similar to my early work, keeping to the style of the text.

YAN NASCIMBENE

I wanted a silent crowd, with a feeling of emptiness and loss: hopefully this comes across.

YAN NASCIMBENE

Composition and cropping are as important as the subject matter itself. As for the subject, no matter how original, in order to be successful it has to reflect the text without being an exact copy.

JOHN JUDE PALENCAR

This is the cover art for the novel *Wild Reel* by Paul Brandon. My goal is to create a sense of mystery on my book covers. I'd rather paint a cover that is enigmatic in its presentation, an image that creates questions, rather than one that delivers answers.

KADIR NELSON

This image was created for the cover of the book *Ellington Was Not a Street* by Ntozake Shange. It is my favorite image from the book. I love the saturated green wall behind the little girl against her light blue dress and her pretty brown skin. She holds a 10-inch record almost as if she is presenting it to the viewer as a gift. I think the image really captures what the book is all about. I really had to push for this image to be the cover because the publisher had other ideas. But I knew this was the right image, so I held my ground. In the end, everyone agreed. It's nice to be right sometimes.

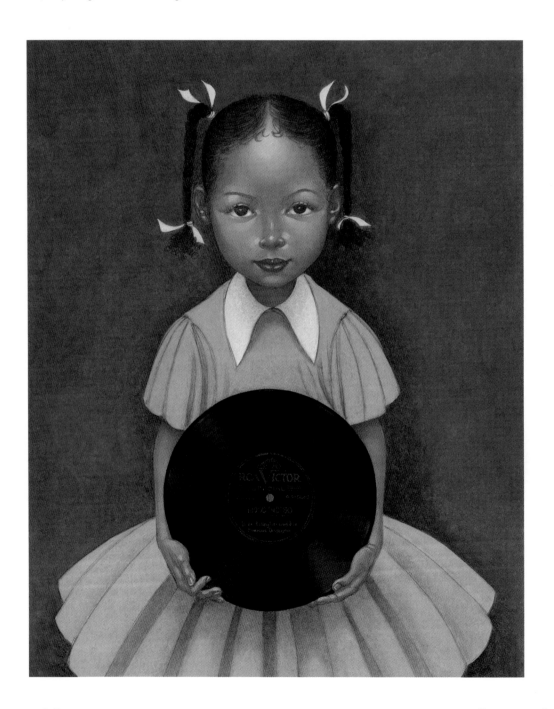

KADIR NELSON

This image was used as an interior piece for the book *Hewitt Anderson's Great Big Life* by Jerdine Nolen. It has turned out to be a favorite of many of the book's readers. I think it's because it shows how it feels to be a little kid, protected and loved by a parent. As a parent, I sometimes wish my kids would stay small because they are so cute at this age. But as my grandmother says, "I guess you can't do that, or else they'd be midgets!"

I was able to work on this book with Dan Potash, a great art director, whose idea it was to extend the giant hand all the way over to the other side of the spread, making the giant hand look all that much more giant! A great idea. We used the idea throughout the entire book. That's my hand, by the way.

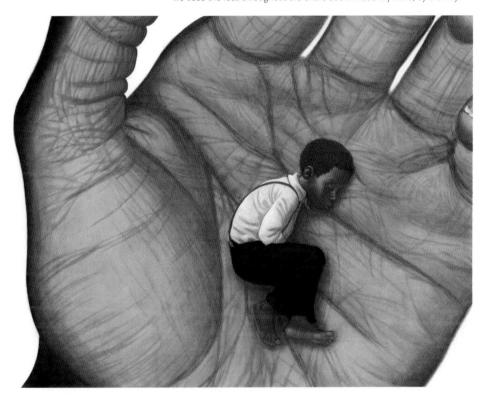

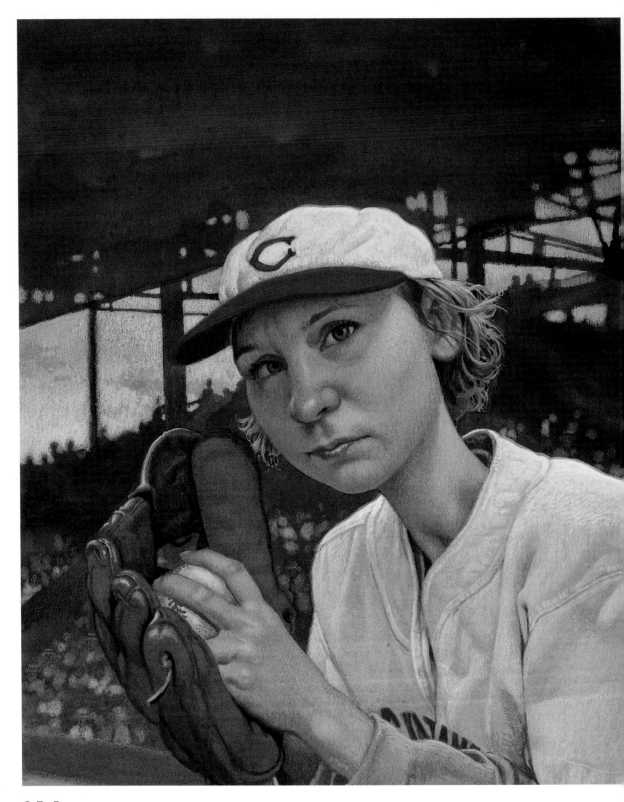

C.F. Payne

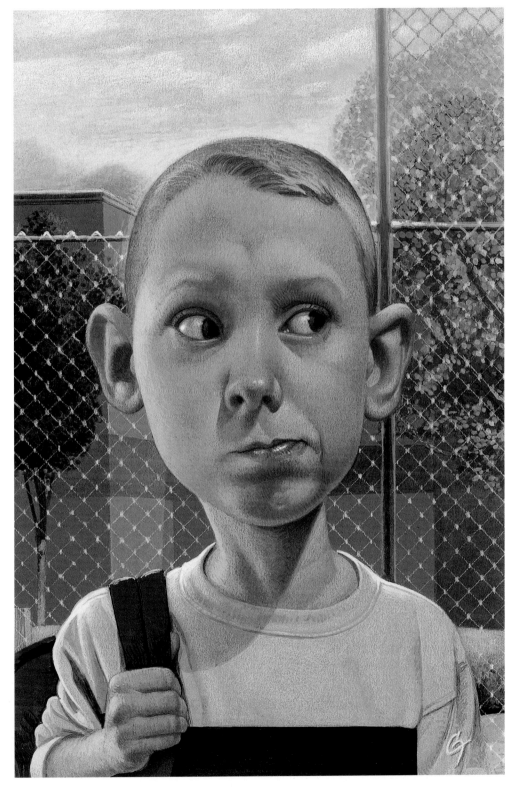

C.F. PAYNE

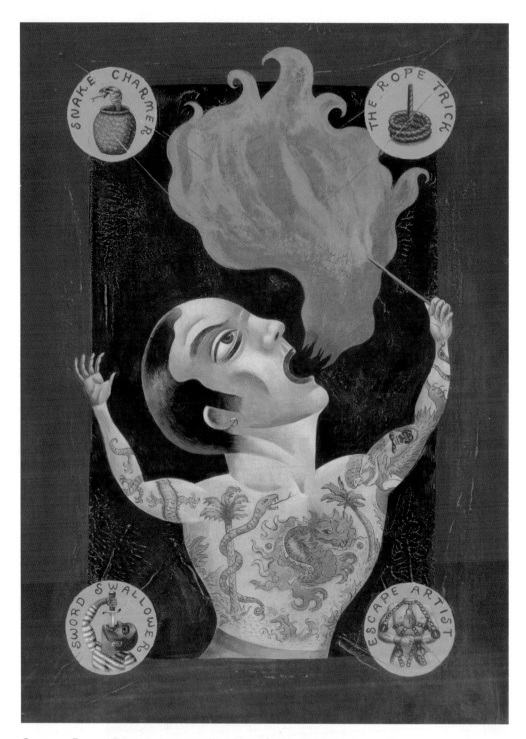

CURTIS PARKER

This was used as a cover for the book *The Fire-Eaters*. The story, set in the 1950s,
is about a boy who goes to the carnival with his father and learns that the man
covered with tattoos and eating fire served with his father in the war.

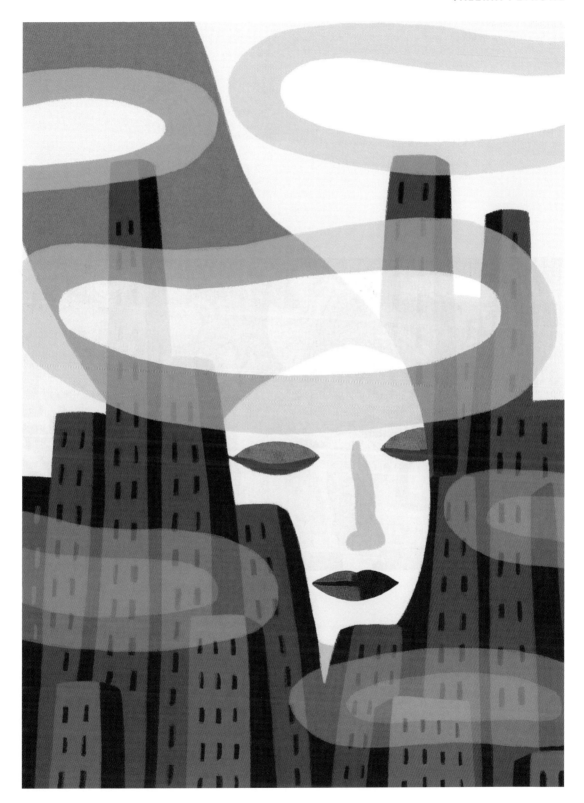

CHRIS PYLE

Around the beginning of 2004 I was asked by designer Mark Murphy to cre-
ate a piece of artwork for his *Dialogue* book project. The idea behind the book
was for each artist involved to base an image on any piece of found written
material that they chose, be it love letters, children's notes, whatever. I chose
to use an old request napkin I'd saved from my days drumming for a honky-
tonk biker band I had played in twenty some years ago. The horribly misspelled
napkin was requesting the band to perform the song *Rockin' Robin*. The scene
surrounding this band at the time was unusually surreal, funny, and scary all at
the same time. My hope was to capture all of those feelings in this piece. The
idea of portraying the audience as birds was a tip of the hat to those card-play-
ing dog paintings, and also to the word "robin" in the song's title.

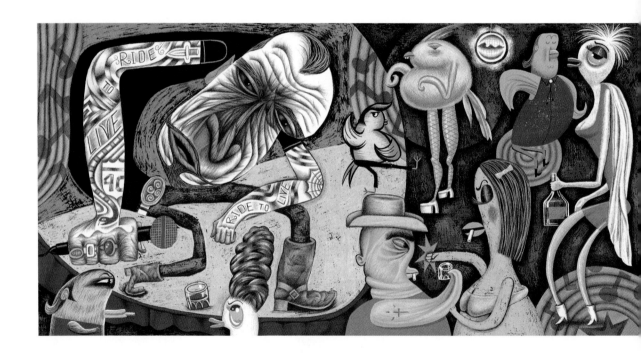

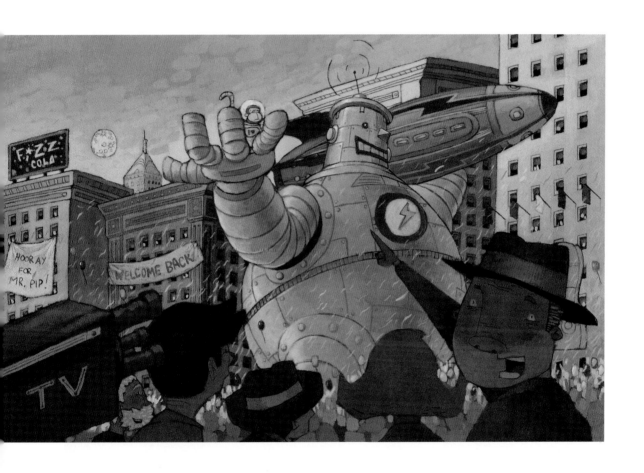

DAN SANTAT

This was an illustration for my children's book, *The Guild of Geniuses*, which is about a movie star named Frederick who sends his pet monkey, Mr. Pip, to a genius club to find out why the monkey is sad. This is one of the last scenes in the book where they're all celebrating on the patio of his huge penthouse suite.

RED NOSE STUDIO

To do the covers for a series of books about runaway kids who live in the true underground of London, kids that avoid growing up and do everything in their power to avoid becoming adults—how cool is that? This piece is all about the lighting and the environment, trying to get to the heart of the gritty lives of the Borribles.

RED NOSE STUDIO

Hey Fred! Nice Red Thread is a series of images and limericks that touch on the little joys and disappointments in life. The book was created for a joint promotional project with the design firm Planet 10, the printer Quality Printing, and Red Nose Studio. As a whole, the book is meant to be read and re-read. The non-sequential nature of the limericks allows the reader to bounce around the pages finding little nuances/surprises in the selective effects that were used. As they spend more time with the book they find several layers to the seemingly naive limericks.

CHARLES SANTORE

This illustration of a barnyard filled with fat identical hens in the foreground crowned by a lofty chicken coop, crowned again by a skinny rooster reminiscent of a weathervane, was done for the line "Coops are constructed for hens" from Charles Edward Carryle's 19th century poem "The Camel's Lament." The poem is a whimsical, funny, lyrical story about a complaining grumpy camel.

CHARLES SANTORE

This illustration of sheep protecting the lambs was done for the line "lambs are enclosed where they're never exposed" from a 19th century poem by Charles Edward Carryle entitled "The Camel's Lament." I could not imagine a more fitting enclosure for lambs then the warm wool of the rest of the flock.

STEPHEN SAVAGE

CHRIS SHEBAN

In addition to being aged by about 30 years, my wife wasn't thrilled when I dragged her outside very early one morning and told her to pretend she was shielding her eyes from the sun and to "pull your T-shirt back like it's a skirt blowing in the wind."

JEFFREY SMITH

ALENKA SOTTLER

Mum is from the picture book *Willi Wants a Brother*, one of 12 color illustrations showing everyday feelings of a child when a sibling enters his family. Willi wants a brother, but gets a sister.

The challenge of the text included how to:

- show everyday life without the multitude of consumer items engulfing children?
- adapt my style to the book format?
- express the hero's feelings?
- avoid repetition in recurring scenes?

- show the physical growth of the two heroes?
- paint consecutive yard scenes without being monotonous?

I painted many alternatives, creating a dummy book with color, variety, and continuity. In *Mum* I avoided the kitch surrounding kids today and treated scenes with a flavor of Renaissance. Drapery helped situate the figures softly. Size and composition showed the importance of Willi's mother and her symbiotic attachment to his younger sister, his being pushed to the side, and his efforts to help and feel included.

ALENKA SOTTLER

The Blue Kerchief evolved out of an abstract, flat background of aimless lines. Leafless branches create depth and volume sculpturally—a fantasy forest scene for the figure.

This illustration was created during an intimate experience in my life. A few days after agreeing to do the book *Fairy Tales of the World*, I learned my mother had only a short time to live. The publisher emphasized the critical deadline. I realized I had to radically change my working process, not knowing how much time my mother's illness would demand.

I decided to shorten my normal work process by omitting self-censu and by illustrating the first idea I had when interpreting each story. M mother passed away and work on this book continued for eight month This was the most difficult and yet liberating work I've ever done.

ALENKA SOTTLER

Keep Your Secrets is one of 25 black-and-white illustrations, 109 vignettes for *Fairy Tales of the World*, for children and adults.

Problem: How to:
- compete with the richness of older books yet express the ancient story with modern style?
- create playful discoveries leading from one illustration to the next?
- reveal the state between dreams and reality, the internal and essential world, hidden in the story?

Process: I created many abstract backgrounds using metal comb and black tempera, enjoying rhythms and waves of black-and-white traces moving aimlessly. Then I read a story and imagined scenes unfolding in the abstract landscapes. Thus the illustration flows both on the surface and in space, a duality enabling the free association and poetry vital to reading fairy tales. The painting was interwoven into the same black-and-white lines on the paper.

RICHARD SPARKS

MARK STUTZMAN

Firethorn is a story of a young woman who faces extreme hardship by possessing an earthly oneness with nature. My goal was to represent the character as a hauntingly beautiful young woman, blending into her natural environment. I dressed her in a tattered gown to suggest her femininity, and wrapped her arms in makeshift sleeves to blend in with the bark of the thorny tree. Her hair mocks the tree's orange berries, while her eyes stare out wildly and cautiously. I wanted to use decorative, eclectic elements to represent the imaginary world she struggles to live in.

Linda Sullivan

Before birds sang, before leaves fell, there lived an old lady and an orphan boy she called Son. They lived alone, deep in the forest with no one to watch over them except the trees. Their struggles unfold in *Fall*, a letterpressed, limited edition children's book. The linocuts and line illustrations reflect the allegorical telling of the first fall and also underscore the themes of the story—love, sacrifice, and renewal.

GREG SWEARINGEN

painted this cover for a paperback reissue of Bruce Coville's alien series. The books were originally published in the '80s so I wanted to give the children a less dated look. In the story, Peter and Susan track their mysterious substitute teacher to his empty house and are shocked to find he's really an alien in disguise! I wanted to create a monster movie poster effect for the series. I used myself as the model for the alien, turning myself into a Martian by taking the photo with an eerie green light, spoons over my eyes and a cheap suit I bought from the thrift store.

PETER SYLVADA

This painting for *Welcome Brown Bird* depicts a new arrival to the forest floor—our brown thrush—as he sings his silvery, circular song.

PETER SYLVADA

The Harcourt book, *Welcome Brown Bird*, tells a warm story of a wood thrush migrating between two boys: one somewhere in Central America, the other in America's Northeast. The boys have no knowledge of one another, yet they have the common bond of the bird's annual visit. To save the thrush's silver song, both boys find value in saving their prospective forests, so the bird will have a home to revisit. This painting depicts one of the boys anticipating the thrush's arrival.

Blair Thornley

BLAIR THORNLEY

CATHLEEN TOELKE

This is a cover painting for a novel in which race, truth, and the nature of family are examined. An African-American woman urges a white woman to acknowledge the truth about the race of the woman's son—that the son is half black. The two women, acquainted during their childhood in the segregated South of the 1950s, are connected as adults living in separate parts of the country. I wanted the cover to show the contrast of the women's color, a conflict between them, and the silent means by which the black woman communicates with the other, by persistent letters sent throughout their adulthoods.

Book cover assignments are among my favorite. I love receiving a new manuscript and diving right into it, making numerous notes and thumbnail sketches as I read. My work has become more graphic in recent years, and this cover was especially interesting to work on due to the contrast between the two women.

SANDY TURNER

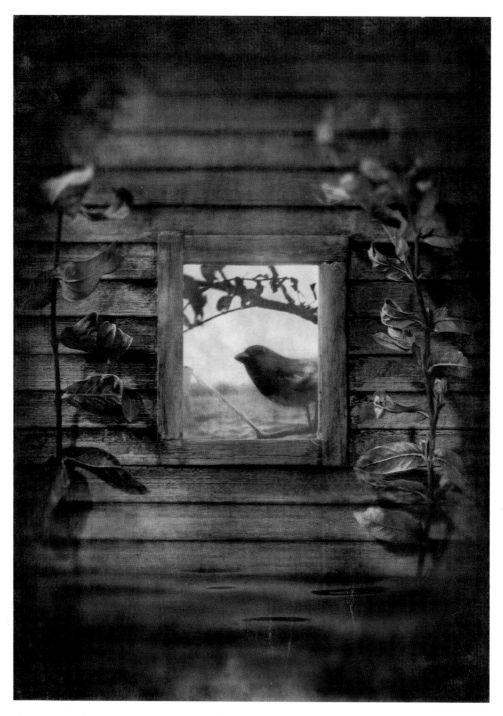

RICHARD TUSCHMAN

I created this work as the cover art for the young adult novel *Not the End of the World* by Geraldine McCaughrean, published by HarperCollins. The story is a fictionalized account of the biblical tale "Noah's Ark" as told by the passengers on the boat. Much of the book is fairly dark, focusing on the hardships and tensions that would have been part of such an ordeal. The ending is fairly hopeful, though, so for the cover we wanted to create a mood that would reflect that general balance. I built a weathered wood background to suggest the hull of the ark with a rough-hewn window in the center. The hopeful scene in the window was photographed separately, printed, and the inkjet print placed in the window. The wooden "hull" was then placed in a tub of colored water, and all photographed as one piece. Additional texture and coloring were added in Photoshop.

JONATHON TWINGLEY

My good buddy Mitchell McInnis called me from Bozeman, Montana, last year and said, "Hey, Man, I'm doing a book of poetry. Would you do some drawings for it? I said, 'Sure." Four months later, we were talking and he happened to say, "Hey, so how are those drawings coming along?" "Drawings?" I said. "Which ones?" "For the book!" "Right," I said, "when do you need 'em?" "Monday," he said. This was on a Friday. So I got crackin' and did twenty drawings over the weekend, and the cover, which is included in this year's annual. I think Aesop said something like, "The best judge of a man is the company he keeps." I was and am proud to keep Mr. McInnis and his poems company.

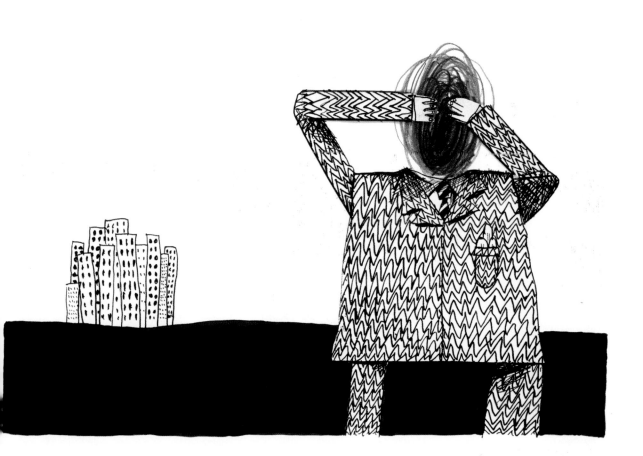

MARK ULRIKSEN

Dog Show was my first children's book and I was anxious to come up with a cover immediately but the wisdom of my editor, Nina Ignatowicz, won out and I waited until the entire book was finished before I tackled the exciting challenge of what the cover would be. Knowing the cast of characters better certainly helped, and after getting them in place, I was able to add dogs I've known over the years into the parade, as well as my daughter, our cat, and my tax accountant.

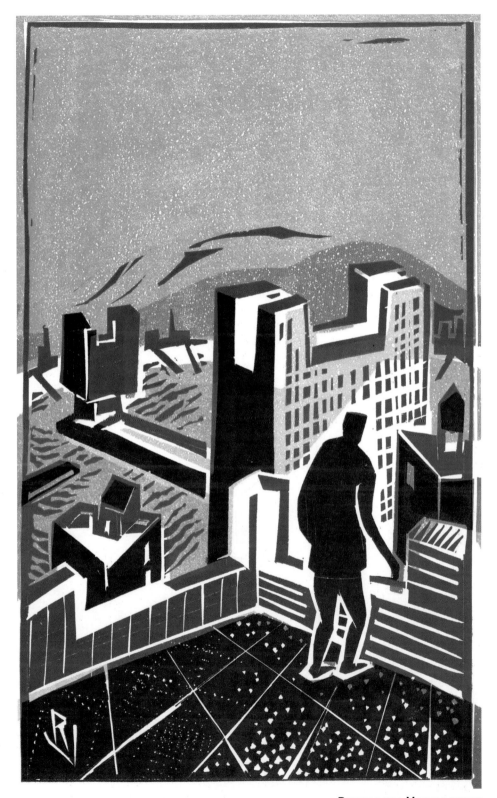

RAYMOND VERDAGUER

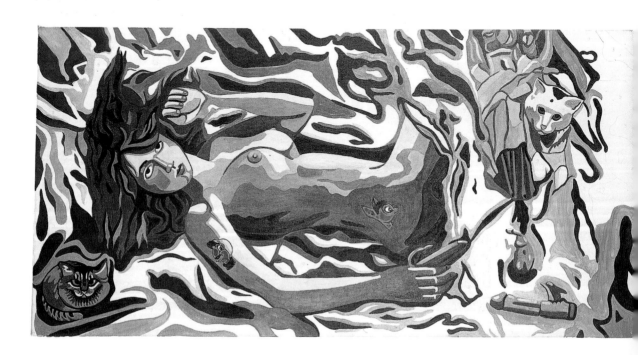

JEFF WONG

When Steve Hoffman of *Sports Illustrated* asked me if I knew anyone who could paint the Sistine Chapel, I thought he was joking. The 50th anniversary of the magazine was nearing and he wanted to commission a sports version of the entire ceiling. I mentioned some illustrators, but couldn't imagine anyone in his or her right mind taking on such a monumental task.

I guess that makes me nuts. The idea of being part of such an important celebration and the challenge of tackling the most ambitious single illustration in recent memory excited me. It was crazy, but a-once-in-a-lifetime opportunity. I asked to do it.

Creating physical art would be impractical; doing it digitally would be manageable. I spent six months, full-time, moving pixels. When I look at the piece today, I'm so glad I had that half-year lapse of reason.

MINKY WOODCOCK

This painting was created for a book titled *Dialogue, The Fine Art of Conversation* by Murphy Design. The assignment was to make a painting, which was influenced by a letter or some form of text. This piece, *Minky's Rats*, is in response to a letter and an art test from Art Instruction Schools. Her tattoos are two of the heads that you are supposed to draw and send in to be judged. Of course, they accept everyone. This was created to look like a paint-by-numbers, a style of painting that can be done by everyone. If you look closely, you can see the numbers through the paint, and there is an unfinished area in the upper right corner.

ANDREA WICKLUND

The Secret of Making Brains is a story about an old man who creates a world of his own, full of creatures and children whose brains he constructs from an intricate system of cogs, crystals, gears, and other hardware that, when intact, needs to be wound up using a special key. In order to portray both the fantastical and the mechanical elements of the story, I began my illustration with soft, organic graphite pencil rendering, enhanced in certain areas wit pen and ink. I collaged wire, fabric, and cut paper to create certain shape and then followed up with glazes of acrylic paint. The values of light and dar are mapped out so as to put focus on the protagonist and to create a brigh light source that refers to the inventive nature of the narrative.

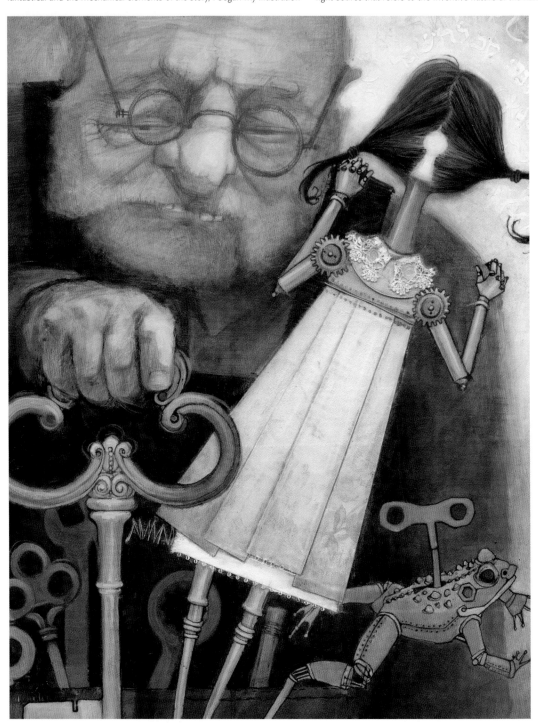

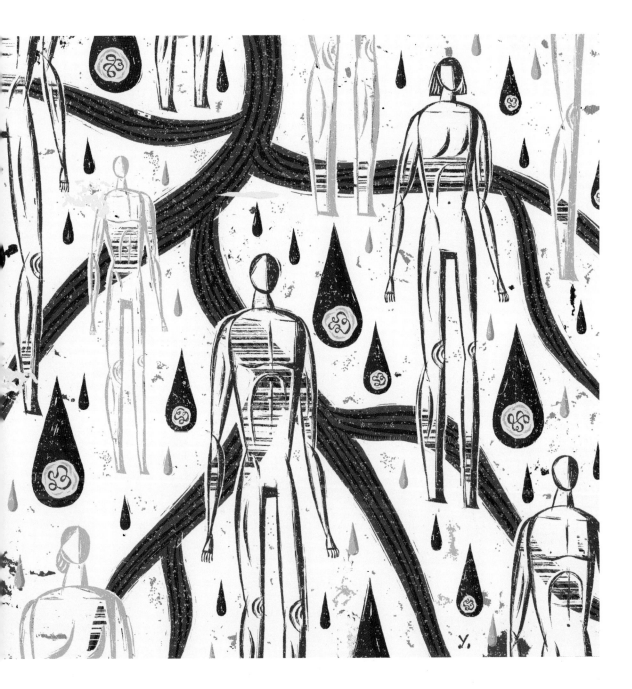

BRAD YEO

This image appears as the lead image for the chapter entitled "Epidemics" in a book published by the Johns Hopkins Bloomberg School of Public Health.

The social or communal component of this story is very important as it is essential to what defines an epidemic. Today, dense urban populations and the frequency of international travel serve to speed the spread of infection, with the potential to carry disease to almost every corner of the globe. The story speaks of a "hot, wet world" in which disease may incubate and spread through waterborne vectors like carrier mosquitoes. As we experience a gradual warming of global temperatures, we are also faced with environmental conditions increasingly favorable to infection.

My intention in this work was to focus on the water/blood connection as it relates to the spread of infection, a sort of dark rain falling over the community, affecting all within it.

Uncommissioned

CHAIR

VICTOR JUHASZ

ILLUSTRATOR
For 30 years, Victor Juhasz's humorous illustrations and caricatures have been commissioned by many of the major national and international magazines, newspapers, advertising agencies, and book publishers. His work appears monthly in *Golf* magazine, *Reader's Digest*, and *The New York Observer*. Victor's caricatures are owned by a number of his subjects, including David Boies, senators John Breaux and Tom Daschle, Tim Zagat, Joe Torre, golf pro David Feherty, and Ken Burns. After a 20-year absence, 2004 marked the artist's return to children's books with the publication of the very successful and critically acclaimed, *D is for Democracy* from Sleeping Bear Press. He is currently working on a new book about poetry for the same publisher. Victor is a board member of the Society of Illustrators. He lives in Stephentown, New York, in the Berkshires, with his wife, Terri, a successful teacher and psychotherapist.

FLORIAN BACHLEDA

DESIGN DIRECTOR,
VIBE
Florian Bachleda was born in Chiang Mai, Thailand, in 1965. He graduated from the School of Visual Arts in 1987. As a senior, he edited and designed the school yearbook with classmate Eric Palma. Florian has since worked as a senior art director at *The Village Voice*, an associate art director at *Entertainment Weekly*, an art director at *New York* magazine, and design director of *P.O.V.* (Point of View) magazine and *Maximum Golf* magazine. For the last four years, he has been the design director of *Vibe* magazine. While he was at *Vibe*, the magazine won a National Magazine Award for General Excellence. Florian has won awards from the Society of Publication Designers, *American Illustration*, American Photography, *Print*, *Communication Arts*, and the Society of Illustrators. Florian currently serves on the board of directors of the Society of Publication Designers. He enjoys reading, soccer, basketball, biking, living in New York City, and playing with his cat, Chairman Mao.

JOSEPH DANIEL FIEDLER

ILLUSTRATOR,
EDUCATOR
Joseph Daniel Fiedler was born and raised in Pittsburgh, Pennsylvania. His entire life has been consumed with a passion for making pictures. He has spent the last eight years living in the mountains of northern New Mexico. He has also lived in Tokyo, Japan, and since December 2003, in the historic Indian Village of Detroit with his faithful cats, Iko and Obeah. He is an associate professor of illustration at the College for Creative Studies in Detroit. His work has appeared in numerous national and international publications including *TIME*, *BusinessWeek*, *The Washington Post*, and many other magazines and newspapers. He has illustrated three children's books, received a Silver Medal from the Society of Illustrators, and has been recognized by *Graphis*, *Print*, *Communication Arts*, *American Illustration*, the Society of Publication Designers, The Spectrum International Annual of Fantastic Art, and the Broadcasting Design Association, among others.
"Since I'm most definitely not a people person, getting lost in the world of pictures is the ideal ticket for me."

CHRISTOPHER A. KLEIN

ART DIRECTOR,
NATIONAL GEOGRAPHIC
Born in suburban Maryland, Chris Klein demonstrated a natural ability for drawing. He went to the University of Maryland, where he studied archaeology and anthropology, and finished his formal education at Cooper Union. After college he worked as a freelance illustrator, finally securing a full-time position at the National Geographic Society in 1979. From being a staff artist for many years, Chris became an art director for the art department of the magazine. Being at the forefront of the digital revolution, Chris has pioneered new approaches to art for the magazine; he has worked on many high-profile stories where he encouraged the use of three-dimensional computer animation, storyboarding techniques, matte, and other digital painting. He is constantly on the lookout for new artistic talent to further his mission in producing the highest quality art for *National Geographic*. He lives with his wife and four cats in rural Maryland, near the Civil War battlefield of Antietam.

ROSS MACDONALD

ILLUSTRATOR
Ross MacDonald's work has appeared in many publications including *The New Yorker*, *Vanity Fair*, *Newsweek*, *TIME*, *The New York Times*, *Rolling Stone*, *The London Sunday Telegraph*, *The Atlantic Monthly*, and *Harper's*, as well as on ads, book covers, a postage stamp, on-air television graphics, and animation for Saturday Night Live. He has worked on *Seabiscuit*, *Van Helsing*, *Duplex*, *The Legend of Zorro*, *The Alamo*, and *Baby's Day Out*, supplying illustrations and props, and as a consultant on historical design, paper, printing, and writing instruments.
He has been honored by *American Illustration*, *Print Regional Design Annual*, *Communication Arts*, the Society of Publication Designers, the American Institute of Graphic Arts, and the Society of Illustrators, and was the subject of a one-man retrospective at *The New York Times*.
His children's book, *Another Perfect Day*, received starred reviews from *Publishers Weekly* and the *Kirkus Review*. The *Noisy Alphabet* was chosen as a book of the week by *Publishers Weekly* and a Best Book of 2003 by *Child Magazine* and *Nick Jr.* magazine.

ERIC PALMA

OWEN PHILLIPS

ALISON SEIFFER

JEAN TUTTLE

ILLUSTRATOR

Eric Palma is a native
New Yorker who has been
an editorial illustrator for
over 15 years. He attended
the School of Visual
Arts, where he met and
later became assistant to
MAD magazine creator
Harvey Kurtzman. Eric's
first regularly published
work appeared in *The
Village Voice* and *7 Days*
magazine. Known for his
caricatures and humorous
line drawings, his work
has appeared in a broad
range of publications
including *The New Yorker,
Entertainment Weekly,*
and *Newsweek.* Eric has
received awards from the
Society of Publication
Designers and *Art
Direction* magazine. He
lives in Brooklyn with his
wife, Sarah, and three year
old daughter Isabel.

ILLUSTRATION
EDITOR, *THE NEW
YORKER*

Owen Phillips is the
Illustration Editor at
The New Yorker. He has
reviewed art, photography,
and restaurants for *The
New Yorker*'s "Goings
on About Town" sec-
tion and contributed
an essay on the scato-
logical anti-art posters of
Jonah Kinigstein for *The
Ganzfeld #4.* He has also
contributed illustrations
to *The New York Times,
The Washington Post,*
and *TIME.* He lives in
Brooklyn with his wife and
three kids.

ILLUSTRATOR

In 1984, Alison Seiffer
received a BFA in illustra-
tion from Parsons School
of Design and illustrated
*Plain Jane's Thrill of
Very Fattening Foods* (St.
Martin's Press). Her black-
and-white scratchboard
illustrations appeared
in *The New York Times,
The Washington Post,*
and *The Boston Globe.*
From 1990 to 1995 she
illustrated the "Letters"
page for the "Arts and
Leisure" section of the
Sunday *New York Times.*
Switching to gouache,
she made illustrations
for *Esquire, Glamour,
Newsweek, BusinessWeek,
TIME, The New Yorker,*
and other magazines here
and abroad. In 1991 she
was commissioned for
a series of bus shelter
and billboard advertise-
ments for Levi's Jeans
for Women for which she
won *Adweek*'s Creative
All Star Award. Other
awards include those from
Communication Arts, the
Society of Publication
Designers, *Print's Regional
Design Annual,* and
American Illustration. In
1994 she illustrated *How
to Make Your Man Behave
in 21 Days or Less Using
the Secrets of Professional
Dog Trainers* by Karen
Salmonson (Workman).
She has been represented
by Gerald and Cullen
Rapp since 1995.

ILLUSTRATOR

Jean Tuttle was raised
outside of Chicago by a
creative mother and an
entrepreneurial father,
both of whom loved
art and were profes-
sionally involved in the
graphic design field. Jean
began her illustration
career in the late '70s in
Manhattan, after receiving
her BFA from Parsons
School of Design. She
first became known for
her high-energy, graphic
scratchboard style before
switching to the com-
puter in the late '80s.
Jean's illustrations have
appeared in many major
publications, as well as
in advertising, corporate
communications, and on
packaging and products.
Her work has been fea-
tured in several books on
illustration and computer
illustration, and has been
recognized by *American
Illustration, Print, How,*
the Society of Publication
Designers and the Society
of Illustrators, from whom
she received a Silver
Medal in 2004. Jean is a
member of the Society of
Illustrators, the Colorado
Alliance of Illustrators,
and a former board
member of ICON, the
Illustration Conference.
She lives in Denver with
her husband James Carr,
features design director of
The Denver Post.

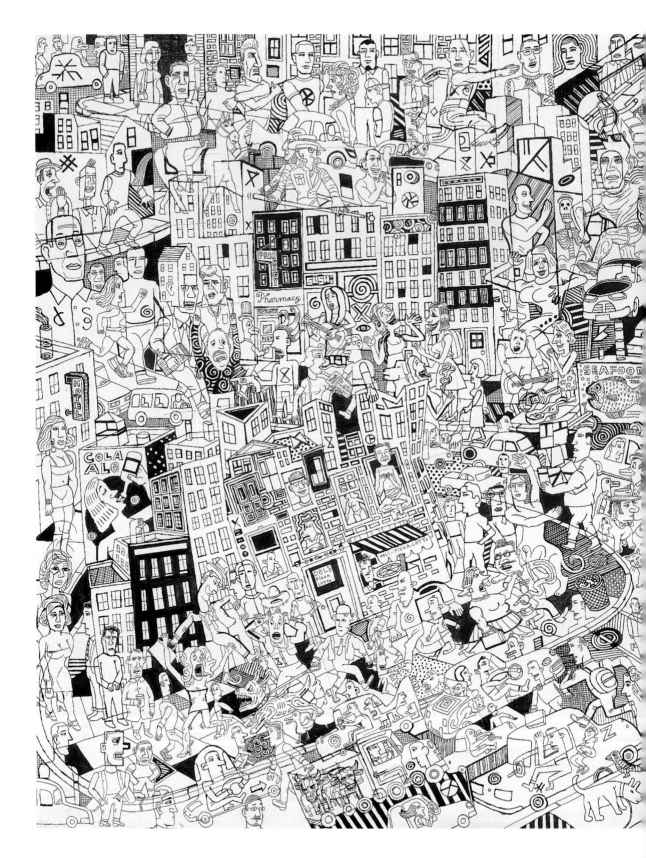

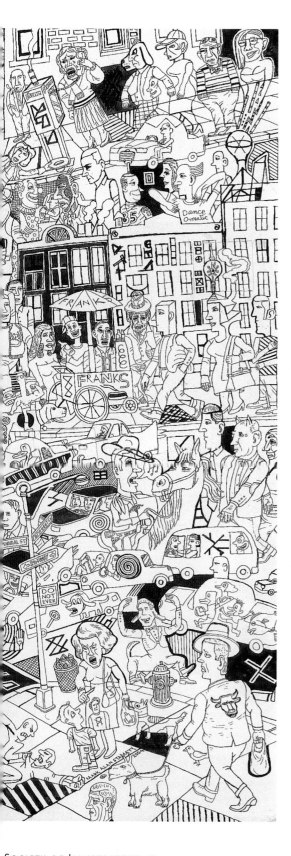

The great thing about the Uncommissioned category is that it offers an opportunity for work to be shown and seen that normally might not be. Work done purely from the intuition, purely for self-fulfillment. Work done from the mysterious place within where the desire to make art originates. I am very interested in that place and that sort of art. This drawing was done over a period of many months. I lost count of how long. I just went to it whenever I had the time and the urge. Sometimes, if I was unhappy with parts of it, I would cut out a smaller piece of plate-finished, two-ply Strathmore and glue it (with Elmer's glue) right over the areas I was unhappy with and continue drawing. To me, this drawing is about energy. Intuitive energy. Not from the head. More from the gut and soul. The art I love best comes from that place. A place I seek always to connect with. And it's about a feeling. About how the making of the picture and looking at the picture makes me feel. It goes beyond the limits of the brain to the place within myself where I most deeply wish to be.

SILVER MEDAL WINNER
ALEX GROSS

This piece was created for gallery exhibition rather than for a traditional illustration client. Therefore, the process was quite different. In my case, I like to start sketching without any pre-conceived plan or idea, and be open to what emerges. Often I get inspiration from imagery that I see somewhere. In this case, it was Audubon's *Birds of America*. I started playing with some sketches after studying his paintings of an Arctic Tern, and that provided the impetus for this piece. From there, I developed the other elements and began to consider the emotional and conceptual aspects of the image. Sometimes I like to employ type in my gallery work, and in this case, after many different attempts, I chose the Japanese word for punishment: Shokei. When I finish a drawing, I transfer it to canvas (in this case about five feet tall) and begin to paint with oils, my preferred medium. I try not to spend more than a month on a painting, but occasionally it does take me longer.

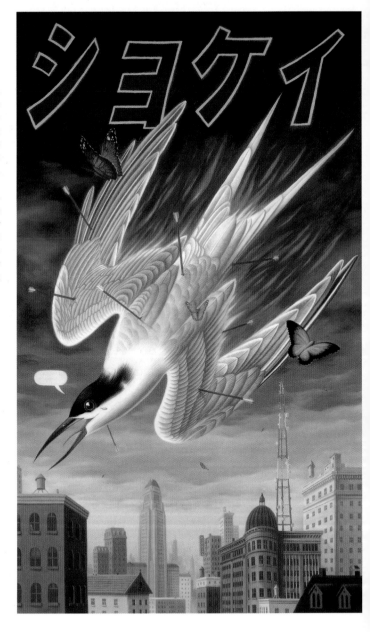

BIRGIT AMADORI

I made this picture to reflect a feeling of eeriness or fear I get after I've consumed my usual massive amounts of ghost stories and ghost movies. It is a bad habit but somehow I cannot leave it behind. It always strikes me how a scene can be cozy or positive during the daytime, but once night falls things become scary—you wouldn't want to be alone in an otherwise beautiful landscape without sunshine.

Tim Bower

A mural depicting characters from American folklore.

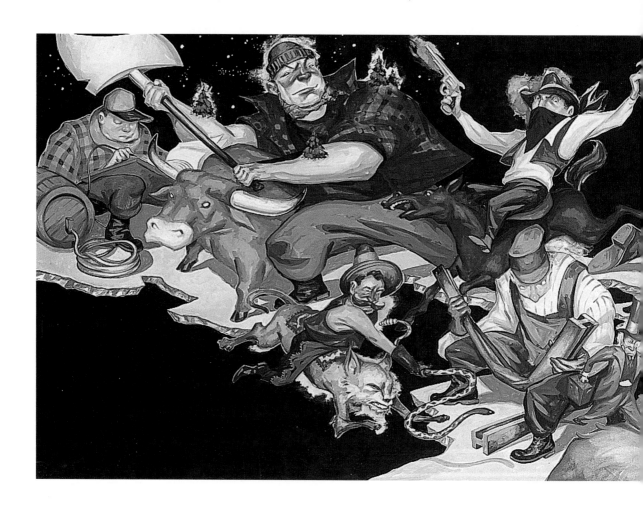

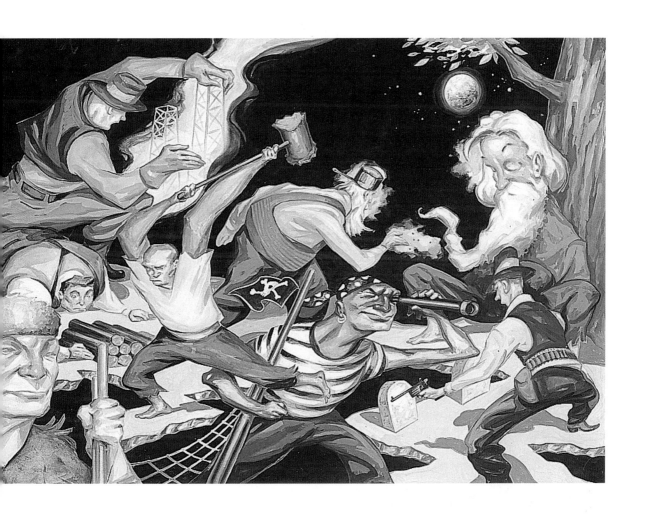

JULIETTE BORDA

This was originally commissioned for *Playboy* for a series of essays by
David Mamet.

JOE CIARDIELLO

This is a portrait of Bluesman Mississippi John Hurt. The print was created by transferring the drawing (on acetate) to a solar etching plate.

FERNANDA COHEN

Pasta and I belongs to the Food Affair series, based on the concept of the rather disproportional state of mind experienced only by those who fall in love or indulge themselves in their ultimate craving. Each piece in the series represents a different emotion through its own different flavor. All 13 pieces from the Food Affair were exhibited as a solo show in the TriBeCa gallery, A Taste of Art, in November 2004.

Pasta and I has also received a Gold Medal for Best in Show at the Society of Illustrators of Los Angeles's IW 43 annual. This particular piece was greatly inspired by the incomparable charm and talent of Mr. Mirko Ilic.

JOHN CUNEO

I live and drink in a small town that's one of the country's oldest designated artists' colonies. Everybody is a painter or a musician. Even if they're a carpenter. Or an illustrator. Conversations like the one here are not uncommon.

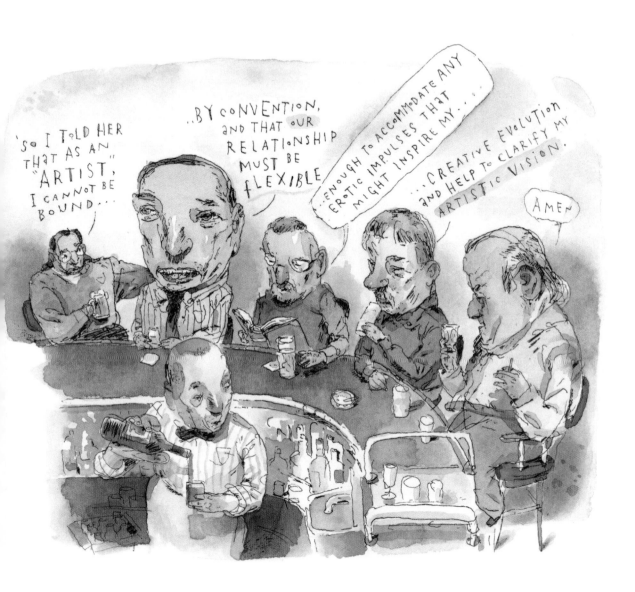

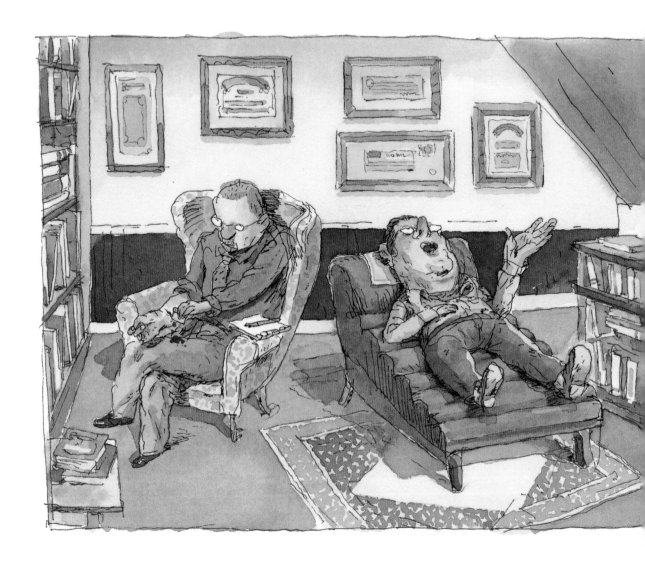

JOHN CUNEO

Somewhere, in some cartoon collection (perhaps even in the inevitable *New Yorker Book of Shrink Cartoons*), there has got to be a picture of a psychiatrist holding a gun to his head, or maybe standing on a chair with a noose around his neck. I simply cannot imagine that this is the first ever drawing that depicts a shrink with suicidal intentions. So, to atone for any unintentional plagiarism, I'd like to point out that, while the bookcases may look okay (they are drawn from reference), there is a good deal of unsightly scrapings around the patient's left foot, and the couch appears to be built entirely out of Lincoln logs.

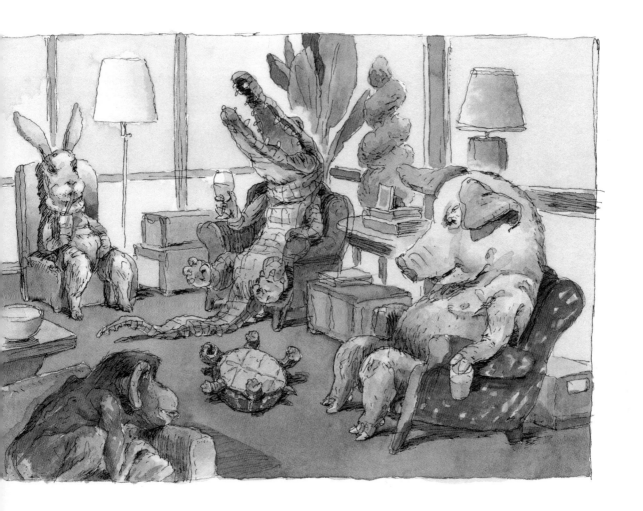

JOHN CUNEO

Sometimes it's a struggle for me to draw things in an environment—to put characters in a room, or a car, or a specific place. I'm always amazed at how other illustrators manage to suggest backgrounds and "context" successfully. And then I try and rip them off. I also rip out photographs of rooms from magazines and try to draw them for practice. Here, I decided to put some animals on the furniture. For better feng shui, the ottoman has been replaced by a helpless turtle.

THOMAS ESCHER

This piece is part of an ongoing linocut series devoted to deer hunting, lost hunters, and dark woods. My hunters seem to have an unusual predilection for becoming "captured by the game." It is a subject that has fascinated me for quite a while—it's hard to tell why. I guess my sources of inspiration here are both the vague memories I have of tales told by the Brothers Grimm, and my own yearning to escape from the city by running off into the woods.

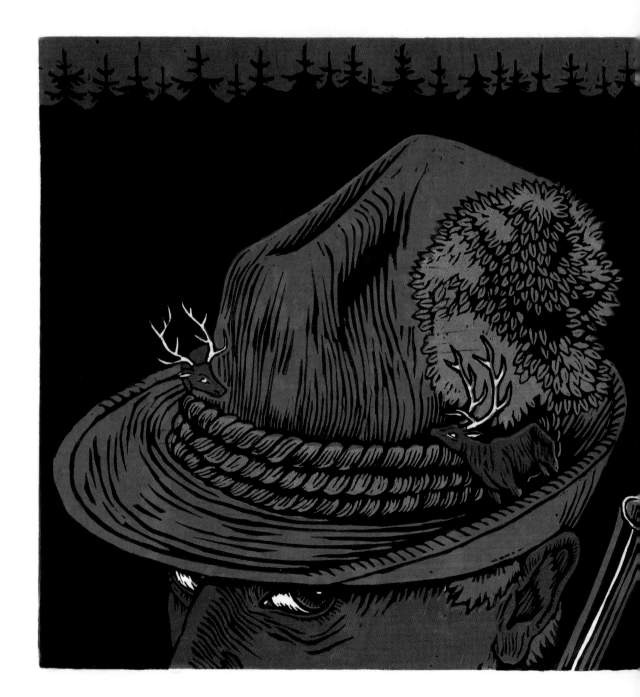

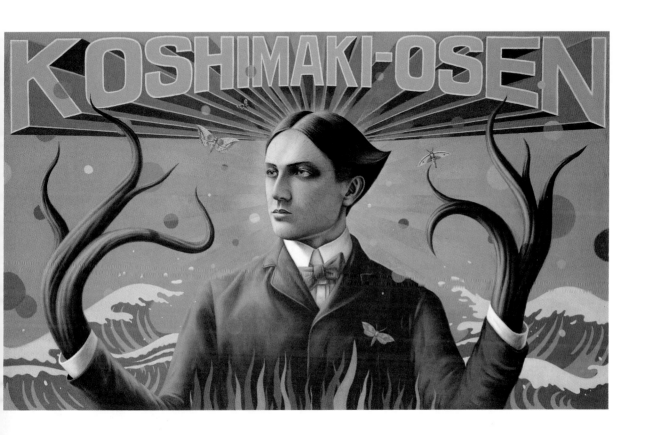

ALEX GROSS

This piece was done for a gallery exhibition. It is a personal work that started with an old photograph that I found. The painting itself is homage to famed Japanese graphic designer Tadanori Yokoo, who has been a big influence on me and my work. The title, *Koshimaki-osen*, comes from a poster that he designed in the late '60s. Also, the graphic depiction of waves in the background was largely referencing him.

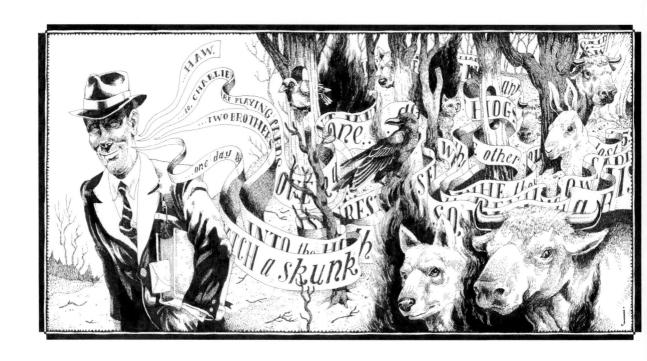

JOHN HENDRIX

This piece is about my grandfather, John W. Johnson. John was a farmer, a simple yet strong-spoken man. The words he chose were few and always important. Chatter in the room always paused when he told a story. But every Sunday, his overalls were replaced with coat, tie, and hat as he left for church. It is that image that always comes to mind when I hear his name. I imagine those stories and jokes are still rattling around in his woods late at night.

John Kascht

When Katharine Hepburn was in her late eighties, and I was in my early thirties, I spent two days with her at her home in Manhattan. I made a pile of drawings—some finished, some scribbles, some of them just a study of her nose or an eye or that tangle of hair.

Apparently, they are the last images made of her. When I met Miss Hepburn, her days of being seen or photographed were past. Not long after our meeting, she moved to Connecticut where she remained in seclusion until her death several years later. That's when *The New York Times Magazine* published four of the drawings and a reminiscence of my visit.

One vignette in particular sticks with me. We were eating dinner on little trays in front of her fireplace. There hadn't been any conversation in a while when she asked softly, "Are you happy?" The question was startling, coming from someone so famously unsentimental. "Yes" I answered honestly, "I am."

"Good." She smiled. "That's the main thing. Be happy."

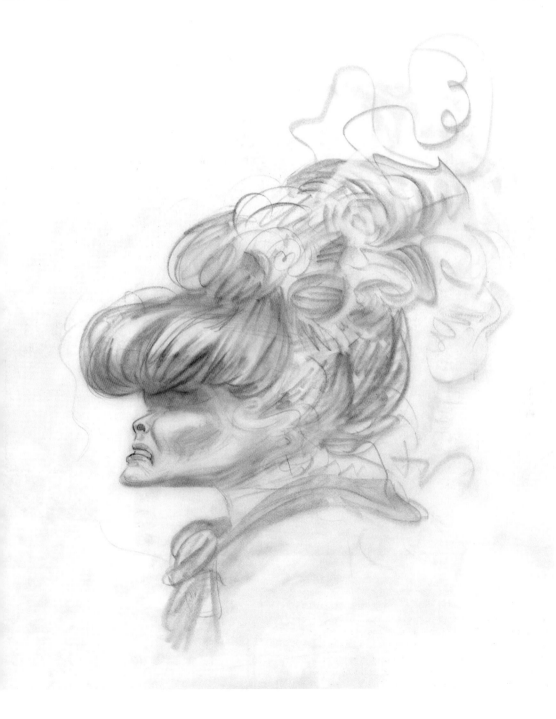

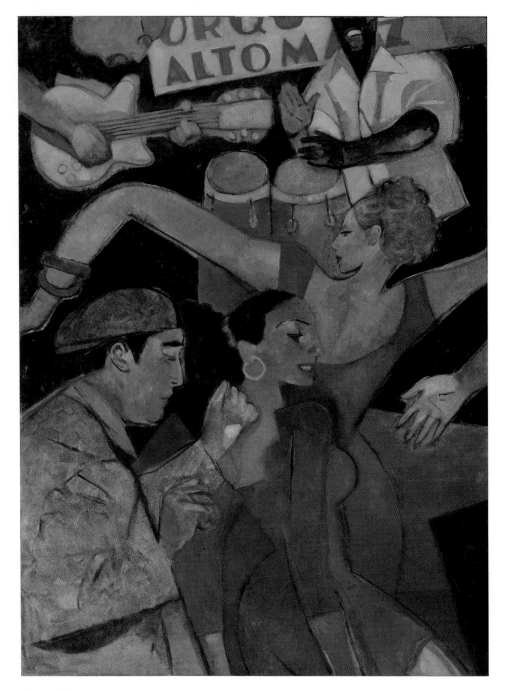

GARY KELLEY

This painting is one of four that line up to complete a single image, a kind of triptych plus one. It recalls an evening well spent in a Rotterdam jazz club a few short years ago. The experience was part of a European tour I joined with some musician friends of mine who play Latin jazz and Salsa. The band traveled from the Montreux Jazz Festival to the North Sea Jazz Festival with a number of club gigs in between. This is one of the recent paintings to emerge from my sketchbook documenting the trip, its colors reflecting the profound effect Montreux had on my palette.

GRAIG KREINDLER

In depicting Lou Gehrig's farewell from baseball, I wanted to not only focus on the power of the moment, but also give the viewer an idea of what it was like to be at Yankee Stadium in 1939. The old stadium had such a great look to it, especially with the copper frieze adorning the upper deck—a defining feature I thought was absolutely necessary for the success of the image. After thorough research, I found the perfect image to portray this memorable event. The National Baseball Hall of Fame was incredibly generous in supplying me with color video footage of the ceremony from which I was able to pull the indispensable details to make the painting seem as "authentic" as possible. I was overjoyed to depict baseball's "Gettysburg Address" with such a level of historical accuracy.

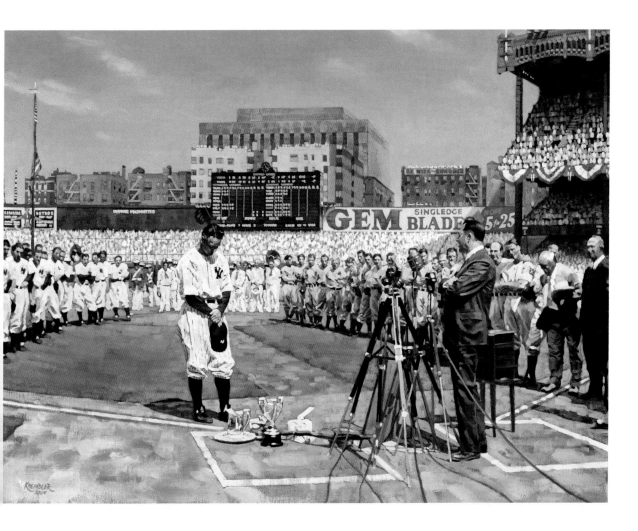

ANITA KUNZ

This was a personal piece in a series of artworks having to do with gender issues. This one is concerned with birth order and the relationships mothers have with their children, leading to consequences later in life for the offspring.

TRAVIS LAMPE

The idea for *Bird Shot* came to me while I was on vacation sketching outside a pub in London. I'd had a vague notion floating around in my head for some time about birds and birdhouses and what the relationship might be between them. The rest was a childhood memory of the first (and last) bird I ever shot with a BB gun, a terrible mistake from which there was no turning back. Only in the memory, the bird wasn't reading a book or wearing glasses.

KATHERINE MAHONEY

When I set myself this project, a sequence of four images, it was my hope to join my love and fascination with the natural world to a character that would experience the seasons as I had realized them visually. Because I imagined these as a poster series, the strength of the graphic design was a major consideration and one of my great pleasures working on it. As the project evolved I was reminded of how we draw sustenance and solace from those living things that travel the same arc of life that we do.

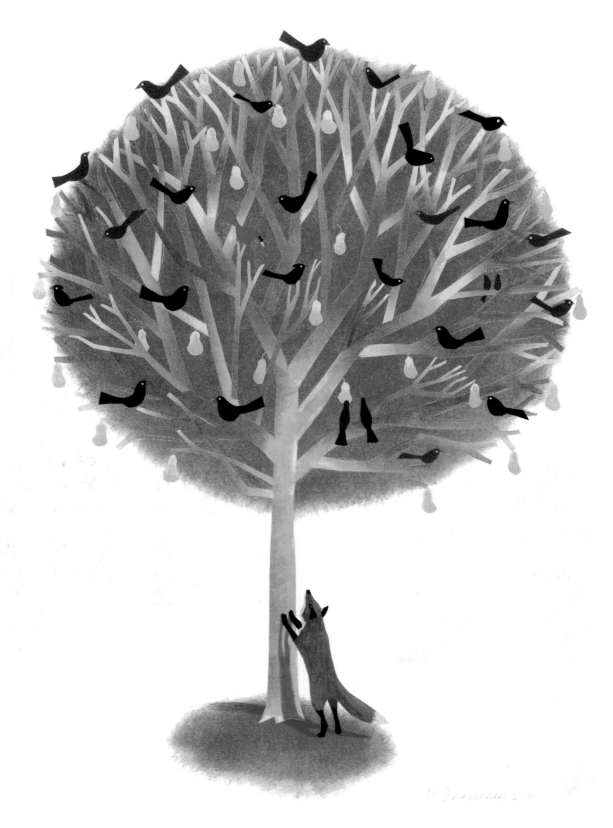

Francis Livingston

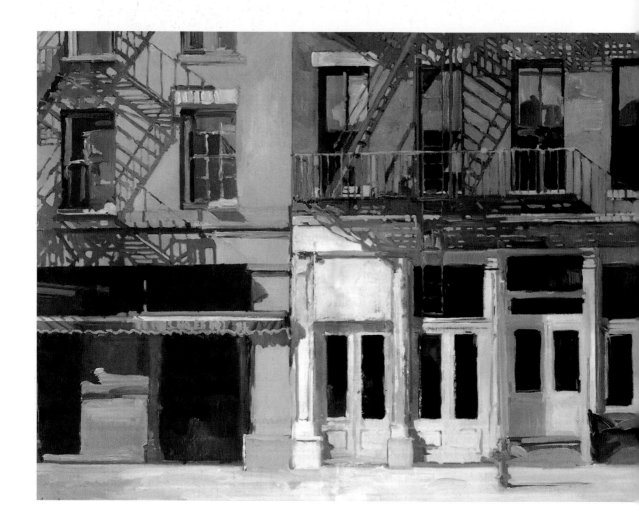

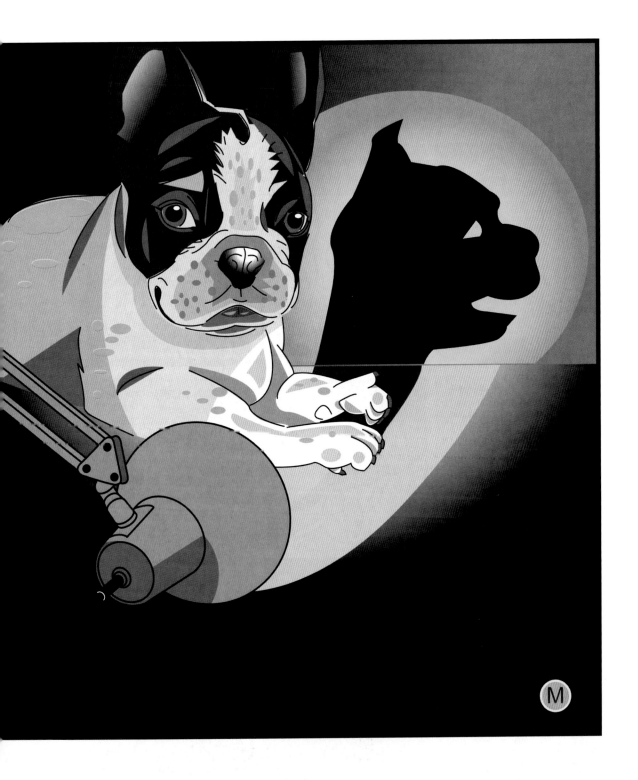

ROBERT MASSA

This work is one in a series of illustrations of my dog Lulu. I'm using this exercise to explore and develop my illustration style and to document the life of this wonderful companion whose personality surprises me every day.

ADAM McCAULEY

This comic was born on a treadmill at the gym, while brainstorming ideas to submit to Joe Kimberling at *Los Angeles* magazine. It being the season of an extremely contentious election year, and myself being extremely worked up about the politics of the day, I chose a political theme. It's no secret that San Francisco, my hometown, is, to put it mildly, "alternative", with the aforementioned gym the perfect alternative microcosm. As I am always ready to exploit any double-entendre I have the good fortune and question able judgment to recognize, these themes just fell into place. Joe loved i but told me flat out there wasn't hope for it in *Los Angeles*. Oh well, there always the "personal work" file. I can at least be thankful that judging day fo this competition happened to coincide with Election Day, so I must assum that the election results helped vote in my piece!

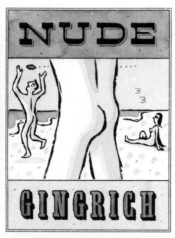
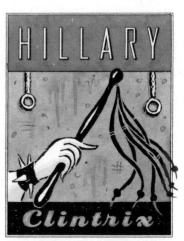
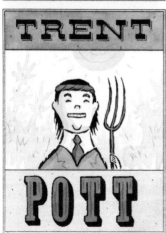
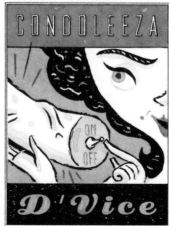

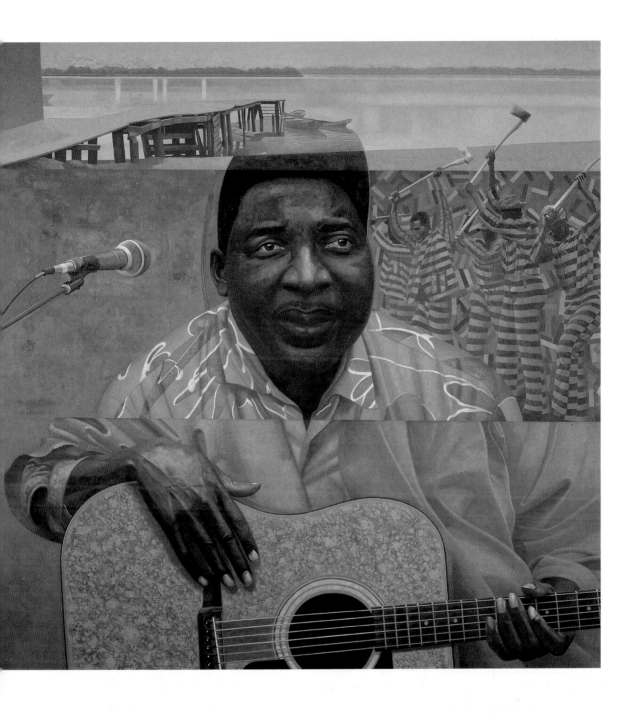

CARLO MOLINARI

KEN ORVIDAS

A photo of a dog leaping after a Frisbee inspired this personal piece. The dog seemed so determined to catch the Frisbee he looked as if he would do almost anything to get it. What scenario would epitomize "determination" to the point that it would be motivational? I think I found it and I think the dog is going to succeed.

TAKASHI SAITO

For this work, I made a variety of monochrome studies based on a single photograph using pencils, charcoal, gouache, etc. While making the studies, I gradually simplified the form. Then, I selected the best study and traced its outline on cardboard ground with sand-mixed gesso. Lastly, I used oils for this work to add effective shading and express a vigorous sense of volume.

Otto Steininger

OTTO STEININGER

MARK TODD

This piece was used for *Why Journal* that featured illustrators from Picture Mechanics, an online co-op of artists. We were asked to explain, through a series of illustrations and interviews, why we do what we do. I had a lot of fun with this piece, wanting to keep it humorous by referencing my childhood, growing up in the suburbs of Las Vegas, collecting comic books. *Iron Man*, Issue 179, was the first comic I ever bought. Years later, my collection had grown into the thousands, each comic carefully read, bagged, boarded, and stored in my closet. Like a lot of illustrators my age, collecting comics propelled my interest in becoming an artist.

Jean Tuttle

This was an experimental piece. I collect religious imagery and have it all around my studio but have never incorporated any into a drawing, oddly enough. However, I was reading a book at the time, *The Secret Life of Bees* by Sue Monk Kidd, in which a Madonna figures prominently, so the Virgin Mary just found her way into my sketchbook and into my computer. I kept the drawing linear, the palette limited, and the line work decorative in hopes of conveying an ethereal quality, versus one of solid flesh and feature.

Jean Tuttle

I had recently moved to Denver after 30 years on the East Coast and was missing old friends. My sketchbook filled up with whimsical drawings of many of them, some of which I finished up as personal projects. This is a portrait of my close friend, Susan, whom I met back at Parsons in the '70s. She is quite beautiful and has a flair for costume, things I love but could never wear. The piece is based on a masked ball she went to a few Halloweens ago and told me about. In reality her outfit was all black, very chic, and included a feathered bird mask. I made it more colorful and feminine to reflect her personality. I was working from my head, not a photo (though I had seen some), and as I refined the drawing, the face started to look less like hers, and more like my own—or so other friends told me. But I liked that, as it symbolizes what happens with old friends, i.e., parts of them begin to overlap.

JONATHAN TWINGLEY

I made this painting for an invitational group exhibition at the Rourke Art Museum in Moorhead, Minnesota. The exhibition had a theme—The Year of the Irish—commemorating the 100th anniversary of Leopold Bloom's walk across Dublin. Ulysses was actually read out loud at the Museum in a series of readings in the months leading up to the exhibition. Yikes. I've read half of *Ulysses* several times, but never the other half.

Mark Ulriksen

New Hampshire Primary is a personal piece. I don't know which came first, the image of a bunch of look-alikes all shouting in a forest or my disgust with politics-as-usual every election season. But if a tree falls in a forest and everyone shouts simultaneously, does it make it any easier to understand what's going on?

KURT VARGO

I began working on celebrity portraits in 2003. I thought it would be interesting to challenge my drawing skills, create new samples, expand the range of my portfolio and increase income revenues.

Pol Pot, leader of the Khmer Rouge movement and Cambodian dictator, was created in 2004. His despicable regime of torture and genocide of the Cambodian people placed him at the frontline of the infamous as a portfolio piece. Since Pol Pot was a sample, there was the luxury to break rules. Different surface textures, color systems, a bolder, more freewheeling black

line and a disturbing tension to the concept, made the piece a cornerstone for additional "New Works."

His disturbing grin, vacant bloody eyes, and "accolade" of skulls hanging on his chest, Pol Pot is not a favorite of art directors. Also, it hasn't generated any work that focuses on the infamous celebrities projected in my portfolio. Yet, it is an image that's been judged and accepted by the standards of my peers and the Society of Illustrators. That's an accomplishment easy to live with.

WALTER VASCONCELOS

The chosen subject for the calendar was time. No text to read or interpret, no pre-established concept ... which made the task extremely pleasant! To tell the truth I often work without any rationalization of concepts. I try to "play" drawing. The word "ludic" is a constant in my vision of illustration. I made some sketches and I liked that mouse. Then I looked for images of clock engines in my archives of old magazines and reference books. With the central image finished, I tried to balance the illustration. The technique is mixed: ink, spots, lines, old papers, tape, and knife, finished in Photoshop with dozens and dozens of layers.

JONATHAN WEINER

WILL WILSON

was invited to participate in a group exhibition with the theme of *trompe-l'oeil*. I have always enjoyed producing fool-the-eye type paintings; my tightly rendered representational style seems to lend itself to that genre. The idea for *Free Range* came to me as I was preparing a large dinner party with Cornish game hens as the main course. The color, form, and texture of the hens provided the main jolt of inspiration for the painting. A couple of days later I

found myself in San Francisco's Chinatown buying a live chicken which I then murdered, plucked, and posed in various positions. I prepared a special panel for this oil painting: a one-and-a-half-inch-deep cradled panel, covered front and sides with a very fine linen coated with gesso. This was done so that the finished painting would appear to be framed when hung on the wall. Three months and a dozen chickens later the painting was finished.

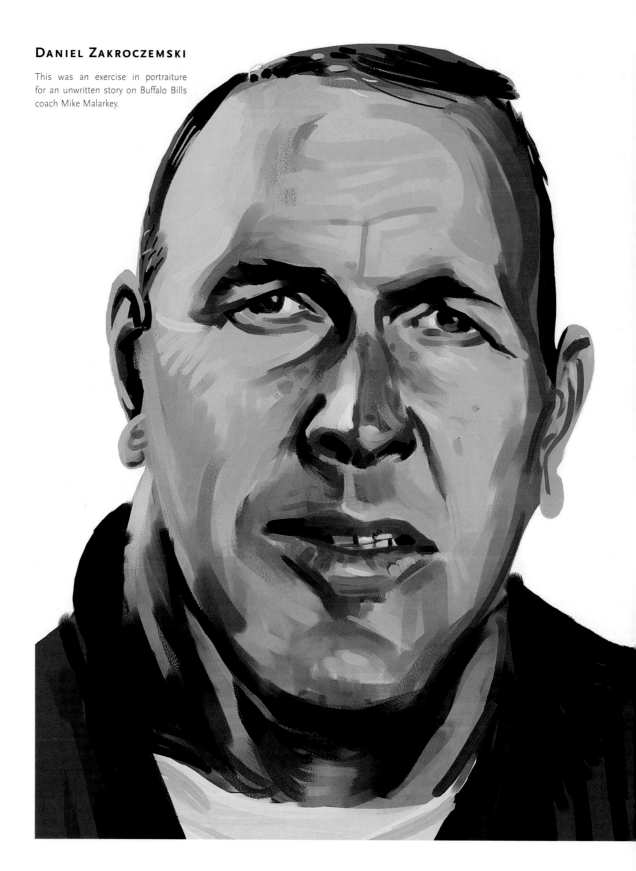

DANIEL ZAKROCZEMSKI

This was an exercise in portraiture for an unwritten story on Buffalo Bills coach Mike Malarkey.

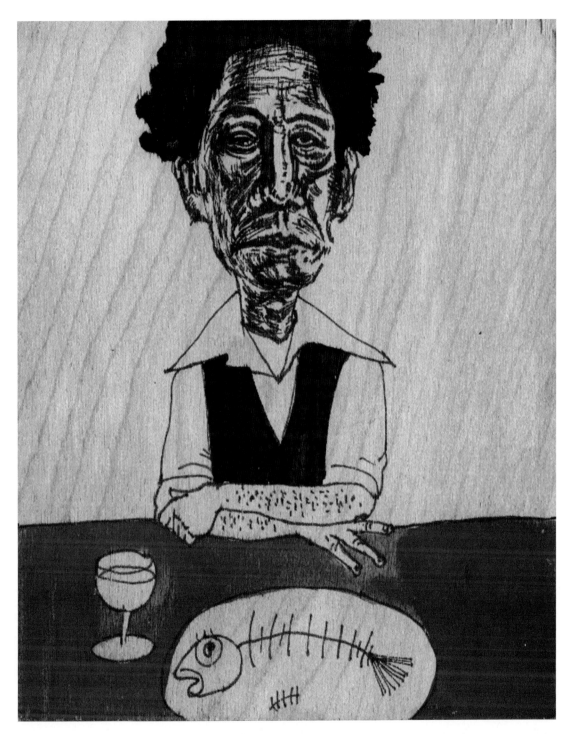

Philip Zhang

Man and Fish is one of the restaurants series I did a while ago. I did nearly a hundred of them in six months. There are a lot of restaurants and bars near where I live, and I did some sketches every time I went there. When I got back home, I painted it on wood. I always try to keep the energy of the drawing and keep the colors minimal.

SEQUENTIAL

SEQUENTIAL JURY

MARSHALL ARISMAN

ILLUSTRATOR, EDUCATOR

The paintings and drawings of Marshall Arisman have been widely exhibited internationally and nationally. His work may be seen in the permanent collections of the Brooklyn Museum, the National Museum of American Art, the Guang Dong Museum of Art, and the Smithsonian Institution.

Heaven Departed, his graphic commentary on the emotional and spiritual impact of nuclear war, was published in book form by Vision Publishers (Tokyo, 1988).

Chairman of the M.F.A. degree program at the School of Visual Arts in New York, Marshall was the first American artist invited to exhibit in Mainland China. His series, "Sacred Monkeys," was exhibited at the Guang Dong Museum of Art in April 1999.

He is the subject of a full-length award-winning documentary film directed by Tony Silver titled *Arisman, Facing the Audience*. The film received the award for creative and artistic achievement at the Santa Barbara International Film Festival.

MONTE BEAUCHAMP

ART DIRECTOR
BLAB!

Monte Beauchamp is an award-winning art director and the creator, editor, and art director of the avant-garde illustration, cartoon, and design magazine *BLAB!*

His books include: *Striking Images: Vintage Matchbook Cover Art* (Chronicle Books, 2006), *The Devil in Design* (Fantagraphics, 2004), *New and Used Blab!* (Chronicle Books, 2003), and *The Life and Times of R. Crumb* (St. Martin's Press, 1998).

His work has appeared in *American Illustration, Communication Arts, Graphis, Print*, and the Society of Publication Design and the Society of Illustrator's award annuals. He has won five New York Festival Awards for excellence in print and television communications.

In late 2005 he launched BLAB! PICTO-NOVELETTES ™, a series of 32-page storybooks for adults, illustrated and written by a potpourri of *BLAB!* talent including Sue Coe and Judith Brody, Camille Rose Garcia, David Sandlin, Drew Friedman, Bob Staake, and Walter Minus.

Monte Beauchamp lives and works in Chicago and Los Angeles.

GREG CLARKE

ILLUSTRATOR

Armed with a degree in art from UCLA and no marketable skills to speak of, Greg Clarke began his professional career as a lackey in an ad agency. On the strength of unsolicited submissions during concept meetings, he was made an art director. He followed this with a stint as a graphic designer before turning to illustration fulltime. His work has appeared in all manner of publications including *Rolling Stone, The New Yorker, The Atlantic Monthly, Mother Jones,* and *TIME.* He is a regular contributor to *BLAB!*, the irreverent comic anthology. Corporate clients have included Purina, Volkswagen, and Merrydown (London). He has been recognized by *American Illustration*, the Society of Illustrators, *Graphis*, and *Communication Arts.* Greg resides with his wife, two kids, and two cats in Newbury Park, California.

JORDAN CRANE

ILLUSTRATOR

Jordan Crane edits, publishes, and draws for the acclaimed anthology "NON." His first book, *The Last Lonely Saturday*, was nominated for both the Eisner and Ignatz awards. A Los Angeles native, he currently lives there.

JON FOSTER

ILLUSTRATOR

Foster studied illustration at the Rhode Island School of Design and graduated in 1989. He made a splash by illustrating for TSR, and later, Wizards of the Coast for whom he did work for their *Alternity* game. He did covers and interiors there and for some magazines such as *Realms of Fantasy* and *Science Fiction Age*. Foster's first *Star Wars* assignment was "The Hunt for Aurra Sing," a four-part arc in the ongoing monthly Star Wars comic. He lives in Providence, Rhode Island.

PAT MORIARITY

ILLUSTRATOR

Pat Moriarity was born in Chicago and graduated from Iowa State University. He worked at the Walker Art Center in Minneapolis while freelancing for such clients as Medialoft, Twin/ Tone Records, the local weeklies, and rock bands. In 1988 he won first prize in the *Twin Cities Reader*'s first annual cartoon contest. After doing comics for Fantagraphics books, Pat moved to Seattle in 1991 and became their art director, and later art director for the award-winning *Comics Journal* magazine. He also moonlighted as alternative comic book artist and his *Big Mouth Comics* was nominated for a Harvey award. Featured as *Rolling Stone* magazine's hot cartoonist in 1996, he then worked for clients like Nickelodeon, the *Rocket*, Subpop Records, *Details*, and CMJ. His work has appeared in *Print* magazine, *National Geographic Kids*, Estrus Records, and *Chrysler* magazine. In 2002 he won the GAP award from the Washington State Arts Commission and the Artist Trust Organization. He had three pieces displayed at the Society of Illustrators 46th annual exhibition. He lives in Port Orchard, Washington, with his wife Lori and son Jack.

MARTHA RICH

ILLUSTRATOR

Originally from Philadelphia, Martha Rich lived the typical suburban life until she followed her husband to Los Angeles where, just short of a picket fence and 2.5 children, her average American life unraveled. To cope with divorce, fate led her to an illustration class taught by the Clayton Brothers. They persuaded her to ditch the cubicle, pantyhose world, quit a human resources job at Universal Studios, and join the world of art. Her illustrations have been seen in magazines from *Rolling Stone* to *CosmoGIRL!*, in *American Illustration 21, 22, 23,* and most recently in a Beck's music video "Girl." A teacher at Art Center College of Design, she is currently based in Pasadena and, with five other illustrators, works out of a studio in Eagle Rock, obsessively painting undergarments, lobsters, and Loretta Lynn.

MARC ROSENTHAL

ILLUSTRATOR

After a satisfying but fruitless career as a painter, Marc Rosenthal worked for graphic designer Milton Glaser as a designer and illustrator. Since 1984 he has worked primarily as an illustrator.

Marc's work is seen regularly in *Rolling Stone, TIME, Newsweek, Fortune, The New Yorker, The Atlantic Monthly, US News & World Report, The New York Times, Boston Globe,* and *The Washington Post.* His corporate clients include ATT, Global Village, Schlumberger, Shell Chemical, and Levi Strauss. He has illustrated many children's books: *First, Second* by Daniil Kharms, *The Absentminded Fellow* by Samuel Marshak (both Farrar, Strauss & Giroux); *The Runaway Beard* by David Schiller (Workman Pub); *Dig!* by Andrea Zimmerman and David Clemesha.

He has also had work in *Blab! 13* and *14,* as well as *Little Lit II,* edited by Art Spiegelman and Françoise Mouly. He lives in Lenox with his wife Eileen and his son Will.

WARD SUTTON

ILLUSTRATOR

Ward Sutton is an illustrator, cartoonist, animator, and filmmaker. His illustrations have appeared on the covers of *The New York Times Magazine, The Village Voice, Rolling Stone, TV Guide,* and *The Nation,* as well as in *Esquire, TIME, Entertainment Weekly,* and many more.

He creates the weekly political cartoon *Sutton Impact* for *The Village Voice.* The first book collection of his political cartoons was published in the spring of 2005 by Seven Stories Press.

Ward has created many concert posters for musicians such as Beck, Pearl Jam, and Phish as well as posters for John Leguizamo's Broadway show *Freak* and the 2000 Sundance Film Festival.

He also creates his own animation and has worked on projects for HBO and VH-1, and has designed the opening segment to the cult hit Comedy Central show, *Strangers With Candy.* He is currently working on his own independent film.

He lives and works in Greenwich Village with his wife Sue Unkenholz, with whom he formed Sutton Impact Studio Inc. in 2000.

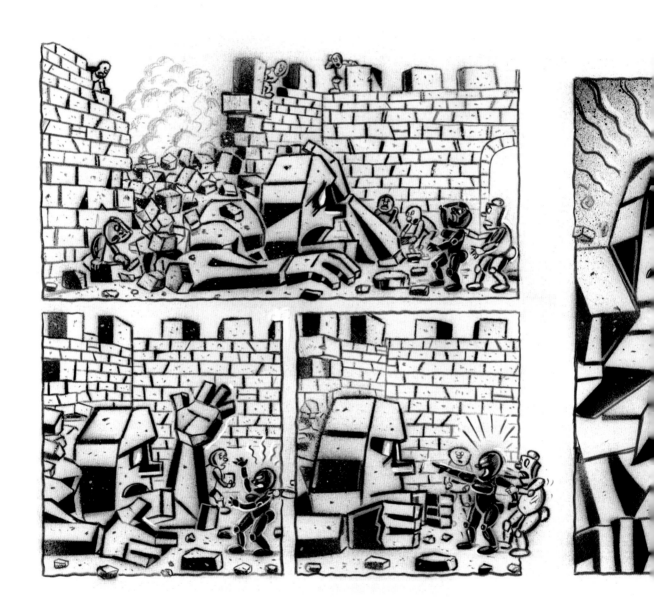

GOLD MEDAL WINNER
PETER KUPER

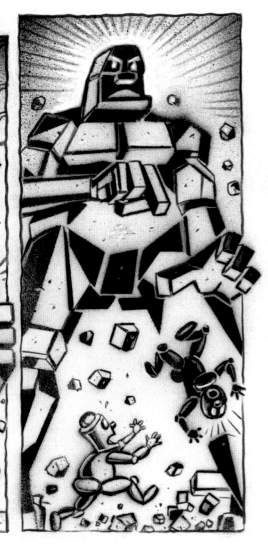

The initial inspiration for my book *Sticks and Stones* came from a comment by the artist Andy Goldsworthy. In the documentary *Rivers and Tides* he talks about his realization that so much of what we consider to be solid and permanent—like mountain ranges—are far from it. Though they appear stationary they have moved miles and changed shape over time.

In this same regard, empires from the Roman to the British that once seemed perpetual have crumbled. The superpower status that the United States now enjoys, with an alarming level of hubris, may too, prove to be another part of this continuum. I decided an allegory would best describe this cycle since it transcends individual politicians or countries. Also, I couldn't bring myself to draw George W. Bush for 128 pages! I made *Sticks and Stones* wordless to make it accessible beyond language barriers and, echoing hieroglyphs, to use pictures as a language of their own.

The art was created by cutting stencils and spraying them with enamel paint. The speckling from the spray paint gave the whole book the texture I was aiming for. I added watercolor, colored pencil, ink, and white acrylic to finish the drawings.

I am honored to receive this award and thankful to live in a country where (as of this writing at least) free expression brings more than just a prison sentence!

The United Airlines "It's Time to Fly" tunnel project consisted of 128 window poster illustrations and two large murals. The works were installed in the London underground. The 170-meter tunnel connected two underground subway trains in the financial district of London. The concept of the project was to play off the tunnels' tube-shaped architecture and convert it to look like a fuselage of a passenger jetliner. As you walked down the tunnel and looked at either side, you were taking a sort of surreal human flipbook journey. The illustrated journey was filled with theatrical takeoffs and landings. The journey began by taxiing on a runway at Heathrow Airport, then taking off and having a bird's-eye view of London, eventually landing in New York City. Taking off from New York City, you bank

around the dazzling skyline of Manhattan and fly off to your final destination: a "sun setting" in San Francisco.

I had a lot of space to work with on this visual journey. Each of the printed murals was enlarged to about 13 feet, while the window posters were 30 inches high. The tube walls were a sterile white, so the contrast of a lot of color and texture in the pieces had a nice impact. I also wanted to play up all the changing variables when flying over great distances: weather, time of day, variety of landscapes, altitudes, and whatever else you might see in the sky. From sketches to finish, I was given about 45 days to complete the project. In the end it was a very rewarding undertaking; my thanks to Fallon UK and United Airlines.

SILVER MEDAL WINNER
MARK ALAN STAMATY

This comic strip was one of a series I did for *The New York Times Book Review* about book-related topics. The subject matter for this strip was *The Jessica Lynch Story*, which was inherently funny because the book got signed and hooked up with a best-selling co-author on the basis of a lot of media hoopla which, by the time the book was being written, turned out to be inaccurate. When the book was finally released, there really was no reason for it to exist. So I let my mind wander to find appropriate metaphors to express the absurdity of this. The strip is in black and white because that particular week they had to print it on a different page than usual, which wasn't a color page. The art director was Steve Heller, who is one of the best in the business. He is scholarly, creative, appreciative of comic art, and open to new ideas. So it is always a pleasure to work with him.

SIGNE BAUMANE

A few years ago I had to have a lot of dental work done. Through the recommendation of a friend I found a really good dentist and diligently started to go to the unpleasant appointments. After the first visit (two hours of rotten root canal fixing), slightly shaken and dazed, I walked into the patient's bathroom. I had to regain my composure before walking into the outside world. There, on the wall, I saw a few etchings from the 17th century picturing dental work from that time. Among them was a horrifying picture of a dentist with crude, horse-sized pliers standing over a patient, pulling a tooth with all his strength.

The patient looked half faint, his face resigned to the unbearable suffering. The picture made me shudder in horror. To my last bone I felt what that patient was feeling. Except, of course, unlike him, I had had some anesthesia to ease *my* sufferings. "What in hell are those pictures doing in my dentist' bathroom?" I thought. "Is he trying to show his patients how much gentle modern dentistry is and how we should be grateful for the invention of anes thesia? Or maybe he is just very insensitive? But what if the dentist were t possess a great sense of humor?" Slowly, an idea for a film emerged.

Kirk Jones leapt into Niagara Falls! And lived!

Steve Gough walked the length of Britain. *NAKED?*

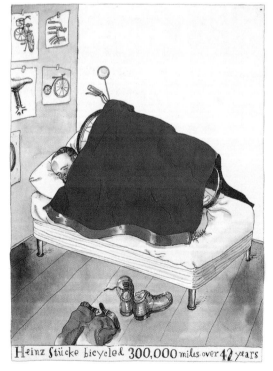

Heinz Stücke bicycled 300,000 miles over 42 years

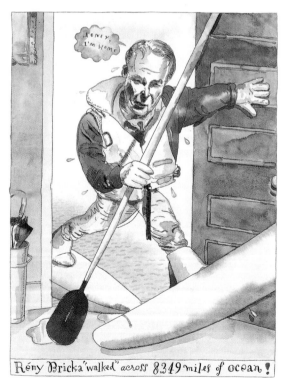

Rémy Bricka "walked" across 8,349 miles of ocean!

BARRY BLITT

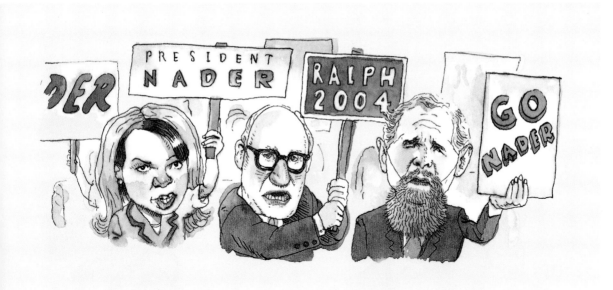

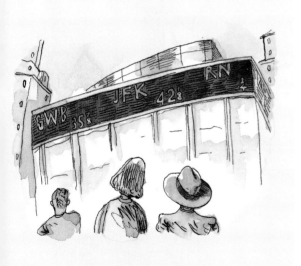

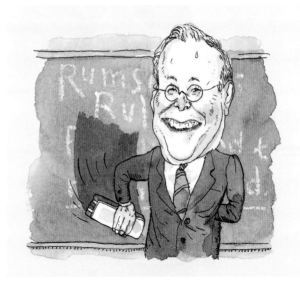

BARRY BLITT

TIM BOWER

Sequential illustrations for an essay in *Harper's* about the purported "Republican Propaganda Machine."

Tim Bower

Sequential illustrations for an essay in *Harper's* that served as a primer for the formulation of a liberal talk radio station.

CALEF BROWN

WILLIAM CARMAN

Surface is my drug of choice. Each one speaks to me in a different way. These pieces were done for a whole show of paintings and drawings on metal and later used for self-promo. They make one wonder if there is something inside. My breath always smelled good during this process.

THE FORLORN FUNGUS

by

GREG CLARKE

Few things inflamed passions like Hervé, a 28 oz. white truffle from the Piedmont region of Italy.

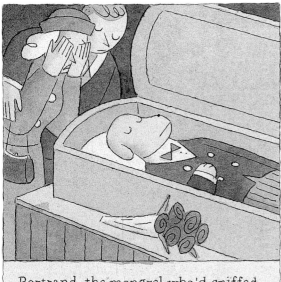

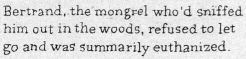

Bertrand, the mongrel who'd sniffed him out in the woods, refused to let go and was summarily euthanized.

Sold at auction for $6,900, Hervé was taken possession of by Claudio, a three star chef from Naples.

GREG CLARKE

Working for Monte Beauchamp is always a pleasure and a chance to stretch a little. I'm interested in objects that inspire extreme passions in people and a trip to Italy gave me the idea for a story about the plight of an anthropomorphized truffle.

GREG CLARKE

The only direction from Joe Kimberling was to do something holiday-related.
This was my take on the shopworn "holiday curmudgeon" theme.

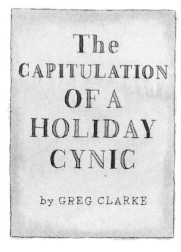

The
CAPITULATION
OF A
HOLIDAY
CYNIC

by GREG CLARKE

Bill loathed the holidays but took great pains to conceal it.

His unsympathetic wife Mia tried hard to understand him.

Each year, he dutifully hung lights to the dolorous strains of Bing Crosby.

He watched with resignation as the orgy of cookies, nuts, and candy nullified his progress at the gym.

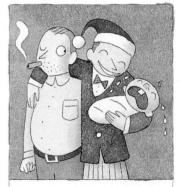

Years of practice had honed his skills in the art of feigning affection for his relatives.

He was moved to tears reading the interminable holiday form letters from so-called friends.

While he preferred visits to the dentist, Bill gamely embarked on gift shopping excursions to the Beverly Center.

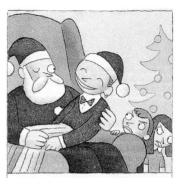

At last, powerless to buck the tides of social convention, his surrender to the dark side was complete.

GREG CLARKE

I wanted to do a story about "flaky" behavior in Los Angeles and Hogarth's *A Rake's Progress* was the inspiration ... not to mention that the play on the title, *A Flake's Progress*, was too good to pass up.

~ A ~
FLAKE'S
PROGRESS

by GREG CLARKE

Tom's animal magnetism had served him well in life.

Adored by a fawning public, it was easy to be blinded to one's own social transgressions.

Refusing to be cowed by conventional notions of time and space, he was unfashionably late for appointments.

He took weeks to return phone calls and email, if at all, and was loath to make social committments more than 24 minutes in advance.

Phil, his former tennis buddy, bitterly recalled the three days it had once taken Tom to return a serve.

Acknowledging the short half-life of physical attraction, he never let his romantic entanglements last more than a month.

In time, the easy manner that once had been so alluring became repellent. Chastened and contrite, he sought professional help.

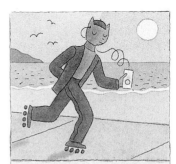

Diagnosed with acute courtesy deficit disorder, Tom moved to L.A., where those with his condition could live without fear of public censure.

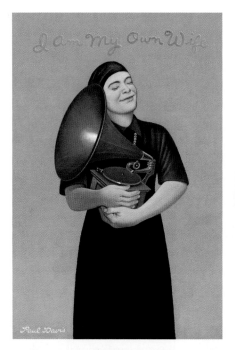

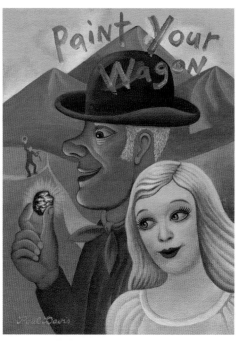

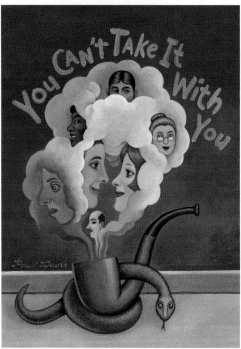

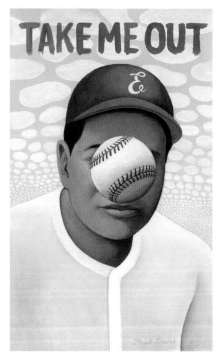

PAUL DAVIS

These are some of the images created for the Geffen Playhouse in Los Angeles for the 2004–2005 season. All together there were eight paintings that were used as posters, postcards, ads, newspaper inserts, and made into coasters for drinks and other premiums. The Geffen honored Karl Malden and I did two portraits of him. These were enlarged and used as onstage posters for a special evening where Tom Hanks presented Malden with an award. It was my third year of working with designer and art director Lisa Wagner Holley. Lisa is married to the illustrator Jason Holley and teaches at Art Center. She is very knowledgeable about illustration and a wonderful designer. It is great to work with someone who knows type so well and is so sensitive to detail. We worked via phone and e-mail and the project took several months to complete. I really enjoyed the experience.

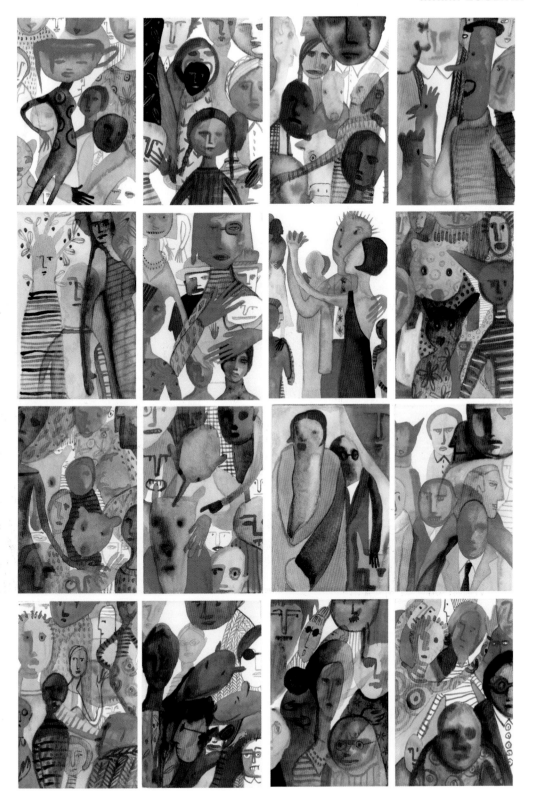

Douglas Fraser

BLAB! Is an annual publication that is more artifact than book, or magazine. Monte Beauchamp is the editor and visionary behind it. Monte has offered me space before. I have used the opportunities to explore a hybrid form between the comic book form and illustration. In the two-page spread, I explore the idea of the pugilist. Ones who struggle and fight their battles with fists. The look of my own illustrations has been described in such a manner. The mix of bloodiness and the "three strikes" rule has kept me struggling to stand back up in the arena of fashion and sacred cows. My work is not classy, just trying to get there. No heroes please, their feet are of clay.

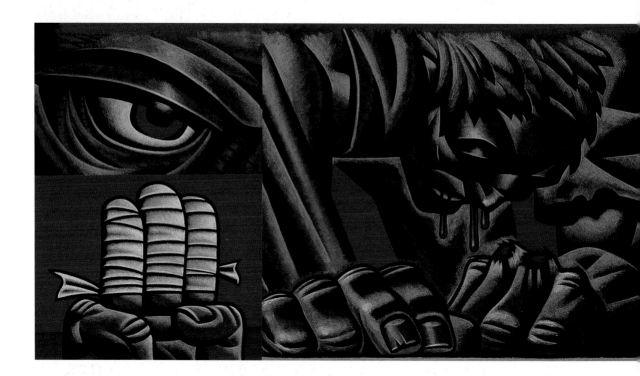

They Want to Be Part of It ...

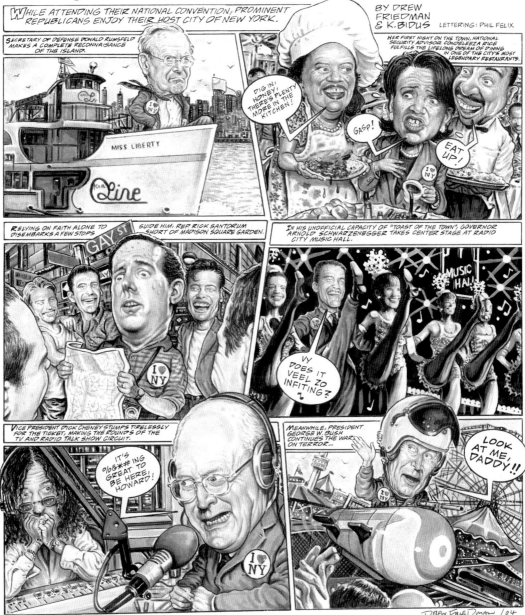

DREW FRIEDMAN

his was proposed to *The New York Observer* as a comment on the then-pcoming Republican convention in New York. It was conceived and writ-en by my frequent collaborator, K. Ridus, and me. We thought it would be musing to imagine members of the Republican Party, obviously out of lace in the overwhelmingly Democratic city of New York, enjoying some of he places of interest offered in such a diverse location.

They are portrayed as being as game as possible under the circumstances, each proudly sporting an "I Love NY" button. The only problem we had was limiting the amount of Republicans we wanted to show, obviously wanting to include Bush and Cheney. I still have some regret that we did not have the space to have Paul Wolfowitz dining at the Carnegie Deli, but we settled on the six that are featured.

ALEX GROSS

This is a series of images that I created while learning etching. Conceptually, I combined imagery from the "Book of Revelations" with the story of Icarus. Both images here were done with pen. Later, I made photoetching plates from those same images and made a small edition of etchings.

JOHN HENDRIX

These spot drawings were a series of chapter illustrations for Sid Fleishman's pirate book, *The Giant Rat of Sumatra*. The giant rat in the title referred to the wooden rodent with emerald eyes on the bow of the pirate ship.

JAMES JEAN

Drawing comics is painful. Usually, the characters suffer along with me. I'm much more at ease contriving a single scene and decorating it for the best effect. Cartooning requires a sense of narrative and timing that I might develop one day; in the meantime, I put all cartoonists on a pedestal, where I admire them with envious eyes.

Tatsuro Kiuchi

This is a series to accompany Naoko Higashi's book of Japanese Tanka poems. In this book there are a total of 50 Tanka poems with more than 30 of my illustrations. In this specific series of images, I wanted to show the four seasons by depicting pools in each season. I worked digitally in Photoshop for this assignment.

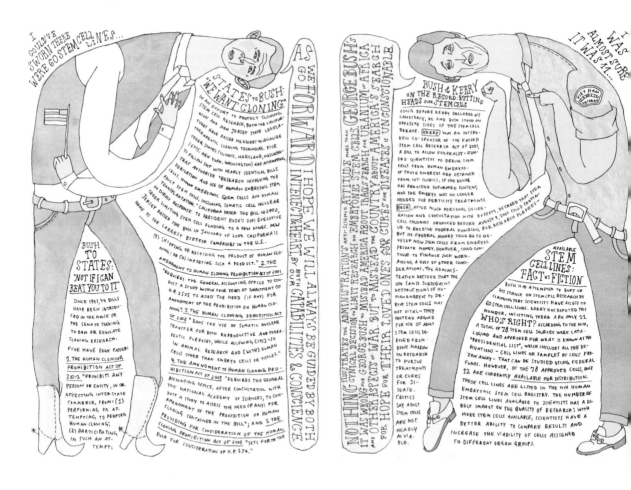

Nora Krug

Seed magazine asked me to illustrate six pages on the 2004 election. Art directors Alex Ching and Jarred Ford were very open to poetic, abstract visual solutions, which gave me a lot of freedom. The fact that they wanted me to hand letter the whole article was wonderful, as I could decide how to lay out the text on each page and use the text as a graphic element in my illustrations. I wanted the text to surround the illustrations without leaving any white space in order to create a dense, newspaper-like unity of image and text. It was tricky because I had to figure out exactly where every word went in relation to the image. Whenever the text was changed, even slightly, I had to redesign the whole page. Putting together the series was like putting together a puzzle—which illustrating always is to me.

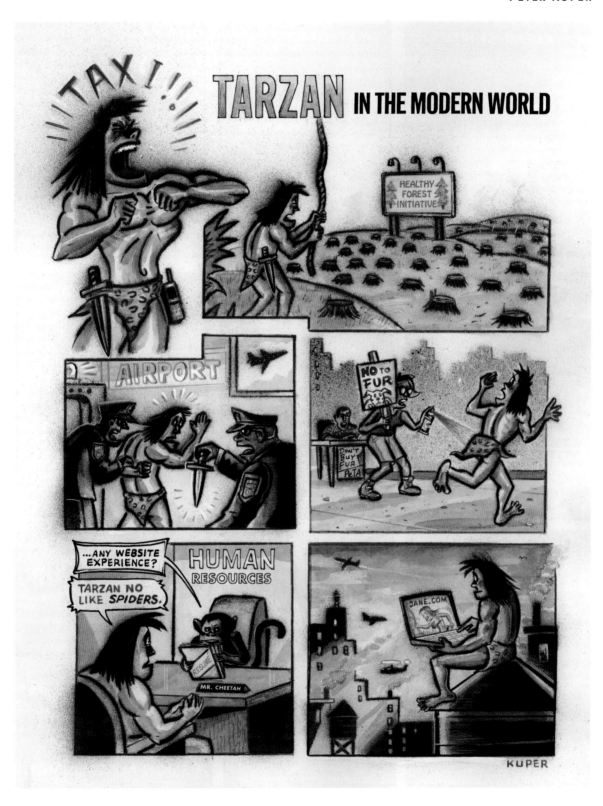

Peter Kuper

CLEAR SKIES.

HEALTHY FOREST.

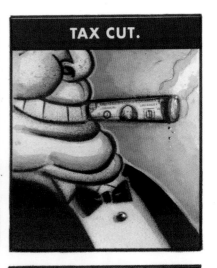

TAX CUT.

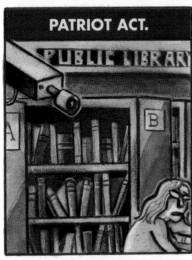

PATRIOT ACT.

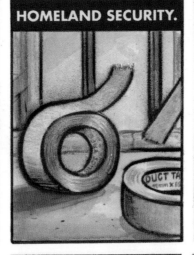

HOMELAND SECURITY.

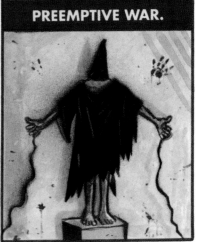

PREEMPTIVE WAR.

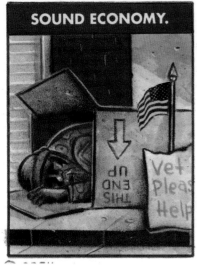

SOUND ECONOMY.

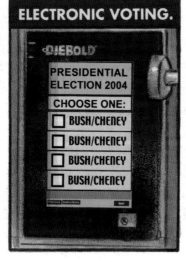

ELECTRONIC VOTING.

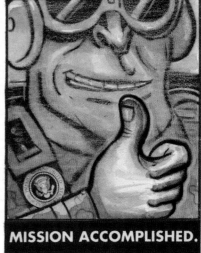

MISSION ACCOMPLISHED.

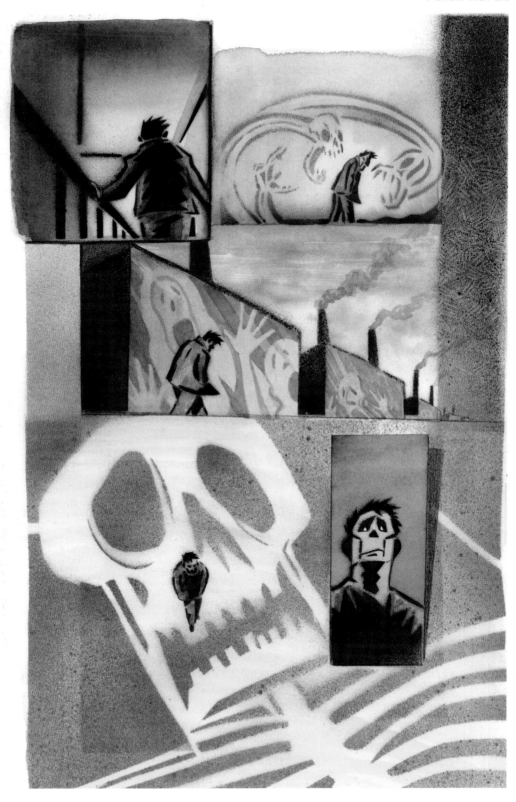

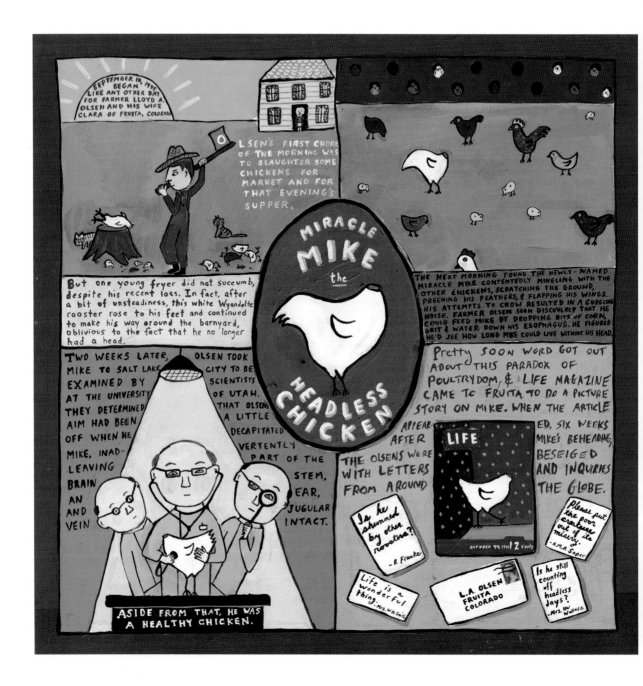

LAURA LEVINE

Miracle Mike the Headless Chicken is one of an ongoing series of non-fiction narrative paintings (aka "documentary illustration") that I've been creating for *Blab!* magazine. Each piece takes several months to complete and is based on extensive archival research, going back to the original source materials of the time.

Written and structured in narrative panels, this illustration relates the true-life story of a famous—yet unfortunate—chicken, and deals with some of the issues that continue to fascinate me, such as obsession, the darker side of fame, and American popular culture.

ADAM McCAULEY

For me, creating works on deadline for mainstream consumption can be a particularly tortuous way to make a living. For one thing, I don't consider myself innately gifted with the wit of, say, Barry Blitt; yet I do feel it's a great opportunity, at the very least, to express myself on a level that's a bit more personal than the average job. The fact that Joe Kimberling at *Los Angeles* magazine regularly gives me the chance to get up on his beautifully designed stage (with the hope of avoiding the throwing of eggs, dirty socks, rotten vegetables, et. al.), always demands that I give it as much as I can muster. Thankfully, this particular assignment was open enough to feel that I could stretch a bit more than other times. The only lament I have is that I wasn't able to include "Fugu Chef" in there somewhere.

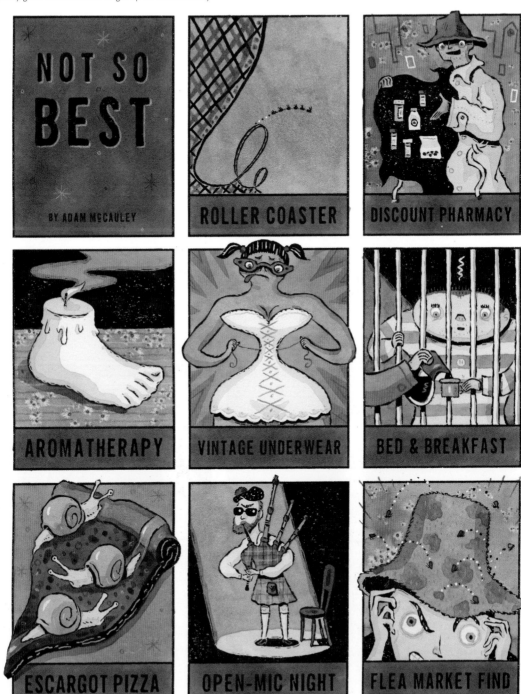

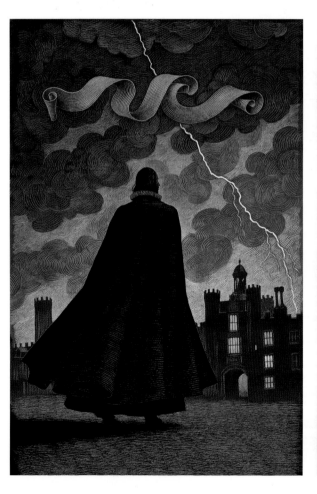

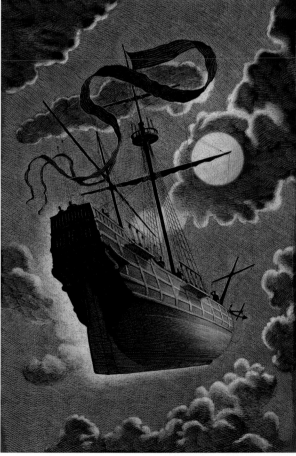

you!

LEIF PARSONS

Remember the scene in a recent movie where the "petroleum culture-hating" fireman insists on taking his bike instead of riding in the fire truck? He promptly gets to the fire, passing the fire truck, which is stuck in traffic. This series of drawings is more or less about that.

On a street in a city some time ago when life was simpler, stood Mr. Solomon's department store. And inside the store stood Stuart, a remarkable mannequin who had worked at the store for four years.

Despite the same blank stare found in the eyes of dummies everywhere, Stuart was special. After only a year he had worked his way from window dressing to center of attention on the floor. Sales went up and Mr. Solomon was pleased.

After every sale due to Stuart's silent salesmanship, Mr. Solomon would tap the dummy affectionately on the shoulder. Everyone knew that Stuart was like a son to him.

But as in any paradise, a snake was hissing with discontent. Milton, the store's cashier had watched Stuart's effortless progress with mounting jealousy. Despite his every effort to curry the favor of Mr. Solomon, Milton felt neglected and overlooked.

M.K. PERKER

This was one of the stories that I did as a project: stories with dark humor, emphasizing the Victorian-style clothing and locations. It was published in *Le Manyak* comic magazine in Turkey and in *Heavy Metal* here in the U.S. In this project I wanted to create an atmosphere and tried to put the style in front of the technique. This work is also an homage to Edward Gorey and A.B. Frost.

RED NOSE STUDIO

Hey Fred! Nice Red Thread is a series of images and limericks that touch on the little joys and disappointments in life. The book was created for a joint promotional project with the design firm Planet 10, the printer Quality Printing, and Red Nose Studio. As a whole, the book is meant to be read and re-read. The non-sequential nature of the limericks allows the reader to bounce around the pages finding little nuances/surprises in the selective effects that were used. As they spend more time with the book they find several layers to the seemingly naive limericks.

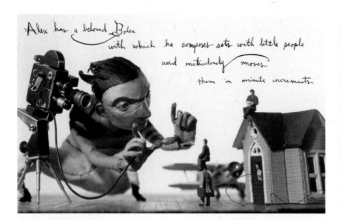

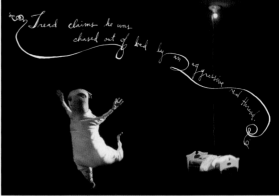

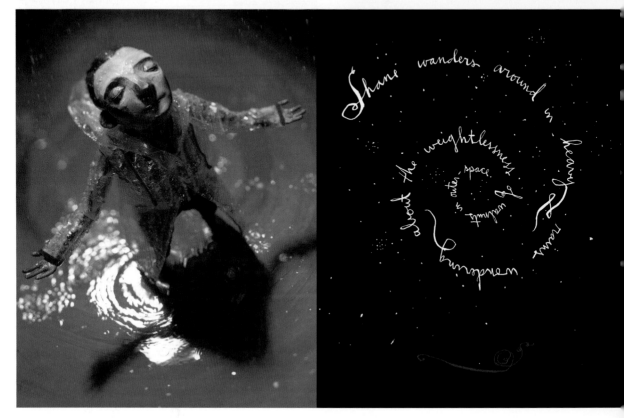

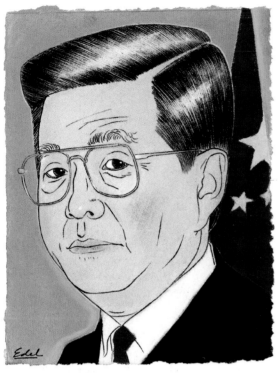
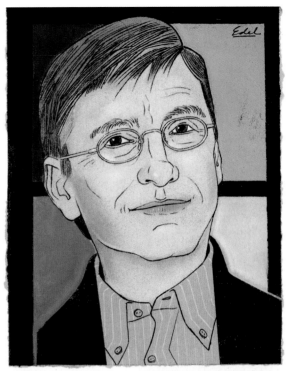
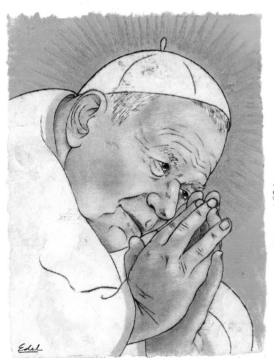
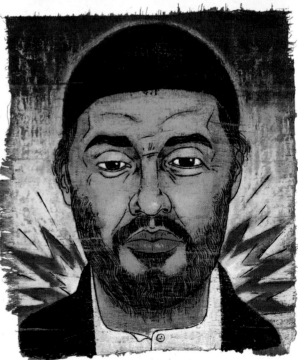

EDEL RODRIGUEZ

This is a series of five portraits done for an issue of *TIME* listing the year's 100 most influential people. The portraits are drawn with pastel and oil-based ink on papyrus, charcoal, and bark paper.

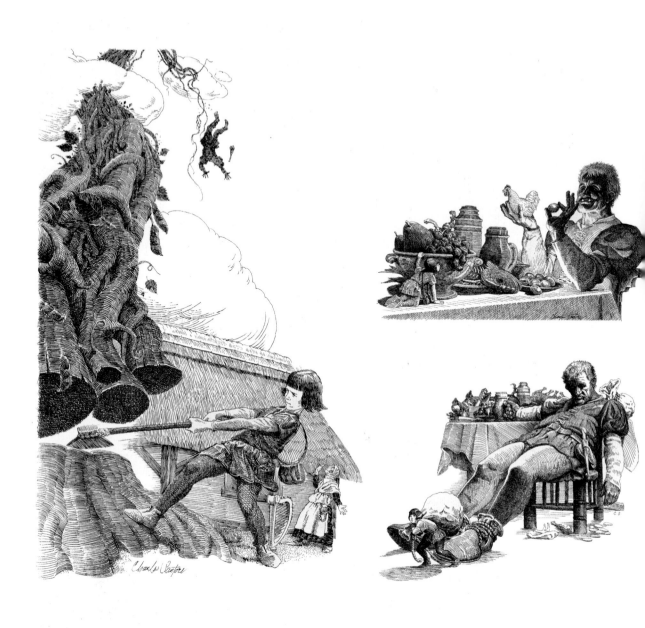

CHARLES SANTORE

Jeffrey Smith

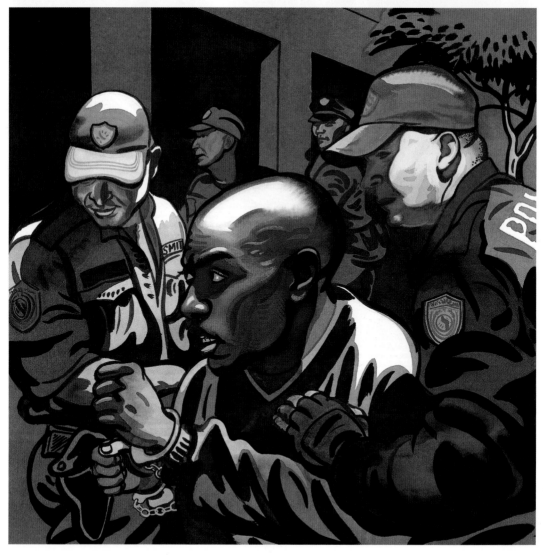

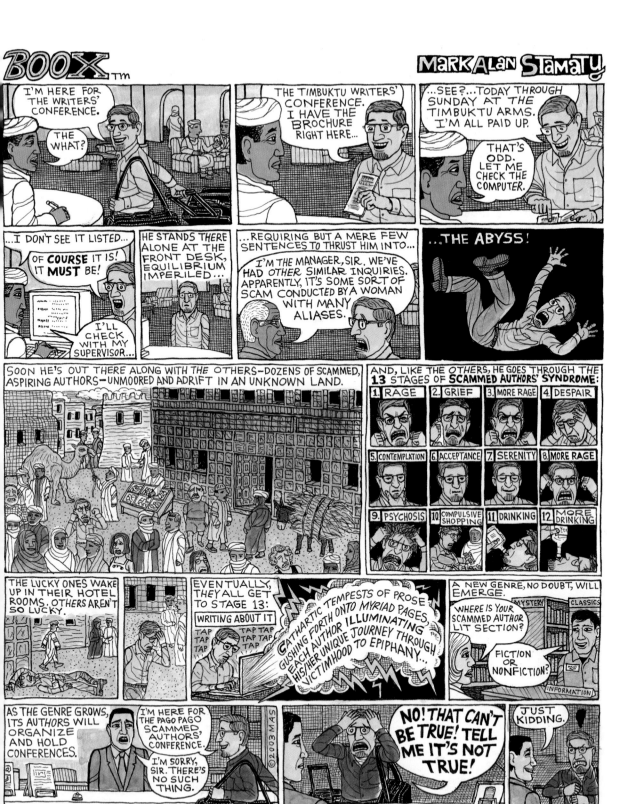

MICHAEL SLOAN

These images are from my first illustrated novel, *Professor Nimbus and the Amazing Spectacles*. It is the story of an astronomer who labors in obscurity until the discovery of a lifetime propels him to fame and fortune beyond his wildest dreams—with terrible consequences. Suddenly all his base desires and fantasies can be fulfilled. Nimbus's life unravels when he learns that his discovery threatens the very existence of the planet Earth.

The story is a morality tale incorporating the seven deadly sins. Illustrating these sins and their sinister consequences was very gratifying.

NEIL SWAAB

This comic strip was commissioned by *Razor Magazine*. As a comic artist, I'm usually given free reign to write and draw about whatever I wish and have it published. This particular comic was no exception. I started out with the concept of the comic first: that because there are a lot of bad parents there should be some sort of test you have to pass in order to become one, since a poorly raised child is far more dangerous to the world than a car, or a forklift, or many other things you need to have a license for. I scripted the comic first and then drew it in pencil. Once everything was sketched out, I tweaked the wording and the punch line to my satisfaction and then inked it. Afterwards, it was scanned into Photoshop and colored digitally

DAVID VOGIN

This series of illustrations was for an article in *Marketing Review* on the three traps of sales techniques in today's society. These traps were explained as the presentation trap, the assumption trap, and the adversarial trap. My first thoughts centered around school lessons and lectures by teachers to students. But with the size of each illustration being approximately a two-inch square, there was a real need to simplify the concept. The concept of see no evil, hear no evil, speak no evil seemed to work for both the lessons learned aspect and the three different sales techniques explained in the article. The use of the megaphone to represent sight, hearing, and speech in each illustration was the key to tying the illustrations together.

ESTHER PEARL WATSON

I found a teen diary in the Girls' bathroom at a gas station. The writer gave few details of what she looked like and so I just filled in the blanks. I really wanted to illustrate a 15-year-old's world where tension never ends; it's painful and funny all at the same time.

ILENE WINN-LEDERER

These four annotated drawings, *Lillith in Shoreditch*, *Mind the Gap*, *Isis at Islington*, and *Eve at Earl's Court*, are from a continuing series entitled *Notes from the London Underground*. Although I have always kept illustrated journals during my travels, the concept for this series began in 2003 during a visit to London where my son is a motion graphics designer. While the city is appealing on many visual and emotional levels, I was especially intrigued by some of her citizens and the back stories they seemed to offer— sometimes

evident in a momentary glance, a brief comment in a pub or shop, but mos often en route to a destination via the Underground. As I sought to captur each of these impressions in my journal, what began as a literal image soor took on a life of its own and became something else entirely, insisting tha I record its story as well.

Dan Yaccarino

Nick Jr. asked me to come up with a little story for their magazine. I dug up a few sketchbooks and found doodles of a zookeeper surrounded by a variety of animals that I thought would make a good picture book some day. I worked on the text and came up with the idea of this zookeeper waking the animals and getting them ready for their day. It turned out to be a very sweet mini book.

STUDENT SCHOLARSHIP

The Society of Illustrators fulfills its education mission through its museum exhibitions, library, archives, permanent collection and, most proudly, through the Student Scholarship Competition. The following pages present a sampling of the 121 works selected from over 4,350 entries submitted by college level students nationwide. The selections were made by a prestigious jury of professional illustrators. Tim O'Brien chairs this program and major financial support is given by Citigroup Foundation, the Geri Bauer Foundation, the Greenwich Workshop, Dick Blick Art Materials, the Illustration Academy, the Illustration Conference, and John Klammer. An endowment from bequests and corporate support and an annual auction of member-donated works makes possible over $60,000 in awards to the students. This year Rudy Gutierrez was selected as the Distinguished Educator in the Arts, an honor now recognized by all as affirmation of an influential career in the classroom. As you will see, the talent is there. If it is coupled with determination, these students will move ahead in this Annual to join the selected professionals. Let's see.

Rudy Gutierrez is the epitome of what a teacher of illustration should be. The following statement of purpose by Rudy does much to describe the essence of his spirit in the classroom: "The highest honor I can achieve is to assist a student to walk on his or her own path."

Rudy started his teaching career at Pratt Institute in 1990 where he had received his undergraduate education in illustration. At Pratt, Rudy studied with and later taught alongside Dave Passalacqua, one of the all-time great teachers of illustration, as well as a previous recipient of this prestigious award. Passalacqua, never one to give praise lightly, felt that Rudy truly possessed the teaching spirit. I could not agree more.

I invited Rudy to teach in the Syracuse University Masters in Illustration program where he performed brilliantly, earning the unanimous praise of the students he worked with. I have spoken with faculty and Masters students at Marywood University where Rudy teaches as a visiting professor.Once again, there was unanimous praise for Rudy the professor,

Rudy the artist, and Rudy the man.

In addition to his great talent as an illustrator and his obvious skill as a teacher, Rudy possesses what cannot be taught. I describe that as his ethical core. There is about Rudy an overarching honesty and integrity that simply will not be compromised.

The following remarks by Rudy are a prelude to each semester and will explain better than I can his visionary spirit: "If art is therapy, if art is to inspire, if art is a weapon, if it is a medecine to heal soul wounds, if it makes one not feel alone in his or her visions, or if it serves as transportation to a higher self, then that is where I aspire to live everyday."

As a teacher as well as coordinator of the Illustration Program at Pratt Institute, Rudy continues to be a profoundly positive influence on every student he comes in contact with.

MURRAY TINKELMAN

FRANK STOCKTON
David Mocarski, Instructor
Art Center College of Design
$4,000 Robert H. Blattner Award
The Illustration Academy Award

ENNIFER GENNARI
Regan Dunnick, Instructor
Ringling School of Art & Design
1,500 Dick Blick Art Materials Award

DOUG COWAN
Floyd Hughes, Instructor
Pratt Institute
$3,000 Geri Bauer Foundation Award
The Illustration Academy Award

MICKEY DUZYJ
Steve Brodner, Instructor
School of Visual Arts
$4,000 Geri Bauer Foundation Award
"Call for Entries" Poster

ANDREW HEM
David Mocarski, Instructor
Art Center College of Design
$3,000 Albert Dorne Award

CORY BRADLEY
Octavio Perez, Instructor
Ringling School of Art & Design
$1,500 Award in Memory of Meg Wohlberg

MICHAEL CAMARR
Chang Park, Instructor
Pratt Institute
$2,000 Albert Dorne Award

SYLVIA J
Kazuhiko Sano, Instructo
Academy of Art Universi
$1,500 Award in Memo
of Alan Goffma

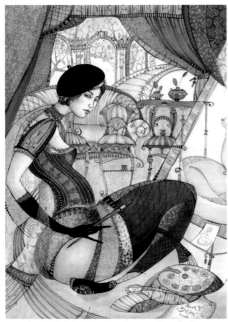

YELENA BALIKOV
Jordan Isip, Instructor
Parsons School of Design
$1,500 Award in Memory of Effie Bowie

ELIZABETH BLACK
Murray Tinkleman, Instructor
Syracuse University
$1,000 The Illustration Conference Award

EVAN McGUIGAN
Kim Mak, Instructor
Fashion Institute of Technology
$1,500 Award in Memory of Helen Wohlberg

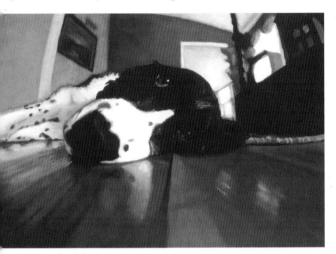

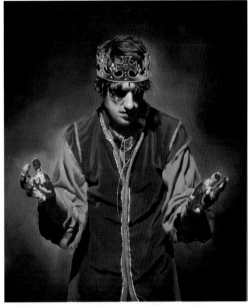

JUSTIN TAYLOR
Bethanne Andersen, Instructor
Brigham Young University
$1,500 Award in Memory of Herman Lambert

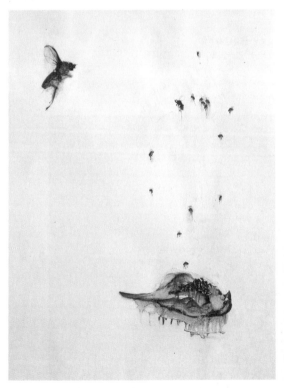

ABBY SCHOENROCK
Tom Francis, Instructor
Atlanta College of Art
$2,000 The Greenwich Workshop Award

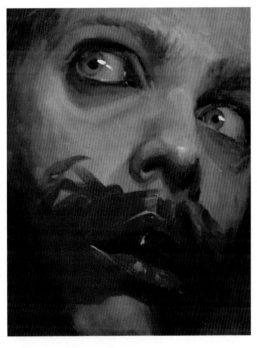

STEPHEN BORASCH
David Luce, Instructor
Art Center College of Design
$1,000 John Klammer Award

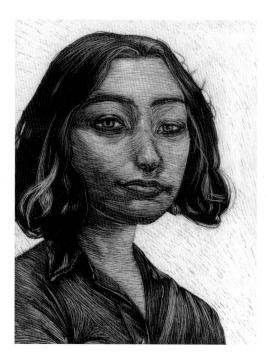

SASHA KATZ
Rick Lovell, Instructor
Atlanta College of Arts
$1,000 Kirchoff/Wohlberg Award
in Memory of Frances Means

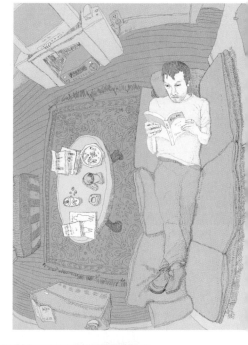

JESSE LEFKOWITZ
Oren Sherman, Instructor
Rhode Island School of Design
$1,000 Award in Memory of Harry Rosenbaum

BARRY BRUNER
Robert Meganck, Instructor
Virginia Commonwealth University
$1,000 Norma and
Alvin Pimsler Award

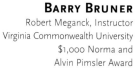

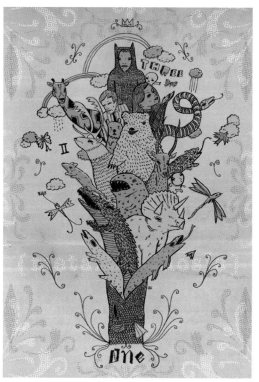

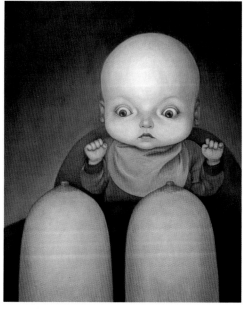

AERA KWON
Sal Catalano, Instructor
Fashion Institute of
Technology
$1,000 Society of
Illustrators Members
Award

RU KUWAHATA
Ronnie Lawlor, Instructor
Parsons School of Design
$1,000 Award in Memory of Verdon Flory

MARK MORENO
Joseph Daniel Fielder, Instructor
College for Creative Studies
$1,000 Kirchoff/Wohlberg Award in Memory of Helen Wohlberg Lambert

MICHELE NICHOLS
Warren Linn, Instructor
Maryland Institute, College of Art
$1,000 Award in Memory of Barnett Plotkin

DANIEL ROBBINS
George Pratt, Instructor
Virginia Commonwealth University
$1,000 Award in Memory of Jerry McConnell

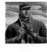

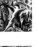

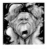
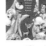
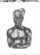

MICHELLE CHANG
30 Main Street #5B
Brooklyn, NY 11201
917-723-1171
bluespider@mindspring.com
www.michellechang.com

P. 66
ART DIRECTOR:
Janet Michaud
CLIENT: TIME
MEDIUM: Oil on board
SIZE: 22" x 23"

DOUG CHAYKA
233 Franklin Street #206
Brooklyn, NY 11222
718-349-7462
dchayka@hotmail.com

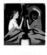
P. 361
ART DIRECTOR:
Joanne Hill
CLIENT: Clarion Books
MEDIUM: Gouache
SIZE: 16" x 22"

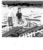
P. 362
ART DIRECTOR:
Joanne Hill
CLIENT: Clarion Books
MEDIUM: Gouache
SIZE: 22" x 29"

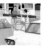
P. 363
ART DIRECTOR:
Joanne Hill
CLIENT: Clarion Books
MEDIUM: Gouache
SIZE: 22" x 24"

IVAN CHERMAYEFF
Chermayeff & Geismar Inc.
15 East 26th Street, 12th Floor
New York, NY 10010
212-532-4499 x237
ic@cgnyc.com

P. 299
ART DIRECTOR: Dana Gioia
CLIENT: NEA
MEDIUM: Collage
SIZE: 20" x 30"

JIM CHEUNG, JOHN DELL/ JUSTIN PONTSOR
10710 Preserve Lake Drive #306
Tampa, FL 33626
813-891-0367
jcheung@comic.com

P. 67
ART DIRECTOR:
Minh Uong
CLIENT: The Village Voice
MEDIUM: Mixed

DAN CHRZANOWSKI
American Greetings
One American Road
Cleveland, OH 44144
216-252-7300 x 4157
dan.chrzanowski@amgreeting.com

P. 300
ART DIRECTOR:
Dan Chrzanowski
CLIENT:
American Greetings
MEDIUM:
Reductive linocut
SIZE: 8" x 12"

JOE CIARDIELLO
35 Little York - Mt. Pleasant Road
Milford, NJ 08848
908-996-4392
joe@joeciardiello.com
www.joeciardiello.com

P. 68
ART DIRECTOR:
Ryoichi Shiraishi
CLIENT: Playboy Japan
MEDIUM: Pen & ink,
watercolor
SIZE: 20" x 17"

P. 301
ART DIRECTOR: Jim Burke
CLIENT: Dellas Graphics
MEDIUM: Pen & ink,
watercolor
SIZE: 22" x 18"

P. 368
ART DIRECTOR:
Joseph Perez
CLIENT: Viking Penguin
MEDIUM: Pen & ink,
watercolor
SIZE: 21" x 16"

P. 369
ART DIRECTOR:
Mark Murphy
CLIENT: Murphy Design
MEDIUM: Pen & ink,
watercolor
SIZE: 17" x 30"

P. 477
MEDIUM: Etching
SIZE: 15" x 13"

GREG CLARKE
214 Twin Falls Court
Newbury Park, CA 91320
805-499-8823
greg@gregclarke.com
www.gregclarke.com
Heflin Reps: 212-366-1893

P. 69
ART DIRECTORS: Devin
Pedzwater, Kory Kennedy
CLIENT: Rolling Stone
MEDIUM:
Watercolor, pastel
SIZE: 10" x 13"

P. 211
ART DIRECTOR: Ed Pagor
CLIENT: Pagor Vineyards
MEDIUM: Ink, Photoshop

P. 535
ART DIRECTOR:
Monte Beauchamp
CLIENT:
Fantagraphics Books
MEDIUM: Ink, watercolor
SIZE: 11" x 11"

P. 536
ART DIRECTOR:
Joe Kimberling
CLIENT:
Los Angeles Magazine
MEDIUM: Ink, watercolor
SIZE: 10" x 13"

P. 537
ART DIRECTOR:
Joe Kimberling
CLIENT:
Los Angeles Magazine
MEDIUM: Ink, watercolor
SIZE: 10" x 13"

TAVIS COBURN
64 Winnifred Avenue
Toronto, Ontario M4M 2X3, Canada
tc@taviscoburn.com

P. 70
ART DIRECTORS: Don
Morris, Josh Klenert
CLIENT: Kingfish Media
for PC Connection
MEDIUM: Digital

FERNANDA COHEN
213 East 21st Street #1C
New York, NY 10010
917-673-3447
info@fernandacohen.com
www.fernandacohen.com

P. 478
CLIENT: A Taste of
Art Gallery
MEDIUM: Gouache
SIZE: 21" x 21"

RAÚL COLÓN
43-C Heritage Drive
New City, NY 10956
845-639-1505
raulcolonill@yahoo.com

P. 71
ART DIRECTOR OF COVERS:
Françoise Mouly
CLIENT: The New Yorker
MEDIUM: Pen & ink,
watercolor
SIZE: 11" x 14"

P. 370
ART DIRECTOR: Ann Bobco
CLIENT: Atheneum Books
MEDIUM: Watercolor, col-
ored pencil, litho pencil
SIZE: 29" x 11"

DAN COSGROVE
Dan Cosgrove Design
203 North Wabash Avenue #1302
Chicago, IL 60601
312-609-0050
dan@cosgrovedesign.com

P. 212
ART DIRECTOR:
Keith Greenstein
CLIENT: Audi of America
MEDIUM: Digital
SIZE: 18" x 24"

DAN CRAIG
118 East 26th Street
Minneapolis, MN 55405
612-871-4539
dancraigart@qwest.net
Bernstein & Andriulli

P. 372
ART DIRECTOR: Tom Egner
CLIENT: HarperCollins
MEDIUM: Acrylic
SIZE: 12" x 15"

P. 373
ART DIRECTOR:
Sylvie Le Floch
CLIENT: Greenwillow
Books/HarperCollins
MEDIUM: Acrylic

JOHN CRAIG
John Craig Illustration
41565 Con Found It Drive
Soldiers Grove, WI 54655
608-872-2371
craigart@mwt.net

**GOLD MEDAL
P. 30**
ART DIRECTOR:
John Korpics
CLIENT: Esquire
MEDIUM: Digital
SIZE: 12" x 16"

TAVIS COBURN

BRIAN CRONIN
847 Steele Road
Shushan, NY 12873
518-854-9031
rosedene@rcn.com
www.briancronin.com

P. 72
ART DIRECTOR:
Vicki Nightingale
CLIENT: Reader's Digest
MEDIUM: Mixed

JOHN CUNEO
69 Speare Road
Woodstock, NY 12498
845-679-7973
john@johncuneo.com

P. 74
ART DIRECTOR:
John Korpics
CLIENT: Esquire
MEDIUM: Pen & ink,
watercolor
SIZE: 6" x 6"

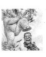
P. 75
ART DIRECTOR:
Martha Geering
CLIENT: Sierra Magazine
MEDIUM: Pen & ink,
watercolor
SIZE: 8" x 10"

P. 479
MEDIUM: Pen & ink,
watercolor
SIZE: 6" x 5"

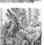
P. 480
MEDIUM: Pen & ink,
watercolor
SIZE: 7" x 6"

P. 481
MEDIUM: Pen & ink,
watercolor
SIZE: 4" x 6"

PAUL DAVIS
Paul Davis Studio
14 East 4th Street
New York, NY 10012
212-420-8789
paul@okdavis.com

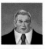
P. 73
ART DIRECTOR:
David Harris
CLIENT: Vanity Fair
MEDIUM: Acrylic on paper

**GOLD MEDAL
P. 186**
ART DIRECTOR: David Dy
CLIENT:
Merrydown Cider Co.
MEDIUM: Acrylic on paper

**SILVER MEDAL
P. 194**
ART DIRECTOR: Jim Miller
CLIENT:
Carol Shorenstein-Haye
MEDIUM: Acrylic on paper

P. 213
ART DIRECTOR:
Lisa Wagner Holley
CLIENT: Geffen Playhouse
MEDIUM: Acrylic on paper

P. 538
ART DIRECTOR:
Lisa Wagner Holley
CLIENT: Geffen Playhouse
MEDIUM: Acrylic on
paper, canvas

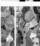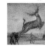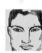

THOMAS FOWLER
Tom Fowler Inc.
111 Westport Avenue
Norwalk, CT 06851
203-845-0700
tom@tomfowlerinc.com

P. 220
ART DIRECTOR:
Thomas Fowler
CLIENT: Connecticut Grand
Opera & Orchestra
MEDIUM: Digital
SIZE: 16" x 29"

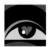
P. 221
ART DIRECTOR:
Thomas Fowler
CLIENT: Connecticut Grand
Opera & Orchestra
MEDIUM: Digital
SIZE: 16" x 29"

DOUGLAS FRASER
1161 Camrose Crescent
Victorial, British Columbia V8P 1M9,
Canada
250-385-4881
doug@fraserart.com

P. 219
ART DIRECTOR:
Diana Coursier
CLIENT: Amerstar Casinos
MEDIUM: Alkyds on paper
SIZE: 14" x 15"

P. 311
ART DIRECTOR:
Jacques Lamarre
CLIENT: Hartford Stage
MEDIUM: Alkyds on paper

P. 540
ART DIRECTOR:
Monte Beauchamp
CLIENT: BLAB!
MEDIUM: Alkyds on paper
SIZE: 8" x 15"

CRAIG FRAZIER
Craig Frazier Studio
90 Throckmorton Avenue #28
Mill Valley, CA 94941
415-389-1475
joni@craigfrazier.com
www.craigfrazier.com

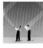
P. 222
ART DIRECTOR:
Wayne Carey
CLIENT:
The Boeing Company
MEDIUM: Cut paper, digital
SIZE: 8" x 10"

P. 312
CLIENT:
Philadelphia University
MEDIUM: Cut paper, digital
SIZE: 8" x 10"

P. 313
ART DIRECTOR:
Andrew Bosman
CLIENT:
Navigant Consulting Inc.
MEDIUM: Cut paper, digital
SIZE: 8" x 10"

P. 379
ART DIRECTOR:
Craig Frazier
CLIENT: Chronicle Books
MEDIUM: Cut paper, digital
SIZE: 10" x 14"

SARAJO FRIEDEN
c/o Lilla Rogers Studio
781-641-2787
sarajo@sarajofrieden.com
www.lillarogers.com

P. 380
ART DIRECTOR:
Lorena Siminovitch
CLIENT: Galison
Mudpuppy Press
MEDIUM: Digital
SIZE: 5" x 8"

P. 381
ART DIRECTOR:
Mark Murphy
CLIENT: Murphy Design
MEDIUM:
Gouache on paper
SIZE: 15" x 10"

DREW FRIEDMAN
1365 Bush Road
Cresco, PA 18326
570-620-1875
drawings@ptd.net

P. 541
ART DIRECTOR:
Peter Kaplan
CLIENT: The New York
Observer
MEDIUM: Watercolor

THOMAS FUCHS
320 West 37th Street #D
New York, NY 10018
212-904-1255
mail@thomasfuchs.com

P. 89
ART DIRECTOR:
Robert Festino
CLIENT: Runner's World
MEDIUM: Acrylic
SIZE: 12" x 11"

CHRIS GALL
4421 N. Camino del Santo
Tucson, AZ 85718
520-299-4454
gallchrisa@qwest.net

P. 382
ART DIRECTOR:
Andrea Spooner
CLIENT: Little, Brown & Co.
MEDIUM:
Scratchboard, digital
SIZE: 10" x 10"

P. 383
ART DIRECTOR:
Andrea Spooner
CLIENT: Little, Brown & Co.
MEDIUM:
Scratchboard, digital
SIZE: 10" x 10"

P. 384
ART DIRECTOR:
Andrea Spooner
CLIENT: Little, Brown & Co.
MEDIUM:
Scratchboard, digital
SIZE: 10" x 10"

IASSEN GHIUSELEV
Kniaz Boris 58
Sofia, 1463, Bulgaria
giuzeleva@hotmail.com

SILVER MEDAL
P. 354
ART DIRECTOR:
Dimitter Savoff
CLIENT:
Simply Read Books
MEDIUM: Gouache
SIZE: 20" x 40"

BEPPE GIACOBBE
c/o Morgan Gaynin
194 3rd Avenue
New York, NY 10003
212-475-0440
info@morgangaynin.com

P. 223
ART DIRECTOR: Bob Barrie
CLIENT: United Airlines
MEDIUM: Digital
SIZE: 7" x 9"

MICHAEL GIBBS
13908 Stonefield Lane
Clifton, VA 20124
mike@michaelgibbs.com

P. 226
ART DIRECTOR:
Kiera Alderette
CLIENT: Pittsburg
Repertory Theater
MEDIUM: Mixed
SIZE: 16" x 20"

DAVID LANCE GOINES
Saint Hieronymos Press
1703 Martin Luther King
Berkley, CA 94709
510-549-1405
dlg@goines.net

P. 224
ART DIRECTOR:
David Lance Goines
CLIENT: Callahan
Piano Service
MEDIUM: Solid color
photo, offset lithograph
SIZE: 17" x 24"

P. 225
ART DIRECTOR:
David Lance Goines
CLIENT: Chez Panisse
MEDIUM: Solid color
photo, offset lithograph
SIZE: 15" x 24"

RICHARD A. GOLDBERG
Ragmedia
15 Cliff Street
Arlington, MA 02476-5907
781-646-1041
rag@ragmedia.com

P. 386
ART DIRECTOR:
Heather Zschock
CLIENT:
Peter Pauper Press
MEDIUM: Digital

P. 387
ART DIRECTOR:
Heather Zschock
CLIENT:
Peter Pauper Press
MEDIUM: Digital

VALERI GORBACHEV
1290 East 19th Street #5A
Brooklyn, NY 11230
718-377-3778

P. 385
ART DIRECTOR:
Stephanie Bart-Horvath
CLIENT: HarperCollins
MEDIUM: Watercolor, ink

JOSHUA GORCHOV
588 Sutter Street #419
San Francisco, CA 94102
415-246-8390
joshua@gorchov.com
www.gorchov.com

P. 90
ART DIRECTORS: Devin
Pedzwater, Kory Kennedy
CLIENT: Rolling Stone
MEDIUM: Acrylic on
wood panel
SIZE: 7" x 8"

RICHARD GRAY
Art Dept
420 West 24th Street #1F
New York, NY 10010
212-243-2103
www.art-dept.com

P. 91
ART DIRECTOR:
Lee Barresford
DESIGN DIRECTOR:
Geraldine Hessler
CLIENT:
Entertainment Weekly
MEDIUM: Mixed
SIZE: 14" x 11"

ALEX GROSS
1708 la Senda Place
South Pasadena, CA 91030
626-799-4014
alexgross@earthlink.net
www.alexgross.com

P. 92
ART DIRECTOR:
Stephen Sedam
CLIENT: The Los Angeles
Times Book Review
MEDIUM: Oil on panel
SIZE: 19" x 16"

SILVER MEDAL
P. 472
MEDIUM: Oil
SIZE: 40" x 60"

P. 483
MEDIUM: Oil
SIZE: 60" x 36"

P. 542
ART DIRECTOR: Alex Gross
MEDIUM:
Sumi ink, digital
SIZE: 24" x 36"

EDDIE GUY
309 Race Track Road
Ho-Ho-Kus, NJ 07423
201-251-7660
eddie.guy@verizon.net

P. 227
ART DIRECTOR: David Dye
CLIENT:
Merrydown Cider Co.
MEDIUM: Digital collage

MICHAEL HAHN
Grafik & Illustration
Hellbrookstr. 61
Hamburg, 22305, Germany
+49 40 6979 4432
michael@hahn-illustration.de

P. 228
ART DIRECTOR:
Michael Hahn
CLIENT: Rathauspassagen
Halberstadt
MEDIUM: Mixed
SIZE: 13" x 10"

P. 229
ART DIRECTOR:
Michael Hahn
CLIENT:
Elbschlob Bleckede
MEDIUM: Acrylic on canvas
SIZE: 19" x 13"

P. 230
ART DIRECTOR:
Michael Hahn
CLIENT: Theater Luneburg
MEDIUM: Drawing, pen,
Photoshop
SIZE: 19" x 13"

OKI HAN

c/o Kirchoff/Wohlberg
866 United Nations Plaza #525
New York, NY 10017
212-644-2020
lford@kirchoffwohlberg.com

P. 388
ART DIRECTOR:
Anahid Hamparian
CLIENT:
Marshall Cavendish
MEDIUM: Watercolor

TOMER HANUKA

24 Welbeck Street, Flat #1
London, W1G 8EN, England
tomer@thanuka.com

P. 93
ART DIRECTOR:
Susanne Ducker
CLIENT: Outside Magazine
MEDIUM:
Pencil, ink, digital
SIZE: 8" x 10"

P. 94
ART DIRECTOR: Jim Turner
CLIENT: Flaunt Magazine
MEDIUM:
Pencil, ink, digital
SIZE: 8" x 11"

P. 95
ART DIRECTOR:
Christine Cucuzza
CLIENT: Premiere
MEDIUM:
Pencil, ink, digital
SIZE: 8" x 6"

GREG HARLIN

Wood Ronsaville Harlin, Inc.
17 Pinewood Street
Annapolis, MD 21401
410-266-6550
wrh@wrh-illustration.com

P. 370
ART DIRECTOR:
Steven Meltzer
CLIENT: Dutton
Children's Books
MEDIUM: Watercolor
SIZE: 20" x 9"

JESSIE HARTLAND

165 William Street #9
New York, NY 10038
212-233-1413
jessiehartland@hotmail.com
www.jessiehartland.com

P. 389
ART DIRECTORS: Denise
Cronin, Kelley McIntyre
CLIENT:
Viking Children's Books
MEDIUM: Gouache
SIZE: 11" x 17"

P. 390
ART DIRECTORS: Denise
Cronin, Kelley McIntyre
CLIENT:
Viking Children's Books
MEDIUM: Gouache
SIZE: 11" x 17"

P. 391
ART DIRECTORS: Denise
Cronin, Kelley McIntyre
CLIENT:
Viking Children's Books
MEDIUM: Gouache
SIZE: 11" x 17"

THE HEADS OF STATE

c/o Frank Sturges Artist Representatives
740-369-9702
frank@sturgesreps.com
www.sturgesreps.com

P. 314
ART DIRECTORS:
Jason Kernevich,
Dustin Summers
CLIENT: TMM
MEDIUM: Silkscreen
SIZE: 18" x 24"

P. 315
ART DIRECTORS:
Dustin Summers,
Jason Kernevich
CLIENT: The Khyber Pass
MEDIUM: Silkscreen
SIZE: 18" x 24"

JOHN HENDRIX

917-597-6310
mail@johnhendrix.com
www.johnhendrix.com

P. 392
ART DIRECTOR:
Kenneth Holcomb
CLIENT:
Knopf, Delacorte, Dell
MEDIUM: Ink, acrylic
SIZE: 10" x 13"

P. 484
MEDIUM: Ink
SIZE: 20" x 12"

P. 543
ART DIRECTOR:
Chad Beckerman
CLIENT: Greenwillow
Books/HarperCollins
MEDIUM: Ink, watercolor
SIZE: Various

LARS HENKEL

Reflektorium
Laurentiusstrasse 27
Bonn, 53123, Germany
011-49-221-420-4676
lars@reflektorium.de
www.reflektorium.de

P. 317
ART DIRECTOR:
Kiera Alderette
CLIENT: Playhouse Dance
Company
MEDIUM: Mixed

P. 318
ART DIRECTOR:
Kiera Alderette
MEDIUM: Mixed

P. 319
ART DIRECTOR:
Mark Murphy
CLIENT: Murphy Design
MEDIUM:
Acrylic on cardboard
SIZE: 15" x 15"

JODY HEWGILL

260 Brunswick Avenue
Toronto, Ontario M5S 2M7, Canada
416-924-4200
jody@jodyhewgill.com

P. 96
DESIGN DIRECTOR:
Geraldine Hessler
CLIENT:
Entertainment Weekly
MEDIUM: Acrylic on
gessoed board

P. 97
ART DIRECTOR:
Kory Kennedy
CLIENT: Rolling Stone
MEDIUM: Acrylic on
gessoed board

P. 98
ART DIRECTOR: John Walker
DESIGN DIRECTOR:
Geraldine Hessler
CLIENT:
Entertainment Weekly
MEDIUM: Acrylic on
gessoed board

SILVER MEDAL

P. 195
ART DIRECTORS: Maggie
Boland, Scott Mires
CLIENT: Arena Stage
MEDIUM: Acrylic on
gessoed board

P. 231
ART DIRECTORS: Maggie
Boland, Scott Mires
CLIENT: Arena Stage
MEDIUM: Acrylic on
gessoed board

P. 232
ART DIRECTOR:
Mark Murphy
CLIENT:
Directory of Illustration
MEDIUM: Acrylic on wood

BRAD HOLLAND

96 Greene Street
New York, NY 10012
212-226-3675
brad-holland@erols.com
www.bradholland.net

P. 99
ART DIRECTOR:
Barbara Denney
CLIENT: Arizona Highways
MEDIUM: Acrylic on board

P. 233
ART DIRECTOR: Burl Seslar
CLIENT: Continental
Construction
MEDIUM: Acrylic on board

P. 234
ART DIRECTOR:
Anthony Padilla
CLIENT: Laguna College
of Art & Design
MEDIUM: Acrylic on board

P. 235
ART DIRECTOR:
Erwin Piplits
CLIENT: Odeon Theater
MEDIUM: Acrylic on board

SILVER MEDAL

P. 355
ART DIRECTOR: Irene Gallo
CLIENT: Tor Books
MEDIUM: Acrylic on board

P. 393
ART DIRECTOR: Irene Gallo
CLIENT: Tor Books
MEDIUM: Acrylic on board

DAVID HOLLENBACH

c/o Frank Sturges Representatives
frank@sturgesreps.com
www.sturgesreps.com

P. 100
ART DIRECTOR:
Jessica Colter
CLIENT: Utne Reader
MEDIUM: Collage
SIZE: 5" x 7"

JOHN H. HOWARD

115 West 23rd Street #43A
New York, NY 10011
212-989-460
joansigman@nyc.rr.com
www.johnhhoward.com
The Newborn Group: 212-989-460

P. 320
ART DIRECTOR:
John Howard
CLIENT:
Ted Milan Restaurant
MEDIUM: Acrylic on canvas
SIZE: 2' x 3'

P. 321
ART DIRECTOR:
Michael Diehl
CLIENT:
Warner Bros./Reprise
MEDIUM: Acrylic on paper
SIZE: 11" x 14"

DAVID HUGHES

The Cottage Cocks Green Lane
Great Welnetham
Burry St. Edmonds, Suffolk IP30 0UE,
England
011-44-1284-386596
w.davidhughes@btinternet.com

P. 101
DESIGN DIRECTOR:
Geraldine Hessler
CLIENT:
Entertainment Weekly
MEDIUM: Mixed

P. 394
ART DIRECTOR: Lee Wade
CLIENT: Atheneum Books
MEDIUM: Collage

PHIL HULING

938 Bloomfield Street
Hoboken, NJ 07030
201-795-9366
philhuling@yahoo.com

P. 236
ART DIRECTOR:
Alan Goughnour
CLIENT:
Jump Start Records
MEDIUM: Mixed
SIZE: 7" x 7"

STERLING HUNDLEY

The Box Studio
3920 Doeskin Drive
Apex, NC 27539
919-779-9750
sterling404@earthlink.net
www.sterlinghundley.com

P. 105
ART DIRECTOR:
Kory Kennedy
CLIENT: Rolling Stone
MEDIUM: Mixed
SIZE: 14" x 18"

P. 238
ART DIRECTOR:
Kiera Alderette
CLIENT: Pittsburgh
Playhouse
MEDIUM: Mixed
SIZE: 20" x 27"

P. 239
ART DIRECTOR:
Kiera Alderette
CLIENT: Pittsburgh
Playhouse
MEDIUM: Mixed
SIZE: 18" x 15"

P. 395
ART DIRECTOR:
Karen Nelson
CLIENT: Sterling Publishing
MEDIUM: Mixed
SIZE: 18" x 24"

MIRKO ILIĆ

207 East 32nd Street
New York, NY 10016
212-481-9737
studio@mirkoilic.com
www.mirkoilic.com

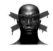

P. 102
ART DIRECTOR:
Carol Kaufman
CLIENT: The Los
Angeles Times
MEDIUM: Digital

P. 103
ART DIRECTOR:
Carol Kaufman
CLIENT: The Los
Angeles Times
MEDIUM: Digital

P. 104
ART DIRECTOR:
Jeffrey Osborn
CLIENT: National
Geographic
MEDIUM: Digital

JAMES JEAN

2424 7th Street
Santa Monica, CA 90405
310-903-1681
mail@jamesjean.com
www.jamesjean.com

P. 544
ART DIRECTOR:
Chris Pitzer
CLIENT: Adhouse Books
MEDIUM: Graphite, digital
SIZE: 6" x 9"

STEVE JENKINS

1627 5th Street
Boulder, CO 80302
303-938-180
steve@jenkinspage.com

P. 396
ART DIRECTOR:
Mary Ellen Hanley
CLIENT: Houghton Mifflin
MEDIUM: Paper collage

STEVE JOHNSON/ LOU FANCHER

Johnson & Fancher
1997 Ascot Drive # H
Moraga, CA 94556
925-377-0452
fancher@dancingpeople.com
www.johnsonandfancher.com

P. 397
ART DIRECTORS:
Lou Fancher
Cathy Goldsmith
CLIENT: Random House
MEDIUM: Oil on paper
SIZE: 9" x 12"

VICTOR JUHASZ

515 Horse Heaven Road
Averill Park, NY 12018
518-794-0881
juhasz@taconic.net

P. 398
ART DIRECTOR:
Kathleen Lynch
CLIENT: Oxford Press
MEDIUM: Pencil,
pen & ink, watercolor
SIZE: 18" x 24"

JOHN KACHIK

7540 Main Street #11C
Sykesville, MD 21784
410-552-1900
kachik@adelphia.net
www.jkachik.com

P. 108
ART DIRECTOR:
Marco Rosales
CLIENT:
American Airlines Nexos
MEDIUM: Mixed,
Photoshop
SIZE: 8" x 17"

SATOSHI KAMBAYASHI

Flat 2, 40 Tisbury Road
Hove, East Sussex, BN3 3BA, England
010441273771539
satoshi.k@virgin.netn
www.stillus.com

P. 322
ART DIRECTORS: Jane
Ryan, Catharine Brandy
CLIENT: Royal Mail
MEDIUM: Digital, mixed

P. 323
ART DIRECTORS: Jane
Ryan, Catharine Brandy
CLIENT: Royal Mail
MEDIUM: Digital, mixed

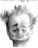

P. 324
ART DIRECTORS: Jane
Ryan, Catharine Brandy
CLIENT: Royal Mail
MEDIUM: Digital, mixed

JOHN KASCHT

136 Golf Hill Road
Honesdale, PA 18431
570-253-2203
jkascht@ptd.net

P. 106
DESIGN DIRECTOR:
Geraldine Hessler
ART DIRECTOR:
Sean Bumgarner
CLIENT:
Entertainment Weekly
MEDIUM: Mixed

P. 107
ART DIRECTOR:
Minh Uong
CLIENT: The Village Voice
MEDIUM:
Watercolor, colored ink

P. 485
MEDIUM: Pencil

GARY KELLEY

226 ½ Main Street
Cedar Falls, IA 50613
319-277-2330
Richard Solomon Artist Representatives
212-223-9545

P. 109
ART DIRECTORS: Joe
Kimberling, Lisa Lewis
CLIENT:
Los Angeles Magazine
MEDIUM: Pastel on paper
SIZE: 14" x 18"

P. 237
ART DIRECTOR: Gary Kelley
CLIENT: Hearst Center
for the Arts
MEDIUM: Monotype
SIZE: 14" x 20"

P. 400
ART DIRECTOR:
Rita Marshall
CLIENT: Creative Editions
MEDIUM: Pastel on paper
SIZE: 19" x 14"

P. 401
ART DIRECTOR:
Rita Marshall
CLIENT: Creative Editions
MEDIUM: Pastel on paper
SIZE: 11" x 14"

P. 486
MEDIUM: Oil on canvas
SIZE: 30" x 88"

TATSURO KIUCHI

c/o Heflin Reps
455 West 23rd Street #8D
New York, NY 10011
212-366-1893

P. 240
ART DIRECTOR:
Sissy Estes
CLIENT: Amtrak
MEDIUM: Digital

P. 399
ART DIRECTOR:
Yoshiaki Takagi
CLIENT: NHK Publishing
MEDIUM: Digital

P. 545
ART DIRECTOR:
Nobuko Okubo
CLIENT: Poplar Publishing
MEDIUM: Digital

JON KRAUSE

2924 Disston Street
Philadelphia, PA 19149
215-338-1531
jk@jonkrause.com
www.jonkrause.com

P. 110
ART DIRECTOR:
Joan Barrow
CLIENT: Connecticut
Magazine
MEDIUM: Acrylic
SIZE: 16" x 12"

P. 111
ART DIRECTOR:
Jane Kaplan
CLIENT: American Lawyer
Magazine
MEDIUM: Mixed
SIZE: 17" x 12"

GRAIG KREINDLER

6 Country Club Road
Airmont, NY 10952
g_kreindler@hotmail.com
www.graigkreindler.com

P. 487
MEDIUM: Oil on linen
SIZE: 38" x 52"

NORA KRUG

c/o Riley Illustration
845-255-3309
norakrug@gmx.net
www.nora-krug.com

P. 546
ART DIRECTORS: Alex
Ching, Jarred Ford
CLIENT: Seed Magazine
MEDIUM: Mixed
SIZE: 21" x 29"

BORIS KULIKOV

2080 84th Street #B3
Brooklyn, NY 11214
718-373-8841
boriskulikov@aol.com

P. 402
ART DIRECTOR:
Dan Potash
CLIENT: Simon & Schuster
MEDIUM: Mixed
SIZE: 20" x 34"

ANITA KUNZ

218 Ontario Street
Toronto, Ontario M5A 2V5, Canada
416-364-3846
akunz@anitakunz.com
www.anitakunz.com

P. 112
ART DIRECTOR:
Nancy Harris
CLIENT: The New York
Times Magazine
MEDIUM: Mixed
SIZE: 12" x 14"

P. 113
ART DIRECTOR OF COVERS:
Françoise Mouly
CLIENT: The New Yorker
MEDIUM: Mixed
SIZE: 8" x 11"

P. 325
ART DIRECTOR:
John English
CLIENT: The Illustration
Academy
MEDIUM: Mixed
SIZE: 10" x 16"

P. 488
MEDIUM: Mixed
SIZE: 8" x 11"

PETER KUPER

235 West 102nd Street #11J
New York, NY 10025
212-932-1722
kuperart@aol.com

GOLD MEDAL
P. 520
ART DIRECTOR: Peter Kuper
CLIENT: Three Rivers Press
MEDIUM: Mixed

P. 547
ART DIRECTOR: Ann Decker
CLIENT: Fortune
MEDIUM: Mixed
15" x 20"

P. 548
ART DIRECTOR:
Steve Brodner
CLIENT: The Nation
MEDIUM: Mixed

P.549
ART DIRECTOR:
Terry Nantier
CLIENT: NBM Publishing
MEDIUM: Mixed

TRAVIS LAMPE

1636 North Wells #1805
Chicago, IL 60614
312-735-2077
travislampe@yahoo.com

P. 489
MEDIUM: Acrylic
SIZE: 36" x 36"

ZOHAR LAZAR
P.O. Box 275
Kinderhook, NY 12106
518-392-6747

P. 114
ART DIRECTORS:
Fred Woodward
Anton Ioukhnovets
CLIENT: GQ
MEDIUM: Digital

P. 115
DESIGN DIRECTOR:
Geraldine Hessler
CLIENT:
Entertainment Weekly
MEDIUM: Digital

MATTHEW LEAKE
1334 East Hewson Street
Philadelphia, PA 19125
610-529-9256
matthew@matthewleake.com
www.matthewleake.com

P. 116
ART DIRECTOR: David Allen
CLIENT: HM Magazine
MEDIUM:
Scratchboard, mixed
SIZE: 8" x 10"

DAVID LESH
1761 Resort Road
Burt Lake, MI 49717
317-253-3141
boardwalk@iquest.net

P. 117
ART DIRECTOR:
Liana Zamora
CLIENT: Cuno Petroleum
Pipeline, Inc.
MEDIUM: Mixed

LAURA LEVINE
444 Broome Street
New York, NY 10013
212-431-4787
laura@lauralevine.com
www.lauralevine.com

P. 550
ART DIRECTOR:
Monte Beauchamp
CLIENT: BLAB!
MEDIUM: Acrylic
SIZE: 21" x 42"

SKIP LIEPKE
2544 West Lake of Isles
Minneapolis, MN 55405
812-374-1458

P. 118
ART DIRECTORS:
Devin Pedzwater
Kory Kennedy
CLIENT: Rolling Stone
MEDIUM: Oil

RICH LILLASH
c/o Frank Sturges Representatives
740-369-9702
frank@sturgesreps.com
www.sturgesreps.com

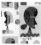
P. 326
ART DIRECTOR:
Mary Jones Smith
CLIENT: Ohio State
University Medical Center
MEDIUM: Cut paper
SIZE: 8" x 11"

FRANCIS LIVINGSTON
110 Elderberry Lane
Belleville, ID 83313
208-788-1978
francislivingston@msn.com

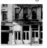
P. 492
MEDIUM: Oil
SIZE: 36" x 48"

PABLO LOBATO
Corrientes 1438 1H
Buenos Aires, CP1042, Argentina
+519-482-0488
info@agoodson.com
Anna Goodson
514-983-9020

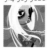
P. 119
ART DIRECTORS:
Devin Pedzwater
Andy Cowles
CLIENT: Rolling Stone
MEDIUM: Mixed

LIZ LOMAX
1 Main Street #7G
Brooklyn, NY 11201
718-222-5995
liz@lizlomax.com
www.lizlomax.com
Levy Creative Management: 212-687-6463

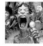
P. 120
ART DIRECTOR:
Devin Pedzwater
CLIENT: Rolling Stone
MEDIUM: Sculpey

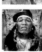
P. 121
ART DIRECTOR:
Devin Pedzwater
CLIENT: Rolling Stone
MEDIUM: Sculpey

LAUREL LONG
6641 Quail Court
La Verne, CA 91750
laurellong@aol.com

P. 403
ART DIRECTOR:
Nancy Leo Kelley
CLIENT: Dial Books for
Young Readers
MEDIUM: Oil
SIZE: 18" x 12"

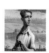
P. 404
ART DIRECTORS:
Nicholas Callaway
Toshiya Masuda
CLIENT:
Callaway Editions Inc.
MEDIUM: Acrylic
SIZE: 12" x 15"

P. 405
ART DIRECTORS:
Nicholas Callaway
Toshiya Masuda
CLIENT:
Callaway Editions Inc.
MEDIUM: Acrylic
SIZE: 12" x 15"

STAN MACK
1887 Greenfield Avenue #309
Los Angeles, CA 90025
310-473-5345
mackchamplin@earthlink.net
www.stanmack.com

P. 406
ART DIRECTOR: Syndy Miner
CLIENT: Simon & Schuster
MEDIUM: Pen & ink

KATHERINE MAHONEY
1033 Riesling Drive
Pleasanton, CA 94566
925-426-1185
kathe@katherinemahoney.com
www.katherinemahoney.com

P. 490
MEDIUM: Cut paper, pastel
SIZE: 16" x 22"

P. 491
MEDIUM: Cut paper, pastel
SIZE: 16" x 22"

MATT MAHURIN
20 Makamah Beach Road
Northport, NY 11768
212-691-5115
mattmahurin@mattmahurin.com

P. 122
ART DIRECTORS:
Fred Woodward
Anton Ioukhnovets
CLIENT: GQ
MEDIUM: Digital

GREGORY MANCHESS
15234 SW Teal Boulevard #D
Beaverton, OR 97007
503-590-5447
manchess@mac.com
Richard Solomon Artist Representatives
212-223-9545

P. 123
ART DIRECTOR:
Jeffrey Osborn
CLIENT:
National Geographic
MEDIUM: Oil

P. 408
ART DIRECTOR: Max Philips
CLIENT: Winterfall, LLC/
Hard Case Crime
MEDIUM: Oil
SIZE: 17" x 26"

P. 409
ART DIRECTOR: Ingsu Liu
CLIENT:
W.W. Norton Publishers
MEDIUM: Oil
SIZE: 23" x 34"

**STANLEY MARTUCCI/
CHERYL GRIESBACH**
34 Twilight Terrace
Highlands, NJ 00732
732-291-5945
griesbachmartucci@earthlink.net

P. 407
ART DIRECTOR:
Sarah Delson
CLIENT: St. Martin's Press
MEDIUM: Oil
SIZE: 24" x 36"

ROBERT MASSA
524 Malden Avenue East
Seattle, WA 98112
206-545-1540
robert@robertmassa.com
www.robertmassa.com

P. 493
MEDIUM: Digital

COCO MASUDA
424 Broadway 6th FLoor
New York, NY 10013
212-226-0767
info@cocomasuda.com

P. 241
ART DIRECTOR: Kim Terzis
CLIENT: United Airlines
MEDIUM: Acrylic
SIZE: 21" x 26"

JOHN MATTOS
1546 Grant Avenue
San Francisco, CA 94133
415-397-2138
john@johnmattos.com

P. 244
ART DIRECTOR:
Dan Radowicz
CLIENT: Amici Americani
Della Miglia
MEDIUM: Digital
SIZE: 13" x 19"

BILL MAYER
240 Forkner Drive
Decatur, GA 30030
404-378-0686
bill@thebillmayer.com

P. 124
ART DIRECTOR:
Andrew Danish
CLIENT: Infoworld
MEDIUM: Gouache,
airbrush, dyes, digital
SIZE: 10" x 15"

P. 125
ART DIRECTOR: Mihn Uong
CLIENT: The Village Voice
MEDIUM: Gouache,
airbrush, dyes, digital
SIZE: 17" x 12"

SILVER MEDAL
P. 197
ART DIRECTOR: Jim Burke
CLIENT: Dellas Graphics
MEDIUM: Gouache,
airbrush, dyes, digital
SIZE: 12" x 16"

P. 242
ART DIRECTOR:
Jacques Lamare
CLIENT: Hartford Stage
MEDIUM: Gouache,
airbrush, dyes, digital
SIZE: 18" x 11"

P. 243
ART DIRECTOR:
Andrea Isom
CLIENT: Integer Dallas
MEDIUM: Gouache,
airbrush, dyes, digital
SIZE: 18" x 11"

P. 410
ART DIRECTORS: Jill Turney
Doug Stillinger
CLIENT: Klutz
MEDIUM: Gouache,
airbrush, dyes, digital
SIZE: 12" x 9"

ADAM MCCAULEY
1081 Treat Avenue
San Francisco, CA 94110
415-826-5668
www.adammccauley.com

P. 126
ART DIRECTOR: Joey Rigg
CLIENT:
San Francisco Chronicle
MEDIUM: Mixed
SIZE: 10" x 14"

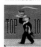

ADAM McCAULEY

P. 127
Art Director:
Scott Feaster
Client: Boys' Life
Medium: Mixed
Size: 11" x 17"
P. 411
Art Director:
Heather Woods
Client: Dutton Books
Medium:
Digital, scratchboard
Size: 5" x 8"
P. 494
Medium: Mixed
Size: 8" x 11"

P. 551
Art Director:
Joe Kimberling
Client:
Los Angeles Magazine
Medium: Mixed
Size: 8" x 11"

GRADY McFERRIN

141 Noble Street #3
Brooklyn, NY 11222
212-899-3337
grady@gmillustration.com
www.gmillustration.com

P. 245
Art Director:
Arlene Owseichik
Client: Bill Graham
Presents
Medium: Digital
Size: 13" x 19"
P. 246
Art Director:
Arlene Owseichik
Client: Bill Graham
Presents
Medium: Digital
Size: 13" x 19"
P. 247
Art Director:
Arlene Owseichik
Client: Bill Graham
Presents
Medium: Digital
Size: 13" x 19"

SCOTT McKOWEN

Punch & Judy Inc.
428 Downie Street
Stratford, Ontario N5A 1X7, Canada
519-271-3049
mckowen@sympatico.ca

P. 412
Art Director:
Karen Nelson
Client: Barnes & Noble
Medium: Scratchboard
Size: 6" x 9"
P. 413
Art Director:
Karen Nelson
Client: Barnes & Noble
Medium: Scratchboard
Size: 6" x 9"
P. 414
Art Director:
Karen Nelson
Client: Barnes & Noble
Medium: Scratchboard
Size: 6" x 9"
P. 552
Art Directors: Nick Lowe
Joe Quesada
Client: Marvel Comics
Medium: Scratchboard

WILSON McLEAN

41 West Court Street
Hudson, New York NY
wilsonmclean@mhcablecom

P. 248
Art Director:
Randall Jones
Client: Opera Company
of Philadelphia
Medium: Oil
P. 495
Medium: Oil

JAMES McMULLAN

18 Bluff Point Road
Sag Harbor, NY 11963
631-725-4323
jim@jamesmcmullan.com

P. 249
Art Director: Jim Russek
Client:
Lincoln Center Theater
Medium: Watercolor
P. 250
Art Director: Jim Russek
Client:
Lincoln Center Theater
Medium: Watercolor
P. 251
Art Director: Jim Russek
Client:
Lincoln Center Theater
Medium: Watercolor

LUC MELANSON

71 Parissi Avenue
Laval, Quebec H7N3S4, Canada
450-975-7836
www.lucmelanson.com

P. 415
Art Director:
Diane Primeau
Client: Dominique et
Compagnie
Medium: Acrylic, pastel
Size: 10" x 18"

DAVID MERRELL

1300 NW 198th Street
Edmond, OK 73003
918-749-9424
david@dwmerrell.com
www.dwmerrell.com

P. 416
Art Director: Terry Groner
Client: Ligonier Ministries
Medium: Digital
Size: 6" x 9"

CHARLES MILLER

394 Henry Street #3
Brooklyn, NY 11201
info@sixmoremiles.com

P. 129
Art Directors:
Devin Pedzwater
Kory Kennedy
Client: Rolling Stone
Medium: Mixed

KURT MILLER

45 Willow Wood Court
York, PA 17402
410-967-0650
www.kmistudio.com

P. 252
Art Director:
Steve Bauman
Client: Computer Games
Medium: Digital

RENÉ MILOT

49 Thorncliffe Park Drive #1604
Toronto, Ontario M4H 1J6, Canada
416-425-7726
renemilot@rogers.com

P. 253
Art Director: David Dye
Client:
Merrydown Cider Co.
Medium: Mixed
Size: 21" x 17"

WENDELL MINOR

Wendell Minor Design
P.O. Box 1135
15 Old North Road
Washington, CT 06793
860-868-9101
wendell@minorart.com
www.minorart.com

P. 327
Art Director: Al Cetta
Client: HarperCollins
Medium: Mixed
Size: 16" x 20"
P. 417
Art Director:
Mathew Miller
Client: The Toby Press
Medium: Mixed
Size: 16" x 20"

CARLO MOLINARI

Via Ezno Vanoni 91 A
Santeramo BA, 70029, Italy
003980 3022506
molinari.c@tiscali.it

P. 496
Medium: Digital

LARRY MOORE

2440 Roxbury Road
Winter Park, FL 32789
407-222-8585
elmodraws@cfl.rr.com

P. 254
Art Director: Laura Knight
Client: Orlando Repertory
Theater
Medium: Pastel
Size: 16" x 20"
P. 255
Art Director: Rita Tyrell
Client:
Annie Russell Theater
Medium: Gouache
Size: 8" x 10"
P. 418
Art Director:
Mark Murphy
Client: Murphy Design
Medium: Gouache
Size: 12" x 24"

JOE MORSE

380 Willard Avenue
Toronto, Ontario M6S 3R5, Canada
416-769-5301
joe@joemorse.com
www.joemorse.com
Heflin Reps: 212-366-1893

P. 256
Art Director: Joe Weaver
Client: Hammer Bowling
Medium:
Oil, acrylic on paper
Size: 22" x 30"

P. 128
Art Director: Liz Hale
Client:
The Los Angeles Times
Medium:
Oil, acrylic on paper
Size: 12" x 17"

SIMONA MULAZZANI

c/o Morgan Gaynin
194 3rd Avenue #3
New York, NY 10003
212-475-0440
info@morgangaynin.com

SILVER MEDAL

P. 356
Art Director:
Karen Nelson
Client: Sterling Publishing
Medium: Acrylic on wood
P. 420
Art Director:
Wendy Burton
Client:
For A Small Fee Inc.
Medium: Acrylic on wood
P. 420
Art Director:
Wendy Burton
Client:
For A Small Fee Inc.
Medium: Acrylic on wood
P.421
Art Director:
Wendy Burton
Client:
For A Small Fee Inc.
Medium: Acrylic on wood

ALEX NABAUM

P.O. Box 11991
Salt Lake City, UT 84147
801-523-0721
alex@alexnabaum.com
www.alexnabaum.com

P. 130
Art Director: Steve Banks
Client:
The Los Angeles Times
Medium: Mixed

YAN NASCIMBENE

1819 Stockton Street
San Francisco, CA 94133
415-391-1433
yan@yannascimbene.com
www.yannascimbene.com

P. 422
Art Director:
Pam Consolazio
Client: Houghton
Mifflin & Co.
Medium:
Watercolor, India ink
Size: 7" x 7"
P. 423
Art Director:
Pam Consolazio
Client: Houghton
Mifflin & Co.
Medium:
Watercolor, India ink
Size: 7" x 7"
P. 424
Art Director:
Pam Consolazio
Client: Houghton
Mifflin & Co.
Medium:
Watercolor, India ink
Size: 7" x 7"

CHRISTOPHER NEAL
512 Grand Street
Brooklyn, NY 11211
chris@redsilas.com

P. 257
ART DIRECTOR:
Michael Signorella
CLIENT: Lemon Sponge
Cake Ballet
MEDIUM: Digital
SIZE: 11" x 14"

KADIR NELSON
6977 Navajo Road #124
San Diego, CA 92119
619-463-0619
office@kadirnelson.com

P. 258
ART DIRECTOR:
Matt Capozzi
CLIENT: EA Sports
MEDIUM: Oil
SIZE: 24" x 36"
P. 426
ART DIRECTOR:
Dan Potash
CLIENT:
Simon & Schuster
MEDIUM: Pencil, oil,
watercolor
SIZE: 12" x 15"

P. 427
ART DIRECTOR:
Dan Potash
CLIENT:
Simon & Schuster
MEDIUM: Pencil, oil,
watercolor
SIZE: 13" x 18"

ROBERT NEUBECKER
Modern Media
2432 Iron Mountain Drive
Park City, UT 84060
435-658-2717
robert@neubecker.com
www.robertneubecker.com

P. 131
ART DIRECTOR:
Carol Kaufman
CLIENT: The Los Angeles
Times Book Review
MEDIUM: Ink, digital
Size: 10" x 13"
P. 132
ART DIRECTOR: Nan Oshin
CLIENT:
The Los Angeles Times
MEDIUM: Ink, digital
SIZE: 10" x 13"
P. 133
ART DIRECTOR:
Kathleen Kincaid
CLIENT: Slate.com
MEDIUM: Ink, digital
SIZE: 8" x 13"

P. 259
ART DIRECTOR:
Stephanie Allen
CLIENT: Fox Searchlight
MEDIUM: Mixed
P. 419
ART DIRECTOR: Anne Diebel
CLIENT: Hyperion
MEDIUM: Ink, digital
SIZE: 12" x 20"

CHRISTOPH NIEMANN
416 West 13th Street #309
New York, NY 10014
212-229-2798
mail@christophniemann.com

P.134
DESIGN DIRECTOR:
Geraldine Hessler
CLIENT:
Entertainment Weekly
MEDIUM: Mixed

CHRISTIAN NORTHEAST
P.O. Box 470818
San Francisco, CA 94147
wig@cynthiawigginton.com

P. 262
ART DIRECTOR:
Cynthia Wigginton
CLIENT: Bermuda
Triangle Service
MEDIUM: Acrylic
SIZE: 14" x 11"

TIM O'BRIEN
310 Marlborough Rd
Brooklyn, NY 11226
718-282-2821
tonka1964@aol.com

P. 135
ART DIRECTORS:
Devin Pedzwater
Kory Kennedy
CLIENT: Rolling Stone
MEDIUM: Oil
SIZE: 14" x 11"

P. 136
ART DIRECTOR: Jane Palecek
CLIENT: Mother Jones
MEDIUM: Oil
SIZE: 10" x 13"

P. 137
ART DIRECTORS:
Devin Pedzwater
Kory Kennedy
CLIENT: Rolling Stone
MEDIUM: Oil
SIZE: 15" x 12"

DAVID O'KEEFE
3520 Buckboard Lane
Brandon, FL 33511
813-684-4099
okeefe4art@juno.com

P. 138
ART DIRECTOR: Minh Uong
CLIENT: The Village Voice
MEDIUM: Clay sculpture

P. 139
ART DIRECTOR: Minh Uong
CLIENT: The Village Voice
MEDIUM: Clay sculpture

RAFAL OLBINSKI
142 East 35th Street
New York, NY 10016
212-532-4328
olbinskiart@yahoo.com

P. 142
ART DIRECTOR: Stefan Kiefer
CLIENT: Der Spiegel
MEDIUM: Acrylic
SIZE: 20" x 30"

P. 260
ART DIRECTOR:
Rafal Olbinski
CLIENT: Opera Nova
MEDIUM: Acrylic
SIZE: 20" x 30"

P. 261
ART DIRECTOR:
Rafal Olbinski
CLIENT: Ministry of
Culture Poland
MEDIUM: Acrylic
SIZE: 18" x 24"

KEN ORVIDAS
16724 NE 138th Court
Woodinville, WA 98072
ken@orvidas.com

P. 141
ART DIRECTORS:
Steven Guarnaccia
John Hendrix
CLIENT: The New York
Times Op-Ed
MEDIUM: Digital

P. 140
ART DIRECTOR:
Steven Banks
CLIENT: The Los Angeles
Times Entertainment
MEDIUM: Digital

P. 328
ART DIRECTOR: Rob Lamb
CLIENT: WPP
MEDIUM: Digital

P. 497
MEDIUM: Digital

KATHY OSBORN
386 Henry Street #3
Brooklyn, NY 11201
kathyosborn@nyc.rr.com

P. 498
MEDIUM: Acrylic
SIZE: 14" x 10"

P. 499
MEDIUM: Acrylic

P. 500
MEDIUM: Acrylic

JUSTIN PAGE
2818 Carlson Boulevard
Richmond, VA 94804
510-528-5107
jstnpg@hotmail.com
www.justinpage.biz

P. 263
ART DIRECTOR:
Arlene Owseichik
CLIENT:
Bill Graham Presents
MEDIUM: Mixed
SIZE: 13" x 19"

JOHN JUDE PALENCAR
3435 Hamlin Road
Medina, OH 44256
330-722-1859
ninestandingstones@yahoo.com
P. 425
ART DIRECTOR: Irene Gallo
CLIENT: Tor Books
MEDIUM: Acrylic
SIZE: 17" x 37"

CURTIS PARKER
1946 East Palomino Drive
Tempe, AZ 85284
480-820-6015
cparker@curtisparker.com

P. 143
ART DIRECTOR:
Joseph Shuldiner
CLIENT:
The Los Angeles Times
MEDIUM: Acrylic
SIZE: 12" x 15"

P. 329
ART DIRECTOR: Scott Hull
CLIENT:
Scott Hull Associates
MEDIUM: Acrylic
SIZE: 5" x 7"

P. 430
ART DIRECTOR:
Isabel Warren-Lynch
CLIENT: Random House
MEDIUM: Mixed
SIZE: 11" x 15"

LEIF PARSONS
634 Manhattan Avenue, 3rd Floor
Brooklyn, NY 11222
718-349-0302
leif@leifparsons.com

P. 553
ART DIRECTOR: Leif Parsons
MEDIUM: Mixed

JOYCE PATTI
c/o Morgan Gaynin
194 3rd Avenue #3
New York, NY 10003
212-475-0440
info@morgangaynin.com

P. 264
ART DIRECTOR:
Kimberley Mallek
CLIENT: The Hain
Celestial Group
MEDIUM: Oil

C.F. PAYNE
3600 Sherbrook Drive
Cincinnati, OH 45241
513-769-1172
cfoxpayne@yahoo.com
Richard Solomon Artist Representatives
212-223-9545

P. 144
ART DIRECTOR: Steve Heller
CLIENT: The New York
Times Book Review
MEDIUM: Mixed
SIZE: 13" x 16"

P. 145
ART DIRECTOR:
Hannu Laakso
CLIENT: Reader's Digest
MEDIUM: Mixed
P. 146
ART DIRECTOR:
Hannu Laakso
CLIENT: Reader's Digest
MEDIUM: Mixed

P. 428
ART DIRECTOR: Dan Potash
CLIENT: Simon & Schuster
MEDIUM: Mixed
SIZE: 13" x 16"

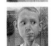
P. 429
ART DIRECTOR: Kate Gartner
CLIENT: Knopf Books for
Young Readers
MEDIUM: Mixed
SIZE: 13" x 17"

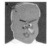

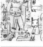
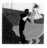

PETER SCANLAN
6 Cedar Lane
Closter, NJ 07624
201-750-0732
pscanlan@aol.com

P. 155
ART DIRECTOR: Minh Uong
CLIENT: The Village Voice
MEDIUM: Digital

TOM SCHAMP
Berkenlaan 20
Wemmel, 1780, Belgium
0032-2-428-90-66

P. 440
ART DIRECTOR:
Laurent Mouilherat
CLIENT: Editions Milan
MEDIUM: Acrylic
P. 441
ART DIRECTOR:
Sandrine Granon
CLIENT: Sevil Jeunesse
MEDIUM: Acrylic

GEORGE SCHILL
American Greetings
One American Road
Cleveland, OH 44144
216-252-7300x4279

P. 333
ART DIRECTOR: Brent Cottrell
CLIENT: American Greetings
MEDIUM: Digital
SIZE: 8" x 11"

JASON SCHNEIDER
75 O'Conner Drive
Toronto, Ontario M4J2S9, Canada
416-421-7733

P. 156
ART DIRECTOR:
Mary Parsons
CLIENT:
The Atlantic Monthly
MEDIUM: Mixed

ERIC SEAT
18826 Shelburne Glebe Road
Leesburg, VA 20175
703-727-5372
eric@ericseat.com
www.ericseat.com

P. 504
MEDIUM: Mixed
SIZE: 11" x 20"

CHRIS SHEBAN
2861 Shannon Court
Northbrook, IL 60062
847-412-9707
csheban@comcast.net

P. 270
ART DIRECTOR:
Al Shackeford
CLIENT: Lands' End
MEDIUM:
Watercolor, pencil
SIZE: 11" x 15"
P. 271
ART DIRECTOR:
Al Shackeford
CLIENT: Lands' End
MEDIUM:
Watercolor, pencil
SIZE: 12" x 15"
P. 439
ART DIRECTOR:
Isabell Warren-Lynch
CLIENT: Wendy Lamb Books
MEDIUM:
Watercolor, pencil
SIZE: 12" x 16"

YUKO SHIMIZU
251 West 102nd Street #2A
New York, NY 10025
yuko@yukoart.com
www.yukoart.com

P. 157
ART DIRECTOR:
Barbara Richer
CLIENT: The New York
Times Travel
MEDIUM: Mixed

P. 334
ART DIRECTOR:
Andrew Johnstone
CLIENT: Design Is Kinky
MEDIUM: Mixed
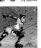
P. 335
ART DIRECTOR:
Mark Murphy
CLIENT: Murphy Design
MEDIUM: Mixed

LASSE SKARBOVIK
Stora Nygatan 44
Stockholm, 11127, Sweden
46-8-222433
lasse@stockholmillustration.com
www.marlenaagency.com

P. 272
ART DIRECTOR: Cia Kilander
CLIENT: Fastighetstidningen
MEDIUM: Digital

MICHAEL SLOAN
39 Linden Street
New Haven, CT 06511
203-787-1243
michaelsloan@earthlink.net
www.michaelsloan.net

P. 562
ART DIRECTOR:
Michael Sloan
MEDIUM: Pen & ink
SIZE: 8" x 10"

JEFFREY SMITH
642 Moulton Avenue #E22
Los Angeles, CA 90031
323-224-8317
jjsillustrator@sbcglobal.net
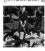
P. 160
ART DIRECTOR:
Kory Kennedy
CLIENT: Rolling Stone
MEDIUM: Acrylic, ink,
watercolor, gouache

P. 161
ART DIRECTOR: Tim Davin
CLIENT: Canadian Business
MEDIUM: Acrylic, ink,
watercolor, gouache

P. 442
ART DIRECTOR:
Robert Washington
CLIENT: Penguin Putnam
MEDIUM: Acrylic, ink,
watercolor, gouache

P. 560
ART DIRECTORS:
Fred Woodward
Ken Delago
CLIENT: GQ
MEDIUM: Acrylic, ink,
watercolor, gouache

OWEN SMITH
1608 Fernside Boulevard
Alameda, CA 94501
510-865-1911
art@retroreps.com

P. 159
ART DIRECTOR:
Kory Kennedy
CLIENT: Rolling Stone
MEDIUM: Oil

RYAN JACOB SMITH
636 North Skidmore Street
Portland, OR 97217
503-281-4443
me@ryanjacobsmith.com
www.ryanjacobsmith.com

P. 273
ART DIRECTOR:
Pamela Rooney
CLIENT: Hit Media
MEDIUM: Acrylic
SIZE: 12" x 12"

FELIX SOCKWELL
22 Girard Place
Maplewood, NJ 07040
917-657-8880
felix@felixsockwell.com

P. 274
ART DIRECTOR:
Matt Dimmer
CLIENT: Ford
MEDIUM: Mixed

CHRIS SOENTPIET
P.O. Box 205
Flushing, NY 11358
chris@soentpiet.com
ww.soentpiet.com

P. 443
ART DIRECTOR:
Loraine Joyner
CLIENT: Peachtree
Publishers
MEDIUM: Watercolor
SIZE: 10" x 17"

CAREY SOOKOCHEFF
265 Withrow Avenue
Toronto, Ontario M4K 1E3
416-406-0191
info@careysookocheff.com
www.careysookocheff.com

P. 162
ART DIRECTOR: Mark Koudis
CLIENT: Saturday Night
Magazine
MEDIUM: Mixed
SIZE: 10" x 11"

P. 275
ART DIRECTOR:
Sarah Taniwa
CLIENT: Theatre
Passe Muraille
MEDIUM: Mixed
SIZE: 9" x 13"

JEFF SOTO
727 Kelly Lane
Riverside, CA 92501
951-328-8776
jeff@jeffsoto.com
www.jeffsoto.com

P. 444
ART DIRECTOR: Irene Gallo
CLIENT: Tor Books
MEDIUM: Oil

ALENKA SOTTLER
Salendrova 6
Ljubijana, 1000, Slovenija
386-1-4264-198
alenka.sottler@guest.ames

P. 445
ART DIRECTOR:
Otakar Bozejovsky
CLIENT: Bohem Press
MEDIUM: Watercolor
SIZE: 15" x 11"

P. 446
ART DIRECTOR:
Niko Grafenauer
CLIENT: Nova Revija
MEDIUM: Tempera

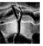
P. 447
ART DIRECTOR:
Niko Grafenauer
CLIENT: Nova Revija
MEDIUM: Tempera

RICHARD SPARKS
18053 Alder Steet
Hesperia, CA 92345
760-947-3368
artbysparks@yahoo.com
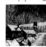
P. 448
ART DIRECTOR:
Michael Baldyga
CLIENT: Eaton Press
MEDIUM: Oil
SIZE: 10" x 14"

MARK ALAN STAMATY
12 East 86th Street #1226
New York, NY 10028
212-396-0744
markstamaty@earthlink.net

GOLD MEDAL
P. 470
MEDIUM: Pen & ink
SIZE: 29" x 23"

SILVER MEDAL
P. 523
ART DIRECTOR: Steve Heller
CLIENT: The New York
Times Book Review
MEDIUM: Ink
SIZE: 10" x 12"

P. 561
ART DIRECTOR: Steve Heller
CLIENT: The New York
Times Book Review
MEDIUM: Ink
SIZE: 10" x 12"

BRIAN STAUFFER
7485 SW 61st Street
Miami, FL 33143
305-666-3846
brian@brianstauffer.com

P. 163
ART DIRECTOR:
Robert Mansfield
CLIENT: Forbes
MEDIUM: Mixed

OTTO STEININGER
167 Avenue A #8
New York, NY 10009
212-598-9792
otto@ottosteininger.com
www.ottosteininger.com

P. 502
MEDIUM: Digital
SIZE: 7" x 10"

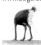
P. 503
MEDIUM: Digital

DUGALD STERMER
600 The Embarcadero
San Francisco, CA 94107
415-777-0110
ds@dugaldstermer.com
www.dugaldstermer.com
P. 278
ART DIRECTOR: Chris Jones
CLIENT: Direct TV
MEDIUM: Pencil, watercolor
SIZE: 14" x 18"

MARK STUTZMAN
Eloqui
100 G Street
Mountain Lake Park, MD 21550
301-334-4086
mark@eloqui.com
www.eloqui.com

P.449
ART DIRECTOR:
John Fullbrook, III
CLIENT: Simon & Schuster
MEDIUM:
Watercolor, airbrush
SIZE: 16" x 20"

LINDA SULLIVAN
Sullivan Office/South Press
1196 West 1460 North
Provo, UT 84604
801-400-2258
sullivan@byu.edu

P. 450
ART DIRECTOR:
Linda Sullivan
CLIENT: Dimi
MEDIUM: Mixed
SIZE: 9" x 19"

MARK SUMMERS
12 Milverton Close
Waterdown, Ontario L0R2H3, Canada
905-689-6219

P. 164
ART DIRECTOR:
Kory Kennedy
CLIENT: Rolling Stone
MEDIUM: Scratchboard

P. 165
ART DIRECTOR:
Richard Barron
CLIENT: Road & Track
Magazine
MEDIUM: Scratchboard

NEIL SWAAB
32-81 38th Street #2R
Astoria, NY 11103
646-331-6999
mail@neilswaab.com
www.neilswaab.com

P. 562
CLIENT: Razor Magazine
MEDIUM: Ink on paper,
colored digitally
SIZE: 12" x 4"

GREG SWEARINGEN
707 South 5th West #2001
Rexburg, ID 83440
503-449-8998
gregswearingen@yahoo.com
www.gregswearingen.com

P. 451
ART DIRECTOR:
Sammy Yuen
CLIENT: Simon & Schuster
MEDIUM: Mixed
SIZE: 6" x 10"

PETER SYLVADA
2219 Cambridge
P.O. Box 1086
Cardiff By The Sea, CA 92007
760-436-6807
petersylvada@cox.net

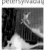
GOLD MEDAL
P. 34
ART DIRECTORS:
Francesca Messina
Donald Partyka
CLIENT:
Guideposts Publication
MEDIUM: Oil

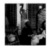
P. 276
ART DIRECTOR:
Peter Sylvada
MEDIUM: Oil
SIZE: 18" x 24"

P. 277
ART DIRECTOR:
Randall Jones
CLIENT: Philadelphia Opera
MEDIUM: Oil
SIZE: 16" x 20"
P. 452
ART DIRECTOR:
Judythe Sieck
CLIENT: Harcourt
MEDIUM: Oil
SIZE: 10" x 18"
P. 453
ART DIRECTOR:
Judythe Sieck
CLIENT: Harcourt
MEDIUM: Oil
SIZE: 13" x 18"

BILL THOMSON
66 Fox Run Drive
Southington, CT 06489
860-621-5501
billt140@cox.net

P. 279
ART DIRECTOR: Peter Good
CLIENT: Connecticut Forest
& Parks Association
MEDIUM: Mixed

BLAIR THORNLEY
3510 Pershing Avenue
San Diego, CA 92104
619-299-3874
blair@blairthornley.com
www.blairthornley.com

P. 454
ART DIRECTOR: Toni Ellis
CLIENT:
Chicago University Press
MEDIUM:
Pen & ink, watercolor
SIZE: 8" x 10"
P. 455
ART DIRECTOR: Toni Ellis
CLIENT:
Chicago University Press
MEDIUM:
Pen & ink, watercolor
SIZE: 8" x 10"

MARK TODD
325 North Adams Street
Sierra Madre, CA 91024
626-836-2210
funchicken@earthlink.net
www.marktoddillustration.com

P. 280
ART DIRECTOR:
James Hitchcock
CLIENT: Country Music
Television
MEDIUM: Mixed
P. 505
MEDIUM: Acrylic on paper
SIZE: 18" x 24"

CATHLEEN TOELKE
P.O. Box 487
Rhinebeck, NY 12572
845-758-5262
cathleen@cathleentoelke.com
www.cathleentoelke.com

P. 456
ART DIRECTOR: Gail Dubov
CLIENT: Avon Books/
HarperCollins
MEDIUM: Acrylic
SIZE: 6" x 9"

ZACH TRENHOLM
3649 Lawton Street #642
San Francisco, CA 94122
415-753-6020
zach@zachtrenholm.com

P. 166
ART DIRECTOR: Marti Golon
CLIENT: TIME
MEDIUM: Digital

P. 167
ART DIRECTOR:
David Schlow
CLIENT: Premiere
MEDIUM: Digital

MIRIAM TROOP
1148 Fifth Avenue
New York, NY 10128
212-427-1927
mtzug@earthlink.net

P. 336
ART DIRECTOR:
Marc Pachter
CLIENT: Profile Smithsonian
National Portrait Gallery
News
MEDIUM: Pencil on
Cameo paper
SIZE: 14" x 11"

POL TURGEON
5187 Jeanne Mance #3
Montreal, Quebec H2V 4K2, Canada
514-273-8329
polturgeon@netaxis.ca
www.polturgeon@netaxis.ca

P. 281
ART DIRECTOR:
Frank Harkins
CLIENT: The Calling
MEDIUM: Mixed
SIZE: 14" x 14"

P. 340
ART DIRECTORS: Mark Shaw,
Anne Yeckley Todd
CLIENT: American Media
MEDIUM: Mixed
SIZE: 14" x 11"

P. 341
ART DIRECTORS: Mark Shaw,
Anne Yeckley Todd
CLIENT: American Media
MEDIUM: Mixed

SANDY TURNER
Rosemount Studios
43 Station Road
Marple, Cheshire SK66AJ, England
david.rosemount@virgin.net

P. 457
ART DIRECTOR: Alicia Milkes
CLIENT: HarperCollins
MEDIUM: Mixed

RICHARD TUSCHMAN
3443 Green Road #2B
Beachwood, OH 44122
216-702-3088
richardtuschman.com

P. 458
ART DIRECTOR:
Alison Donalty
CLIENT: HarperCollins
MEDIUM: Digital
SIZE: 7" x 10"

JEAN TUTTLE
c/o Morgan Gaynin
www.jeantuttle.com

P. 506
MEDIUM: Digital
SIZE: 8" x 10"

P. 507
MEDIUM: Digital
SIZE: 8" x 10"

JONATHAN TWINGLEY
615 West 172nd Street #53
New York, NY 10032
917-613-2144
twingley@verizon.net

P. 168
ART DIRECTOR:
John McCauley
CLIENT: Boston Magazine
MEDIUM: Acrylic
P. 459
ART DIRECTOR:
Jonathan Twingley
CLIENT: Mitchell Mcinnis
MEDIUM: Mixed

P. 508
MEDIUM: Acrylic

MARK ULRIKSEN
841 Shrader Street
San Francisco, CA 94117
415-387-0170
ulriksen@prodigy.net
www.markulriksen.com

P. 169
ART DIRECTOR: Wesla Welle
CLIENT:
Los Angeles Magazine
MEDIUM: Acrylic
SIZE: 16" x 12"

P. 460
ART DIRECTOR: Martha Rago
CLIENT: Henry Holt & Co
MEDIUM: Acrylic
SIZE: 23" x 19"
P. 509
MEDIUM: Acrylic
SIZE: 24" x 24"

JACK UNRUH
8138 Santa Clara Drive
Dallas, TX 75218
214-327-6211
jack@jackunruh.com

P. 170
ART DIRECTOR: Judy Pryor
CLIENT:
The Los Angeles Times
MEDIUM: Ink, watercolor
SIZE: 12" x 17"

P. 171
ART DIRECTOR:
Vicki Nightingale
CLIENT: Reader's Digest
MEDIUM: Ink, watercolor

P. 172
ART DIRECTORS:
Mary Parsons
Lee Caulfield
CLIENT:
The Atlantic Monthly
MEDIUM: Ink, watercolor
SIZE: 8" x 10"

P. 282
ART DIRECTOR: Lissa Aickle
CLIENT: Port of Freeport
MEDIUM: Ink, watercolor
SIZE: 17" x 15"
P. 338
ART DIRECTOR: Don Sible
CLIENT: EXTO Energy
MEDIUM: Ink, watercolor
SIZE: 12" x 24"

KURT VARGO
5 Cosway Court
Savannah, GA 31410
912-897-9595
majiks@comcast.net
www.vargoart.com

P. 510
MEDIUM: Acrylic
SIZE: 12" x 15"

WALTER VASCONCELOS
c/o Frank Sturges Representatives
740-369-9702
www.sturgesreps.com

P. 511
MEDIUM: Mixed

ANDREA VENTURA
69 First Place
Brooklyn, NY 11231
andreaventura@earthlink.net
Richard Solomon Artists Representatives
212-223-9545

P. 173
ART DIRECTOR:
Alicia Kowalewski
CLIENT: Toro Magazine
MEDIUM: Mixed

RAYMOND VERDAGUER
337 East 9th Street #8
New York, NY 10003-7780
212-674-2953
raymond@rverdaguer.com
www.rverdaguer.com

P. 461
ART DIRECTOR:
Olivier Etcheverry
CLIENT: Librairie Genetale
Francaise
MEDIUM: Multicolored
Linoleum Cut
SIZE: 14" x 19"

CHARLES VESS
152 East Main Street
Arlington, VA 24210
276-623-0796
charles@greenmanpress.com
www.greenmanpress.com

P. 559
ART DIRECTOR: Charles Vess
CLIENT: Tor Books
MEDIUM: Pen & ink

DAVID VOGIN
314 East 3rd Street
Frederick, MD 21701
301-695-6847
david@davidvogin.com

P. 564
ART DIRECTOR: Ron Mele
CLIENT: Marketing Review
Magazine
MEDIUM: Digital

BRUCE WALDMAN
18 Westbrook Road
Westfield, NJ 07090
908-232-2840
swgraphics@comcast.net

P. 283
ART DIRECTOR:
Stephen A. Fredericks
CLIENT: The New York
Society of Etchers
MEDIUM: Etching
SIZE: 9" x 12"

TOMASZ WALENTA
c/o Marlena Agency
322 Ewing Street
Princeton, NJ 08540
609-252-9405
www.marlenaagency.com

P. 337
ART DIRECTOR: Alissa Levin
CLIENT: Point Five Design
MEDIUM: Mixed

HIROSHI WATANABE
4-1-18-104 Nishiikuta Tama-Ku
Kawasaki-Shi
Kanagawa, 214-0037, Japan
81-4-4953-3425
wata-h@pop07.odn.ne.jp

P. 286
ART DIRECTOR:
Toshihide Hori
CLIENT: Amana
MEDIUM: Pastel

ESTHER PEARL WATSON
325 North Adams Street
Sierra Madre, CA 91024
626-836-2210
funchicken@earthlink.net
www.estherwatson.com

P. 565
ART DIRECTOR:
Esther Pearl Watson

KYLE T. WEBSTER
101 North Chestnut Street #10
Winston-Salem, NC 27101
336-765-5612
kyle@kyletwebster.com
www.kylewebster.com

P. 342
ART DIRECTOR:
David Shapiro
CLIENT: North Carolina
School of the Arts
MEDIUM: Mixed
SIZE: 24" x 36"

JONATHAN WEINER
c/o Levy Creative Management
300 East 46th Street #8E
New York, NY 10017
212-687-6463
info@levycreative.com
www.levycreative.com

P. 174
ART DIRECTORS: Devin
Pedzwater, Kory Kennedy
CLIENT: Rolling Stone
MEDIUM: Mixed

P. 343
ART DIRECTOR:
Mark Murphy
CLIENT: Murphy Design
MEDIUM: Oil

P. 512
MEDIUM: Oil

ANDREA WICKLUND
620 Cabrillo Street
San Francisco, CA 94118
415-699-4251
awicklund@hotmail.com
www.andreawicklund.com

P. 464
ART DIRECTOR:
Lara Cleveland
CLIENT: Realms of Fantasy
MEDIUM: Mixed
SIZE: 10" x 13"

KENT WILLIAMS
315 North Detroit Street
Los Angeles, CA 90036
323-252-3165
kent@kentwilliams.com
www.kentwilliams.com

P. 175
ART DIRECTOR: Tom Staebler
CLIENT: Playboy
MEDIUM: Mixed

WILL WILSON
750 Post Street
San Francisco, CA 94109
415-447-8302
wilburbuds3@hotmail.com

P. 513
MEDIUM: Oil
SIZE: 26" x 26"

NICHOLAS WILTON
P.O. Box 470818
San Francisco, CA 94147
415-383-9026
nick@zoclo.com

P. 176
ART DIRECTOR: David Bayer
CLIENT: Wine Spectator
MEDIUM: Mixed

ILENE WINN-LEDERER
986 Lilac Street
Pittsburgh, PA 15217
412-421-8668
ilene@winnlederer.com

P. 566
ART DIRECTOR:
Ilene Winn-Lederer
MEDIUM: Mixed

JEFF WONG
7708 5th Avenue
Brooklyn, NY 11209
718-238-9046
jeffwong@nyc.rr.com
www.jeffwong.com

P. 463
ART DIRECTOR:
Steve Hoffman
CLIENT: Sports Illustrated
MEDIUM: Digital

MINKY WOODCOCK
CVB Space
407 West 13th Street
New York, NY 10014
646-221-5239
cynthia@drawbridge.com

P. 462
ART DIRECTOR:
Mark Murphy
CLIENT: Murphy Design
MEDIUM: Mixed
SIZE: 28" x 18"

NOAH WOODS
927 Westbourne Drive
Los Angeles, CA 90069
310-659-0259
noahwoods@mindspring.com
www.theispot.com

P. 177
ART DIRECTOR: Tom Staebler
CLIENT: Playboy
Enterprises Inc.
MEDIUM: Collage

P. 284
ART DIRECTOR: David Dye
CLIENT:
Merrydown Cider Co.
MEDIUM: Collage
P. 285
ART DIRECTOR:
Barbara DeWilde
CLIENT: Nonesuch Records
MEDIUM: Collage

DAN YACCARINO
95 Horatio Street #705
New York, NY 10014
212-675-5335
dsyac@concentric.net
www.danyaccarino.com

P. 344
ART DIRECTOR:
Margaret Garrow
CLIENT: Peaceable
Kingdom Press
MEDIUM: Mixed
SIZE: 8" x 10"

P. 345
ART DIRECTOR:
David Plunkert
CLIENT: Spur Gallery
MEDIUM: Mixed
SIZE: 11" x 17"

P. 567
ART DIRECTORS:
Don Morris, Jennifer Starr
CLIENT: Nick Jr. Family
Magazine
MEDIUM: Gouache

BRAD YEO
602 8th Avenue NE
Calgary, Alberta T2E 0R6, Canada
403-237-5553
bradyeo@bradyeo.com

P. 178
ART DIRECTOR:
Stacey Clarkson
CLIENT: Harper's
MEDIUM: Acrylic

P. 465
ART DIRECTOR:
Robert Ollinger
CLIENT: Johns Hopkins
Bloomberg School of
Public Health
MEDIUM: Mixed
SIZE: 10" x 10"

NECDET YILMAZ
86-05 253rd Street
Bellerose, NY 11426
718-470-6247
necdetyilmaz@yahoo.com

GOLD MEDAL
P. 192
ART DIRECTOR:
Gurbuz D. Eksioglu
CLIENT: Aydin Dogan
Foundation
MEDIUM: Ink
SIZE: 10" x 13"

DANIEL ZAKROCZEMSKI
168 Olean Street
East Aurora, NY 14052
716-849-4168
dzakroczemski@buffalonews.com

P. 180
ART DIRECTOR: John Davis
CLIENT: The Buffalo News
MEDIUM: Digital
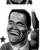
P. 181
ART DIRECTOR: John Davis
CLIENT: The Buffalo News
MEDIUM: Digital

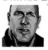

DANIEL ZAKROCZEMSKI
P. 514
ART DIRECTOR: John Davis
CLIENT: The Buffalo News
MEDIUM: Digital

HONGNIAN ZHANG
24 Speare Road
Woodstock, NY 12498
845-679-5865
hzhang@zhangwolley.com

P. 179
ART DIRECTOR:
Jeffrey Osborn
CLIENT: National
Geographic
MEDIUM: Mixed

PHILIP ZHANG
20359 Lake Erie Drive
Walnut, CA 91789
626-215-9273
philipzh@philipzhang.com
www.philipzhang.com

P. 515
MEDIUM: Mixed
SIZE: 5" x 3"

ART DIRECTORS

YANKEE DOODLE AMERICA
The Spirit of 1776 from A to Z

G.P. Putnam and Sons

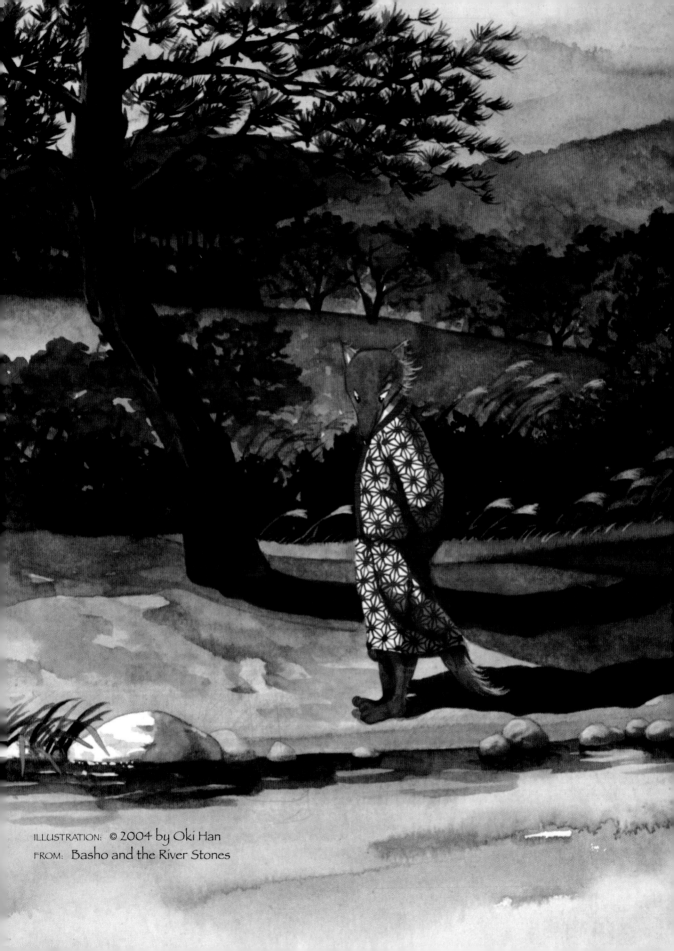

Kirchoff/Wohlberg

Artist Representatives since 1930

866 United Nations Plaza New York, New York 10017

Phone: 212-644-2020

Fax: 212-223-4387

www.KirchoffWohlberg-ArtistRep.com

Aaron Zorn

Read Pate

Katherine Arnold

Read Pate

Great illustrators represent **Gerald & Cullen Rapp**

Brian Ajhar

Philip Anderson

Daniel Baxter

Brian Biggs

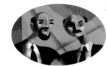
Stuart Briers

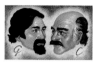
David M. Brinley

Lonnie Busch

Harry Campbell

Jonathan Carlson

R. Gregory Christie

Jack Davis

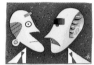
Robert de Michiell

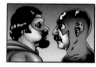
Dynamic Duo Studio

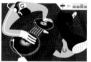
Leo Espinosa

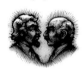
Phil Foster

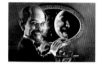
Mark Fredrickson

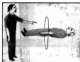
Arthur E. Giron

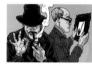
Asaf Hanuka

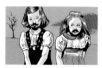
Tomer Hanuka

Peter Horjus

Celia Johnson

Douglas Jones

James Kaczman

J.D. King

Laszlo Kubinyi

PJ Loughran

Bernard Maisner

Coco Masuda

Hal Mayforth

Grady McFerrin

Bruce Morser

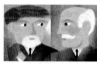
James O'Brien

Dan Page

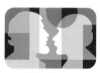
John Pirman

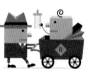
Fred Rix

Marc Rosenthal

Alison Seiffer

Seth

Whitney Sherman

James Steinberg

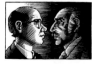
Elizabeth Traynor

Anders Wenngren

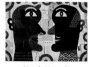
Michael Witte

Noah Woods

Brad Yeo

And **Gerald & Cullen Rapp** has represented great illustrators since 1944

420 Lexington Ave., PH, NY, NY 10170 | Phone 212 889 3337 | Fax 212 889 3341 | www.rappart.com

THE DAVID P. USHER/GREENWICH WORKSHOP
MEMORIAL AWARD

Raúl Colón

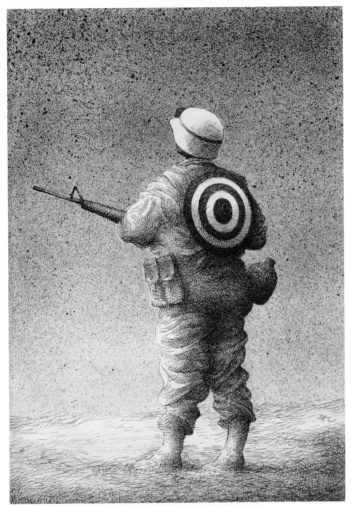

"Army of One" *The New Yorker*, cover

The selection was made from all of the works exhibited in the 47th Annual.

The jury included: Steve Brodner, Nancy Stahl and Tim O'Brien

A CASH PRIZE ACCOMPANIES THE AWARD

The Greenwich Workshop

THE ORIGINAL ART

25TH ANNUAL EXHIBITION

FOUNDED IN 1980 TO "CELEBRATE THE FINE ART OF CHILDREN'S BOOK ILLUSTRATION," THIS EXHIBITION HAS BEEN SPONSORED BY THE SOCIETY OF ILLUSTRATORS FOR THE PAST 15 YEARS.

THE SELECTION PROCESS WAS BY A JURY OF OUTSTANDING ILLUSTRATORS, ART DIRECTORS AND EDITORS IN THE FIELD OF CHILDREN'S BOOK PUBLISHING.

JURY
Steve Geck
Betsy Lewin
Emily Arnold McCully
Richard Michelson
Marc Simont
Mo Willems
Vera Williams

G. BRIAN KARAS, CHAIR, "The Original Art 2005
DILYS EVANS, FOUNDER, "The Original Art"

GOLD
ILLUSTRATOR: *Kadir Nelson*
BOOK: *Hewitt Anderson's Great Big Life*
ART DIRECTOR: *Dan Potash*
EDITOR: *Paula Wiseman*
PUBLISHER: *Simon & Schuster*
IMPRINT: *Paula Wiseman Books/Simon & Schuster Books for Young Readers*

SILVER
ILLUSTRATOR: *Nick Maland*
BOOK: *Snip Snap! What's That?*
ART DIRECTOR: *Paul Zakris*
EDITOR: *Virginia Duncan*
PUBLISHER: *HarperCollins Publishers*
IMPRINT: *Greenwillow Books*

SILVER
ILLUSTRATOR: *Quentin Blake*
BOOK: *Michael Rosen's SAD BOOK*
ART DIRECTOR: *Beth Aves*
EDITOR: *Caroline Royds*
PUBLISHER: *Candlewick Press*

SOCIETY OF ILLUSTRATORS

16TH ANNUAL MEMBERS' OPEN EXHIBITION

"Our Own Show" presents annually the Stevan Dohanos Award as the Best in Show
in this open, unjuried exhibition.

*Our
Own
Show*

SI

STEVAN DOHANOS AWARD
Jonathan Bouw

AWARD OF MERIT
Bob Jones

AWARD OF MERIT
M.K. Perker

AWARDS JURY
Lisa Falkenstern, Randi Hazan, Minh Uong, Roberto Parada, Daniel Dos Santos, Tim Bower and Mark Texeria